FIFTY AMERICAN FACES

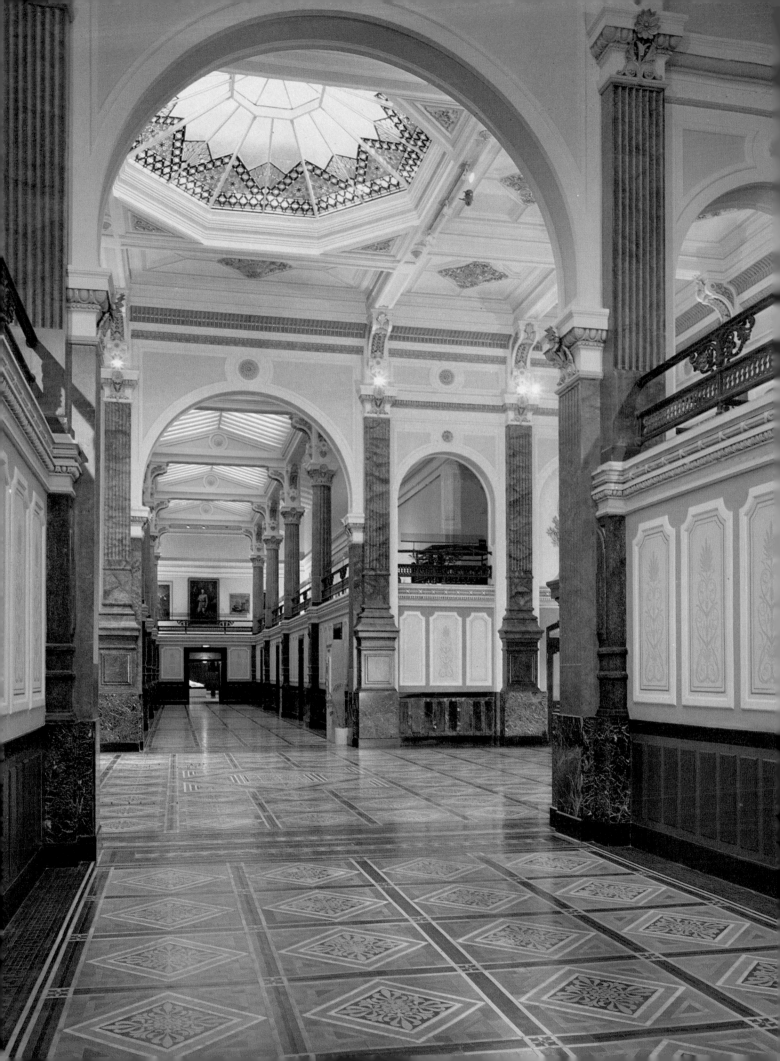

FIFTY AMERICAN FACES

FROM THE COLLECTION OF THE NATIONAL PORTRAIT GALLERY

MARGARET C. S. CHRISTMAN

Published for the National Portrait Gallery by the Smithsonian Institution Press
Washington City, 1978

Frontispiece: The Great Hall, National Portrait Gallery
Photograph by Eugene Mantie

Library of Congress Cataloging in Publication Data
Christman, Margaret C. S.
Fifty American faces from the collection of the
National Portrait Gallery.
Bibliographies included
Includes index.
1. Portraits, American—Exhibitions. 2. United
States—Biography—Portraits—Exhibitions.
I. National Portrait Gallery, Washington, D.C.
II. Title.
N7593.C49 760 78-3526

For sale by the Superintendent of Documents
United States Government Printing Office
Washington, D.C. 20402
Stock number 047-006-00017-1

CONTENTS

Acknowledgment is owed to all of those who have ploughed the ground before me. My debt to the countless authors whose books I have ransacked is an enormous one. ❲ I am under special obligation to the National Portrait Gallery's Curatorial Department, whose research provided the basis for most of the entries. Robert G. Stewart, Curator, Monroe H. Fabian, Associate Curator, and Ellen Miles, Associate Curator, have generously shared their knowledge and expertise. ❲ My thanks go to the three contemporary artists who recalled for me the circumstances of their portrait sittings. Una Hanbury answered my questions about Rachel Carson; Soss Melik provided information regarding Cole Porter; Miriam Troop wrote a detailed reminiscence of Richard Wright. ❲ I am obliged to Professor Sidney Kaplan of the University of Massachusetts and Louise Daniel Hutchinson, Coordinator of Research for Anacostia Studies, for their investigations concerning the Frederick Douglass portrait. Ethel I. Newell of the Historical Collections of the Massachusetts Institute of Technology graciously shared her study of Katherine Dexter McCormick. Professor Richard S. Cramer of the California State University, San Jose, kindly furnished the Gallery with an English translation of O.P.H. Balling's autobiography. ❲ Marc Pachter, Historian of the Gallery, read the entire manuscript and offered cogent suggestions for its improvement. Painstaking Editor Frances Stevenson Wein saved the author from many an embarrassment, including some outrageous syntax. Eloise P. Harvey typed and retyped the whole mass—undaunted by the numerous marginal scrawls and constant changes of mind. I am extremely grateful to all three. ❲ Marvin Sadik, Director of the National Portrait Gallery, conceived the project, selected the portraits, read the essays many times over—often at five in the morning—asked the hard questions, zapped the verbosities, and guided the book along every step of the way. The errors that remain do so despite his best efforts. The responsibility is mine. To Marvin my awed appreciation for caring so much. ❲ My one regret—and it is a poignant one—is that my gladsome young friend, Mary Danielski Brooks, did not live to see the publication of these sketches. To the memory of Mary, who laughed in all the right places, I dedicate this effort.

MARGARET C. S. CHRISTMAN
Washington City, October 1977

The fifty portraits discussed in this volume were selected from the permanent collection of the National Portrait Gallery, which at this writing is rapidly approaching some 1500 likenesses. In making our choices, we endeavored, in microcosm as it were, to fulfill the mandate which guides our whole effort, as set forth by the Act of Congress creating the Gallery, to encompass the range and scope of our national life as revealed through portraits "depicting men and women who have made significant contributions to the history, development, and culture of the people of the United States."

Among those individuals dealt with here are: public officeholders of many political parties; novelists of various styles, a lexicographer, and a journalist; civil rights agitators, a fiery zealot who fought with the sword, along with others who joined the battle with the pen; two businessmen, one a philanthropist and an eccentric, the other an inventor and a rogue; religious leaders of several persuasions and polemics, and a saint; America's first great portraitist, its finest impressionist, and its most evocative realist of the modern era; military leaders of different wars and sides; theatrical figures in costume and character, as well as in mufti; Indian chiefs (limned in captivity); a pair of our most notable jurists; an innovative mid-nineteenth-century physician; a First Lady whose salons were legendary in her own time and remain so in ours, and a hotelkeeper's wife who became one of the nation's pioneering collectors of modern French painting; two ecologists, whose similar philosophies were separated by a century; a couple of the country's most popular and enduring twentieth-century composers; a woman who became the first of her sex to argue a case before the Supreme Court, and another who was one of the first of either sex to triumph over seemingly insurmountable physical infirmities; one of the land's most brilliant documentary filmmakers; and an honorary American, who in addressing the Congress of the United States as the Prime Minister of Great Britain, could not "help reflecting that if my father had been American and my mother British, instead of the other way round, I might have got here on my own."*

If all of our sitters are reasonably familiar, some of their faces are less so, particularly those subjects depicted at an early moment in their careers: Winfield Scott and Frederick Douglass in their late twenties, John C. Calhoun in his early forties, and Edward Hopper at twenty.

All the major media and the variations within them (with the exception of the film, which the Gallery is just beginning to collect) are represented, including pho-

* With the exception of Presidents of the United States, portraits are not admitted to the permanent collection until ten years after the demise of the subject. Presidential portraits have been omitted from this book inasmuch as they are dealt with as a group in another National Portrait Gallery publication.

tography, the life mask, caricature, and folk art (a mode which is one of the most powerful of all in expressing certain qualities of the American character, and in which the collection unfortunately is, and probably will remain, sadly deficient).

Here also are most of the great names usually thought of in American portraiture, with certain exceptions: Charles Willson Peale, Rembrandt Peale, Thomas Sully, Mathew Brady (other portraits by whom the Gallery owns), and Thomas Eakins (a marvelous photograph of whom, by Susan Macdowell Eakins, was acquired after the text of this book had been completed, but an example of whose own portraiture we do not as yet possess).

While scholars have learned to deal with many kinds of documentary materials, portraits are almost always used merely as illustrations. Yet the portrait, because it is a visual record of a person and an era, bears strong witness to each sitter's role in the American experience, and must be studied as a critical piece of historical evidence in its own right. Some portraits are quite literally documents in this sense. That of Charles Cotesworth Pinckney, for example, X-rayed (as works frequently are in connection with their cleaning and restoration), reveals that Pinckney's uniform was altered from the scarlet of his formerly royal regiment to the blue garb of another allegiance, a visible testimony to the fact that, as the subject was later proud to proclaim, "My heart is altogether American." Another (and very different) kind of document is the caricature. Thomas Nast's satirical portrayal of Horace Greeley "bears strong witness" to the manner in which the artist exploited the eccentric (but politically irrelevant) attire his subject habitually wore, in order to ridicule Greeley's candidacy against Ulysses S. Grant (one of our poorest Presidents, who was himself scarcely more sartorially acceptable). It is interesting to note that Nast, in a splendid portrait by John W. Alexander in the Gallery's collection (but not dealt with in these pages), comes off less the bounder after political corruption for which he is best celebrated than the self-satisfied establishmentarian whose deeply prejudiced hatred of blacks and Catholics is generally overlooked.

Carlyle once wrote: *Often I have found a Portrait superior in real instruction to half-a-dozen written 'Biographies,' as Biographies are written; or rather, let me say, I have found that the Portrait was as a small lighted candle by which the Biographies could for the first time be read, and some human interpretation be made of them.* As much as is known, and recorded here in words, of the life and look of such an eminent figure as Chief Justice Marshall, how better can we understand the probity of his interest and the steadfastness of his judicial purpose than to behold the visible evidence of his large and noble head, with its remarkable black eyes which William Wirt said possessed an "irradiating spirit, which proclaims the imperial powers of the mind that sits enthroned within." The seemingly inaccurate proportion of Marshall's figure and its awkward pose, in relation to that head, is dispelled by Justice

Story's description of his Chief's body as "without proportion," his arms and legs appearing to be "half dislocated." This aspect of his appearance not only confirms the way Marshall looked but the way he was: his natural posture and his total lack of posturing. "This extraordinary man," Wirt wrote, "without the aid of fancy, without the advantages of person, voice, attitude, gesture, or any of the armaments of oratory, deserves to be considered as one of the most eloquent men in the world."

That a portrait can tell us something about the artist as well as about the sitter goes without saying. Here, the most striking example of the phenomenon is John Singer Sargent's oil of Henry Cabot Lodge. Although Sargent was born in Italy and spent most of his life abroad, he was as quintessentially Bostonian as Lodge. The two were a perfectly matched pair—brilliant, sophisticated, extraordinarily self-confident, and just a little shallow.

By dealing with these sitters at the moments in their lives when they were portrayed, as well as with their lives as a whole, and by approaching their portraitists in the same manner, interweaving the two, these shrewd and sensitive biographical syntheses, alongside the portraits themselves—one helping us to "read" the other— enable us more fully to comprehend the physical and psychological factors, the ideas and idiosyncracies, the events and achievements which animated the personalities they reveal.

MARVIN SADIK, Director

FIFTY AMERICAN FACES

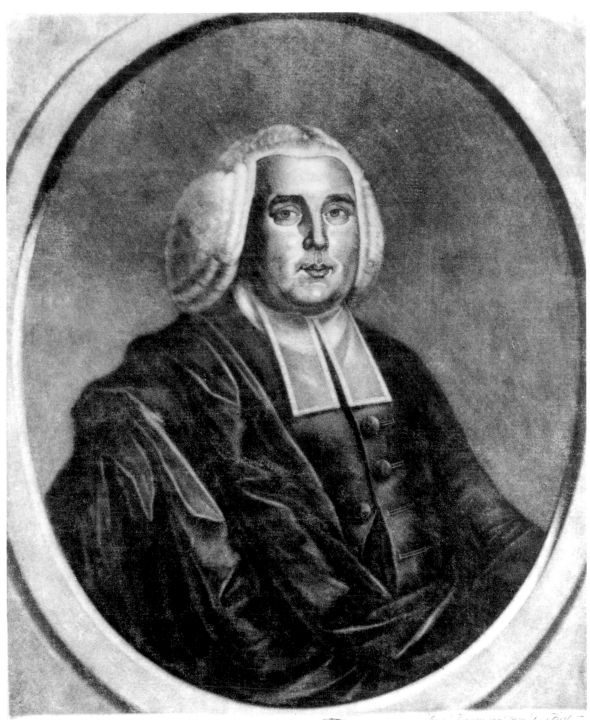

Jonathan Mayhew by Richard Jennys, 1766

Jonathan Mayhew 1720–1766
By Richard Jennys *floruit* 1766–1799
Mezzotint
36.2 x 26 cm (paper); 32 x 24.8 cm (plate)
Signed: *Rich^d. Jennys Jun^r. pinx^t. & Fecit* [lower right]
Inscribed: *The Rev^d. Jonathan Mayhew D.D./Pastor of the West Church in
Boston./Printed & Sold by Nat. Hurd/Engra^r. on y^e Exchange*

1766

NPG.74.63

When the Reverend Dr. Jonathan Mayhew, minister of the West Church in Boston, succumbed, after a month's illness, on July 9th, 1766, Richard Jennys was quick to scrape a print of his recent portrait of Boston's most-talked-about minister. In the same issue of the *Massachusetts Gazette* (July 17th, 1766) which carried Mayhew's obituary and the account of his funeral, appeared the advertisement for the prints "Of the late Rev. Jonathan Mayhew D.D. done in Metzotinto by Richard Jennys, jun" for sale by "Nathaniel Hurd, Engraver, near the Exchange."

Mayhew, sure that God and reason were on his side, had made himself a figure of controversy during the entire nineteen years of his West Church pastorate. Indeed, during the last decade of his life, there was "seldom a moment," as his biographer, Charles W. Akers, has noted, "in which he was not involved in one or more theological, ecclesiastical, or political quarrels." To many he was looked upon, in the words of Robert Treat Payne, as "The Father of Civil And Religious Liberty in Massachusetts and America." To others he was seen as a heretic and rabble-rouser. While Mayhew was alive, few could regard him dispassionately. But when he died, cut off in the prime of his career, in his forty-sixth year, his funeral was attended by "all ranks of people of every denomination," and he was followed to his grave by "as numerous and melancholy a procession as was ever known in this town."

Mayhew, one of the few colonials with a European reputation, was eulogized as *a great divine, an excellent preacher, one of the greatest polemical writers this or any other country has seen. He was a singular and rare instance of ready, keen and piercing wit, united with sound judgment, deep understanding, and profound erudition. His works have been published, re-published, read and admired both in Europe and America.*

Mayhew came from a background that nourished individuality. He grew up on Martha's Vineyard, a member of the noted missionary family that had preached to the Indians through four generations. The Mayhews, however, were not of the college-educated ministry, and hence not cast in the rigid Calvinistic mold. Jonathan's father, Experience, a rather freethinking man of common sense, ignored the great orthodox tenet of predestination and preached a simple gospel which emphasized God's love.

Jonathan Mayhew was seventeen before he entered Harvard, some few years older than the customary admission age. Clifford K. Shipton, in writing Mayhew's biography for *Sibley's Harvard Graduates*, related that "Jonathan was an example of the rule that future theological liberals were disorderly undergraduates." Mayhew's impecunious father must have been hard put to pay his many fines. The most serious incident came during his senior year, when he was caught with other members of the Class of 1744 "drinking prohibited Liquors." The offense itself was common enough to be relatively unimportant, but Mayhew "in a very impudent manner made impertinent Recrimination upon some of the immediate Government of the House."

For his insolence he was degraded in class rank—the ultimate punishment—and only upon "humble confession of his crime" was he restored to good standing. In later years he would come to say, "My natural temper is perhaps too warm."

Harvard forgave Mayhew, and he was awarded a three-year fellowship for theological study. The young divinity student early gained a reputation as a forceful speaker. At Worcester he was a candidate for a vacant pulpit, but, as John Adams reported it later, the general opinion was that "Dr. Mayhew was a smart man, but he embraced some doctrines not generally approved." Worcester wanted no part of anyone who held out the possibility of salvation for all, and Mayhew received but two votes out of the whole congregation.

By this time Mayhew's liberal religious philosophy had been clearly formulated, and from it flowed, as a natural corollary, the political philosophy which caused him to become a harbinger of the American Revolution. In an autobiographical passage in his most famous sermon, "The Snare Broken," he described how this came to be: *If I may be indulged here in saying a few words more, respecting my notions of liberty in general, such as they are, it shall be as follows. Having been initiated, in youth, in the doctrines of civil liberty, as they were taught by such men as Plato, Demosthenes, Cicero and other renowned persons among the ancients; and such as Sidney and Milton, Locke and Hoadley, among the moderns, I liked them; they seemed rational. Having earlier still learned from the Holy Scriptures that wise, brave and virtuous men were always friends to liberty; that God gave the Israelites a king (or absolute monarch) in his anger, because they had not sense and virtue enough to like a free commonwealth, and to have himself for their King; that the Son of God came down from heaven to make us "free indeed," and that where the spirit of the Lord is, there is liberty; this made me conclude, that freedom was a great blessing. Having, also, from my childhood up, by the kind providence of my God, and the tender care of a good parent now at rest with Him, been educated to the love of liberty. . . . I would not, I cannot now, though past middle age, relinquish the fair object of my youthful affections, Liberty . . . the delight of the wise, good and brave; the protectress of innocence from wrongs and oppression, the patroness of learning, arts, eloquence, virtue, rational loyalty, religion!*

Fortunately, Mayhew quickly found a congregation that welcomed his gospel of the Enlightenment. In 1756 he was called to be minister of the West Church in Boston. The liberal congregation, just over the shock of having their first minister run off to join the Anglican Church, was not at all disturbed by Mayhew's heretical reputation, and offered the young minister firewood, house rent, and one of the highest ministerial salaries in Boston. Nor were they concerned when the Boston clergy refused to sanction their choice; Mayhew was installed by a council of country ministers, with not one member of the Boston clergy in attendance. Jonathan Mayhew would remain, through the whole of his famous ministry, outside the pale and would never be invited to join the Boston association of ministers.

Within a few months of his inauguration, the new minister was the gossip of the Boston–Cambridge circuit. Returning to Harvard to receive his master's degree, Mayhew publicly insulted President Edward Holyoke. A contemporary diarist recorded "An affront Put on . . . Edward Holyoke President of the Colledges at Cambridge by Mr. Jonathan Mayhew minister at New or West Boston meeting." Mayhew, whose salary was much larger than Holyoke's, cavalierly added a tip of two copper halfpence to the £4 fee for his M.A. degree. The diarist added that, when "the President seem'd angry at the Copper," Mayhew insisted that "if he did not take all he'd pay him none." In view of the fact that Holyoke had done Mayhew many kindnesses during his years at Harvard, the young minister's action can only be construed as a

lack of grace or a failure of judgment. Despite the childish incident at graduation, Mayhew was ever a loyal son of Harvard and was later instrumental in blocking the attempt, made by the orthodox congregationalists and the Anglican establishment, to found a rival college in western Massachusetts.

The West Church, made up, it was said, more than any other church in Boston of ambitious and self-made men, remained well pleased with its choice of a minister. Mayhew might rail at those in his mercantile congregation who were "concerned in that common practice of carrying on an illicit trade and running of goods," but he also told them that it was a sin not to transgress an iniquitous law. No matter how outrageous his utterances, how slashing his language, how belligerent his posture, his constituents supported him loyally. The church weathered many a theological storm, particularly the protest and cries of outrage that came when Mayhew sarcastically derided the Trinity. "Nor should they think that nonsense and contradictions can ever be too sacred to be ridiculous," he snorted.

Mayhew quickly became one of the most noted American ministers of his time. Within two years of his installation, he published a volume of seven sermons which "raised a great reputation" both in Europe and in America. The book won him Aberdeen University's honorary Doctorate of Divinity, an almost unprecedented honor for a colonial. Harrison Gray, a longtime member of his congregation, remembered with pride that Mayhew's sermons "were admired by Gentlemen of the best taste in England, and by the Clergy in General. In short it was a surprise to many Gentlemen of learning, that America should produce such a Brilliant Genius."

In 1750 Mayhew fired what became known as "the Morning Gun of the Revolution" when he preached, on the anniversary of the beheading of Charles I, a sermon entitled "Discourse Concerning Unlimited Submission and Non-Resistance to Higher Powers." Instead of the establishment requirement that the day be used as an occasion to preach against disobedience to authority, Mayhew took the opportunity to proclaim the right of revolution. "Rulers have no authority from God to do mischief," said Mayhew in his most remembered sentence. Twenty five years before the Declaration of Independence, he went on to say: *Those in authority may abuse their trust and power to such a degree that neither the law of reason nor of religion requires that any obedience or submission be paid to them; but on the contrary that they should be totally discarded, and the authority which they were before vested with transferred to others, who may exercise more to those good purposes for which it is given.*

John Adams, recalling in his old age the "revolution which took place in the minds and hearts of the people," wrote that Mayhew's sermon "seasoned with wit and satire superior to any in Swift and Franklin . . . was read by everybody; celebrated by friends, and abused by enemies." Adams went on to explain, *The persecutions and cruelties suffered by their ancestors under these reigns [the Stuarts], had been transmitted by history and tradition, and Mayhew seemed to be raised up to revive all their animosities against tyranny, in church and state, and at the same time to destroy their bigotry, fanaticism, and inconsistency.*

The celebrated Reverend Dr. Mayhew seems to have been too preoccupied during the first nine years of his ministry to look about for a wife, but in 1756, at the age of thirty-five, he married twenty-two-year-old Elizabeth Clarke. It was four years before their first child, Elizabeth, was born. In March of 1763 they welcomed Jonathan Mayhew, their only son, who died a little more than a year later. A second daughter, born in 1765, lived but briefly. Elizabeth grew up to marry Peter Wainwright, an Englishman, and they called their first child Jonathan Mayhew Wainwright, a name that for five generations has been passed down to the eldest son of

the family. General Jonathan Mayhew Wainwright, the hero of Corregidor, was the fourth of that name. Ironically, the first Jonathan Mayhew Wainwright, grandson of the ferocious watchdog against the establishment of an Episcopate in America, became an Episcopal Bishop of New York.

Jonathan Mayhew's life came to a climax during the turbulent time of the Stamp Tax. On Sunday the 25th of August, 1765, he preached a sermon on the text "I would they were even cut off which trouble you. For, brethren, ye have been called unto liberty; only use not liberty for an occasion to the flesh, but by love serve one another." The following day the most violent mob yet seen in America unleashed a savage attack on the home of Lieutenant-Governor Thomas Hutchinson, destroying the house and looting its contents. Rightly or wrongly, Mayhew was blamed for inflaming Boston. The rumor spread, as the story was told later, that "some of his Auditors, who were of the Mob, declared, whilst the Doctor was delivering it they could scarce contain themselves from going out of the Assembly and beginning their Work." Whether or not any of the mob was actually at the church service has never been established.

Mayhew, horrified that he was accused of approving, indeed encouraging, violence, wrote to Thomas Hutchinson, "God is my witness, that from the bottom of my heart I detest these proceedings; that I am sincerely grieved for them, and have a deep sympathy with you and your distressed family on this occasion." The minister disclaimed any responsibility for the incident, saying, "I cautioned my Hearers against the abuses of liberty. . . . In truth I had rather lose my hand, than be an encourager of such outrages as were committed last Night."

The following Sunday he preached on the abuse of liberty.

One of the last sermons Mayhew delivered was in thanksgiving for the repeal of the stamp tax. In "The Snare Broken," preached on May 23rd, 1766, he said, *I will not meddle with the thorny question whether, or how far, it may be justifiable for private men, at certain extraordinary conjunctures, to take the administration of government in some respects into their own hands. Self-preservation being a great and primary law of nature . . . the right of so doing, in some circumstances, cannot well be denied.*

On the 9th of June Mayhew traveled to Rutland, Vermont, to participate in a church council. He returned home exhausted and was soon seized with a "violent nervous Disorder" that left him paralyzed. A month later he died.

Mayhew's fame may have been eclipsed by time, but far worse has been the fate of Richard Jennys, an artist whose identity has been all but forgotten. Neither his birth nor death dates can be found; the details of his life are almost unknown.

In the early nineteenth century, William Dunlap, compiling information for his history of American art, could find little about his artist. "Jennings," Dunlap called him, *is the name of an engraver, who is supposed to have come from England about the beginning of the insurrectionary movements in Boston, and retired again immediately to be out of the way of trouble. All we know of him, is from our friend Buckingham, who says he engraved a head of Nathaniel Hurd, from a likeness painted by Copley. It was in mezzotinto. Probably the first mezzotinto scraped in America. While in this country he resided altogether in Boston.*

The only truth in this account is that Jennys very likely did execute an engraving of Hurd after John Singleton Copley's circa 1765–1770 portrait of the silversmith. Although the mezzotint itself has never come to light, the *New England Magazine*, published in Boston in 1832, contains a lithographic portrait of Hurd with a caption indicating that it was taken from "a mezzotint made by a man by the name of Jennings."

In 1925 art historian Frederic Fairchild Sherman discovered the companion por-

traits of a Brookfield, Connecticut, couple, Isaac and Tamar Hawley, which were signed by Richard Jennys and dated 1798. On the basis of these two pictures, Sherman was able to identify a number of unsigned portraits from the Brookfield, New Milford, and Washington areas of Connecticut as being by the hand of Jennys.

Sherman determined that Richard Jennys, Junior, was the son of Richard Jennys, a Boston notary public who died in 1768 (Sherman belives that the artist dropped the "Junior" upon his father's death). Subsequent to the advertisement for the Mayhew engraving, nothing further is known of Jennys until 1771, when he advertised in the Boston newspapers as a dry goods merchant. In October of 1783 he turned up in Charlestown, South Carolina, announcing, in the *Weekly Gazette*, that *Richard Jennys, Portrait Painter, Just arrived from the Northward, Begs Leave to inform the Gentlemen and Ladies of this City and State, that he proposes following the Business of Portrait Painting, in its various branches; and as he has followed that Business at the Northward, and in the West-Indies, with considerable success, he flatters himself able to give satisfaction to all those who may think proper to make trial of his Abilities.*

Many questions about Richard Jennys's life and work remain unanswered.

Akers, Charles W. *Called unto Liberty.* Cambridge, Mass.: Harvard University Press, 1964.

Rossiter, Clinton. "The Life and Mind of Jonathan Mayhew." *William and Mary Quarterly*, series III, no. 7, October 1950, pp. 530–57.

Sherman, Frederic Fairchild. *Richard Jennys: New England Portrait Painter.* Springfield, Mass.: The Pond-Ekberg Co., 1941.

Shipton, Clifford K. *Sibley's Harvard Graduates*, vol. XI. Boston: Massachusetts Historical Society, 1960.

Charles Cotesworth Pinckney 1746–1825
By Henry Benbridge 1743–1812
Oil on canvas
76.2 x 63.5 cm
Unsigned
Circa 1773
NPG.67.1

Descended in the Pinckney family

Charles Cotesworth Pinckney was first painted by Henry Benbridge in the fall of 1773 or the spring of 1774. The American-born, European-trained Benbridge posed Pinckney in an attitude of nonchalance, as well suited to the self-assured Carolinian "nabobs" as it was to the English country gentry. Pinckney, born with a "passion for glory," was shown originally in the scarlet uniform of his royal allegiance, lieutenant in the elite corps of the Charles Town Militia. About two years after the original sitting, Pinckney asked Benbridge to make some changes in the portrait. By June of 1775, Pinckney, captain in the South Carolina First Regiment (later to become the First South Carolina regiment of the Continental Line), was in rebellion against his sovereign. The man who later would recall "I entered into this Cause after reflection, and through principle, my heart is altogether American" wished to be recorded in the uniform of his new adherence.

Laboratory X-rays have revealed the full scarlet uniform beneath the patriotic attire. Also evidenced is the presence of a light flintlock or fusil, indicating perhaps

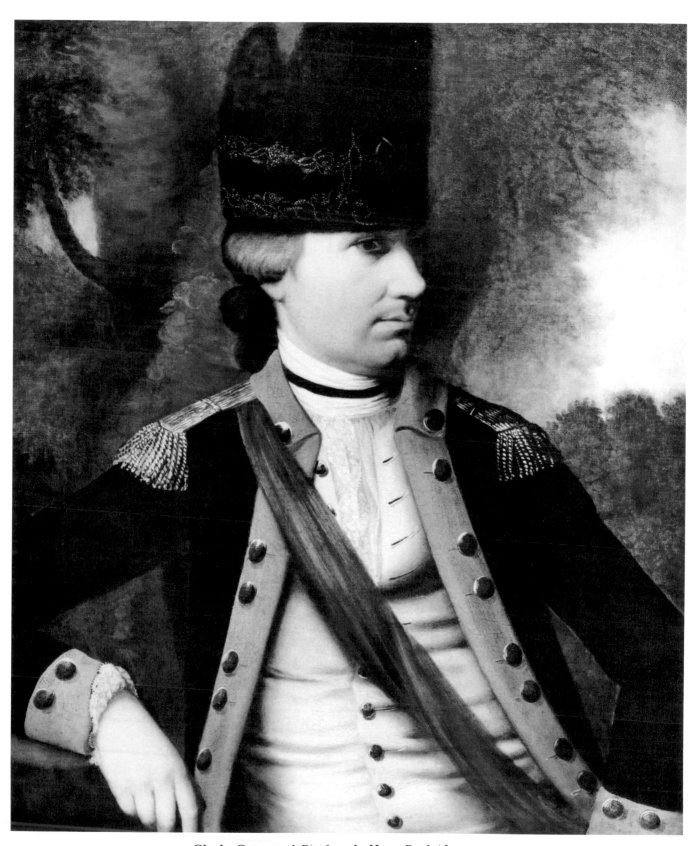

Charles Cotesworth Pinckney by Henry Benbridge, c. 1773

that the overpainting occurred about the time Pinckney was promoted to major in November of 1775. As captain, Pinckney would have been armed with a fusil as well as with a sword; as major he would have flourished only the sword.

Pinckney was the eldest son of Charles Pinckney, an English-trained barrister who had become rich representing Charles Town and London merchants in the local courts. His mother was Eliza Lucas, who when but a girl had assumed management of her father's rice plantation and undertook experimentation which led to the first successful indigo culture in South Carolina. Both of the Pinckneys were extraordinarily innovative parents, trying to help Charles Cotesworth "play himself into learning" by contriving "a set of toys to teach him his letters by the time he can speak."

In 1753, when Charles Cotesworth was seven, his father was appointed by the governor as chief justice of the province, a high honor and one for which Pinckney was eminently qualified. He had served but a few months when the appointment was summarily revoked by the Crown to make way for an English favorite in need of a job. The incident, Charles Cotesworth Pinckney wrote in 1819, "carries me near to my first recollection."

His official duties terminated, Charles Pinckney moved his family to England in order that his three children might be properly educated. In 1758 the parents returned to South Carolina and, within a few weeks of their arrival, Charles Pinckney died suddenly. The responsibility for carrying on the family honor descended to twelve-year-old Charles Cotesworth. "Though you are very young," his mother wrote, "You must know the welfair of a whole family depends in a great measure on the progress you make in moral Virtue, Religion and learning, and I dont doubt but the Almighty will give you grace and enable you to answer all our hopes, if you do your part."

If ever a life gave proof of the saying "as the twig is bent, the tree will grow," it was Charles Pinckney's. Young Pinckney, who had, as his mother noted, "rather a serious than Wild turn of mind," pursued a diligent course through Westminster, followed by Christ Church, Oxford, and the Middle Temple of the Inns of Court. He worked so hard that his mother had cause to worry about his health. "I am alarmed, my dear child," she wrote, *at the account of your being extremely thin, it is said owing to intense study. . . . Should I by my over solicitude for your passing thro' life with every advantage, be a means of injuring your constitution, and depriving you of that invaluable blessing, health, how shall I answer to myself, the hurting a child so truly dear to me, and deservedly so; who has lived to near twenty-three years of age without once offending me.*

Exhausted by his legal studies, Pinckney moved to France for a stay of some months. Utilizing this time as an opportunity to broaden his education, he studied botany and chemistry. Most importantly, he gratified his love of playing soldier by enrolling at the Royal Military Academy at Caen. Beyond personal predilection was the realization that military training would be practical preparation for leadership in a colony where the threat of Spanish coastal raids, Indian uprisings, and slave insurrection was never out of mind.

He returned to Oxford, finished his legal course, and was called to the bar in January of 1769. After riding one circuit in England, he came home, ready to take his place in the life of South Carolina.

Charles Cotesworth Pinckney arrived in Charles Town no earlier than July of 1769. He was twenty-three years old and had been sixteen years in England. His speech and his manners must have marked him apart from his countrymen. Such was his birthright that less than three months after his arrival in Charles Town, he was elected to the Commons House of the South Carolina Assembly.

At the time Benbridge painted his portrait, Pinckney had been six years back in America. His political career was well established, and the young scion was also making his presence felt in the cultural and social life of the Carolina low country. More bookish than most of his contemporaries, he was quick to join the Charles Town Library Society. Well schooled in music, he was an enthusiastic member of the St. Cecilia Society, subscribing to their concerts and on occasion playing the violoncello at their balls. Botany was another of his great interests, and in 1773 he helped found a museum for the study of science. A devout Anglican, he lost no time in assuming leadership in his parish church. He was elected church warden with the same speed as he was elected to the Commons Assembly, and promotion to vestryman followed a few years later.

On the 28th of September 1773, he married Sarah Middleton, an event which was aptly described by the *South Carolina Gazette* as "an Alliance . . . between two as respectable Families as any in the province." Sarah's portrait was likewise painted by Benbridge (Private Collection).

Approximately a year after Pinckney proudly posed in his scarlet uniform, we find him engaged in acts of treason against the British Government. Pinckney, now a member of the Provincial Congress, was appointed to the Secret Committee of five, one of whose functions was to gather munitions to supply the rebels and at the same time prevent stores from falling into the hands of the local tories. On the night of April 22nd, just after the news of the Concord fight reached Charles Town, Pinckney, along with others of prominent name, seized the public powder in the magazine and emptied the armory in the upper part of the State House. Future expeditions netted over five thousand pounds of desperately needed gunpowder for the newly formed Continental Army.

Other activities of the Secret Committee were not as gallant. In the uncertain days of transition from one government to another, the committee took upon itself the task of imposing loyalty to the revolutionary government. In this connection it selected those who were to receive "suits of tar and feathers" on at least one occasion for no more than an insolent speech damning the rebels.

The clandestine activity and intrigue was not suited to Pinckney's open nature. The role he really relished—that of a front line soldier—was not long in coming. In June of 1775, when the Provincial Congress voted to raise two regiments "Officered by Gentlemen, with hired soldiers in the ranks," he was chosen Captain of the first South Carolina regiment. In search of an army, he set out for North Carolina, and by early September was back in Charles Town enthusiastically whipping his corps into proper military form. His recruits sometimes failed to live up to his expectations. He anguished over their repeated "drunkenness and rioting," fretting that his regiment would disgrace its commanding officer. Soldiers should regulate their lives by the worthiest standards, he told them over and over again in his orders of the day.

To be an esteemed good soldier, as he was wont to tell his men, is to procure "the most glorious of all characters." And so Benbridge has captured the gentleman soldier ready to respond to the call of duty and expected glory. With Pinckney's romantic notions of soldiering, it was likely one of the happiest times in his life.

His well-groomed and disciplined troops were destined to stand idly by at Fort Johnson, as the first battle for Charles Town was decided at Fort Sullivan, and the laurels went to Colonel William Moultrie. When the war moved north, Pinckney left his own regiment, hoping to find action with Washington's army. He was present when the Continental Army was defeated at Brandywine and Germantown but found no opportunity to distinguish himself or even make Washington aware of his presence. Pinckney came back to the South only to participate in some of the greatest

disasters of the war. It was ironic that the soldierly Pinckney should find himself in-volved in the most unmilitary expedition of them all, the East Florida trek of 1778 which was marked by sickness, bad weather, lack of supplies, and a jealous bickering between the continental and militia troops that resulted in "a Chaos of Command." Returning from this fiasco, he was next engaged in the ill-fated attempt to retake Savannah. His only consolation was that his own regiment held steady under fire.

When the British attacked Charles Town in 1780, Pinckney was in charge of Fort Moultrie. The enemy fleet, given a good southern breeze at flood tide, sailed right on past. Throughout the siege, Pinckney gave General Benjamin Lincoln incredibly bad military advice, urging him to continue the defense of the city when it should have been obvious that Lincoln's five thousand ill-fed, ill-clothed, and ill-disciplined men could not possibly hold the place against a British force twice their number. Even when the escape routes were cut off and everyone realized that the city was doomed to fall, Pinckney, in a heated speech before the assembled military and civil leaders, declared, "My voice is for rejecting all terms of capitulation and for con-tinuing hostilities to the last extremity."

In the end, Lincoln's whole army and most of South Carolina officialdom was taken prisoner. Thus it was that on May 12th, 1780, Pinckney's career as a Revolu-tionary soldier was all but ended. By the time he was paroled in 1782 and joined the forces of General Nathaniel Greene, the war was over. Pinckney had not been in-volved in a single successful battle during the entire conflict. Throughout, however, he had conducted himself "as becoming an American officer, a man of honour, and a devotee to the freedom and independence of his Country." As he told his brother-in-law, Edward Rutledge, at the time when his British captors were suggesting that he renege on his American allegiance, "You . . . may be assured that I will not do anything however I may be oppressed at which my friends may blush."

Pinckney never lost his military ardor. All of his known portraits, with the excep-tion of a miniature done by Charles Fraser (Gibbes Art Gallery, Charlestown), show him in uniform. At the very end of the war, on the 3rd of November 1783, he was brevetted brigadier general, and for the rest of his life, even as he served as a delegate to the Constitutional Convention, minister to France, candidate for vice-president, and twice for president, he was always referred to as General Pinckney. In the early years of the Republic, President George Washington offered him many appoint-ments, including those of supreme court justice and secretary of state. But the finan-cial losses he had suffered during the Revolution made it impossible for him to accept any of them. "Inevitable Ruin," he told Washington, would be the result if he aban-doned his law practice. One post he declined, with great regret, was that of secretary of war. He wrote to Washington that of "all the public offices in our Country the one you mention to me is the one which I should like best to fill; except in the case of a general War, when if other matters would admit, I should prefer being in the field." He was then forty-eight.

Pinckney has been little remembered. Obscurity, likewise, has been the fate of Henry Benbridge, one of the most important painters of late-eighteenth-century America.

Born in Philadelphia, Benbridge had a natural inclination toward art; as a boy he was said to have painted the whole of the walls of a house belonging to his family with "subjects . . . taken from prints and painted the size of life." The English por-traitist John Wollaston, painting in Philadelphia in 1758, gave him a view of the professional artist, but, like West and Pratt before him, Benbridge looked to Europe for serious art instruction. In October of 1764, when he reached his twenty-first birth-day, he received a small inheritance from his father's estate and soon thereafter went

to Italy, studying there from 1765 to 1769. Before he returned to America in the summer of 1770, he had also spent some months in England, living and working in proximity to Benjamin West.

Pinckney was still in England during that time, and it is possible that he went to see the Benbridge portrait of General Pascal Paoli, the Corsican freedom fighter who had captured not only the British imagination, but the American as well. Charles Town, as Pinckney must have known, had named a street in his honor. He would not, however, have had the opportunity to meet the artist, since Benbridge would not appear in London until some months after he had returned to America.

In England Benbridge had painted a portrait of Benjamin Franklin (unlocated), and when the artist returned to Philadelphia in the late summer of 1770, Franklin wrote to his wife, recommending *our ingenious countryman Mr. Benbridge, who has so greatly improved himself in Italy as a Portrait painter that the Connoisseurs in that Art here think few or none excell him. I hope he will meet with due encouragement in his own country and that we shall not lose him as we have Mr. West. For if Mr. Benbridge did not from affection chuse to return and settle in Pennsylvania, he certainly might live extremely well in England by his profession.*

Benjamin West, writing to a friend in Philadelphia, referred to Benbridge as "an agreeable Companion" and added, "His merit in art must procure him great incouragement and much esteem. I deare say it will give you great pleasure to have an ingcnous artist residing amongst you." And so, too, the people of Charles Town thought when Benbridge, after a year of two, forsook Philadelphia and came to live among them.

Benbridge, on an exploratory trip to Charles Town in 1772, found that the wealthy and fashion-conscious city was indeed a ripe portrait market. The only competition was the Swiss artist Jeremiah Theus, who had, since 1739, virtual artistic monopoly, save for the years 1765–67 when John Wollaston was in residence. Theus was now in his mid-sixties (he would be dead by 1774), and Benbridge undoubtedly calculated that with his up-to-date European style he could hold his own against the old-fashioned Theus.

Such proved to be the case, as the Charlestonians found that Benbridge's Arcadian classicism fit in perfectly with their visions of themselves. From the very beginning Benbridge was financially successful but, like some others, he was at least for a time critical of the hedonistic nature of Charles Town society. He wrote, soon after he was settled, "Everything of news here is very dull, the only thing attended to is dress and dissipation, & if I come in for share of their superfluous Cash, I have no right to find fault with them, as it turns out to my advantage."

So it was that he stayed with them for twenty years, and when the city fell in 1780, he was one of those regarded by the British as "dangerous or subversive." Rounded up along with many of his patrons, he was sent to prison camp at St. Augustine, Florida. He returned to Charlestown in January of 1784, heralded by the *South Carolina Gazette*, which said, "Anticipating the Progress of the ARTS, which we trust soon to see flourish in our State, the gentleman's arrival will give no little pleasure to the Lovers of PAINTING." It was Benbridge who, in 1788, carried the banner of the limners in the grand procession celebrating South Carolina's ratification of the Constitution—which Charles Cotesworth Pinckney, by his suggestion that the slave trade be allowed to continue until 1808, had made acceptable to the South.

Pinckney, Elise, ed. *The Letterbook of Eliza Lucas Pinckney*. Chapel Hill: The University of North Carolina Press, 1972.

Ravenel, Harriott Horry. *Eliza Pinckney*. New York: Charles Scribner's Sons, 1896.

Rogers, George C., Jr. *Charleston in the Age of the Pinckneys*. Norman: University of Oklahoma Press, 1969.

Rossiter, Clinton. *1787: The Grand Convention*. New York: Macmillan Co., 1968.

Stewart, Robert G. *Henry Benbridge (1743–1812): American Portrait Painter*. Published for the National Portrait Gallery, Smithsonian Institution. Washington, D.C.: Smithsonian Institution Press, 1971.

Zahniser, Marvin R. *Charles Cotesworth Pinckney: Founding Father*. Published for the Institute of Early American History and Culture at Williamsburg, Virginia. Chapel Hill: The University of North Carolina Press, 1967.

John Singleton Copley 1738–1815
Self-portrait
Oil on canvas
46 cm diameter
Unsigned
Circa 1780–84
NPG.77.22

*Acquired, with matching funds, through a grant from the
Morris and Gwendolyn Cafritz Foundation*

John Singleton Copley, whom John Adams thought "the greatest Master, that ever was in America," here records his own appearance at about the age of forty, near the auspicious beginning of his English career. Copley was, noted one who saw him just about this time, "very thin, pale, a little pock marked, prominent eye-brows, small eyes, which, after fatigue, seemed a day's march in his head." Like the first of his self-portraits, the watercolor miniature (Private Collection) and derivative pastel (Henry Francis Dupont Winterthur Museum), both executed around 1769 when Copley was at the crest of his American career and newly married to the daughter of a prominent Boston merchant, this portrait also celebrated a period of success and personal happiness. The two images, however, are markedly different. The first, as Jules Prown has noted in his definitive study of Copley, displays an attitude of "bland assurance"; the latter exhibits "restless, almost nervous, vitality." The self-taught colonial, arrived at last on center stage, looks worldly-wise and very ambitious. "It is [not] enough to be a painter; You must be conspecuous in the Croud if you would be happy and great," he had observed not long before.

By the time Copley executed the portrait, around the years 1780–1784, his hard-edged provincial style had given way to a more painterly technique. As he had continually hoped, the opportunity to "see those fair examples of art that have stood so long the admiration of all the world" enabled him to acquire a "bold free and gracefull stile of Painting." Without altering the realistic approach which was fundamental to his manner, Copley had mastered those fine points of sophisticated European art which he had tried in vain to learn through transatlantic correspondence.

Ever since 1766, when his portrait of his half-brother Henry Pelham, *Boy with a Squirrel* (Museum of Fine Arts, Boston), had astonished the English art world—"a *wonderful Picture* to be sent by a Young Man who was never out of New England, and had only some bad Copies to study"—Copley had been urged to come to Europe. He could become one of the finest painters in the world, said Sir Joshua Reynolds,

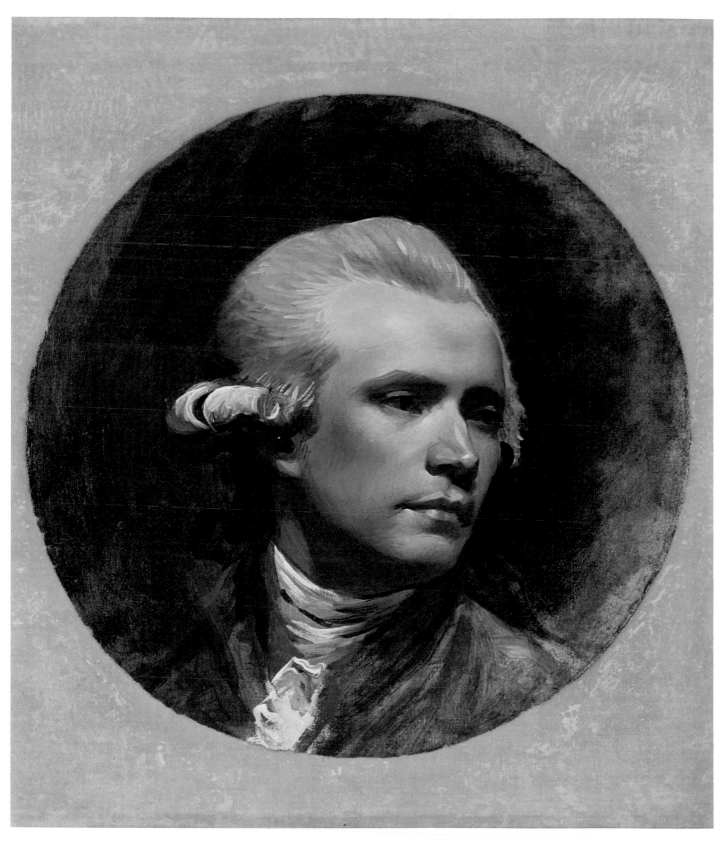

John Singleton Copley, self-portrait, 1780–84

provided he came "before it was too late in Life, and before your Manner and Taste were corrupted or fixed by working in your little way at Boston."

Copley was fully cognizant of the limitations of the provincial environment, where *a taste of painting is too much Wanting to affoard any kind of helps; and was it not for preserving the resembla[n]ce of peticular persons, painting would not be known in the plac[e]. The people generally regard it no more than any other usefull trade, as they sometimes term it, like that of a Carpenter tailor or shew maker, not as one of the most noble Arts in the World. Which is not a little Mortifing to me.*

By the time he was twenty, Copley was painting better pictures than any he had seen. "Perhaps History," wrote Dr. John Morgan of Philadelphia, in introducing Copley to acquaintances in Europe, *cannot furnish a single Instance of any Person, who with so little Assistance from others, and so few Opportunities of seeing any thing worth studying has by the force of his Genius and by close Application to study Nature, arrived to such preeminence in Painting as Mr. Copley.* After the death of his stepfather, the mezzotint engraver Peter Pelham, when Copley was fifteen, the ingenious and persevering youth had made his own way by devouring books on anatomy and art theory and utilizing English mezzotints to help him with costumes and poses. Save for John Smibert's copies of a few European masterpieces and some portraits by the native-trained Robert Fcke and John Greenwood, there were no canvases to study. Joseph Blackburn, however, coming from England in 1755, provided exposure to the shimmering richness of the stylish rococo, thereby giving Copley the final ingredient for an unsurpassed rendition of self-satisfied colonials.

The artist's talent and his clients' expectations were happily joined, and Copley, adept at turning out likenesses which were, as John Adams later recalled, so real that "you can scarcely help discoursing with them, asking questions, and receiving answers," soon had as much business as he could handle. Copley's very success militated against new enterprises. As West and Reynolds continued to urge that he come to Europe, he explained his dilemma· *I am now in as good business as the poverty of this place will admit. I make as much as if I were a Raphael or a Correggio; and three hundred guineas a year, my present income, is equal to nine hundred a year in London. . . . Were I sure of doing as well in Europe as here, I would not hesitate a moment in my choice; but I might in the experiment waste a thousand pounds and two years of my time, and have to return baffled to America.*

What if, he worried, "least after going I shall not find myself so good an artist, as to merit that incouragement that would make it worth my while." The serious-minded Copley added, very practically, that "an easy income is a necessary thing."

Prudence, however, could not completely douse the flame of aspiration. "Fame," he wrote, "cannot be durable where pictures are confined to sitting rooms, and regarded only for the resemblance they bear to their originals. . . . My ambition whispers me to run this risk; and I think the time draws nigh that must determine my future fortune." It would be seven more years, nonetheless, before he would finally make up his mind to leave America.

Except for the turn of political events, one wonders if Copley ever would have hazarded his fortunes in Europe. The awkwardness of having past and potential clients divided in their passions, the futility of trying to mediate between his Tory in-laws and the Sons of Liberty, and most importantly the realization that the disorder of the times was not conducive to the portrait business, all conspired to force his hand. As he had once written to Benjamin West, Copley was "desireous of avoideing every imputation of party spir[it], Political contests being neighther pleasing to an artist or advantageous to the Art itself." By the spring of 1773 Copley had made up his mind that the time for departure was ripe, but, as long as portraits continued to be commissioned, he delayed his journey.

Leaving his pregnant wife and three small children to the care of relatives, Copley at last sailed to Europe in June of 1774. He arrived in England—his reputation long since made by pictures sent there for exhibition—and was warmly embraced by Benjamin West and a host of other admirers. He wrote to his wife, "I am sure you would like England very much; it is a very paradise; but so I think is Boston Common, if the town is what it once was." Flushed with excitement, he told her, "I am impatient to get to work, and to try if my hand and my head cannot do something like what others have done, by which they have astonished the world and immortalized themselves, and for which they will be admired as long as this earth shall continue." Though besieged by those who would have their portraits done, he refused to be deterred by any commissions until he had seen Italy.

In late August he set out on what would be his fourteen-month pilgrimage through France and Italy. Exuberantly he wrote to John Greenwood from Rome that "there is a kind of luxury in *seeing*, as in eating and drinking, and the more we indulge our senses in either the less are they to be restrained."

His rapture was momentarily interrupted by news of Lexington and Concord. Frantic over the safety of his family, he wrote almost hysterically to Henry Pelham, "be neuter at all events." Warning his half-brother against taking up arms, Copley wrote, "I have this exceedingly at heart and trust you will implicitly oblige me in this way for God's Sake, dont think this is a Triffling thing. My reasons are very important." In a subsequent letter he added, "go on with your Studys, and let those fight that chuse to fight." Once Copley's anxiety had been relieved by the news that his family had arrived safely in England, he marveled that everything had indeed worked out for the best.

Earlier he had observed: *Could any thing be more fortunate than the time of my leaving Boston? Poor America! I hope the best but I fear the worst. Yet certain I am She will finially Imerge from he[r] present Callamity and become a Mighty Empire. and it is a pleasing reflection that I shall stand amongst the first of the Artists that shall have led that Country to the Knowledge and cultivation of the fine Arts, happy in the pleasing reflection that they will one Day shine with a luster not inferior to what they have done in Greece or Rome in my Native Country.*

In October of 1775 Copley was back in London for a happy reunion with his family, an event which he subsequently celebrated by painting a group portrait of his wife, children, father-in-law, and self (National Gallery of Art, Washington). Loyalist Judge Samuel Curwen, taking tea with the Copleys in April of 1776, was amused as he watched the artist's "performance in painting" the family piece "of all of Whom, I observed a very striking likeness." With the brush strokes carefully hidden, the work was executed much in the technique of Copley's American pictures.

Copley settled in fashionable Leicester Square just across the way from Sir Joshua Reynolds. The well-appointed residence he regarded, no doubt, as a proper substitute for his elegant establishment on Beacon Hill, "the farm" just adjacent to John Hancock's place.

In Rome he had bought black velvet to make a suit of clothes and then went on to purchase crimson satin for the lining and lace for the shirt ruffles. He also flourished a sword and a hickory walking stick with an ivory head.

All the portraits of Copley show him to be a man of style and rich taste. In the watercolor miniature (and its derivative pastel) he is seen in a brocaded silk dressing gown; in the family portrait it can be discerned that he is wearing a garment of rich green stuff; he sat to Gilbert Stuart (National Portrait Gallery, London) in red velvet coat and ruffled shirt; he posed for the group portrait of the Royal Academicians (Royal Academy of Arts, London) leaning on his walking stick and affecting a

fashionable stance; he was drawn in profile by George Dance (etched by William Daniell) dressed to the height of 1790s fashion.

Although Copley made it clear that he had settled in England for professional and not political reasons, the fate of his American land remained very much in doubt, and so, ever fearful that he might not be able to support his family, he put aside thoughts of ambitious history pieces—unless one were to be commissioned—to concentrate on the more certain portrait market. In the knowledge that his double portrait of South Carolinians Mr. and Mrs. Ralph Izard (Museum of Fine Arts, Boston), painted while he was in Rome, had been hailed by the British critics as better than West's attempts at portraiture, he began his new career with optimism. In November 1776 he was elected an Associate of the Royal Academy.

Copley's first commission for a history painting came in 1778, when London merchant Brook Watson ordered a picture commemorating his rescue from the jaws of a shark, an incident which had taken place when, as a boy of fourteen, Watson was swimming in Havana Harbor. The dramatic and romantic canvas (National Gallery of Art, Washington) drew much attention and acclaim when it was exhibited at the Royal Academy in 1778, and Copley was hailed as "a Genius who bids fair to rival the Great Masters of the Ancient Italian Schools." The following year he was elected to full membership in the Academy.

Buoyed by the triumph of *Watson and the Shark*, Copley immediately began work on an enormous historical piece depicting the sensational and poignant collapse of the Earl of Chatham (William Pitt the Elder) in the midst of parliamentary debate. *The Death of the Earl of Chatham* (Tate Gallery, London), which contained over fifty separate portraits, at least half of which were done from life, occupied most of Copley's time during the next two years. Taking a certain amount of artistic license—peers in debate, for instance, would never have been clad in their ceremonial red robes—Copley gave a contemporary event in English history a visual excitement that had great public appeal. When the picture was shown in the spring of 1781 (apart from the Royal Academy exhibition, which ran concurrently), over twenty thousand people paid to see it, and the subscription list for the proposed engraving rose to twenty-five hundred. Notwithstanding the bad feelings engendered by its being, in effect, in competition with the Academy exhibition, and a subsequent dispute about the issuing of engravings, the endeavor had been an unqualified success. Copley had proven himself master of the highest branch of his profession. He stood now as a history painter on a par with the great West himself.

During the next few years, Copley painted some of the finest portraits of his English career, and executed what many consider his finest historical work, *The Death of Major Peirson* (Tate Gallery, London). This last, an action-filled piece which showed the mortal wounding of a young English officer just after he had rallied his troops and repulsed a French attack on the British Isle of Jersey in 1781, so impressed King George III that Copley was given the opportunity to paint a conversation piece featuring three of the royal daughters. Copley saw this good fortune as the means of scaling the final heights and becoming a favorite artist of the court circles. But it was not to be. *The Three Princesses* (Her Majesty Queen Elizabeth II), derided by competitor John Hoppner, who wrote in a review, "So, Mr. Copley, is this the fruit of your long studies and labours? . . . Is it because you have heard *fine feathers* make fine birds, that you have concluded *fine cloaths* will make *Princesses?*" brought him no patronage from the highest sitters in the land. The indifferent reception afforded this work marked the beginning of a reversal in Copley's fortunes.

The years ahead were marred by blighted hopes. Overconcerned with his prestige, Copley worked relentlessly to please his clients and surpass his rivals. But success all

too often evaded him. Personal deterioration accompanied his artistic decline. He bickered constantly with his Academy colleagues, particularly with Benjamin West, as jealousy caused past kindnesses to be forgotten. So peevish and surly did Copley become that diarist Joseph Farington noted, with perfect astonishment, that the artist "accosted me civilly, for the first time in several years." Beset by financial difficulties, embroiled in numerous lawsuits, Copley became disillusioned, disappointed, and eaten up with regrets—regret that the classical casts he had purchased in Rome in long-ago 1776 had been broken in shipment; regret, as his wife reported to their daughter in 1807, that he had not returned to America "many years since"; regret that he had been bilked into selling his Beacon Hill property for a fraction of what it turned out to be worth. About this last, Farington recorded that "upon this He ruminates, & with other reflections founded upon disappointment, Passes these His latter days unhappily."

Samuel F. B. Morse, seeing Copley in 1811, wrote: *He is very old and infirm His powers of mind have almost entirely left him; his late paintings are miserable; it is really a lamentable thing that a man should outlive his faculties. He has been a first rate painter, as you well know. I saw at his room some exquisite pieces which he painted twenty or thirty years ago, but his paintings of the last four or five years are very bad.*

But Copley never gave up his artistic strivings. Not many months before his death, his wife reported to their daughter, "Your father grows feeble in his limbs; he goes very little out of the house, for walking fatigues him; but his health is good and he still pursues his profession with pleasure, and he would be uncomfortable could he not use his brush." Nearly half a century earlier, Copley himself had noted, "Painters cannot Live on Art only, tho I could hardly Live without it." He continued to paint until felled by a stroke in August of 1815. A month later he died.

Amory, Martha Babcock. *The Domestic and Artistic Life of John Singleton Copley, R.A.* Boston: Houghton, Mifflin & Co., The Riverside Press, 1882.

Copley, John Singleton, and Henry Pelham. *Letters & Papers 1739-1776*. Boston: The Massachusetts Historical Society, 1914.

Parker, Barbara Neville, and Anne Bolling Wheeler. *John Singleton Copley*. Boston: Museum of Fine Arts, 1938.

Prown, Jules David. *John Singleton Copley* (2 vols.). Cambridge, Mass.: Harvard University Press, 1966.

John Jay 1745–1829
By John Trumbull 1756–1843
Oil on canvas
128.3 x 101.6 cm
Unsigned
Begun circa 1783; finished probably circa 1804–8
NPG.74.46

First owned by Peter Augustus Jay, eldest son of the sitter, who left it to his eldest son. Descended in the Jay family

Traditionally the portrait of John Jay has been labeled as the joint work of two great American artists, Gilbert Stuart and John Trumbull. Stuart sketched in the head from life. What remains for our eye is basically the work of John Trumbull, who

finished the portrait. Jay, later to become the first chief justice of the United States, is seen as he appeared in 1783, when he was thirty-eight years old. Along with Benjamin Franklin and John Adams, he had recently completed negotiations bringing the American Revolution to an end.

Jay had come to the negotiating table with a reputation for punctiliousness almost unequalled in the colonies. A loyalist source noted that when Jay was a member of the New York committee overseeing compliance with the non-importation agreements, he went so far as to report the names of the ladies who drank tea at the assemblies. Jay's rigidity of character and his insistence upon following procedural details served as a necessary balance to the personal, freewheeling diplomatic style of Dr. Franklin. "The principal merit of the negotiation was Mr. Jay's," said John Adams. "A man and his office were never better united than Mr. Jay and the commission for peace. Had he been detained in Madrid, as I was in Holland, and all left to Franklin as was wished, all would have been lost."

Shortly after the final Peace Treaty had been signed in Paris, Jay embarked for England "in quest of health." He arrived in mid-October, and a month spent at Bath "removed the pain in my breast which has been almost constant for eighteen months." He remained in England until late January 1784, "between three and four sad months. Bad weather and bad health almost the whole time."

We learn, however, from the reports of John Adams and his son John Quincy, that the sojourn was not as gloomy as Jay made it out to be. The two Adamses, arriving in London in late October, found Jay comfortably lodged with the William Binghams. Bingham, a prominent Philadelphia financier, and his wife were living in fashionable Cavendish Square. John Quincy Adams wrote to Jay's nephew that although his uncle had been very unwell, "I think he looks better at present, than I ever have seen him." In subsequent weeks the younger Adams related that Jay dined abroad and attended them to the theatre. John Adams, who found that "our American painters had more influence at court to procure all the favors I wanted" than all the ministers of state or ambassadors, reported that Benjamin West, in asking George III's permission to show the Americans the West paintings installed in Buckingham Palace, had been told to show them "the whole house." Accordingly, on the 8th of November, Jay and Adams explored all the apartments at leisure.

Abigail Adams, upon her arrival in England some months later, reflected that the Americans, John Singleton Copley and Benjamin West, were "the 2 most celebrated painters now in Britain." Both Jay and Adams agreed to pose for Benjamin West's proposed portrait depicting the signing of the preliminary peace treaty. The picture was never executed, and Jay's likeness is the only completely finished figure in the preliminary sketch (Henry Francis Dupont Winterthur Museum).

Jay posed also, at this same time, for another American artist, Gilbert Stuart. In negotiating and signing the document which ended a long war and guaranteed the independence of his country, Jay had just performed what to date had been the crowning act of his life. A man with his pride of family would surely find this an appropriate moment for an "ancestral" portrait.

Stuart, the son of a Scottish millwright and a Rhode Island farm girl, had been in America a world apart from Jay, whose father was a wealthy merchant and whose mother was from a patroon family, the Van Courtlandts. Jay, with a King's College education followed by a legal apprenticeship, was thoroughly schooled in his profession. Stuart, who from the age of thirteen copied such prints as his Newport environment afforded, was essentially self-educated.

Stuart had come to England in 1775 with little money and no letters of introduction. The first year he almost starved to death. In desperation, the proud and spirited

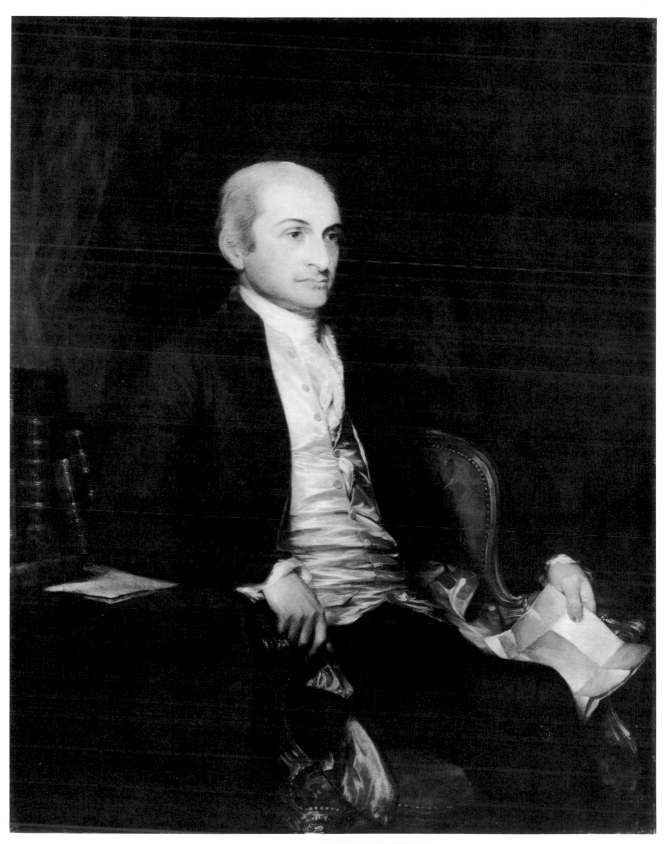

John Jay by John Trumbull, c. 1783, finished before 1808

young artist wrote to Benjamin West humbly asking for help: *Pity me good sir I've just arrived at the age of 21, an age when most young men have done something worthy of notice and find myself ignorant without business or friends, without the necessities of life so far that for some time I have been reduced to one miserable meal a day and frequently not even that, destitute of the means of acquiring knowledge.* The beneficent West, of course, took him in, and there Stuart remained for five years. West provided Stuart not so much with instruction in technique—Stuart saw things through his own eyes—but rather with an ambience which nourished his innate genius and provided an exposure to the world of culture and sophistication.

In November 1784 William Temple Franklin would report to his grandfather that Stuart was "esteemed by West and everybody as the first portrait painter now. . . . I hear West says that 'he nails the face to the canvas.' " Jay probably heard about Stuart through William Bingham, who was soon to become one of the artist's most important patrons.

Jay posed for Stuart—perhaps even as he sat to West—sometime during his London visit. A greater contrast in personalities can scarcely be imagined—the sober, meticulous, calm, responsible, prudent, pious, and bigoted (particularly against Roman Catholics) Jay versus the gay, unorganized, mercurial, irresponsible, reckless, irreverent, and tolerant Stuart.

The two men nonetheless shared a quality of assurance and had come together at a time when they both had particular reason for self-satisfaction. Jay would soon be returning to America, as John Adams put it, "like a bee to his hive, with both legs loaded with merit and honor." Stuart had reached the top of his profession and knew that he could compete with the best of them—Sir Joshua Reynolds, George Romney, Thomas Gainsborough—and command prices commensurate with his growing reputation.

Moreover, under Jay's somewhat glacial exterior lurked a dry wit, and the man who cherished a lifelong friendship with the irrepressible Gouverneur Morris could not have found Stuart altogether outrageous. Like most other people, Jay no doubt was captivated by the Stuart charm. When Stuart arrived in New York in the spring of 1793, Jay was among the first to commission a portrait, ordering another three-quarter-length picture, this time posing in academic robes (Jay Family, on loan to the National Gallery of Art). He also agreed to provide Stuart with a much-coveted letter of introduction to George Washington.

In London Stuart had painted a three quarter-length portrait of John Jay, showing him dressed in a black suit (Jay Family, on loan to the Department of State). A second portrait, however, was never completed. Once the head was sketched in, Stuart abandoned the canvas—not an unusual practice with him. As it was with the "Athenaeum" head of Washington, he may have intended the sketch for use in painting replicas. In any case, Stuart cared little for anything beyond the face; the mundane details of dress and background bored him. Procrastination was also legendary with him. The fact that Stuart did not finish this portrait of John Jay is not nearly as puzzling as the question of why John Trumbull did and under what circumstances.

Trumbull and Stuart first met in 1780, when Trumbull was a fellow student of Benjamin West. Like Stuart, Trumbull, too, at a very early age had shown a "natural talent for Limning," drawing pictures on his mother's "nicely sanded" floors. Their family backgrounds, however, were vastly different. Trumbull came from a prominent Connecticut family and, thanks to the aspirations of his father Jonathan, substantial merchant and later Revolutionary War governor of Connecticut, he would prove to be America's first college-educated professional artist. His father had intended him for the ministry or, failing that, the law. Dismissing his son's desire to study with

Copley, he sent him off to Harvard. Visiting Copley's studio, Trumbull found "an elegant looking man, dressed in fine maroon cloth, with gold buttons"—and paintings the like of which he had never dreamed. This brief glimpse of a successful artist reinforced his predilection toward art. Trumbull graduated from Harvard in 1773 at the age of seventeen. At loose ends, he taught school briefly. He joined the Continental Army, saw the battle of Bunker Hill from a distance, and served for a few weeks on Washington's staff. The twenty-three-year-old Trumbull who was, as the nineteenth-century art historian Henry Tuckerman commented, "morbidly sensitive," resigned in February of 1777 over a misdating of his colonel's commission. Except for a brief service with General John Sullivan in Rhode Island during the summer of 1778, his military career was over. Nevertheless he remained all his life Colonel Trumbull and built a good part of his later career on Revolutionary War contacts.

Intent on pursuing art, he took Smibert's old rooms in Boston and occupied himself making copies of the paintings the artist had left behind. With Copley in Europe, there was no one from whom he could seek instruction. Notwithstanding the war, he determined to go to England. He went first to Paris, where Benjamin Franklin gave him a letter of introduction to Benjamin West, and hence to London, arriving during the summer of 1780. Trumbull recalled that after he had impressed West by reproducing his copy of a Raphael Madonna, the artist turned to him, saying, "I will introduce you to a young countryman of ours who is studying with me—he will show you where to find the necessary color, tools, etc., and you will make your copy in the same room." Thus, said Trumbull, "began my acquaintance with Mr. Stuart, who was afterwards so celebrated for his admirable portraits."

Trumbull had not been long with West when he was arrested "on suspicion of high treason," actually a reprisal for the hanging of Major André. He was imprisoned in Bridewell, where he was given comfortable quarters that included a parlor and garden. He spent his time copying several of West's paintings. In June of 1781, after nearly eight months' confinement, Trumbull was released on the surety of West and Copley and on condition that he immediately leave the country.

While Trumbull was in prison, Stuart painted his portrait. Trumbull recalled later, "I sat every day for a week and then he left off without finishing it, saying 'he could make nothing of my damn'd sallow face.'" In a letter transmitting the portrait to the Pilgrim Society in 1840, Trumbull recounted that his friend "Stewart" had painted the face. "I painted the other parts, and it is probably more curious from this fact than from the likeness."

As soon as the Treaty of Paris was signed, Trumbull returned to London. He arrived in January of 1784 and went immediately to Benjamin West's. There he may have found John Jay still posing for *The Signing of the Treaty of Peace*.

The Gallery's portrait of Jay was engraved by John Durand in 1834 and published in Volume II of James Herring's *The National Portrait Gallery* the following year, thus establishing the latest possible date for its completion. Exactly how and when Trumbull came into possession of the unfinished painting has not been discovered.

Trumbull, before he left England in 1789, had acquired the necessary skills for the masterly execution displayed in his finished portrait. Soon after his return to West's studio he had, with the encouragement of the master and the advice of Adams and Jefferson, embarked upon a series of paintings depicting the twelve most momentous events of the American Revolution. While still in England, he had completed *The Battle of Bunker's Hill* and *The Death of General Montgomery* and had done preliminary work on others, including *The Declaration of Independence*. These small canvases, about thirty-by-twenty-inches (Yale University Art Gallery), testify to Trumbull's attainments as a well-trained artist.

Back in America, he worked with singleminded determination, willing to go to

any length to assure the accuracy of his "national history" series. He traveled the East Coast, from New Hampshire to South Carolina, visiting battlefields, seeking out uniforms and other clothing of the past, making sketches and miniature oil paintings of all those who had played salient roles in the winning of American independence. In this connection he painted a miniature of John Jay in 1793, probably intended as part of a projected picture depicting the signing of the Peace Treaty. This was never executed and is known only through a very rough sketch (Historical Society of Pennsylvania).

During these years in America, Trumbull and John Jay became good friends, the association beginning about 1792 when Jay commissioned a bust portrait of his friend Alexander Hamilton. Trumbull and Jay were philosophically akin. Theodore Sizer, in *The Works of Colonel John Trumbull, Artist of the American Revolution*, has described the artist as "a traditionalist in spite of being a revolutionist. He had fought for political freedom, not for social change. Formal, correct, a man of property and an ardent Federalist." The characterization might just as well have been applied to Jay. So it was that in 1794, when Jay was sent by President Washington to England to resolve matters of dispute which threatened another war, he was delighted when Colonel Trumbull consented to go along as his secretary. The diplomatic assignment came at a happy time for Trumbull, since subscriptions for engravings of his historical pieces were not meeting his expectations. He was ready to throw down his brush and move on to a new occupation. Jay, Trumbull, and Jay's eighteen-year-old son, Peter Augustus, arrived in London in May of 1794.

Trumbull seems never to have regarded drawing on the work of another beneath his dignity. He had completed Joseph Wright's portrait of George Washington for Thomas Jefferson. In undertaking posthumous portraits of Alexander Hamilton, he was agreeable to working from the Cerrachi bust instead of from his own life-portrait. Further, Trumbull maintained a high regard for Stuart. In 1794 he advised the South Carolina Society that Gilbert Stuart was the "best painter who has ever been in America." There is evidence enough to indicate that the proud Trumbull might take on the finishing as a matter of course. The quality of the painting indicates that he did so with pleasure and in his usual sound and meticulous way.

It might be presumed that the picture was finished at least by the time the Jays left England in 1795—unless of course Gilbert Stuart still had the canvas. It seems improbable that he would have kept it as part of his baggage as he moved to Ireland and then to America. However, a letter written by Walter Robertson, an Irish miniature painter, gives us pause. Robertson, who had arrived in the United States in 1793, on the same ship with Stuart, wrote to John Jay, then governor of New York, on April 15th, 1796, requesting a sitting. He noted that he had "already sketched the Governor's features from an unfinished portrait of Mr. Stewart's." Robertson's letter confirms the existence of the Stuart life sketch and also appears to indicate that the portrait was not completed until sometime after Trumbull's return to America in 1804.

Trumbull planned to work in Boston but, hearing that Stuart intended to move to that city, decided that "Boston was too small to offer an adequate field of success for two rival artists," and settled instead in New York. Jay had recently retired to his country estate in Westchester County, and Trumbull was commissioned by the City of New York to paint a whole-length portrait of Jay in 1824. It was exhibited in the National Academy exhibition but is now unlocated. In the event that the portrait was not finished in England, Trumbull had ample opportunity to complete it later in America, using either the justice himself or his son Peter Augustus, a New York lawyer, as models for the figure.

The portrait, first engraved by Durand in 1834, was copied by other engravers dur-

ing the nineteenth century, and became in consequence the best-known likeness of John Jay.

Between the two, Stuart and Trumbull have captured a likeness that agrees with contemporary descriptions of Jay. He was, said one observer, "six feet in height, of thin but well formed person, of colorless complexion with blue penetrating eyes, aquiline nose and pointed chin. His hair was usually drawn back from his forehead tied behind and lightly powdered. His manners were gentle and unassuming." John Adams's daughter, Abigail Adams Smith, found him to be "a most pleasing man, plain in his manners, but kind, affectionate and attentive; benevolence is stamped on every feature."

Ide, John Jay. *The Portraits of John Jay.* New York: The New-York Historical Society, 1938.

Jaffe, Irma B. *John Trumbull, Patriot-Artist of the American Revolution.* Boston: New York Graphic Society, 1975.

Jay, William. *Life of John Jay, in Two Volumes.* Freeport, N.Y.: Books for Libraries Press, 1972 (first published 1833).

Johnson, Herbert Alan. *John Jay 1745–1829.* Albany: The University of the State of New York, the State Education Department, Office of State History, 1970.

Morris, Richard B. *The Peacemakers.* New York: Harper & Row, 1965.

National Gallery of Art & Museum of Art, Rhode Island School of Design. *Gilbert Stuart: Portraitist of the Young Republic.* Providence: 1967.

Sizer, Theodore, ed. *The Autobiography of Colonel John Trumbull.* New Haven: Yale University Press, 1953.

Frederick Augustus Conrad Muhlenberg 1750–1801
By Joseph Wright 1756–1793
Oil on canvas
119.4 x 94 cm
Signed: *J. Wright 1790* [lower right]
1790
NPG.74.1

Muhlenberg family until acquired by the Gallery

Joseph Wright has depicted Frederick Augustus Conrad Muhlenberg, the first Speaker of the House of Representatives, in his official capacity. The reporter for the *Columbian Magazine,* once observing him in his role, wrote that Muhlenberg, *by his portly person and handsome rotundity, literally filled the chair. His rubicund complexion and oval face, hair full powdered, tambored satin vest of ample dimensions, dark blue coat with gilt buttons, and a sonorous voice . . . all corresponding in appearance and sound with his magnificent name.*

The description was written as Muhlenberg sat in the House Chamber in Independence Hall, Philadelphia; the portrait was executed some months earlier in the first meeting place of the Congress, Federal Hall in New York City. Visible on one of the bills awaiting signature are the words "5 Act to regulate the." From this partial inscription, Monroe H. Fabian, associate curator of the National Portrait Gallery, was able to determine that Muhlenberg is shown signing House Bill Number 65, "An

Frederick Augustus Conrad Muhlenberg by Joseph Wright, 1790

Act to regulate Trade and intercourse with the Indian Tribes." Speaker Muhlenberg signed the engrossed parchment copy of this bill, as well as another bill relating to Indian affairs and a third concerning lighthouses, on July 20th, 1790, just three weeks before the adjournment of the last session held in New York. The wide chair ("to hold two, I suppose," remarked Vice-President Adams), ordered specifically in 1789 for the Speaker of the House, and its mate, intended for the president of the Senate, are now in the Governor's Room of the present New York City Hall.

As fate would have it, Muhlenberg, a member of the leading German family in Pennsylvania, was painted for posterity in the city where he arrived at the turning-point of his own life. Fourteen years earlier he had been minister of the Lutheran "Old Swamp Church" (Christ Church) which stood at the corner of Frankford and William Streets.

Frederick, along with his elder brother Peter and younger brother Henry, had come to the ministry by heredity. Their father, Henry Melchior, the most prominent German in the colonies, was the founder of the Lutheran Church in America. The three boys had been sent to Germany to receive a sound religious education. From the age of thirteen until he was twenty, Frederick studied at Halle, the great center of Lutheran education, learning logic, theology, Hebrew, Greek, Latin, French and, at the specific request of his father, music. He returned to America in September of 1770 and, together with his brother Henry, was invited to preach a service of Thanksgiving at the newly erected Zion Church in Philadelphia. The proud father reported that "thousands filled the church and listened and looked attentively as if they had never seen or heard the like before." On October 25th, having exhibited a knowledge of scriptural Hebrew, Greek, and Latin and having passed an examination in the doctrines of the Church, Frederick was ordained to be assistant to the senior of the United Evangelical Lutheran Congregation in Pennsylvania. The young minister recorded in his diary, "This day is and always will be to me the most important day of my life." But for the pressure of national events, he might have continued ever after in the footsteps of his father.

The upheaval of revolution, however, forced Muhlenberg to reassess his life. His older brother Peter dramatically exchanged his ministerial robes for the uniform of the Continental Army, telling his congregation, "There is also a time to fight! And that time has now come!" Frederick, who told Peter that "I have always been, and still am, as firm in our American cause as you are," nevertheless disagreed with his brother's new role. In the course of a "gigantic" letter, he told Peter that he thought he was "wrong in trying to be both soldier and preacher together. Be either one or the other. No man can serve two masters." He went on to say, "I have long had some doubts of my own.... I recognize well my unfitness as a preacher.... I incline to think a preacher can with good conscience resign his office and step into another calling." So it happened that, with Sir William Howe's fleet approaching New York and most of his congregation scattered, Frederick Muhlenberg left the city and essentially the Lutheran ministry also. He continued a few years longer as a saddlebag preacher in Pennsylvania, but this was no more than an interim occupation. The watershed had been reached. When other possibilities appeared, he was prepared to seize them.

Muhlenberg found his new career in the politics of revolution. In March of 1779 he was elected to fill an unexpired term in the Continental Congress. He was now, groaned his father, "in the Hurle burle till his waxen wings are melted." Not until 1796, when it was "Damn everyone who won't damn John Jay!" and Muhlenberg cast the deciding vote favoring the explosively unpopular Jay Treaty, would his waxen wings be melted. And even after his career in national politics had been shattered, he

would continue to hold local office until his sudden death from apoplexy in 1801. His father reflected sadly that his middle son was lost "in the political dungheap," but for Frederick it was unfolding opportunity.

Years later John Adams had cause to be fully sensible of the political power of the Muhlenbergs. Speaking of Frederick and Peter, Adams remarked that "these two Germans, who had been long in public affairs and in high offices, were the great leaders and oracles of the whole German interest in Pennsylvania and the neighboring States." He wrote bitterly in 1816 that "these two Muhlenbergs addressed the public with their names, both in English and German, with invectives against the administration, and warm recommendations of Mr. Jefferson," thereby playing a crucial part in denying him a second term.

In the first election to be held under the new Constitution in November 1788, both Frederick and Peter were candidates for Congress. Frederick ran as a Federalist; Peter as an anti-Federalist. The Muhlenberg name transcended factional differences and both were elected, Frederick receiving the highest vote of any delegate from Pennsylvania.

The two Muhlenbergs arrived in New York in March of 1789 and waited, during the next four weeks, for the arrival "of a sufficient number of members to form a House." During this time, two subjects occupied the attention of those already in New York: the choice of a permanent seat of government and the choice of a Speaker of the House. Frederick wrote to Benjamin Rush, "My friends here who indeed entertain a much better Opinion of my Abilities than I deserve think of me as a Candidate for the Speakers Chair. . . . the Thought of it makes me tremble." On April 1st Peter Muhlenberg reported that "a bare Majority of the Members attended, and took their Seats—The House immediately proceeded to the choice of Their Speaker and elected Fred. A. Muhlenberg." Another delegate observed that, although "the competitor of Mr. Mughlenberg was Col. Trumbull from Connecticut, a gentleman well known for his singular Merritt & Respectability," the majority which "preponderated . . . in favour of Mr. Muhlenberg was very considerable." In the end Frederick Muhlenberg was elected unanimously. The official record of the Congress reported that the Speaker was "conducted to his chair from whence he made acknowledgments to the House for so distinguished an honor."

It was intended that the speakership, modeled after that of the British House of Commons, should be an office of high honor and responsibility. To underline its importance, Muhlenberg was escorted into the city by a troop of cavalry, and on New Year's Day both houses of Congress in a body paid their respects to him. The salary was twice that of other Congressmen, twelve dollars a day. Nevertheless the obligations for providing hospitality were so extensive that Muhlenberg, who had tried futilely over the years to supplement his income with not-very-successful ventures into the importing and sugar refining businesses, found that he was unable to afford to keep a horse. Nevertheless he had resolved, some years before, when a member of the Pennsylvania Assembly, "I am here not my own master, and must be satisfied to serve where my fellow citizens want me."

The Pennsylvania Germans saw Muhlenberg's elevation to the speakership as a tribute to the largest minority group in Federal America. An anonymous letter to the *Philadelphische Correspondenz* proclaimed that *the blood of the grandchildren of our grandchildren will proudly well up in their hearts when they will read in the histories of America that the first Speaker of the House of Representatives of the United States of America under the new Constitution was a German, born of German parents in Pennsylvania.*

Muhlenberg's election, however, was due not to his ethnic background, but to the

geography of his constituency. The president was from the South; the vice-president was from New England. Muhlenberg provided representation for the middle-Atlantic states.

In personality and character Muhlenberg was an excellent choice for presiding officer. He was not an extreme partisan. Moderate and good-natured, he antagonized no one. He had a reputation for fairness and also for hard work. His years in Europe had given him poise, but he was innocent of pretension. He was friendly and had a rolicking sense of humor. Moreover he had considerable experience as a presiding officer, having served in that capacity in the Pennsylvania Assembly and also at the state convention which called for ratification of the federal Constitution.

Twenty years earlier his father had written that Frederick "has by nature an honest heart, some experience of God's grace, a tolerably clear head, a sound stomach and moderate bodily vigor. He can endure hardships. . . . He has a fine, clear penetrating voice." These qualities, which the elder Muhlenberg had hoped would make for success as the "Lord's sheep dog," served him equally well as Speaker of the House of Representatives.

No question but that this was a man of hearty appetite, one famed in Congressional circles for hosting memorable oyster suppers. Wright shows us a corpulent man, with a top-heavy torso above short, spindly legs. The fault of the proportions, it must be assumed, lies not with the artist. Henry Tuckerman, in describing Wright's portrait of George Washington (Historical Society of Pennsylvania) as "remarkable for fidelity to details of feature, form, and costume; and, although inelegant and unflattering, it is probably authentic to a remarkable degree," might just as well have been speaking of the Muhlenberg portrait.

Wright, like Muhlenberg, had a family heritage that directed his career. Born in Bordentown, New Jersey, he was the son of the "ingenious Mrs. Wright," the celebrated modeler of life-sized wax figures. When left a widow with three children to support, Patience Wright went to New York, where she set up a waxworks that soon became a popular attraction. In 1772 she moved her family to England where her success accelerated. In consequence she was not only in a position to provide Joseph with financial security but also with entry into the social, political, and artistic life of London. She taught her son to model, and John Hoppner, the English artist who had married her daughter, began his painting instruction. Benjamin West added his advice. Thanks to them all, Wright had the opportunity, when he was in his early twenties, to paint the Prince of Wales, later George IV. In 1781 Wright went with his mother to Paris, where she modeled a figure of Benjamin Franklin which so delighted the American diplomat that he donated a suit of his own apparel to clothe it. Franklin, grateful also for Patience Wright's services to the cause of independence (she had long been an American spy, shipping him secret information inside her wax heads), did whatever he could to support the interests of her son. Through his good offices Wright received commissions to paint several Parisian ladies. Franklin himself agreed to pose for the artist, and Wright received at least three orders for Franklin portraits.

Before Wright's return to America in 1783, Franklin provided him with a letter of introduction to George Washington. Shipwrecked on the voyage, he arrived in America destitute of possessions but with the prized letter in hand. In October of 1783 he traveled to Washington's headquarters near Princeton and painted both the General (Historical Society of Pennsylvania) and Mrs. Washington (unlocated). William Dunlap recalled that he met Wright here and saw the two portraits. "I thought they were very like," he recorded in his *History of the Rise and Progress of the Arts of Design in the United States.*

By 1786 Wright had settled in New York, where he enjoyed the patronage of many of the leading figures of the Federal Republic, including the secretary of foreign affairs, John Jay (New-York Historical Society). In New York he sketched Washington once again, surreptitiously taking his likeness as he attended church services at St. Paul's, and from this drawing etched a profile likeness.

Wright, after moving to Philadelphia with the federal government, met an untimely death there in the yellow fever epidemic of 1793. He was thirty-nine years old and had been working in America for only ten years. His brief career accounts in part for the scarcity of his work—a little more than a dozen authenticated Wright paintings are known. It must also be acknowledged that he was not the most diligent of men. "Mr. Wright," said George Washington, as he awaited the delivery of a commissioned portrait "is said to be a little lazy" and must "be stimulated to the completion." Nonetheless, the president allowed, in a letter written early in 1784, that Wright "is thought . . . to have taken a better likeness of me than any other painter has done. His forte seems to be in giving the distinguishing characteristics with more boldness than delicacy."

Dunlap, William. *History of the Rise and Progress of the Arts of Design in the United States* (2 vols.). New York: Dover Publications, 1969 (first published 1834).

Fabian, Monroe H. "Joseph Wright's Portrait of Frederick Muhlenberg." *Antiques*, February 1970, pp. 256–57.

Hess, Stephen. *America's Political Dynasties*. Garden City, N.Y.: Doubleday & Co., 1966.

Tuckerman, Henry T. *Book of the Artists*. New York: James F. Carr Publisher, 1966 (first published 1867).

Wallace, Paul A. W. *The Muhlenbergs of Pennsylvania*. Philadelphia: University of Pennsylvania Press, 1950.

Alexander Hamilton 1755/7–1804
By Giuseppe Ceracchi 1751–1801/2
Marble (derived from 1791 life sitting)
46.3 cm
Unsigned
Date unknown
NPG.66.30

Original terra cotta bust has disappeared. First marble was cut in 1794 and presented by Ceracchi to his sitter. It remained in the family until bequeathed to the New York Public Library by Hamilton's grandson. National Portrait Gallery bust was originally owned by Levi Woodbury (1799–1841), New Hampshire governor and congressman, secretary of the navy and the treasury, and associate justice of the United States Supreme Court

The Italian sculptor Giuseppe Ceracchi, back in Europe after a year-and-a-half in America, wrote to Alexander Hamilton in July of 1792 that he was "impatient to receive the clay that I had the satisfaction of forming from your witty and significant physiognomy." Hamilton had been among the twenty-seven "Great Men of America" who had posed for Ceracchi in 1791–92. Some of the resulting terra cotta busts—Hamilton's among them—were intended as models for those in marble. Ceracchi

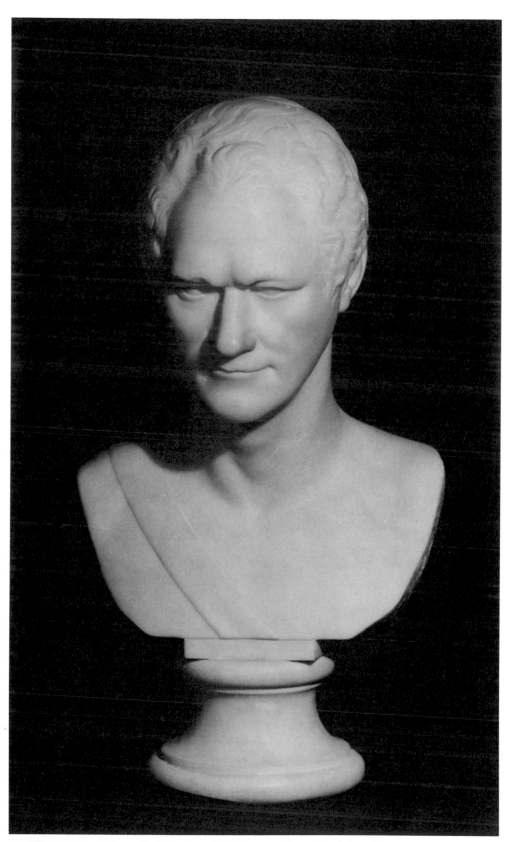

Alexander Hamilton by Giuseppe Ceracchi, date unknown

planned, as he told Hamilton, "to have the satisfaction of driving my chisel into the marble to develop some American heroes."

Ceracchi was famous in Europe for his colossal groups and portrait busts. Just before his voyage to America, he had been working in Rome, executing a large-scale memorial to a Dutch Protestant hero and modeling, simultaneously, the busts of the Pope and two cardinals. In January of 1791 he had come to America, intent on winning the commission for an equestrian statue of Washington, a project approved by the Continental Congress in 1783 but still unfunded. Thomas Jefferson, in recommending the artist to John Hancock, wrote: "The things which he has done here [in Philadelphia] suffice to prove him superior to any artist of his line that I have ever met with." Others were also impressed with "the famous Ceraqui" and agreed with Dr. William Thornton that his presence was "a great acquisition for our republic." He was soon elected to membership in the American Philosophical Society in Philadelphia, an honor which placed him in fellowship with the finest minds in America.

As he waited for a congressional appropriation, Ceracchi busied himself in the modeling of a bust of Liberty, six feet tall, which he intended should be placed behind the Speaker's chair in Congress Hall in Pennsylvania. He also requested sittings from the most influential people in federal America. His letter to Dr. Hugh Williamson, a member of Congress from North Carolina, indicates his line of approach. He wrote, *Mr. Ceracchi requests the favour of Mr. Williamson to sit for his bust, not on account of getting Mr. Williamson's influence in favour of the National Monument; this is a subject too worthy to be recommended; but merely on account of his distinguished character—that will produce honour to the artist, and may give to posterity the expressive features of the American Cato.* Williamson refused, saying that he believed that "posterity will not be solicitous to know what were the features of his face." Most others, however, including President George Washington, Vice-President John Adams, Secretary of State Thomas Jefferson, Chief Justice John Jay, Governor De Witt Clinton, Senator James Monroe, Representative James Madison, and President of the American Philosophical Society David Rittenhouse, "thinking to do him service, sacrificed their time to what they thought his wish to possess their portraits." He modeled them all from life in river clay.

Near the end of 1791, Ceracchi formally submitted to the House of Representatives a plan for "a monument to perpetuate American liberty and independence." Federal funds not forthcoming, he left for New York the following March in an effort to raise money by private subscription. Hamilton wrote him a letter of introduction but said privately, "While I warmly wish success to the plan I would not embarrass my friends by urging it to the prejudice of public objects."

Impatient with a feeble public response, Ceracchi returned to Europe. But, as his letter to Hamilton written soon after his arrival in Amsterdam indicates, he was far from giving up his grandiose project. Mindful of Hamilton's association with financial matters, he took great pains to describe and detail the cost of his proposed "Monument to American Liberty." To give Hamilton an idea of the grandeur of the monument he asked him to imagine a group sculpture sixty feet high, composed of eleven colossal statues fifteen feet high, and six of smaller dimensions. It would, he estimated, take ten years to complete.

In the meantime Ceracchi worked in Rome on a large statue commemorating the unification of the Palatine and Bavaria. His liberal views which, he said, had "much improved in America," eventually got him into trouble with the papal authorities, and he was obliged to abandon his work. By 1794 he was back in America, bringing with him the finished marble busts of Washington (Metropolitan Museum of Art), Jefferson (destroyed in the Library of Congress fire in 1851), Rittenhouse (American

Philosophical Society), and Hamilton, and medallion portraits of Adams (unlocated) and Madison (United States Department of State). All of these were offered as gifts to the subjects. He also brought a six-foot scale model of his proposed monument to American Independence. It featured the goddess of Liberty seen in a chariot drawn by four horses, darting through a volume of clouds to descend on the shore of America. Liberty's arrival was heralded by groups of allegorical figures fifteen feet in height. The cost of this spectacle was estimated at $100,000. James Madison immediately told Ceracchi that such a sum would never be appropriated by Congress and advised that he try private funding. Members of the cabinet agreed to form a commission for the sale of subscriptions. Washington put his name at the head of the list.

Delays in the issuing and processing of solicitations angered the impatient Ceracchi, and he summarily gave up the project and returned to Europe. Frustrated and in need of money, he sent angry letters to the recipients of the marble portraits, demanding payments for what had been accepted as gifts. Hamilton noted in his account book, under the date of March 3rd, 1796, that he paid $620 to Ceracchi "This sum through *delicacy* paid upon Ceracchi's draft for making my bust on his own opportunity, and as a favor to me."

Ceracchi shows Hamilton with a classical coiffure and, save for a strap across the right shoulder, heroically nude. Like Ceracchi's other American sitters, Hamilton appears in the guise of a Roman statesman, an approved style of the day and one which particularly appealed to a society that considered itself attuned to the Roman Republic. Ceracchi's contemporaries found no difficulty in discerning true resemblances in persons thus depicted. Indeed, the Ceracchi busts were frequently looked upon as the most accurate of all likenesses. Jefferson's family found his bust more exact than the one by Jean-Antoine Houdon. Ceracchi's Washington "had been declared," said the nineteenth-century art historian Henry Tuckerman, to have "more truly the expression of the mouth than any other work." And, although John Trumbull painted Hamilton from life in 1792, when he came to do his posthumous Hamilton portraits, he preferred to work from the Ceracchi bust. The Hamilton portrait on the ten-dollar bill, though based on Trumbull's portrait, derives from Ceracchi's portrayal.

It was often remarked that Hamilton's visage bore a dual aspect—a severe look about the eyes but a kindly look about the mouth. The Ceracchi bust, capturing the intensity of eye and the subtle half-smile, pictures the man as his contemporaries knew him.

The French traveler Moreau de St. Méry, who met Hamilton in 1794, recalled: *He was small, with an extremely composed bearing, unusually small eyes, and something a little furtive in his glance. He spoke French, but quite incorrectly. He had a great deal of ready wit.... He had no desire for private gain, but was eaten up with ambition.*

Another who observed Hamilton at about the same time described him as follows: *He was under middle size, thin in person, but remarkably erect and dignified in his deportment.... His hair was turned back from his forehead, powdered, and collected in a club behind. His complexion was exceedingly fair, and varying from this only by the almost feminine rosiness of his cheeks. His might be considered, as to figure and color, an uncommonly handsome face. When at rest it had a rather severe and thoughtful expression; but when engaged in conversation, it easily assumed an attractive smile.*

The "bastard brat of a Scotch pedlar," to use John Adams's phrase, went through life as if he had been to the manner born. "There are strong minds in every walk of

life that will rise superior to the disadvantages of situation, and will command the tribute due to their merit, not only from the classes to which they particularly belong, but from society in general," Hamilton had written in one of the *Federalist* papers. It was an apt description of his own career. A superior mind united with driving ambition had skyrocketed him to the highest circles of wealth and power. At twenty-two he was Washington's aide-de-camp; at twenty-five he married into one of the oldest New York families, the Schuylers; at thirty he had a major influence on the ratification of the Constitution. Now, at thirty-four, he was not only the secretary of the treasury, but virtually the prime minister in Washington's cabinet, interfering at will in the affairs of all departments of government. He was, in fact, at the time Ceracchi saw him, the most influential man in America.

His was a superior genius, untempered by an understanding for those of lesser minds. Even those who loved him conceded his arrogance. Gouverneur Morris, at the very time he wept for his slain friend, confided in his diary that Hamilton had been "vain and opinionated." But there was no denying his charm, particularly when he was among the socially elite. He was a witty and sparkling conversationalist, a "good fellow" at stag affairs and, in mixed company, gallant to the ladies. It was said that he was "the greatest boon to womanhood ever to descend upon Philadelphia for his flattering attention caused husbands to be more solicitous of their own wives." His public speeches were lucid, dispassionate masterpieces of logic. Such was his reputation for persuasiveness that Congress would not permit him to present his reports in person on the grounds that he might unduly sway its judgment.

The year 1791, in which he sat to Ceracchi, was one of important accomplishment for Hamilton. Triumphant over his success in establishing the credit of the young republic through the funding of the national debt and federal assumption of state debts, he moved now toward the completion of his financial program. Called upon to defend the constitutionality of a cornerstone in his fiscal structure, the National Bank, he swiftly wrote a defense which has come to be regarded as a major state paper in American history. His assertion that "It is not denied that there are implied, as well as express powers, and that the former are as effectually delegated as the latter" not only established the bank's legitimacy but the Constitution's flexibility as well.

The year saw success also in establishing a national mint, a program marked by a rare moment of agreement with Thomas Jefferson. The two, in accord over little other than their assessment of "that scoundrel" Aaron Burr, were unified in approval of a decimal system.

Hamilton began another major undertaking in 1791, his report on the plan "for the encouragement and promotion of manufactures," the final piece in his financial organization. Undertaking a considerable correspondence with people all over the country, and utilizing treasury agents, he compiled data on the extent, variety, conditions, and problems of American manufacturing. With an enormous mass of material in hand, he wrote a paper which, although acknowledging the primacy of agriculture, called for a balanced economy, and enumerated the ways in which the government should encourage manufacture. Among his recommendations were measures for protection of infant industries, encouragement of inventions, and building of roads and canals.

Early in his marriage he had written that "it is impossible to be happier than I am in a wife," and he held to that sentiment in principle to the end of his life. He was devoted to his wife and eight children. Nonetheless, he had, as his friends often remarked, an inordinate fondness for women. During his wife's absence in the summer of 1791, he entered into an "irregular and indelicate amour" with Mrs. Maria Reynolds, an entanglement that proved to have political consequences. Forced into pay-

ing blackmail to Mrs. Reynolds's husband, Hamilton appeared, to his enemies, to have used public funds for private speculation. But in 1797, refusing any longer to suffer accusations against his public honesty, Hamilton made public the whole sordid affair, characteristically placing his honor as secretary of the treasury above any personal consideration.

Near the end of 1791 came the portent for his final tragedy. Aaron Burr was chosen over Hamilton's father-in-law, Philip Schuyler, to be senator from New York. One of Hamilton's supporters, assessing the situation, wrote to him that Burr was "avowedly your Enemy, & stands pledged to his party for a reign of Vindictive declamation against your Measures." Less than a year later, Hamilton himself would write of "the appearance of Mr. Burr on the stage," noting that "he is for or against nothing, but as it suits his interest or ambition." Hamilton concluded, "I feel it a religious duty to oppose his career."

Hamilton's death in the 1804 duel with Burr shocked the nation. He was an instant martyr, and his virtues could now be appreciated by those who had feared that he might singlehandedly succeed in establishing a monarchy. In death he obtained the kind of popular adulation that had eluded him in his lifetime. In its wake came the demand for his portrait, and Ceracchi's bust of a timeless Hamilton was regarded as a particularly appropriate image. And, although Ceracchi had met death by guillotine in 1801 (declared guilty of plotting against the life of his most recent patron, Napoleon Bonaparte), the bust was reproduced by others who advertised it in the newspapers as "the celebrated bust by Ceracchi." Hundreds of plaster casts were quickly turned out, and at least two American artisans offered copies in marble at $100 each. A number of these marble versions were produced, and eight are known today, including the one Nicholas Biddle ordered for "Andalusia," his country seat, and the one Thomas Jefferson purchased for Monticello. Jefferson placed the two Ceracchi portraits, his own and Hamilton's, in facing positions across his hall: "Opposed in death as in life."

Bland, Harry MacNeill, and Virginia W. Northcott. "Life Portraits of Alexander Hamilton." *William and Mary Quarterly*, April 1955, pp. 187–98.

Cooke, Jacob E., ed. *Alexander Hamilton: A Profile*. New York: Hill & Wang, 1967.

Desportes, Ulysse. " 'Great Men of America' in Roman Guise." *Antiques*, July 1969, pp. 72–75.

Hamilton Papers, Vols. VII, VIII, and IX. New York: Columbia University Press, 1963 and 1965.

Kline, Mary-Jo, ed. *Alexander Hamilton*. New York: Newsweek and Harper & Row, 1973.

Morris, Richard B., ed. *Alexander Hamilton and the Founding of the Nation*. New York: The Dial Press, 1957.

Schachner, Nathan. *Alexander Hamilton*. New York: Thomas Yoseloff, 1946.

Elizabeth Ann Bayley Seton 1774–1821
By Charles-Balthazar-Julien Févret de Saint-Mémin 1770–1852
Engraving on paper (trimmed to the edge of the image)
5.7 cm diameter
Inscribed: *Mrs. Wm. Seaton*, 1797 [above the image]
Circa 1797
NPG.74.39.328

One of a set of 761 portrait engravings assembled by the artist himself.
After Saint-Mémin's death the collection was eventually acquired by

Elizabeth Ann Bayley Seton, destined to become America's first native-born saint, was one of approximately 850 Americans of the early federal Republic portrayed by the exiled Frenchman Charles-Balthazar-Julien Févret de Saint-Mémin. Her likeness, along with that of her husband, was traced late in 1797. She had been married for three years, and was the mother of two children and pregnant with the third. She could be described either as "the wife of William Seton, distinguished merchant of New York" or as the "daughter of the celebrated Dr. Richard Bayley." Like most women of her time, she had no identity of her own.

Many years later, the Saint-Mémin profile would serve as the basis for another likeness. The features remained untouched, but over the fashionable wig and the neoclassical dress of the late eighteenth century was superimposed Italian mourning garb, the first habit adopted by the American Sisters of Charity. This change in the Saint-Mémin likeness was instigated by the Filicchis, European associates of Mr. Seton's firm, the family which befriended her in Italy after her husband's death there, and introduced her to the teachings of the Catholic Church. The overpainting portrays her as Mother Elizabeth Seton, founder in 1809 of the first American Roman Catholic Sisterhood and mother superior, until her death in 1821, of the Emmitsburg, Maryland, community of the Sisters of Charity. (Some thirty years ago the Federation of Mother Seton's Daughters designated, as the official picture of their founder, the so-called "Filicchi Portrait," a half-length based on the likeness which members of the Filicchi family had presented to the Emmitsburg community in the 1870s.)

Mrs. Seton's features were "taken and engraved" early in what was to be Saint-Mémin's nearly twenty-year career of traveling the Atlantic seaboard, depicting the citizens of New York, Philadelphia, Baltimore, Richmond, Washington, Charleston, and smaller places in between. Saint-Mémin, ex-officer in the Palace Guard of Louis XVI, had lost his property and prospects with the French Revolution. Coming with his family to America in 1793, he cast about for a way of making a living. His European education had included some training in drawing, and he found that he could readily execute landscape views of New York City that were much admired for their exactitude. Making a commercial success of his artistic talent was another matter. However, Saint-Mémin also had a bent for things mechanical, and descriptions found in the pages of an encyclopedia sufficed to teach him the techniques of engraving. Able now to successfully reproduce his drawings of panoramas, buildings, and maps, he had a new profession, but not much income. The lucrative market, he soon realized, was in portraiture. Again utilizing his mechanical abilities, he built an automatic tracing device, called a physiognotrace, based on those already being used in France. Once the features were outlined with absolute accuracy by this mechanical means, the form-building shadows and details of hair and costume were filled in by hand. The large profile was reduced, with the aid of another mechanical device, the pantograph, to a diameter of approximately two inches. The small image was then engraved on a copper plate and the desired number of prints struck.

Saint-Mémin described his business thus: *The creation of my little engravings is so much my own work that I was obliged to be at the same time draughtsman and engraver, builder of pantograph, physionotrace, hand-press, manufacturer of roulettes and other tools necessary to engraving, brayer of my ink, and, furthermore, my own printer.* He also made picture frames for the original crayons, placing the profiles in gold frames. For the fairly moderate price of $25, a male sitter received the large likeness and twelve small engravings. Female subjects, whose more elaborate costume

Elizabeth Ann Bayley Seton by Charles-Balthazar-Julien Févret de St. Mémin, c. 1797

necessitated extra work, were charged $10 more. Additional impressions could be had at $1.50 for a dozen.

Saint-Mémin set up shop in New York sometime in 1796, and almost immediately the parade of fashionable New Yorkers flocked to have their likenesses recorded.

Trained as she was in the proper female accomplishments, Elizabeth Seton spoke French fluently (throughout her life she preferred to pray in French), and, interestingly enough, Saint-Mémin was likely one of the first Catholics with whom she had contact. Late-eighteenth-century New York, predominantly Episcopalian (as was Mrs. Seton), afforded her a view of Deisim, Quakerism, Methodism—a whole smorgasbord of sects and creeds—but Catholicism was practiced by few, and these few were below her in class. "Dirty, filthy, red-faced," her sister would describe them at the time the future saint was pondering about conversion.

Elizabeth Seton was twenty-three years old when she sat to Saint-Mémin, but she looks close to middle age and indeed is muffled up to the neck like an old woman. The retention of the profile, to depict her as a nun in her forties, does not seem untoward. Sending the Saint-Mémin portrait to one of her closest girlhood friends, Mrs. Julia Scott, then living in Philadelphia, she wrote on June 3rd, 1798: *Colonel Giles leaves us tomorrow, and expects to be with you the day after. He will present you with the long-promised little pictures which I hope you will like; not the lively, animated Betsy Bayley, but the softened matron with traces of care and anxiety on her brow. This is much more expressed in the large picture than in the small ones. Present one pair to my brother Samuel and one to Batchelor. Tell them I wish that they may receive half the pleasure I experience when I contemplate theirs; they shall always retain their place over my darling cabinet.* She added, in reference to her husband's portrait, that "My William's likeness will strongly remind you of a Manager at the Assembly; he committed the same fault as brother John, not having his hair cut."

In a subsequent letter, noting that Charlotte Seton, her husband's half-sister, had been offended because she had not received a pair of the engravings, Elizabeth wrote, "I recollect that my Seton brought only the three pair which were struck off expressly because the Colonel was expected to set off immediately. If there had been more copies I might have had more reflection." Without in any way implying cause and effect, it is curious to observe that "sister Charlotte," who would hold Elizabeth directly responsible for the conversion of her younger sister Cecilia, turned violently hostile toward Mrs. Seton who long remembered her threat "that the house would be burned over my head, calling me siren, etc. etc." Julia Scott, on the other hand, would view Mrs. Seton's Catholicism as nobody's business but her own, and moved immediately to help her friend financially when the newly widowed Elizabeth attempted to set up a school in New York.

Looking at the profile of this solemn, self-contained matron, it is hard to imagine that she had just lately been a vivacious young girl who loved music, dancing, and the theatre. Many years later, her daughter, at age eighteen, was staying with Julia Scott, and wrote to Elizabeth Seaton (who was by then a mother superior), "Mrs. Scott says I am so extremely like you, only I do not laugh so much as you once did."

By 1797 the laughter had subsided. Mrs. Seton's husband, long tubercular, was in precarious health, and early in her marriage she wrote, *Every hour I pass shows me the instability of every expectation which is not founded on reason. I have learnt to commune with my own heart, and I try to govern it by reflection, and yet that heart grows every day more tender and softened, which in great measure I attribute to the state of my William's health, that health on which my every hope of happiness depends, and which continues me either the most perfect human felicity or sinks me in the lowest depths of sorrow. That health certainly does not mend, and I often*

think very much decreases, and although it is my fixed principle both as a Christian and a reasonable being never to dwell on thoughts of future events which do not depend on myself, yet I never view the setting sun or take a solitary walk but melancholy tries to seize me.

She was, in 1797, the picture of domesticity. "And what balls or amusements can compensate that quiet, calm tranquillity which Sunday, and particularly Sunday evening affords—with husband shaking his slippers by a good coal fire and a volume of Blair [probably James Blair, Episcopal divine who wrote a work in four volumes entitled *Our Savior's Divine Sermons on the Mount*] opened on the table." One of the "most elegant evenings" of her life was described as the solitary hours spent reading of the "High and Lofty One Who Inhabits Eternity" while the world "lessens and recedes."

In this year too, Mrs. Seton ventured forth to do good works, helping to found a society for the aid of destitute widows. But even this early on, she was preoccupied with thoughts of eternal life. In the spring of 1798 she wrote to Julia Scott, *So you remember the day we rode as far as Hornbrooks on the East river? When we had ascended the hill and were viewing the delightful scenery in every direction, I told you that this world would always be good enough for me, that I could willingly consent to be here forever. But now, Julia, since that short space of time, so thoroughly is my mind changed that nothing in this world, were all its best pleasures combined, would not tempt me to be otherwise than what I am—a passenger.*

At the very time she was sending off the portraits, Elizabeth Seton was, as she told Mrs. Scott, "in the midst of . . . sorrows and perplexities." She goes on to say, "I think I have never in my life suffered so much from the anticipation of evil (as it is a source of uneasiness which I never indulge) as during the last fortnight; for in that space of time we have every hour expected to lose our dear papa Seton, and dreadful have been the hours." In characteristic vein she muses on "the debt we pay for this beautiful creation." "Human life and sorrow are inseparable," she concludes.

A few days later her father-in-law died, "and with him we have lost every hope of fortune, prosperity and comfort." The worst of her forebodings came to pass, and in truth her father-in-law's death marked the beginning of a chain of tragedies which would change the pattern of her life. The family business soon began to fail, and by 1801 her husband was bankrupt. Her own father died in 1801, and her husband two years later, leaving her with five children to support.

In 1805, after a year of painful indecision, Elizabeth Seton converted to Catholicism—much to the delight of her mentors, the Filicchi brothers, but much to the horror of most of her family and many of her New York friends. Once convinced that the Roman Catholic Church was the one true church, Mrs. Seton took this momentous step without regard to social or economic consequences. "To receive the Daily Bread and to do the Sacred Will—that is the fixed point," she wrote, both explaining her choice and at the same time charting the course of the rest of her life. Over a hundred years following her death, Vatican officials, charged with a minute examination of her more than three thousand letters, judged that she had practiced "to a heroic degree" the cardinal Christian virtues of faith, hope, and charity. Thus was the way paved for her eventual sainthood.

By the time Saint-Mémin returned to his native Dijon in 1814, Elizabeth Seton was head of the first American order of nuns, the Sisters of Charity of St. Joseph, a community established in rural Emmitsburg in the foothills of Maryland. In a letter of November 14th, 1809, to Antonio Filicchi, Mother Seton (she had pronounced her first vows of poverty, chastity, and obedience in the presence of Archbishop John Carroll in Baltimore on March 25) described the new venture: *You will laugh when*

I tell you that your wicked little sister is placed at the head of a community of saints, the most pious souls you could wish, considering that some of them are young and all under thirty. Six more postulants are daily waiting till we move in a larger place to receive them, and we might be a very large family if I received half who desire to come; but your Reverend Mother is obliged to be very cautious for fear we should not have the means of earning our living during the winter. Yet, as Sisters of Charity, we should fear nothing.

The new sisterhood was modeled on the rule of the French Daughters of Charity of St. Vincent de Paul, but with modifications to accord with the American circumstances. Most importantly, Mrs. Seton desired, as she told Archbishop Carroll, "the uncontrolled privileges of a mother to my five darlings." Further, although Mother Seton's order had "the entire charge of the religious instruction of all the country round" and the duty of ministering to the poor though "the villages round us are not very extensive," it soon became evident that the cornerstone of the American group would not be charity, as was the case with the French order, but rather education. With financial survival at stake, the main function of the Emmitsburg community soon came to be the running of a boarding school for daughters of Maryland's wealthy Catholics, but admitting without charge, to segregated classes, the children of the local parish. At the very time Saint-Mémin was returning to France, however, the organization was reaching out in other directions, as three of the Emmitsburg nuns went to Philadelphia to take charge of an orphan asylum there, a project, incidentally, which would be generously supported by Julia Scott.

Saint-Mémin had, on the eve of his departure, smashed his physiognotrace which he had come to regard as the symbol of years of drudgery. He retained two or three proofs of each engraving. These he assembled into sets, mounting them on cardboard, naming each sitter and dating the portrait. By the time Saint-Mémin got around to labeling Mrs. Seton's portrait, she was dead, having succumbed to the same disease that had killed her husband, two of her daughters, and the two young nuns who had been her sisters-in-law. "Death grins broader in the pot every morning, and I grin at him," she wrote to her confessor near the close of her life.

Elizabeth Ann Bayley Seton was beatified by Pope John XXIII on March 17th, 1963, and canonized by Pope Paul VI on September 14th, 1975.

Barthel, Joan. "A Saint for All Reasons." *New York Times Magazine*, September 14, 1975, pp. 13 ff.

Code, The Rt. Rev. Msgr. Joseph B. *Letters of Mother Seton to Mrs. Julianna Scott*. New York: The Father Salvator M. Burgio Memorial Foundation in Honor of Mother Seton, 1960.

Dexter, Elias. *The St.-Mémin Collection of Portraits Consisting of 750 Medallion Portraits Principally of Distinguished Americans*. 1862.

Dirvin, Joseph I. *Mrs. Seton: Foundress of the American Sisters of Charity*. New York: Charles Scribner's Sons, 1951.

Melville, Annabelle M. *Elizabeth Bayley Seton 1774–1821*. New York: Charles Scribner's Sons, 1951.

Norfleet, Fillmore. *Saint-Mémin in Virginia*. Richmond: Dietz Press, 1942.

Joel Barlow 1754–1812
By Jean-Antoine Houdon 1741–1828
Plaster (derived from 1803 life sitting)
71.1 cm
Signed: *J. Barlow, 50 ans* [under left shoulder]; *houdon an XII*
[under right shoulder]
Date unknown
NPG.73.17

*First mentioned in the Smithsonian Institution's Annual Report
of 1858 as one of a group of busts acquired from the National
Institute. The Pennsylvania Academy of the Fine Arts has a plaster
which it secured in 1812, the year of Barlow's death. According to
H. H. Arnason, author of The Sculptures of Houdon, original plasters
are also owned by the National Academy of Design, New York,
and the New-York Historical Society. Arnason suggests that, since
the three (and the National Portrait Gallery bust as well) are finished
and closed at the back, they may have been made from a marble version.
Several marble busts were known to have been chiseled, including
one ordered by Robert Fulton in 1813. The marble owned originally
by the Barlow family is now in the White House. A plaster bust of
"M. Barlow, minister of the United States to France, author of the
poem Colombiade" was listed as part of the contents of Houdon's
studio in the sale held after his death in 1828.*

"J. Barlow, 50 ans" wrote the sculptor Jean-Antoine Houdon in cursive script under the left shoulder of the completed bust—an unusual notation, probably requested by the sitter. Under the right shoulder the artist placed, as he more commonly did, his own signature and the date "houdon an XII," (the twelfth year of the French Republic, 1803). Thus did the greatest French sculptor of the Age of Reason document his image of Joel Barlow, poet, businessman, diplomat, and radical.

Joel Barlow was preparing to return to America. After fifteen years in Europe, he was winding up his business affairs and looking forward to basking in the glory of Thomas Jefferson's presidency; and, among other projects, writing a history of the United States from the anti-Federalist point of view. Before he left France, he must have felt it particularly appropriate to have his visage modeled by the man who had earlier immortalized Franklin, Washington, and Jefferson.

The ex-Connecticut farm boy had come to Europe in search of a living. His Yale education had exhausted his small patrimony, but he wrote optimistically to Noah Webster, also a member of the famous wartime class of 1778, *You and I are not the first men in the world that have broke loose from college without friends and without fortune to puff us into public notice. Let us show the world a few more examples of men standing upon their own merit and rising in spite of opposition.* His confidence notwithstanding, it was not easy for one whose main talent was writing poetry to make his way in late eighteenth-century America. He tried teaching school and hated it. A commission as a chaplain in the Third Massachusetts Brigade gave him a livelihood and the leisure to work on his first epic poem, *The Vision of Columbus.* Barlow, however, even with the orthodoxy of Yale fresh upon him, knew that he was not suited to the ministry. He turned to law and then to publishing, and finally, in 1788, came the opportunity to serve as agent for a company selling Ohio land to Europeans. The venture ended in legal and financial disaster but, amidst the ruin, Joel Barlow

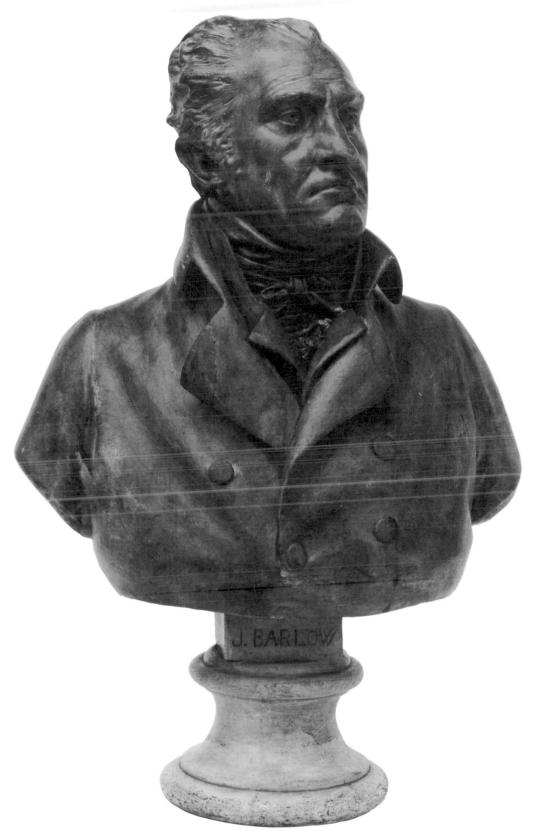

Joel Barlow by Jean-Antoine Houdon, date unknown

had discovered Europe and was born again. The product of Calvinist federalist Yale proved to be, as Vernon Parrington has remarked, "as receptive to new ideas as Timothy Dwight was impervious." Knowing Thomas Paine and Joseph Priestley, meeting Thomas Jefferson in Paris, moving in the society of English liberals, Barlow soon became Republican and deist. Excited as were the others of his circle by the prospects of the millenium as a result of the Revolution in France, Barlow wrote a treatise on the defects of the French Constitution of 1791. He followed this in 1792 with *Advice to the Privileged Orders*, a landmark dissertation in which he proclaimed, among other things, the supremacy of human rights over property rights. This polemic was as provocative in its time as Paine's *Rights of Man*, and almost as widely read. The ministry of William Pitt banned the book and banished the author; the revolutionary government of France made him an honorary citizen.

Barlow moved to France, where he continued to meddle in French politics. The poet and politician proved also, in these next few years, to have a shrewd Yankee business head. Acting as a middleman buying and selling goods for the French, he had by 1794 amassed enough money to turn his attention to a rich variety of outside interests. Like Jefferson, Barlow was a true child of the Enlightenment, absorbed in art, science, agriculture, politics, and literature, and was particularly fascinated by the technological progress of the times. His enthusiasm for invention and experimentation found a focus in his friendship with the American artist-turned-inventor, Robert Fulton, whom the Barlows had met in France in 1797. Although a little more than a decade younger than Joel and Ruth Barlow, Fulton became in a sense the son that the childless Barlows never had. "Toot," as they called him, became a member of their household and lived with them in an enormous and magnificent establishment which Barlow had purchased from an émigré. Barlow delighted in coaching the ill-educated Fulton in French, Italian, and German. Together they delved into works of literature and philosophy, and studied high mathematics, physics, and chemistry. Together they planned canals and tinkered with models of submarines and steamboats. Barlow provided financial backing for Fulton's experiments and also acted as his business manager and advisor, traveling frequently to England (where as a successful businessman he now found acceptance) on behalf of Fulton's projects.

The two friends sat to Houdon at the same time, and the resulting marble busts were on exhibition together in the Salon of 1804.

At the time Barlow posed for Houdon, he was near to completing what he regarded as the great work of his life, the epic poem *Columbiad*, an account of the American past from the time of Columbus to the present and including a prospectus for the future of mankind—some 3,675 couplets in all. Under Barlow's sedulous direction the book was finally published in Philadelphia in 1807. In quarto size, with carefully chosen paper and print, and ten steel-plate illustrations supervised by Robert Fulton, plus a frontispiece engraving of Fulton's portrait of Barlow, the first edition was described as "the very summit of perfection in the mechanical part of book making." Otherwise the work was a fiasco. Stultifying and bombastic, the poem was aptly described by Nathaniel Hawthorne as "a ponderosity of leaden verses." Barlow, as the critic from the *Edinburgh Review* observed, "in his cumbrous and inflated style . . . is constantly mistaking hyperbole for grandeur, and supplying the place of simplicity with huge patches of mere tameness and vulgarity."

The *Columbiad* became best known for its tirades against the tyranny of organized religion, which Barlow's Yale friends took to be his "atheistic principles." His fellow cultural nationalist, Noah Webster, found that, whatever merit the book might have as literature, "the principles of irreligion you avow . . . form the partition wall which has separated you from your old friends."

Vernon Parrington's assessment is kinder than was contemporary opinion. Writing in 1927, he said, *The humanitarian note is strong. War, slavery, monarchy, injustice, the tyranny resulting from political inequality, and a host of other evils, social and political, are assailed in vigorous declamation. It may not be good poetry but the sentiments are those of an enlightened and generous man.*

Barlow, for all his wit, seemed often without the capacity to laugh at himself, and would certainly not be amused to know that he is remembered in American literature not for his much-labored-over *Columbiad*, but rather for the mock epic *Hasty-Pudding*. The latter, which he regarded as a humorous bit of trivia, was written in a moment of nostalgia when, at the time he was campaigning for election to the French General Assembly, he came upon the traditional Yankee dish in the province of Savoy.

Houdon captured, as certainly his dignified subject had intended that he should, the Barlow of the *Columbiad* and not the Barlow of *Hasty-Pudding*. Observing the image of this truculent-looking man, it is difficult to realize that he was one of the most prominent of the Hartford Wits, a writer of satiric and playful verse. But that was in the past, when Barlow could write that he was determined "to love mankind if they kill me." There had been much disillusionment since then. Hopeful though he still was for America, he perceived that dreams of equality and fraternity would not be fulfilled in France, the other country of his affections. "Bonaparte," he said, "has thrown back the progress of civilization & public happiness about one age." The face that Houdon modeled shows displeasure with the world. The brow is furrowed; the mouth tight. He looks older than his fifty years. Despite the arrogant thrust of the chin, the man looks nearly burned out. Barlow would live but eight more years.

Returning to America finally in 1805, Barlow spent his last years but one at Kalorama, a "miniature palace," one visitor called it, "situated on a high hill surrounded with about fifty acres of large forest trees ... Washington, Georgetown, the President's house, the Capitol, Alexandria & the majestic Potomac in full view." Here Barlow created a center of hospitality for friends of the administration. In the role of elder statesman, he gave advice to the president and cabinet, and occupied himself with promoting various public projects, notably a plan for a national university which he saw as the way of furthering equal opportunity and hence egalitarianism. Preoccupied with his house and garden, and with political concerns of the present and future, he found little time to devote to his projected history of the United States. Jefferson chided him for his procrastination, writing, *You owe to republicanism, and indeed to the future hopes of man, a faithful record of the march of this government, which may encourage the oppressed to go and do likewise. Your talents, your principles, and your means of access to public and private sources of information, with the leisure which is at your command, point you out as the person who is to do this act of justice to those who believe in the improvability of the condition of man.* Sadly, the man who had, albeit briefly, seen the American Revolution from the vantage point of the militia, who had known intimately many of the founders of the Republic, who had at his disposal the papers of Thomas Jefferson and James Madison, and whose prose style was "clear and sensible," would never chronicle his country's beginnings. Sent in 1811 by James Monroe as minister to France, Barlow traveled 1,400 miles by coach, first through mud and then later in bitter cold, to Wilna, Poland, where, he had been promised, Napoleon would finally negotiate a treaty of commerce. Before the long-sought agreement could be consummated, Napoleon's army was in retreat from Moscow. Barlow, fleeing with the rest, developed pneumonia and died on December 24th, 1812, in a small town in Poland.

Like Barlow, Houdon came from a poor family. And, like Barlow also, he was for-

tunate in his opportunities. Born in Versailles, where his father was a porter in the Ecole Royale, he grew up in the ateliers there, knowing from his earliest days the feel of clay. By the time he was thirteen, he was formally enrolled in the school and was subsequently awarded the Ecole Royale prize which entitled him to three years' study at the French Academy in Rome. He returned to Paris, equipped with an excellent artistic training which included a thorough knowledge of anatomy. Added to this technical proficiency was an innate ability to capture the essence of character in an individual expression. He was deservedly sought after. By 1784, when the Virginia Assembly was looking for a sculptor for a full-length statue of George Washington, it was obvious to both Franklin and Jefferson that the choice should be Houdon. As Jefferson wrote, "There could be no question . . . the reputation of Mons. Houdon, of this city, being unrivalled in Europe." Houdon, for his part, felt honored by the assignment, for, as Jefferson again noted, *Mons. Houdon . . . was so anxious to be the person who should hand down the figure of the General to future ages, that without hesitating a moment he offered to abandon his business here, to leave the statues of Kings unfinished, and to go to America to take the true figure by actual inspection and mensuration.* The sculptor felt he had a mission to "preserve forms with perfect truth, and to render almost imperishable the likeness of men who have been at once the glory and the happiness of the state."

Barlow, not long after he sat for his portrait, wrote to a college classmate, "We belong to the generation that is going off the stage." So, too, was it with Houdon. The animated intellectual faces of the French Enlightenment might be said to have been cast expressly for the sparkling crispness of Houdon's style—never had an age and a sculptor been more truly joined. After the Revolution the whole world had a different look. Although he would still produce occasional works of genius, Houdon's time was essentially over. He would cease exhibiting after 1814. His intense and perceptive bust of Barlow is one of the finest examples of his late work—a reflection, we may surely conclude, of an extraordinary empathy between artist and sitter.

Arnason, H. H. *The Sculptures of Houdon.* New York: Oxford University Press, 1975.

Parrington, Vernon Louis. *The Colonial Mind 1620–1800.* New York: Harcourt, Brace & Co., 1927.

J. B. Speed Art Museum. *Nineteenth Century French Sculpture: Monuments for the Middle Class.* Louisville, Ky.: 1971.

Woodress, James. *A Yankee's Odyssey: The Life of Joel Barlow.* Philadelphia: J. B. Lippincott Co., 1958.

Absalom Jones 1746–1818
By Raphaelle Peale 1774–1825
Oil on paper
87.6 x 74.3 cm
Unsigned
1810
NPG.1.71

Perhaps commissioned by Jones's congregation, and owned at one time by the St. Thomas African Episcopal Church, Philadelphia. Lost for many years and known only from a rare engraving by W. R. Jones and J. Boyd, published by J. How of Philadelphia on December 12th,

*1823. In 1938 it came into the possession of the Absalom Jones School
of Wilmington, Delaware, and in 1965 was given to the Wilmington
Society of the Fine Arts, Delaware Art Museum, from which it is
on indefinite loan to the National Portrait Gallery*

The Reverend Absalom Jones, prominent leader in Philadelphia's free black community, was painted by Raphaelle Peale in 1810. Charles Willson Peale wrote, on February 3rd of that year, that "Raphaelle . . . painted a Portrait in oil of Absalom Jones a very excellent picture of the Revd. Gentleman."

Born a slave in Sussex, Delaware, Jones was brought to Philadelphia to work in a store. Given permission to attend a Quaker school at night, he learned to read and write. Laboring on his own time for wages, he was able to accumulate enough money, first to purchase his wife's freedom, and next his own. Diligent and ambitious, the Joneses saved enough money to buy several houses, to be used as rental properties.

Along with many other blacks, Jones regularly attended the St. George's Methodist Episcopal Church. On one memorable Sabbath in the autumn of 1787, the blacks were denied their usual seats and interrupted as they sought to kneel in prayer. Jones, molested by a white trustee, calmly retorted, "Wait until prayer is over, and I will get up and trouble you no more." The trustee, reinforced by another, pulled him off his knees. The Reverend Richard Allen, who was also present, reported, "We all went out of the church in a body, and they were no more plagued with us in the church." Out of this indignity came the beginnings of the independent black church in America.

Six months later Jones and Allen founded the Free African Society, which was formed "without regard to religious tenets, provided, the persons lived an orderly and sober life, in order to support one another in sickness, and for the benefit of their widows and fatherless children." The group hired a storeroom for religious services but "differed in their religious sentiments," and so there was no denominational affiliation.

Jones and Allen nevertheless had dreams of a fully organized independent black church with its own building. Late in 1790 they began an appeal for funds for the establishment of "The African Church of Philadelphia" and, once $360 had been collected, ground was broken for the new church. In the words of Allen, "We then held an election, to know what religious denomination we should unite with." The majority voted to affiliate with the Episcopal Church. Both Allen and Jones, who favored the Methodists, were stunned. Allen, declining to be the newly formed church's first minister, left the group. Thereupon they turned to Jones who, in a remarkable display of conciliation and flexibility, put his own feelings aside and agreed to follow the religious tenets of the majority.

Winning the cooperation and financial support of the white hierarchy by the summer of 1794, the St. Thomas African Episcopal Church of Philadelphia was dedicated. Jones, who had been licensed as a lay preacher in the Methodist Church, did not meet the educational standards for Episcopal ordination. Not easily surmounted was the required knowledge of Latin and Greek. A compromise was agreed upon. Bishop William White of Philadelphia consented to a waiver of the prerequisites with the understanding that the African church would relinquish its right to send delegates to denominational sessions "at present." Jones was ordained a priest in 1804.

Sitting to Peale at the age of sixty-four, Jones looks the very epitome of a proper Anglican clergyman. Peale has captured the streak of steely determination in his character. Pragmatic and accommodating though he might be, he spoke out force-

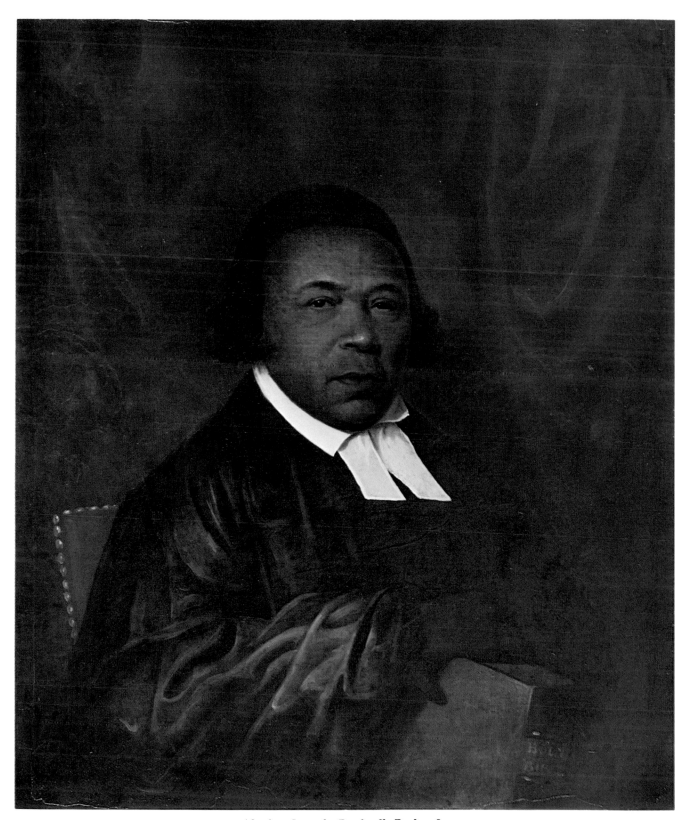

Absalom Jones by Raphaelle Peale, 1810

fully when it came to a defense of his race. As co-author with Allen of *A Narrative of the Proceedings of the Black People, During the Late Awful Calamity in Philadelphia in the Year 1793 and a Refutation of Some Censures Thrown upon them in some late Publications,* Jones emphatically repudiated those who maligned the services of blacks during the yellow fever epidemic of 1793: *Soon after, the mortality increasing, the difficulty of getting a corpse taken away was such, that few were willing to do it, when offered great rewards. The black people were looked to. We then offered our services in the public papers, by advertising that we would remove the dead and procure nurses. Our services were the production of real sensibility;—we sought not fee nor reward. . . . It was very uncommon at this time, to find any one that would go near, much more, handle a sick or dead person.* The two went on: *When the sickness became general, and several of the physicians died, and most of the survivors were exhausted by sickness or fatigue; that good man, Dr. [Benjamin] Rush, called us more immediately to attend upon the sick. . . . This has been no small satisfaction to us; for, we think that when a physician was not attainable, we have been the instruments, in the hand of God, for saving the lives of some hundreds of our suffering fellow mortals. . . . We have bled upwards of eight hundred people.* Giving lie to the misrepresentation that blacks were immune to the disease, the authors noted: *As many coloured people died in proportion as others. In 1792, there were 67 of our colour buried, and in 1793 it amounted to 305; thus the burials among us have increased fourfold, was not this in a great degree of effects of the unjustly vilified black people?*

Most eloquent of all the literature in which Jones had a hand was the petition addressed to the president and Congress in 1799: *If the Bill of Rights or the declaration . . . are of any validity, we beseech, that as we are men, we may be admitted to partake of the liberties and inalienable rights therein held forth . . . the extending of Justice and equity to all classes of people would be a means of drawing down the blessings of Heaven upon this land.*

Just the year before the portrait was painted, Jones, along with Richard Allen and James Forten, had formed a group which they called the "Society for the Suppression of Vice and Immorality," an organization designed to supervise the morals of the whole black community. Jones and the others singled out for particular attention the "loathsome and harmful practice of drinking" and called for total abstinence.

Jones no doubt realized that drink was already proving to be Raphaelle Peale's undoing. It was common knowledge in Philadelphia that the artist was regularly picked up and brought home by the city watch. Two years earlier, Peale had been committed briefly to the Pennsylvania Hospital for "Delirium," and his wife told her father-in-law, in response to his exhortations that Raphaelle drink only water, that if he passed one day without drinking a "tremor" came upon him. Artistic genius though he might be, overindulgence had made him unreliable, and few people in those days were coming to him for portraits. He had turned primarily to still lifes. He was thirty-six, and the pattern of drink and improvidence, which would govern the rest of his life, had already been set. Peale's father, who blamed his problems on his wife Patty's "violent temper," was the major support for them and their increasing family. The elder Peale, ever optimistic and loving, wrote to Raphaelle: *If you applied yourself as you ought to do, you would be the first painter in America. . . . Your pictures of still life are acknowledged to be, even by the painters here, far exceeding all other works of that kind—and you have often heard me say that, with such talents of exact imitation, your portraits ought also to be more excellent. My dear Raphaelle, why will you neglect yourself? Why not govern every unruly passion?*

Why not act the man, and with a fine determination act according to your best judgment? Wealth, honors and happiness would then be your lot!

And so it should have been. Raphaelle Peale's start in life had been as auspicious as Jones's had been inauspicious. He was the eldest son of one of the best-known and best-liked artists of his time. He grew up in a happy home, run, as Charles Coleman Sellers has noted, "upon a principle of affectionate indulgence." He was immersed in the rich and varied interests of his father's life, participating in experiments, collecting and mounting specimens for the family museum, and practicing, from his earliest days, both manual dexterity and mental agility. By the time he was ten, his artistic talent was apparent. At sixteen he was his father's assistant, traveling with him on portrait-painting trips. Soon he was adept at copying his father's portraits for the "Gallery of Distinguished Personages" in Peale's Philadelphia Museum. He traveled about collecting specimens for the museum, upon one occasion as far as South America.

When portrait commissions lagged, his ever-fostering parent gave him the use of a physiognotrace for taking profiles. Traveling throughout the South, he was successful beyond his highest expectations. During the summer of 1804, Raphaelle Peale invited the public of Charlestown, South Carolina, "to see a display of *three thousand profiles*, taken from a collection of more than *one hundred thousand*, drawn by him in Virginia." In cavalier acknowledgment of competing profile cutters, Peale advertised that he would leave the merit of his own work "to the decision of those who can either whistle, sing, or play upon any musical instrument." Raphaelle of course whistled, sang, and played the clarinet, flute, guitar, and mandolin. In addition he was a mimic and ventriloquist.

Shortly after the triumphal southern progress, things started going badly for him. A trip through New England was disappointing. On the strength of his earlier success, he had purchased an expensive house, and his need for money was increasing at the same time the popularity of his profiles was waning. So, too, his wife's nagging increased proportionately to the decline in his income. To make matters worse, he had begun to be bothered by gout in his hands and feet.

Nevertheless, until the very end when he was found drunk in the gutter and taken home to die, his humor never wavered. Even in the midst of illness and degradation, he remained the laughing boy, delighted with practical jokes and deceptions, wryly advertising in his later years that he painted "Still Life" which included both "fruit pieces and portraits of the deceased." He reveled in watching unsuspecting visitors bruise their knuckles on the wall as they reached for a picture entitled *Catalogue for the Use of the Room*. His most famous deception, *After the Bath*, contrived to dupe his termagant wife into thinking that the figure of a naked woman lay hidden behind the white linen towel (Nelson Gallery and Atkins Museum, Kansas City), was painted just two years before his death at a time when his fingers were crippled by gout and his hand unsteady from years of intemperance.

Absalom Jones, we might well expect, shook his head often as tales of Raphaelle Peale reached his ears. Not only would Jones have been disturbed and dismayed by Peale's alcoholic indulgence, but he was also very likely completely bewildered by the artist's carefree abandon. The solemn Reverend Mr. Jones must have found it hard indeed to understand anyone who refused to live life in earnest.

Time and distance have given the proper assessment of Raphaelle Peale. Charles Coleman Sellers put it well when he wrote, in 1963, "Laughing in the face of tragedy and woe, striving toward perfect arrangement and illusion with an intuitive intensity, he will always be considered by many the greatest of the Peales."

George, Carol V. R. *Segregated Sabbaths: Richard Allen and the Rise of Independent Black Churches, 1760–1840.* New York: Oxford University Press, 1973.

Hawks, Elizabeth H. *American Painting and Sculpture—Delaware Art Museum.* Wilmington: The Wilmington Society of the Fine Arts, 1975.

Kaplan, Sidney. *The Black Presence in the Era of the American Revolution 1770–1800.* National Portrait Gallery, Smithsonian Institution. Boston: New York Graphic Society, 1973.

Sellers, Charles Coleman. *Charles Willson Peale.* New York: Charles Scribner's Sons, 1969.

Gouverneur Morris 1752–1816
By James Sharples circa 1751–1811
Pastel on paper
25.4 x 21 cm (arched top)
Unsigned
1810
NPG.74.47

Descended through the family of Morris's nephew, Gouverneur Morris Wilkins. Gift from his great-granddaughter, Miss Ethel Trumbull, in memory of her brothers, John Trumbull and Gouverneur Morris Wilkins Trumbull. (An almost identical pastel in the City Art Gallery, Bristol, England, is believed to be by the hand of Mrs. Sharples, who is known to have made copies of her husband's work.)

Gouverneur Morris, whose lucid pen had given final form to the Constitution of the United States, noted in his diary, "Sunday May 20th, 1810. Mr. Evans presents a Mr. James Sharples this morning, a painter who wishes it seems to take my picture as one of an American Collection he made several years ago." On Friday the 25th Morris recorded, "Mr. and Mrs. Sharples and their daughter arrive while we are at breakfast. He commences my Portrait."

Sharples and his family, his third wife Ellen, sons James, Jr., and Felix, and baby Rolinda—ultimately artists all—had come first to America in 1794. As an established and successful painter in his native England, James Sharples had worked primarily in oils. But, sensing the New World's market for relatively inexpensive portraiture, he turned to pastels as an ideal medium for the execution of small, cabinet-size likenesses, and a way also of speedily assembling a collection of famous faces which might be exhibited for a fee. Sharples came, reported his American contemporary William Dunlap, *carrying letters to persons distinguished, either military, civil or literary, with a request to paint their portraits for his collection. This being granted, and the portrait finished in about two hours, the likeness generally induced an order for a copy and brought as sitters all who saw it.* They were, said Dunlap, "very valuable for characteristic portraiture." Later critics would refer to the nine-by-seven-inch pastels as "sturdily honest" and report that "in every picture the countenance, like the clothes, is the man's familiar wear." These pleasing and authentic likenesses sold for $15 profile and $20 full face, prices which probably included the glass and frame, since both of these were an immediate necessity for protecting the fragile pastel image. For eight years the Sharples family worked in America, part of the time traveling around in a vehicle especially designed by the mechanically minded James, to provide safe portage for the entire family and their painting and framing supplies. They met with great

success. Mrs. Sharples remarked, "There certainly is no country where talents and useful accomplishments are more appreciated or none where greater hospitability or kindness can be shown to strangers."

By 1798 "Mr. Sharples' Collection of Portraits of distinguished characters" had grown to "upwards of 200 original paintings of the most celebrated personages of the United States, besides foreign ministers and other foreigners of distinction" to be "seen and copies obtained." The subjects included John Adams, Thomas Jefferson, Alexander Hamilton, Aaron Burr, James Monroe, Henry Clinton, Horatio Gates, Robert Livingston, and, the greatest coup of all, George Washington. The business flourished, and the family, said Mrs. Sharples, "lived in good style associating in the finest society." Problems with property they owned in Bath, however, necessitated a return to England in 1801. In July of 1809 they were back in America, and settled in New York City.

Morris had not been among those who had posed for Sharples during the first American soujourn, likely because he was in Europe during most of that period. It was to rectify this omission that the Sharpleses journeyed to "Morrisania," the family estate in what is now the Bronx. They spent three days at the fashionable dwelling which Morris had built in 1800 as a replacement for the "leaky and ruinous" family homestead. Morrisania was, Mrs. Sharples recorded, "a large elegant house superbly furnished and delightfully situated near the Sound, and the junction of the Haerlaam and East rivers." She noted in her diary, *The attentions of Mr. and Mrs. Morris, their agreeable conversation, the various amusements of viewing prospects, pictures, sculpture, tapestry, plate, china, etc., contributed to interest us, and make the time pass very swiftly. At dinner we had three courses every day on a magnificent service of silver, dessert on the most beautiful French China.* She neglected to mention that the fastidious Morris had even installed a bathroom!

"Luxury," Morris had once written, is not "such a bad thing as people believe." This son of one of New York's great patroon families, schooled in the French culture of his Huguenot mother, came to his aristocratic milieu by inheritance, but to the wealth that enabled him to indulge his expensive tastes through his own efforts.

James Sharples, referred to in the histories of Philadelphia as "a rapid English painter," demanded little time from his sitters. He manufactured his own pastels, finely powdered crayons, which he kept in small glass cups. The colors were applied with a camel's-hair brush to a thick grey paper which was softly grained and of a woolly texture.

On May 26th Morris wrote, "Mr. Sharples finished my Portrait." On June 2nd he recorded in his account book, "Portraits (Self and Wife) $50," a price $10 higher, Katherine McCook Knox has pointed out, than Sharples had previously charged for full-face portraits.

Morris was fifty-seven, and his great contributions to the founding of the Republic were now in the past. Thirty-three years earlier, as the youngest delegate in the provincial assembly, he had played a major role in drafting the New York State Constitution, evidencing at twenty-four the political philosophy that would mark his whole career—a deep-rooted distrust of the masses and a tenacious regard for the rights of private property. However, when it came to individual human rights, Morris was far to the left of most of his contemporaries, urging the abolition of slavery and calling for *absolute* religious liberty. A member of the Continental Congress, "the tall boy" was recognized as an amazing genius and also known as "an eternal speaker . . . and for brass equal to any" as he stirred up the convention by demanding individual ayes and nays on every vote. At a time when Continental currency was inflated to the point where it cost more to print than it was worth, he worked with Robert Morris

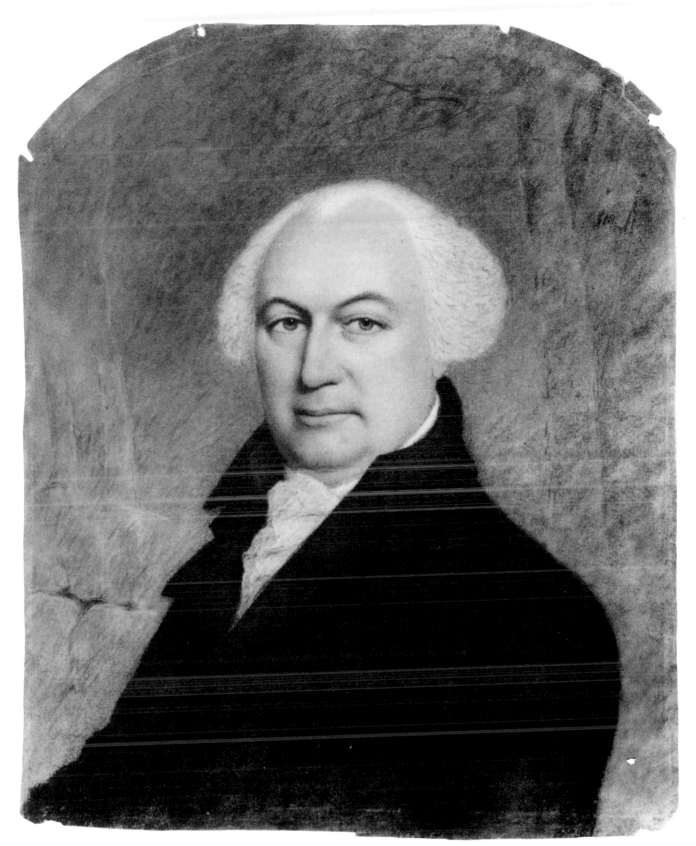

Gouverneur Morris by James Sharples, 1810

(no relation) for some stabilization of the country's finances. As a delegate from Pennsylvania to the Constitutional Convention, Gouverneur Morris spoke more times than anyone else, but, concluded Catherine Drinker Bowen in *Miracle at Philadelphia,* never said anything "foolish or tedious." Appointed a member of the Committee on Style and Arrangement, Morris saw to it that the "whole of the Constitution," as Caleb Strong of Massachusetts put it, was "expressed in the plain, common language of mankind." James Madison, who over the years had cause to feel the sting of Morris's trenchant prose, was unstinting in praise of his colleague's contribution to the Constitutional Convention, writing in 1831 that "the finish given to the style and arrangement of the Constitution fairly belongs to the pen of Mr. Morris." He added that "a better choice" than Morris "could not have been made." Speaking of the "able, eloquent and active Morris," Madison went on, *To the brilliancy of his genius, he added, what is too rare, a candid surrender of his opinions, when the lights of discussion satisfied him, that they had been too hastily formed, and a readiness to make the best of measures in which he had been overruled.* For example, Morris originally held that the president should not be impeachable. However, after Benjamin Franklin remarked that "he'd either be impeachable or he'd be assassinated," Morris replied at once, "My opinion has changed."

In 1798 Morris had come back to America after a decade spent in Europe, where he had been engaged in business and diplomacy. Shortly after his return he was chosen to fill an uncompleted term as Senator from New York. Arriving in Washington in 1801, a city which he found to be lacking in "houses, winecellars, kitchens, educated men, amiable women and other little bagatelles of that nature," he followed "the trade of Senator" and found "a nonchalant amusement in watching the little intrigues, the mad Hopes and the vain Projects of that proud and feeble Animal which is Man." Morris, whom Sharples would depict some ten years later formally attired in the powdered wig of courtly civilization, was horrified by the slovenly dress and casual manners of the Jefferson administration. He wrote to Alexander Hamilton that "there is such an Abandonment of Manners and such a Pruriency of Conversation as would reduce even Greatness to the Level of Mediocrity." In 1803 Morris failed to win election to a full senatorial term, just as earlier he had failed to gain a second term in the Continental Congress. As he remarked upon the first occasion, "Perhaps I may not have thoroughly accorded with the views of my constituents." No man could take defeat with better grace.

Morris returned to his manor. In a letter to one of many female friends from his French sojourn, he described his retirement: *My establishment is pleasant and though expensive not beyond the means which I ought to possess and which time will either bring or take away. My health is excellent, save a little gout. . . . I can walk three leagues, if the weather be pleasant and the road not rough. My employment is to labor for myself a little, for others more; to receive much company and forget half those who come. I think of public affairs a little, read a little, play a little, and sleep a great deal. With good air, a good cook, fine water and wine, a good constitution and a clear conscience I descend gradually toward the grave, full of gratitude to the giver of all good.* Morrisania was, one visitor reported, "a place of great sociability and mirth added to splendor in the extreme," and Morris "lives literally like a nobleman and he has all this world can give him but a good wife and amiable children." Soon these also would be his.

Morris was not one to move into an uneventful old age. Famous since the days of the Continental Congress for "making oblations to Venus," Morris had long held that celibacy was an "impious and unnatural doctrine." His years in France had been filled with romantic exploits, the most famous of which was his liaison with Adelaide

de Flahaut, who was simultaneously the mistress of Talleyrand. Morris had, however, never married. Precipitously, at the age of fifty-seven, he decided to marry his house-keeper. The lady was Anne Cary Randolph, a member of the noted Virginia clan, whom Morris had met once or twice when she was a child. She was twenty-two years his junior. Nancy, as she was called, had had a sensational past. Seventeen years earlier she had been accused, along with her brother-in-law Richard Randolph, of the murder of their illegitimate child. In a celebrated trial, Patrick Henry and John Marshall, acting for the defense, proved to the satisfaction of the jury that no pregnancy, and hence no murder, had taken place. Two years later, following Richard Randolph's death, Nancy found herself turned out into the world. In the spring of 1809 Morris wrote to her, offering the place as his housekeeper, feeling, he said, that a reduced gentlewoman could keep peace among his domestics.

The union understandably brought cries of outrage from his expected heirs. In replying to his niece who charged him with having "committed a folly in marriage," Morris replied, *If I had married a rich woman of seventy the world might think it wiser than to take one half that age without a farthing, and, if the world were to live with my wife I should certainly have consulted its taste; but as that happens not to be the case, I thought I might, without offending others, endeavor to suit myself, and look rather into the head and heart than into the pocket.*

The marriage proved to be a happy one, and the equanimous Morris remained unperturbed when the irascible John Randolph of Roanoke revived the old charges of infanticide and further claimed that Nancy had poisoned his brother Richard. Nancy, in refuting his allegations, admitted that she had a child that long-ago October of 1792, but that it had been born dead. The father was not her brother-in-law Richard Randolph but Randolph's brother Theodorick, to whom she had been betrothed, and who had died soon after the child's conception. Near the end of his life, Morris wrote a letter which he knew would have wide circulation in Virginia. In it he said, "The woman to whom I am married has much genius, has been well educated and possesses . . . an affectionate temper, industry and a love of order." She was, he added, "a kind companion and a tender feminine friend."

At the time of the Sharpleses' arrival in May 1810, Morris was a happy bridegroom, "riding about town with my wife to pay visits." Very likely because of his pretty new wife he particularly welcomed the Sharpleses and an opportunity to have a portrait of his wife executed (Private Collection).

James Sharples has painted the face of a contented man. In 1772, when Morris was twenty, he had written to Kitty Livingston, the one woman who apparently turned him down, "I am (as you know) constitutionally one of the happiest among Men." It was said by one of the many ladies who found refuge with him during the Terror—alone among the foreign ministers he had stayed in Paris—that he was "habitually serene and ever at peace with himself." His sanguine nature carried him through a life that was not without pain.

In his late twenties, he had been involved in "an unlucky accident." As William Bingham reported it to John Jay, "In attempting to drive a pair of wild horses in a phaeton he was thrown and in the fall his left leg caught in the wheel and was greatly shattered. He was under the necessity of having it amputated." Gossip had it that Morris's hasty drive had been occasioned by the unexpected return of an outraged husband. John Jay, who often found cause to deplore his dear friend's "foibles," wrote him, "I have learned that a certain married woman after much use of your legs had occasioned your losing one." In any case, it could be reported that "he bears it with becoming fortitude." A peg leg did nothing to daunt Morris's self-assurance. He continued to be a great walker; he even danced at times. Dr. John W. Francis, as a

63

boy of fifteen, saw Morris in 1804 and recalled that his "superb physical organization enlisted attention. Few men ever equalled his commanding bearing."

It was this presence that prompted Thomas Jefferson in 1789 to request that he pose for the body of Jean-Antoine Houdon's statue of Washington. Morris, who had admired Washington extravagantly since the two had first met, when he was assigned to investigate conditions at Valley Forge, unselfconsciously agreed to do so. With his typical wit he noted in his diary, "Go to M. Houdon's. . . . I stand for his statue of General Washington, being the humble employment of a manikin. This is literally taking the advice of St. Paul, to be all things to all men."

Sharples shows Morris looking out at the world with a bemused, slightly quizzical expression. Here is a sophisticated man, completely at home in a far-from-perfect world, a gentle cynic who once said, "The art of living consists, I think, in some degree of knowing how to be cheated." John Adams called him "a man of wit and . . . pretty verses; but of a character *très leger*." Morris himself was the first to admit that he had "a natural taste for pleasure," but it was obvious also that his extensive knowledge of government and science was not the product of an indolent life. Robert Morris, who early appreciated the young Gouverneur, wrote to John Jay, "You must cherish his friendship. It is worth possessing. He has more virtue than he shows and more consistency than anyone believes." Those who knew him well found this to be true. For his part, he could assure his friends, even in the last of his life, that they would still find him with the "gayety of inexperience and frolic of youth."

Bowen, Catherine Drinker. *Miracle at Philadelphia.* Boston: Little, Brown & Co., 1966.

Dunlap, William. *History of the Rise and Progress of the Arts of Design in the United States* (2 vols.). New York: Dover Publications, 1969 (first published 1834).

Knox, Katharine McCook. *The Sharples.* New Haven: Yale University Press, 1930.

Mintz, Max M. *Gouverneur Morris and the American Revolution.* Norman: University of Oklahoma Press, 1970.

Rossiter, Clinton. *The Grand Convention.* New York: Macmillan Co., 1966.

Swiggett, Howard. *The Extraordinary Mr. Morris.* Garden City, N.Y.: Doubleday & Co., 1952.

John Randolph of Roanoke 1773–1833
By John Wesley Jarvis 1780–1840
Oil on panel
76.2 x 63.5 cm
Unsigned
1811
NPG.70.46

Descended in the family of Charles Sterret Ridgeley of Elk Ridge, Maryland. Subsequently acquired by Gerard B. Lambert, a descendant of the artist, and given to the Gallery by his widow, Mrs. Grace Lambert

John Randolph of Roanoke was, for nearly thirty years, one of the most notorious members of the House of Representatives. John Wesley Jarvis was, during this same period, one of America's most famous portrait artists. Artist and sitter converged

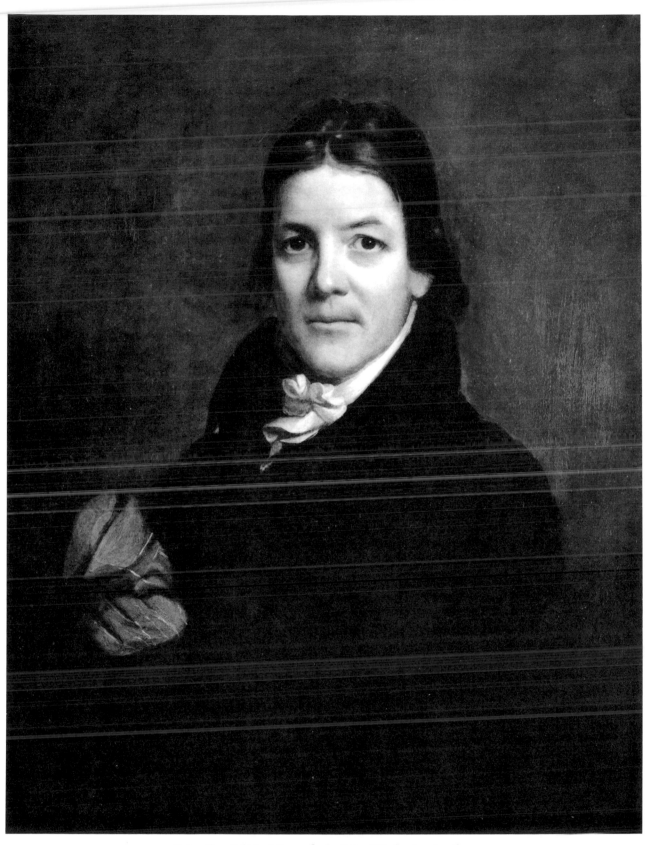

John Randolph of Roanoke by John Wesley Jarvis, 1811

when each was near the height of his powers, before insanity in the case of Randolph, and debauchery in the case of Jarvis, overwhelmed their talents.

Thanks to the pen of Washington Irving we know something of the circumstances surrounding the portrait's execution. Irving, en route to Washington in January of 1811, stopped off at Baltimore and found Jarvis, his fellow New Yorker, there "in great vogue . . . painting all the people of note and fashion, and universally passing for a great wit, a fellow of infinite jest;—in short—'the agreeable rattle'." Returning through Baltimore, Irving wrote on March 16th: *By-the-bye, that little "Hydra and chimera dire," Jarvis, is in prodigious great circulation in Baltimore. The gentlemen have all voted him a rare wag and most brilliant wit; and the ladies pronounce him one of the queerest, ugliest, most agreeable little creatures in the world. The consequence is that there is not a ball, tea-party, concert, supper or any other private regale, but that Jarvis is the most conspicuous personage; and, as to a dinner, they can no more do without him, than they could without Friar John at the roystering revels of the renowned Pantagruel. He is overwhelmed with business and pleasure, his pictures admired and extolled to the skies, and his jokes industriously repeated and laughed at.*

Irving reported further that "Jack Randolph was at Baltimore for a day or two after my arrival. He sat to Jarvis for a likeness for one of the Ridgeleys."

Irving knew Jarvis well. Not only did the two both move in New York's convivial circles but, in addition, Irving himself had been painted by Jarvis in 1809. Irving also knew John Randolph, but as a public figure and not as an intimate eating and drinking companion. He had seen him first in 1807 in Richmond, at the time when Randolph was the foreman of the grand jury at Aaron Burr's trial. Like so many others, Irving was fascinated by the wispy figure with the silver voice. In Washington, Irving had gone to watch Randolph's famed performance in the House chamber. He wrote to his brother, on February 20th, 1811, *There is no speaker in either house that excites such universal attention as Jack Randolph. But they listen to him more to be delighted by his eloquence and entertained by his ingenuity and eccentricity, than to be convinced by sound doctrine and close argument.*

Happening upon Jarvis painting Randolph, Irving decided that he himself would like a portrait of this arresting person, and Randolph consented that he should have one. Irving was "in hopes of receiving it before I leave Philadelphia, and of bringing it home with me." However, stopping by to see about it on April 2nd, he found *the elegant Jarvis . . . sleeping on a sopha bed in his painting room, like a sleeping Venus, and his beautiful dog couched at his feet. I aroused the varlet, and bid him on pain of death to have the likeness of Randolph done on my return; he breakfasted with us, and entertained us with several jokes, which had passed the ordeal of Baltimore dinner tables.*

The portrait was eventually finished, and it hung in Irving's Hudson River home, "Sunnyside," for forty years. A little more than a year before his death, Irving presented it to the New-York Historical Society, noting that "it was copied for me, with Mr. Randolph's consent, by Jarvis in Baltimore, in 1811, from the original portrait by himself."

The original portrait, now in the National Portrait Gallery, descended in the Ridgeley family. William Dunlap reported, "I find by a letter of John Randolph, of Roanoke, that he paid Jarvis for his portrait $80." The size is not mentioned, but the reference to price is puzzling since in the spring of 1809 Jarvis was advertising portraits with hands at $60 and without at $40. According to Dunlap's recollection, Jarvis raised his prices to "$100 for a head, and $150 for head and hands," around 1808 or 1809.

Jarvis, in 1811, had been in the portrait-painting business only about six years but

already had the reputation of being the best portraitist in New York City. Born in England, he had been brought to New York as a child sometime around 1785. His teenage years were spent in Philadelphia, and there he frequented the studios of Clark, "a miniature painter," Gullager, "a painter of portraits and signs," Jeremiah Paul, who lettered the books in Gilbert Stuart's full-length Washington portraits, and Rutter, "an honest sign painter." "These worthies," he wrote, "when work was plenty—flags and fire buckets, engines and eagles in demand—used to work in partnership, and I, between school hours worked for them all, delighted to have the command of a brush and a paint pot." Matthew Pratt particularly encouraged his visits. Jarvis remembered, "I frequently passed my out-of-school hours at his shop, making figures of what passed for men and things by dint of daubing on my part, and imagination on the part of the beholder."

When it came time, as he put it, "to learn something besides *learning*, or expect to starve with the Philadelphia market at my elbow," he spurned painting, seeing it as a sign painter's craft rather than a fine art. Instead, finding in the "prints displayed at the shop windows, something much more perfect, and more to my taste, I preferred being an engraver." He was apprenticed in 1796 to Edward Savage. By 1803 Jarvis, in partnership with Joseph Wood, a silversmith's apprentice turned miniature painter, advertised that they took profiles with a physiognotrace. Jarvis and Wood also kept a drawing school. In the New York City Directory of 1804, the two are listed as "portrait and miniature painters."

Jarvis embarked on a career as a portrait painter, as he tells the story, after he saw the work of James Martin (a pastel and crayon portraitist who worked in New York from 1797 until about 1820), who, he was assured, was the best portrait painter in New York. "If that is the case," Jarvis said, "I will be the best portrait painter in New-York tomorrow, for I can paint better than Mr. Martin." He recounted, "I was the best painter, because others were worse than bad—so *bad* was the best."

William Dunlap, fellow artist and future author of *History of the Rise and Progress of the Arts of Design in the United States*, who lived down the street from Jarvis, remembered that "these were piping times—and what with Jarvis's humour, Wood's fiddling and fluting—and the painting executed by each, they had a busy and merry time of it. But I fear '*merry and wise*,' was never the maxim which guided either." Already Jarvis, the great-great nephew of the founder of Methodism, had a reputation as a jovial drinking companion, a habitué of the theatre, a pursuer of women, and "the best story teller that ever was."

Nevertheless, without seeming to do so, he was also working diligently at his painting. The pioneer art critic John Neal reported that "he works hard and faithfully; but would not have it known." Jarvis assiduously studied anatomy with Dr. John Augustine Smith of the New York College of Physicians and Surgeons, and was said to have been the first American portrait painter to apply phrenological science to the art of portraiture.

For Jarvis the time was auspicious. There was in New York, as Aaron Burr told John Vanderlyn, "the rage for portraits." The demand for likenesses, it might be noted, extended even unto the brink of the grave, as Jarvis duly cautioned in his advertisements that "those who wish to have Portraits of their deceased friends should be particular to apply time enough before they inter them." Once John Trumbull left for England in 1808, Jarvis had virtually no competition. Gilbert Stuart was in Boston; John Vanderlyn, Charles Bird King, Rembrandt Peale still in Europe; and Thomas Sully and Samuel Finley Breese Morse soon to go. By default alone, Jarvis was guaranteed success, but his popularity came about also as a result of his own considerable abilities.

Jarvis dressed with a flair. He "probably thought it aided him in his profession,"

Dunlap remarked. He went about New York in "a long coat, trimmed with furs like a Russian prince or potentate from the north pole." Two enormous dogs accompanied him through the streets and were trained to carry home his market basket.

In John Randolph, Jarvis had a sitter whose theatrical qualities must have hit a kindred note in the painter's own personality. Moreover, the sitter, who had added to his family coat of arms *"Fari quae sentias"* (Do what you feel), must have met the artist on his own terms.

John Randolph had, it would appear by design, made himself one of Washington's tourist attractions. Astride a splendid-blooded horse, followed by his two slaves, Jubal and John, likewise well mounted, he was a familiar figure on the streets of the young capital city. In full riding dress, he would swagger onto the floor of the House of Representatives, several hound dogs in train. For hours at a time he would hold forth, feverish in intensity, his "Indian black eyes" aglow, spewing forth his indignation against the world, punctuating his shrill falsetto with the crack of his riding whip against his boots. It was said that the jingle of silver spurs and the sound of padded footsteps automatically caused the galleries to fill.

Miss Phoebe Morris, a young friend of Dolley Madison's, who saw Randolph just about the time Jarvis painted his portrait, wrote: *His appearance is eccentric in the extreme. At a distance you would almost suppose him to be a youth of not more than sixteen, though I am told at a nearer view he appears quite old. His hair is long and simply confined by a ribbon, not in the style of a queque . . . only it looked so droll on him. When he began to speak, what a silence reigned throughout the House! every one appeared to wait in anxious, almost breathless, expectation, as if to catch the first sound of his voice, and what a voice!—clear, melodious, and penetrating, it fascinates and arrests the attention which had before slumbered over the humdrum of the preceding speakers. You forget for a moment in listening that he is an enemy to our revered and excellent President. I heard but a few words, yet those few impressed me with an admiration which I was afterwards angry with myself for having felt.*

John Quincy Adams, who saw him as "the image and superscription of a great man stamped upon base metal," nevertheless included Randolph on the list of famous orators recommended for his son to study. He told Charles Francis, *Even in the mind of that fragment physical, moral and intellectual of a man, overspread as it is with stinking weeds and stinging nettles an occasional sweetbriar shoots up and sheds its fragrance round him. But the metempsycosis is no fable. Surely John Randolph sat for that picture when nineteen hundred years ago Ovid wrote the lines:*

> *Ghastly pale in face and thin in frame . . .*
> *His breast alive with bile, and poison*
> *dripping from his tongue.*

Randolph's contemporaries spoke of him as a man with a "young-old" face. Gilbert Stuart painted him in 1805 (National Gallery of Art), six years previous to Jarvis's portrait, and the painting is frequently miscalled "John Randolph as a boy." Randolph was thirty-two years old. As he grew older, his face grew parchment-yellow and wrinkled but retained, somehow, an adolescent quality. He was always slight of frame.

Randolph apparently suffered from an endocrine imbalance which stunted his sexual development. His bilious humor and deliberate malevolence have been seen as an overcompensation for his lack of masculinity. Upon one occasion he threatened to kill a man who called him a eunuch. But, in another circumstance, he rebuffed one who taunted him for impotence with the comment "Why should a man take pride in a quality in which a jackass is infinitely his superior?"

His embittered personality, too, may have been a reflection not only of the inner

furies which gnawed at his vitals, but also of very real physical discomfort. He suffered from a variety of ailments all his life, and his nights were commonly sleepless. For more than fifteen years he responded to greetings of "How are you?" with "Dying, sir, dying." It was probably correct that during most of his public life his "genius was dangerously near the dim border line of insanity," and after 1818 he had periods of definite dementia. It is worth noting, however, that "Mad Jack" Randolph ran his plantation incredibly well, as Jonathan Daniel has pointed out in *The Randolphs of Virginia,* increasing his inheritance rather than decreasing it as was the case with so many of his Tidewater contemporaries.

The year before he was painted by Jarvis, Randolph had moved from his childhood home, "Bizarre," to his plantation at Roanoke. It was then that he added the "of Roanoke" to his signature, the reason being, he said, to distinguish himself from a detested cousin. At Roanoke he lived alone, "like Robinson Crusoe in the Woods," often sitting over his fruit and wine "without the company of a solitary fly."

Randolph, a seventh-generation descendant of Pocahontas, had been born into the vaunted world of the Virginia aristocracy. His father died when he was two, and he was brought up by his stepfather, St. George Tucker, whom he first idolized and then inexplicably grew to hate. When he was fourteen his mother died, and by the time he was twenty-three both of his brothers were dead, leaving him, save for his young nephews, alone in the world. Primarily because of his own nature, his education had been desultory. He went restlessly from one course of study to another at Princeton, Columbia, William and Mary, and leaving each place as he took umbrage at some minor affront. He turned to law but never quite finished the first volume of Blackstone. He was, however, a voracious reader and managed, in between gambling, drinking, and dueling, to amass all the baggage of a cultured eighteenth-century gentleman. As he approached twenty-five he had one primary interest in life, racing horses and breeding them and their accompanying dogs.

Under the sponsorship of Creed Taylor, a local political leader, he was elected to Congress in 1799. Like Jarvis, Randolph found little to hinder a meteoric rise in his career. There was a paucity of talent in the first Congresses of the nineteenth century, and Randolph had the intellectual powers and the personality to speedily dominate the mediocre. He had, noted one contemporary, "as much self-consequence as any two-footed animal I ever saw." Within a year he was appointed chairman of the standing committee on ways and means, and for the next five years served as Thomas Jefferson's floor leader, deftly manipulating parliamentary procedures for the benefit of the administration.

Randolph had always been out of sympathy with his cousin Jefferson's democratic ideas. "I am an aristocrat: I love liberty, I hate equality," he said. He had an obsessive fear of executive tyranny. A break with Jefferson was inevitable—the astonishing part of the matter is that Randolph was able to remain a "team player" for almost six years. The definite rupture came in 1806 over the Florida question. Surprisingly, Randolph, the strictest of the strict constructionists, nonetheless supported the Louisiana Purchase. However, when it came to the acquisition of West Florida, Randolph balked at Jefferson's plan for a secret appropriation of $2 million, calling it a bribe to Napoleonic France for the purpose of bullying Spain into ceding the territory. From here on Randolph turned his slashing invective against Jefferson, dubbing him "St. Thomas of Cantingbury," and continually berated him for deserting what Randolph regarded as the true tenets of the democrat-republicans. Henceforth John Randolph, a man to whom hate was a pastime, would ever be in the role of the opposition and, although his figure would command attention for the rest of his life, his days of effective political power were over.

The defense of state's rights became the be-all and end-all of Randolph's political philosophy. In a characteristically Randolphian statement he summed the matter up: "To ask a State to surrender part of her sovereignty is like asking a lady to surrender part of her chastity." From his overriding belief in the absolute sanctity of state's rights flowed all of his political positions, including his vehement opposition to anything that would interfere with a state's right to maintain slavery. However, he appreciated liberty far too much not to find the system personally repugnant. He once said, "The greatest orator I ever heard was a woman. She was a slave. She was a mother, and her rostrum was the auction block." He insisted, nevertheless, that "we must concern ourselves with what is, and slavery exists . . . it . . . is to us a question of life and death . . . a necessity imposed on the South, not a Utopia of our seeking." His will, made in 1821, freed his slaves and ordered that lands be purchased for them in Ohio. In the dementia of his last days he changed his mind and ordered that they be sold upon his death. After long litigation the last will was turned aside by reason of his insanity.

By the time Jarvis painted Randolph's portrait, the new young breed of leadership had been elected to Congress, and in Henry Clay and John C. Calhoun Randolph met his match. Before the year was out, he would be engaged in one of the most passionate fights of his life, opposition to the War of 1812, which he would describe as one of "conquest and dominion." In a long and passionate speech, he would warn, among other things, of the South's most dreaded nightmare, slave insurrection, and would ask how men could talk of taking Canada when "some of us are shuddering for our safety at home?"

As it happened, the war that Randolph opposed so violently indirectly brought to Jarvis his greatest fame and highest artistic success. Following it he was commissioned to paint, for the New York City Hall, a series of full-length portraits of the heroes of the conflict. These, the great challenge of his life, he executed with brilliance. The portraits of Commodore Thomas Macdonough, General Jacob Brown, Commodore Oliver Hazard Perry, and Commodore Isaac Hull did (as William Dunlap prophesied) "keep him in public remembrance for a short-lived immortality, by their situation in the City Hall of New York, and their great merit." Recalling these portraits and seeing Jarvis in his alcoholic decline, Dunlap reflected sadly on the "real waste of nature's gift in dissipation."

Adams, Henry. *John Randolph.* Greenwich, Conn.: Fawcett Publications, 1961 (first published 1882).

Biddle, Francis. "Scandal at Bizarre." *American Heritage*, August 1961, p. 10.

Daniels, Jonathan. *The Randolphs of Virginia.* Garden City, N.Y.: Doubleday & Co., 1972.

Dickson, Harold E. *John Wesley Jarvis: American Painter 1780–1840.* New York: The New-York Historical Society, 1949.

Dunlap, William. *History of the Rise and Progress of the Arts of Design in the United States* (2 vols.). New York: Dover Publications, 1969 (first published 1834).

Stokes, William E. "Randolph of Roanoke." *American Heritage*, Spring 1952, pp. 48–51.

Winfield Scott 1786–1866
By William Rush 1756–1833
Plaster
52.7 cm
Unsigned
Circa 1814
NPG.73.19

Winfield Scott was just at the beginning of a long and brilliant military career when William Rush, America's first native-born sculptor, modeled him. Acclaimed as the defender of the Niagara frontier, and the victor of Chippewa, Scott was a great popular hero of the War of 1812. He had been seriously wounded at the battle of Lundy's Lane, in upper New York State, first by a spent ball in his side, and next by a shot which passed directly through his left shoulder. He probably sat to Rush sometime between June and October, in 1814, when "flattened and feeble the soldier had at length reached Philadelphia" and placed himself under the care of Dr. Philip Syng Physick.

Twenty-six years later the shoulder would still bother him. In 1840 he and his competitor for the Whig presidential nomination, Henry Clay, together awaited the decision of the convention. When word came that the two favorites had been cast aside in favor of William Henry Harrison, Clay, in his agitation, slapped Scott sharply on the shoulder. Scott said with a grimace, "I beg you not to lay your hand so heavily on that shoulder. It is the shoulder wounded at Lundy's Lane."

The journey to Philadelphia had been a triumphal progress. Scott was accorded, as his 1846 biographer, Edward Mansfield, noted, "honors and memorials from various civic bodies and public authorities such as seldom have been conferred upon one person, and upon one so young—perhaps never." He was dined and feted on every hand. New York awarded him a sword; Virginia did the same and in addition named a county after him. Princeton granted him an honorary degree. James Madison, who had continually protested that he was too young for promotion, now gave in. "Put him down a major general. I have done with objections to his youth," the president was reported to have said. Scott was twenty-eight.

Chippewa had been a small battle, but it was the first land victory for a dismally inept military establishment. The Americans, though outnumbered, had decisively defeated a crack British regiment and, what is more, pursued the enemy to obtain the final fruits of victory. It was an enormous boost for the morale of the army and dispelled some of the gloom surrounding an unpopular war. Scott candidly reported in his memoirs that "history has recorded many victories on a much larger scale than that of Chippewa; but only a few that have wrought a greater change in the feelings of a nation." As the news spread southward, bonfires were lit on village greens, and churchbells were sounded in thanksgiving. "The pulse of America recovered a healthy beat," wrote Scott. Since blue cloth had not been available, Scott's regiment had been clothed in grey. As a tribute to the first American regulars to defeat a superior force in hand-to-hand combat, the cadets at West Point would ever after wear grey uniforms.

The victory had not come about by chance. It had been won because the young military amateur had dragged with him to headquarters at Buffalo a "five foot shelf" containing the best and the latest books on military organization and tactics. Scott, an anomaly in a country which had an innate distaste for a professional military organization, recognized that battles were won by dint of careful training and scientific

planning. He restructured his corps, set up an efficient general staff, reorganized supply procedures, and saw to it that his recruits were rigorously trained. He also provided inspiration and imbued his troops with the importance of vigorous pursuit. "Scott, he'll take you into hell, boys, but he'll go fust," his men said in admiration. He was always out front, a massive six-foot-five figure, in the glories of his full dress uniform, providing dramatic leadership but presenting also a very visible target. Asked to change to less conspicuous dress, he replied with a smile—as it was reported by the press—that he would "die in my robes."

Scott, who more than any other man deserves the title of founder of America's professional army, was a self-made soldier. By training he was a lawyer. The son of a small Virginia planter, Scott attended the College of William and Mary briefly, leaving to continue his legal education at law offices in Petersburg, Virginia. British harrassment of American shipping precipitated his military career. In 1807 he was present at the Aaron Burr trial in Richmond when word came that Thomas Jefferson had summoned the state militias to enforce his interdict against the use of American rivers and harbors by British men-of-war. Scott belonged to no military organization, *but early the next morning at the parade of the Petersburg troop of cavalry . . . I was in their ranks, mounted and fully equipped for the field, having travelled twenty-five miles in the night, obtained the uniform of a tall, absent trooper, and bought the extra fine charger under me.* Brandishing his father's revolutionary war sabre, Scott had his first taste of military glory when he captured a rowboat full of British soldiers who had come to shore to get water. He nearly provoked a war, and Jefferson who, as Scott was wont to say, had a "low estimate of, or rather a contempt for, the military character," warned him not to do it again.

In 1808, when, in the face of continuing British hostilities, Jefferson asked Congress to increase the size of the small army, Scott was commissioned captain of light artillery. The young lawyer, whose military knowledge began and ended with the flourishing of the sword, had never so much as handled a piece in a drill. Characterstically, he brushed up his schoolboy French and learned the art of warfare out of the latest treatises from Napoleonic France.

In his student years he had immersed himself in Goldsmith, Locke, Adam Smith, Addison, Milton, Johnson, Shakespeare, and, above all, Plutarch. "As a summary of my whole life," he said in his autobiography, "a certain love of letters—sometimes amounting to a passion—has kept my mind in constant health and in the way of progress." This love of letters would provide him, over the next fifty years, with the ringing rhetoric which would spur his army to magnificent effort. Early in the War of 1812, for example, he exhorted his men in classical language: *Let us die arms in hand. Our country demands the sacrifice. The example will not be lost. The blood of the slain will make heroes of the living. Those who follow will avenge our fall, and our country's wrongs. Who dare to stand?*

Scott, whose delight in gold braid, silk sashes, ornate swords, gleaming medals, and waving plumes never diminished, has come down in history as "Old Fuss and Feathers." Clad in resplendent uniform astride a steed of complimentary grandeur, Scott was magnificent to behold. When, during the Mexican War, he entered Mexico City as conqueror, so awe-inspiring was the sight that the sullen silence was broken and spontaneous cheers rang out. It was perhaps the only time in history when an enemy leader was so greeted.

Rush saw Scott before his enormous appetite for dress, food, honors, and glory were fully manifest. The bombast which often dominates later images of Scott is not yet apparent. The bust is that of a proud young major general, but Rush seems to have sensed also the essential gentleness of Scott's nature. One can picture him in

Winfield Scott by William Rush, c. 1814

the tumult of battle, athirst for the glories of victory, but one can also imagine him as the general who personally nursed his men during the cholera epidemic of the Black Hawk War.

Just about the time he was sitting to Rush, Congress voted that a gold medal be struck in Scott's honor, expressing the gratitude of the United States government for "his uniform gallantry and good conduct in sustaining the reputation of the arms of the United States." This was a compliment paid to no other officer.

Rush, thirty years older than Scott, had grown up in Philadelphia when it was the second largest city in the British Empire. The son of a ship carpenter, Rush as a boy spent his time fashioning ships from blocks of wood. When he was fifteen, he was apprenticed to Edward Cutbush, an artisan who had come to Philadelphia from London and who apparently operated a sizable woodcarving establishment. By the third year of his apprenticeship, Rush, outperforming his master, carved figureheads in walking attitudes. Extraordinary for their animation and realism, these works soon gave him a reputation throughout the maritime world. Some thirty-five years later, in 1811, Benjamin Latrobe would look back on Rush's production of ship carvings and say, "There is a motion in his figures that is inconceivable. They seem rather to draw the ship after them than to be impelled by the vessel."

Beginning very likely sometime in the early 1780s, Rush began to carve portrait busts. By the first decade of the new century, he was carving free-standing figures. The pine figures of *Comedy* and *Tragedy*, which he did for the Chestnut Street Theatre, still survive (Edwin Forrest Home for Aged Actors, Philadelphia). In 1809 he shocked some in Philadelphia with a life-size figure of a water nymph clad in figure-revealing drapery. Philadelphians would have been all the more shocked had they realized that the model had posed in the nude, undoubtedly a first for American art. Clearly by this time Rush had moved from "curious carver" to sculptor, taking the native tradition of woodcarving beyond craft into the realm of art. "Mr. Rush, who, though by trade a carver of ships' heads, was, by talent and study, an artist," said William Dunlap in summary.

His close association with Charles Willson Peale's efforts to found an Academy of Fine Arts in Philadelphia indicates his thinking beyond the apprenticeship tradition and into the sphere of academic training. Along with Peale and others, Rush participated in the formation of the short-lived "Columbianum," an association of American artists "for the protection and encouragement of the Fine Arts" and, in 1805, the founding of the Pennsylvania Academy of the Fine Arts. He served on the board of trustees and on the building committee of the latter, and exhibited at each of the annual exhibitions, from the first in 1811 until 1833, the year of his death.

The earliest evidence of Rush's work in clay dates from that first National Academy exhibition in 1811, when he displayed a plaster bust of the late artist, Joseph Wright (Pennsylvania Academy of the Fine Arts). Philadelphia tradition holds that it was Wright, the son of the modeler in wax Patience Wright, who gave Rush his first instruction in modeling in clay. Wright lived in Philadelphia from 1783 until 1785, and again in 1790 until his death during the yellow fever epidemic in 1793.

The maturity evidenced in the bust of Joseph Wright, and seen even more strongly in the busts of Dr. Philip Syng Physick (Pennsylvania Academy of the Fine Arts) and Dr. Benjamin Rush (Pennsylvania Hospital, Philadelphia), done in the fall of 1812 or early 1813, indicates that Rush had been working in clay for some years previous to his first exhibited pieces in "clay burnt." Rush modeled only in wood or in clay. "His time would never permit, or he would have attempted marble," reported William Dunlap.

In 1814, at about the same time that he modeled Scott, Rush executed the standing figure of George Washington in wood (Independence National Historical Park).

He had, he said, previously modeled Washington from life. He hoped to turn out large numbers of plaster-of-Paris casts of the Washington but, to his disappointment, only two subscriptions were forthcoming.

The same seems to have been true for reproductions of his busts of prominent people such as Scott, Perry, and Lafayette. Of Rush's twenty recorded busts, only those of Caspar Wistar, Philip Syng Physick, and Benjamin Rush were known to have been duplicated, and these were ordered specifically by the organizations with which the sitters were associated, namely the Pennsylvania Hospital and the American Philosophical Society.

The bust of Winfield Scott was first shown in 1817 at the sixth annual exhibition of the Pennsylvania Academy of the Fine Arts. It disappeared from sight for over a hundred years and was known only from entries in exhibition catalogues. In the early 1950s Charles Coleman Sellers recognized this "unknown subject by an unknown artist" to be the lost bust of Scott by Rush. Later the discovery of a watercolor sketch by Titian Ramsay Peale, showing the arrangement of the Peale Museum in 1822, proved that the Scott bust, along with those of Rush and Physick (which Peale recorded he had purchased for $20), had been on prominent display in the museum.

Dunlap, William. *History of the Rise and Progress of the Arts of Design in the United States* (2 vols.). New York: Dover Publications, 1969 (first published 1834).

Mansfield, Edward D. *The Life of General Winfield Scott.* New York: A. S. Barnes & Co., 1846.

Marceau, Henri. *William Rush 1756–1833: The First Native American Sculptor.* Philadelphia: Pennsylvania Museum of Art, 1937.

Scott, Winfield. *Memoirs of Lieut.-General Scott, LL.D.* (2 vols.). New York: Sheldon & Co., 1864.

Smith, Arthur D. Howden. *Old Fuss and Feathers.* New York: The Greystone Press, 1937.

Stone, Irving. *They Also Ran.* Garden City, N.Y.: Doubleday & Co., 1966.

John Caldwell Calhoun 1782–1850
Attributed to Charles Bird King 1785–1862
Oil on canvas
76.2 x 63.5 cm
Unsigned
Circa 1818–25
NPG.65.58

Purchased by Andrew Mellon in 1936 and, by indenture of the A. W. Mellon Educational and Charitable Trust, dated August 1942, held "for exhibition in a National Portrait Gallery," if such a gallery should be established within a period of twenty years

John C. Calhoun was secretary of war in James Monroe's cabinet when Charles Bird King painted his portrait. King depicted "the man who would be President" in the full flourish of his national career, a decade before the child of his fantastic intellect, the doctrine of nullification, would cause him to become the embodiment of sectionalism. Calhoun, not yet forty, foretold Harriet Martineau's famous description of "the cast iron man, who looks as if he had never been born and never could be extinguished." Said another contemporary, "Had I come across his likeness in a copy of Milton's *Paradise Lost*, I have at once accepted it ... as a masterpiece of some

great artist who had a peculiar genius for Satanic portraiture. . . . His features were strongly marked and their expression was firm, stern, aggressive." "On his quivering lips," added one other, "there hung an almost Mephisthophelean scorn." Calhoun rarely smiled.

Later, when no foreign visitor could "think of leaving Washington without seeing Mr. Calhoun," he was described: *His appearance is unlike that of other men. . . . His action is quick, and both in society and in the Senate very expressive. He speaks with the utmost rapidity, as if no words could convey his speed of thought; his face is all intellect, with eyes so dazzling, black and piercing that few can stand their gaze. . . . I have seen but one alone with eyes so beautiful. Sometimes their intense look is reading each thought of your bosom; sometimes they are beaming with the inspirations of his own. I believe they give out light in the dark. . . . Mr. Calhoun's general expression is that of unceasing mental activity and great decision. . . . The mouth is thin, and somewhat inclined downwards at the corners; it is the proud and melancholy lip of Dante.*

Mrs. Jefferson Davis, one of the several women whom Calhoun treated as an intellectual equal, said, "He always appeared to me rather as a mental and moral abstraction than a politician, and it was impossible, knowing him well, to associate him with mere personal ambition. His theories and his sense of duty alone dominated him."

Calhoun, of Scotch–Irish descent, had spent his formative years in the solitude of the South Carolina frontier. Calvinist to the core, he was stern and self-righteous. Given the added ingredient of a brilliant intellect, is it any wonder that it would come to be noted that "his mind was incapable of exchanging ideas with other minds?" Margaret Coit, in her biography of Calhoun, has written that he had "a mind so powerful, so sharp-edged and clear, despite its narrowness, that in all American history, perhaps, only the intellect of Jonathan Edwards can compare with it."

Ironically, the man who more than any other articulated the philosophic basis for the "southern way of life" was, in his own nature, alien to the self-indulgent and romantic overtones of that society. The man who said that "life is a struggle against evil" must never, for example, have understood the gaiety of Charleston. He lived in that city but briefly, completing his legal education in Chancellor Henry De Saussure's law offices. The young lawyer saw the city as Babylon: "so corrupt . . . so inattentive to every call of religion." He regarded the outbreak of fever there in 1807 as "a curse for their intemperance and debaucheries." At the time of his death, however, it was this same city that petitioned his family that "the remains of him we loved so well be permitted to repose among us." And so it was done, amid an orgy of mourning that caused even the palmetto trees to be draped in black. One cannot help but reflect that Calhoun would have preferred to rest in the soil of his beloved up-country plantation, "Fort Hill."

John Randolph of Roanoke, his adversary in 1812 when Calhoun was one of the leading Congressional warhawks, spoke scathingly of the "Yale College orator." Deriding Calhoun for his "cold unfeeling Yankee manner," Randolph confided, in a letter to a friend: "That gentleman has not been educated in Connecticut for nothing. He unites to the savage ferocity of the frontierman all the insensibility of the Yankee character in a compound most marvelously offensive to every man having pretentions to the character of a gentleman." Little did John Randolph realize that Timothy Dwight's Yale and Tapping Reeve's Litchfield Law School would prove to have been the spawning ground for Calhoun's elaborate exposition of state sovereignty. Nor did Randolph perceive that Calhoun's passion for the land would trans-

John Caldwell Calhoun attributed to Charles Bird King, c. 1818–25

cend all else and cast him forever as the protector and defender of plantation economy.

At the time Calhoun sat to King, the rumblings of sectional conflict were still in the future. In fact Calhoun was in the forefront of those thinking in nationalistic terms. He favored a national bank, roads, canals, even a tariff, which, this early on, posed little threat to the economy of his own constituency. When men talked of future presidential prospects, there was no reason to suppose that Calhoun's candidacy would not receive support from all parts of the country. John Quincy Adams, his fellow cabinet member, found him to be "a man of fair and candid mind, of honorable principles, and of ardent patriotism. He is above all sectional and factional prejudices." Soon enough, nevertheless, Adams would look askance at his rival's "hurried ambition" to become president.

At the time of the portrait the two could still walk the streets of Washington and engage in frank and friendly discussion of their opposing views. Following a cabinet meeting in which Adams had argued that slavery was incompatible with the Declaration of Independence, he noted in his diary that Calhoun "said that the principles which I had avowed were just and noble; but that in the Southern country, whenever they were mentioned, they were always understood as applying only to white men."

Calhoun, in his discussions with Adams, acknowledged that slavery was an evil in the abstract, but was economically and socially necessary to the South and legally proper under the Constitution. By 1836, however, when he came to feel that any suggestion of the immorality of slavery was a direct threat to the minority interest of the white South, he rationalized that slavery was not a necessary evil but rather a positive good.

Frederick Douglass, who was fascinated by this "great man of perverted faculties," referred to Calhoun over and over again, calling him "the master spirit of the South, the great champion of human bondage." He wrote: "How completely has slavery triumphed over the mind of this strong man! It holds full, complete, and absolute control in his mind; so much so, that seeing it, he cannot and does not desire to see anything else than slavery." Douglass enunciated that Calhoun doctrine concisely: "Slavery is there; he knows it to be there; it has a right to be there; and anything inconsistent with it is wrong, immoral, and has no right to be there."

Calhoun himself owned somewhere between thirty and ninety slaves. To be a "just and kind master" he took to be a solemn duty, and he saw to it that his slaves were adequately clothed, fed, and housed. Upon occasion he found it necessary to order that one of them be whipped, but overall he was genuinely concerned that his people be "well and contented." Convinced as he was that physical security was the only "freedom" that could have meaning to a slave, he was not only hurt but truly bewildered when his coachman ran away "under the seduction . . . of . . . free blacks."

Charles Bird King, who habitually made replicas of his own paintings, executed two sets of Calhoun likenesses. Two related canvases are owned respectively by the Redwood Library, in Newport, Rhode Island, and the Chrysler Museum, in Norfolk, Virginia. The National Portrait Gallery's Calhoun is in turn closely associated with one in the Corcoran Gallery of Art, which was known to have been commissioned by Virgil Maxcy (1785–1844), a Maryland lawyer who was an early supporter of his old friend Calhoun's presidential aspirations. All four portraits show Calhoun as he appeared during the years when he was secretary of war and were painted, apparently, sometime between late 1818 when King arrived in Washington and early 1825 when Calhoun became vice-president. Judging from the appearance of the sitter, the Portrait Gallery–Corcoran version is slightly earlier in date.

From a notation in the diary of John Quincy Adams, we know that King had two portraits of Calhoun completed or at least well under way by early 1819. Under the

date of March 24th of that year, Adams noted that *I had received a letter from Mr. [Joseph] Delaplaine, requesting me to sit for my Portrait, for his Gallery, to Mr. King's the painter. . . . I called this morning at his rooms. . . . He was now painting the foreign Ministers, who are all shortly going away. . . . The Portraits that he has taken, are almost without exception very strong likenesses; and good Pictures. He had General Jackson, Genl. Parker, and Coll. Butler, Calhoun twice. . . . There were only three or four of the whole number that I did not immediately recognize at first sight.*

King exhibited a *Portrait of J. C. Calhoun Esq. Secretary of War for Delaplaine's National Gallery* at the Pennsylvania Academy of the Fine Arts Exhibition in 1822 and 1823. In 1824 he exhibited a Calhoun portrait once again, identifying his sitter simply as secretary of war, and, in 1825, with the label *Portrait of J. C. Calhoun Esq. Vice President of the United States.* It is impossible to determine which image of Calhoun was presented at which year's exhibition, or indeed to know whether the four separate entries refer to one, two, three, or four different pictures.

When Calhoun first sat to King, the artist had tentatively settled in Washington after an itinerant time spent in New York, Philadelphia, Baltimore, and Richmond. Born in Newport, King had passed seven diligent years in London at the Royal Academy School under the tutelage of Benjamin West. Thomas Sully, recalling those days, wrote, *I found him, as a fellow student the most industrious person I ever met with. He limited his hours of sleep to four—was jealous of the least loss of time—his meals were dispatched in haste, even then (while eating) he read some instructive book. By this unremitting assiduity he has amassed a fund of useful knowledge.*

King had not been in the capital long before he acquired a reputation, as John Quincy Adams noted, as "one of the best Portrait Painters in this Country," and "little inferior" to Gilbert Stuart. Delaplaine recommended him as "a very respectable man and an excellent portrait painter." He painted his pictures, Delaplaine told those chosen for inclusion in his gallery, in two sizes, costing $80 and $120. Delaplaine, who paid but half of the charges, urged the prospective sitters to commission the large size, which, he pointed out, would make a better show in his gallery.

To judge from Adams's experience, sitting to King was no little inconvenience. Adams sat to him sixteen or seventeen times, sometimes for two hours at a time. One wonders how the very busy secretary of war, wrestling with a chaos of unsettled accounts, dealing with the extraordinary burden of certifying 30,000 pension applicants, drawing up plans for coastal fortifications, dealing with the rivalry and jealousy among his prima-donna officers, and sending out commissioners to offer inducements for Indian resettlement beyond the Mississippi, found time to sit for his portrait. Well on his way to becoming one of the greatest secretaries of the war in American history, Calhoun spent some fifteen hours a day at his office.

At the time he posed for King, Calhoun was more concerned with Indian problems than with slavery. Late in 1818 he had recommended to Congress a new and far-reaching Indian policy, with proposals for settling the tribes on lands of their own with the distinct understanding that no more demands for territory would be made upon them. His program included provisions for education and, ultimately, the granting of citizenship with full political rights. It would be a hundred years before his ideas were completely realized. Immediately, however, he withstood the pressures from John Jacob Astor and other fur traders, who wished to see the Indian trade turned over completely to private companies. Calhoun, the son of an Indian fighter and whose grandmother had been killed by Indians, had far greater empathy for the Indians than he did for the blacks.

Ironically, Charles Bird King, whose father had also been killed by Indians, would base a major part of his career on their portrayal. That this came to be must be credited, at least in part, to John C. Calhoun who, in 1821, first summoned tribal

chiefs to Washington, and who agreed to Superintendent of Indian Trade Thomas L. McKenney's plan for a gallery of Indian likenesses. It may well be that Calhoun recommended King for the initial government commissions. In any case, during the next two decades, King was hired by the War Department to paint 143 Indian portraits and, in addition, to make replicas for presentation to the sitters. As the more or less official painter of the succession of Indians brought to Washington to be impressed by the power of the Great White Father, King was assured of a steady income, surely one of the factors that induced him to settle permanently in Washington.

Visiting the Indian gallery in 1832, Frances Trollope noted the walls covered with portraits by Mr. King and remarked that these, "it cannot be doubted, are excellent likenesses, as are all the portraits I have ever seen from the hands of that gentleman."

Coit, Margaret L., ed. *John C. Calhoun: Great Lives Observed.* Englewood Cliffs, N.J.: Prentice-Hall, 1970.

———. *John C. Calhoun: American Portrait.* Boston: Houghton Mifflin Co., 1950.

Cosentino, Andrew J. "Charles Bird King: An Appreciation." *The American Art Journal,* May 1974, pp. 54–70.

Dunlap, William. *History of the Rise and Progress of the Arts of Design in the United States* (2 vols.). New York: Dover Publications, 1969 (first published 1834).

Oliver, Andrew. *Portraits of John Quincy Adams and His Wife.* The Adams Papers, Series IV. Cambridge, Mass.: Harvard University Press, Belknap Press, 1970.

Thomas, John L., ed. *John C. Calhoun: A Profile.* American Profiles. New York: Hill & Wang, 1968.

Wiltse, Charles M. *John C. Calhoun* (3 vols.). New York: Russell & Russell, 1968.

Ira Aldridge 1804–1867
By Henry Perronet Briggs 1791/3–1844
Oil on canvas
21.9 x 101.6 cm
Unsigned
Circa 1830
NPG.72.73

Presented to the Garrick Club, London, in 1907, by Sir George Alexander, actor and manager of St. James's Theatre

Ira Aldridge, the New York-born tragedian, was well known in England, acclaimed in France, extremely popular in Germany, and idolized in Russia, but in his lifetime almost totally unknown in his native country. The English historical and portrait painter Henry Perronet Briggs shows him near the beginning of his long stage career, dressed as Othello, the African Prince.

Aldridge, as he himself attested when applying for British citizenship in 1863, had come to England in 1824. The son of a lay preacher, he had been educated at New York's African Free School. How he came to the acting profession is not known, but, growing up in New York in the early 1800s, he would have had the opportunity to see, if only from the fourth tier, the great English and American actors of the day, including James Wallack and his brother Henry, Edmund Kean, and Junius Brutus Booth. Moreover, by 1820 the free blacks of New York had started their own theatre,

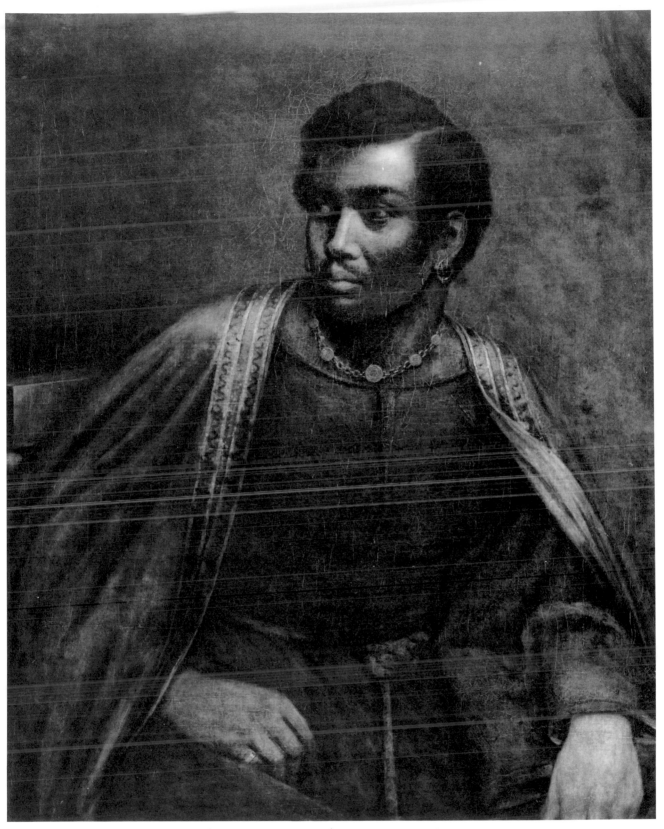

Ira Aldridge by Henry Perronet Briggs, c. 1830

and it is likely that Aldridge had had experience in playing Shakespearean as well as other roles in the African Theatre on Mercer Street. According to the *Memoir and Theatrical Career of Ira Aldridge the African Roscius*, published anonymously in London in 1849, Aldridge *fell to work and studied the part of Rolla in the play of* Pizzarro, *and in that character he made his first appearance on any stage. This was at a private theatre where he was singularly successful and his fellow-performers were of his own complexion.*

The first mention of Aldridge's presence in England occurs with the October 1825 reviews of his appearance as the black hero Oroonoko in *The Revolt of Surinam, or A Slave's Revenge*. The play, presented at the Royal Coburg, a minor London theatre, was described as "a most faithful portrait of the horrors that arise out of that dreadful traffic, which is the proudest boast of Britain to use her best efforts toward suppressing." The play, the reviewer went on, *must receive an immense portion of additional interest from being supported in its principal character by a* Man of Colour, *and one of the very race whose wrongs it professes to record; being the first instance in which one of that Complexion has displayed a striking degree of Histrionic Talent, and which has secured him the rapturous Approbation of an enlightened Public on the other side of the Atlantic.*

Aldridge, appearing under the stage name of Mr. Keene, an appellation he used until about 1831, was received with mixed reviews. One critic reported that "it is extremely difficult to criticize a black actor, on account of the novelty of the spectacle." On the 11th of October the reviewer for the London *Globe* wrote: *Curiosity led us last night to see the black tragedian from the African Theatre at New York. . . . Had Mr. Keene appeared on the boards of one of the minor theatres merely as a provincial performer and an Englishman, he would have merited considerable applause, but considering he has attained his eminence under all the disadvantages of the present state of American society, his claims must belong to a much higher grade. . . . His enunciation is distinct and sonorous, though his voice is deficient in modulation and flexibility; his features appear too hard and firm to admit of outwardly exhibiting the darker passions and most embittered sufferings of the heart. But he looks his character.*

A few days later, on December 17th, Aldridge played Othello for the first time in the theatre at Brighton. The critic for the Brighton *Gazette* reported that he was less successful as Othello than as Oroonoko: "The drama of Shakespeare is evidently beyond his reach, and in the dignified, although fierce passion of the noble Moor, he fell far short of the force and propriety which marked his delineation of the sable prince." The London *Morning Post* reported that Aldridge *was not so much at home in the character, however, as he had previously been in that of Oroonoko, but he evinced a talent sufficient to bring down frequent peals of applause. . . . In the intellectual ability which Mr. Keene, however, has manifested in his several personations here, much good perhaps, may result to the sable brethren, inasmuch as they have afforded a powerful illustration that blacks as well as whites may be equally fashioned by education—and that to education, principally, is to be ascribed that mental superiority which the latter have too often endeavoured to persuade themselves that they exclusively enjoy.*

Years later, when he was a thoroughly seasoned actor, the famed French drama critic Théophile Gautier saw him perform Othello in St. Petersburg, Russia, and described him thus: *His first part was Othello, and, thanks to his origin, Ira Aldridge was able to dispense with all the colouring aids of liquorice juice or coffee grounds; he had no need to hide his arms under a chocolate-coloured woolen covering. He had the natural skin for the part, and it was no effort for him to assume the role. His first*

entry was magnificent, he was Othello himself, as created by Shakespeare, his eyes half closed as though dazzled by an Afric sun, his manner orientally carefree, with that Negroid grace of movement no European can imitate. . . . We had been anticipating a vigorous style, somewhat uncontrolledly energetic, a little wild and fierce, after the manner of Kean; but the coloured tragedian, doubtless in order to appear no less cultured than the white man, acts wisely and restrainedly, in a majestically classical style much resembling that of [William] Macready. In the last scene his passions remain within bounds; he smothers Desdemona in a most gentlemanly way, and he roars most decorously. In one word as far as one can judge an actor under such circumstances, he appeared to us to have more talent than fire, more skill than inspiration. Nevertheless, let us hasten to state that he produced a great performance which drew forth endless applause. A more lurid and fiercer Othello might perhaps have succeeded less well. After all, Othello had lived for a long time among Christians, and the lion of St. Mark must have tamed the lion of the desert. Also reviewing Aldridge's performance of King Lear, Gautier concluded that he was better in the part of Lear, for in Lear he acted, and "in Othello he was just himself."

Whether or not Briggs saw Aldridge perform or only heard or read about the "African Roscius," there can be no doubt that the painter of a Shakespearian series, which included characters from *Henry IV, Twelfth Night, The Merry Wives of Windsor, King Lear, The Taming of the Shrew,* and *The Tempest,* would have had his imagination stirred by the opportunity to paint an Othello of the hue which Shakespeare had intended. Briggs perhaps looked to surpassing his portrait of the great English tragedian, William Macready, in the character of Macbeth.

Now in mid-career, Briggs had displayed his talents early. While still a schoolboy, he had done two well-executed engravings for the *Gentleman's Magazine.* His precocious talents, and no doubt his family connection to John Opie, professor of painting at the Royal Academy school, gained him an early admittance to that institution. He first exhibited at the Academy in 1814 and, save for the year 1815, was represented every year until his death. He was primarily known as a history painter, executing, in addition to his Shakespearean series, large canvases such as *Lord Wake of Cottingham sets fire to his castle to prevent a visit from King Henry VIII who was enamoured of his wife* and *Discovery of the Gunpowder plot and taking of Guy Fawkes.* After he was elected to the Royal Academy in 1832, such was the demand for his portraits that, against his own wishes, he "abandoned historical painting in favour of that more lucrative art."

In 1826 Briggs exhibited, at the Royal Academy, a picture entitled *Othello relating his adventures, act 1, scene 3 "Her father loved me, etc."* The picture, measuring, with its frame, five feet ten inches by four feet nine inches, does not correspond in its dimensions to the one owned by the National Portrait Gallery. It is possible that the then twenty-two-year-old Aldridge served as a model for this historical painting, but the Gallery's portrait, showing a somewhat older Aldridge, would appear to have been painted around 1830.

Aldridge's acting career spanned over forty years, and in that time he played, in white face, Lear, Hamlet, Richard II, Shylock, Macbeth, and countless roles in other plays long since forgotten. Throughout his life he continued to play Othello, which he almost always followed with the comic part of Mungo, the West Indian slave in *The Padlock.* The part was an opportunity to display his versatility as well as musical talents.

Aldridge won his greatest acclaim from audiences on the Continent, particularly in Russia where, even though he spoke his parts in a foreign tongue, his acting transcended the language barrier. The Russian historian M. P. Pogodin noted that *such*

is the power of his spirit, such is the might of his art, that you surrender to him from the very first minute, you understand what he says, you apprehend all that he feels, you listen, it seems, to every beat of his heart. You pass with this magician through every stage of human passion.

Almost without exception, descriptions of Aldridge have come from the drama reviews. Seldom was he seen "out of character." A rare glimpse of Aldridge off-stage was given by the Irish critic Maurice Lenihan, who saw him in the spring of 1833. Lenihan, writing in 1872, remembered, *He was of a rather robust make, tall, with all the peculiarities of his Negro race as to his features, except that his colour was a deep brown or bronze rather than black. His manners were bland and polite; he spoke English with a good accent, not yet entirely divested of the peculiarity which is attached by his countrymen to the pronunciation of certain syllables. . . . I wrote and published critiques of Ira Aldridge's performances, which pleased him very much. He wrote in consequence in a fair and clear hand, a short note to me thanking me for my kindness in this regard.*

The Russian actor Davydov, who played with him in Moscow when Aldridge first came to that city in 1862, remarked that *he was good-natured in private life, but on the stage he was demanding and insistent and his stage business* (mis en scène), *his plan of acting, he carried out with exceptional thoroughness, according to a well-prepared and thoroughly worked-out scheme, taking into consideration, of course, the acting of local artistes, the production, and the conditions of the stage and theatre.*

The most intimate picture of Ira Aldridge has come from the daughter of the poet and revolutionary, Taras Shevchenko, who came to know him in St. Petersburg in 1858. Despite a language barrier, the actor and poet became friends. "Aldridge, by gestures and mimicry, could represent everything he wished to say," Shevchenko's daughter reported. She recalled that Aldridge visited the family every day. "He was very fond of us, and we could not help but be fond of him. He was a sincere, good, careless, trusting, and loving child." She remembered vividly the occasion when Shevchenko drew Aldridge's portrait (Tretiakov Gallery, Moscow): *For a minute only the scratching of the pencil on paper could be heard—but could Aldridge stay long in one place? He began to squirm, we cried out to him that he had to sit at attention, he made faces and we could not keep from laughing. Shevchenko angrily stopped his work, Aldridge made a frightened face and once again sat for a while quietly without moving, then suddenly he said, "May I sing?" "Oh you. . . . All right sing!" Then began a touching, sad Negro melody, which gradually passed into a more lively tempo and ended with a mad jig by Aldridge around the studio. Following that, he would act a whole comic scene. . . . Despite the fact that these merry and interesting pastimes . . . dragged out the sessions, the portrait was finished and turned out to be a lifelike and good resemblance.*

Aldridge never returned to America, although several times he planned to do so. As early as August 1834 he wrote that he was "on the eve of returning to my native country." Henry Wallack, whose brother was then operating a theatre in New York, had suggested an American tour in 1858, but Aldridge wrote later, "My dear wife would not entertain the idea; her prejudice is so rooted against the Americans for their treatment of our oppressed race generally." At the time of his death he was planning an American engagement. In the edition one day previous to the announcement of his death, the *Chicago Times* gave notice in its theatrical column that "Ira Aldridge Negro Tragedian, is to play in the Academy of Music soon," and went on to list, for the benefit of readers who had never heard his name, his honors and decorations, which included an honorary commission as Captain and Aide-de-Camp Extraordinary to the president of Haiti, the gold medal of the Prussian Academy of Arts and Sciences, the White Cross of Switzerland, and a knighthood of Saxony.

Marshall, Herbert, and Mildred Stock. *Ira Aldridge: The Negro Tragedian.* Carbondale: Southern Illinois University Press, 1968.

Stephen, Sir Leslie, and Sir Sidney Lee, eds. *The Dictionary of National Biography.* London: Oxford University Press, cumulative since 1917.

John Marshall 1755–1835
By William James Hubard 1807–1862
Oil on canvas
61.6 x 38.4 cm
Unsigned
Circa 1832
NPG.74.71

Painted for the subject's eldest son, Thomas, and retained by the family until its acquisition by the National Portrait Gallery in 1974. It was the chief justice's practice to have multiple images made for various members of the large Marshall family. At least six versions of the Hubard painting are known

When the venerable John Marshall posed for William James Hubard, he had been chief justice of the United States for some three decades. The momentous decisions firmly establishing the Supreme Court as a coequal branch of the government were now behind him. Hubard, born six years after Marshall's appointment to the Court, had just recently turned from cutting silhouettes to painting in oils.

Chief Justice Marshall, now moving into his late seventies, had for some years been flirting with thoughts of retirement, a time, he told his dear friend Associate Justice William Story, when he planned "to read nothing but novels and poetry." The election and subsequent reelection of President Andrew Jackson, however, stayed his resignation. John Quincy Adams put it bluntly in his diary, when he confided his fear that if Marshall should step down Jackson would appoint "some shallow-patted wildcat . . . fit for nothing but to tear the Union to rags and tatters." And, although Jackson's vigorous repudiation of South Carolina's doctrine of nullification relieved the minds of nationalists, he nonetheless remained anathema to American conservatives. Marshall himself wrote to Associate Justice William Story, "You know how much importance I attach to the character of the person who is to succeed me, and calculate the influence which probabilities on that subject would have on my continuance in office."

Hubard, born in England, was as a child found to be uncommonly clever at cutting profiles in paper. Under the management of a man named Smith, young "Master Hubard" exhibited his skills throughout the British Isles. In 1824, when he was about seventeen, he was brought to the United States, where he cut silhouette profiles in seconds, much to the delight and amazement of New York audiences. Late in the following year, the Hubard gallery moved on to Boston, where Master Hubard continued to cut silhouettes "by the hundreds." It was noted in his promotional literature that "since his arrival in America, he has conceived a strong passion for painting in oils, and . . . he will one day rank among the first painters of his age and country." Family tradition holds that while in Boston the young Hubard received encouragement from Gilbert Stuart. William Dunlap, however, relates that it was the New York artist Robert Weir who persuaded Hubard to try oils and provided him with

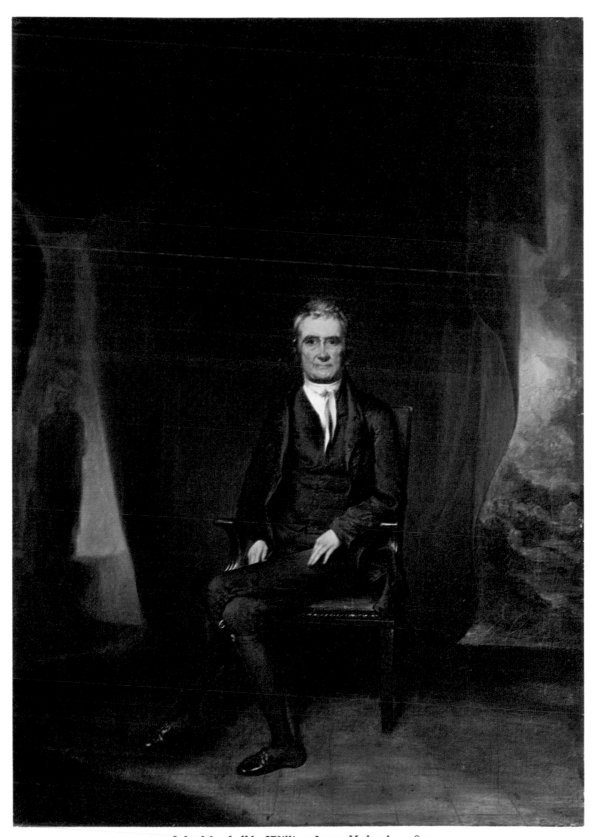

John Marshall by William James Hubard, c. 1832

materials. Whatever the source of inspiration, Hubard exhibited an oil portrait in May 1827, at the first loan exhibition of the Boston Athenaeum. Along about this time Hubard seems to have broken with Smith and was making his way as a theatrical-scene painter. By January of 1828 he was working in New York but, by 1830, had moved to Philadelphia. From 1829 to 1832 he exhibited "small whole length" portraits at the Pennsylvania Academy of the Fine Arts.

Before 1833 he had executed cabinet portraits of some of the leading figures on the national scene—President Andrew Jackson (unlocated), Vice-President John C. Calhoun (Corcoran Gallery of Art), and Senator Henry Clay (University of Virginia). All of these are similar in composition and appear to be part of a series. In each the subject is seated in the center of the canvas amidst what would seem to be his own household furnishings but with the addition of a background of drapery and landscape reminiscent of theatrical scenery. In all likelihood Hubard intended these paintings to be engraved.

The portrait of John Marshall appears to belong to this same series. A silhouette of Marshall (John Marshall House, Richmond), labeled and signed by Hubard, is dated 1832, thus giving a reasonable date for the oil painting also. Conceivably it could have been painted in Richmond, Virginia, or in Raleigh, North Carolina, where Marshall rode circuit. However, since Washington was the location common to all of the subjects of the associated portraits, it may be assumed that Hubard spent some time in that city. Interestingly, in the background stands a figure that appears to be Jean-Antoine Houdon's full-length statue of Washington, indicating possibly a Richmond setting, but included more likely as a reference to Marshall's *Life of George Washington*. (Hubard, incidentally, later made six casts in bronze of the Washington statue.)

Marshall, a man known for his cooperative spirit, sat to many artists. In Philadelphia, in October of 1831, when he was preparing to undergo a dangerous operation for kidney stones, he was asked by the members of the bar association to "permit his portrait to be taken" by "an eminent artist of this city." Much to the dismay of his doctor, the eminent Dr. Philip Syng Physick, he "stepped to the office of a portrait painter" (Henry Inman).

Presumably Hubard painted Marshall during or following the Supreme Court Session of 1832. It was a sad time for the old judge. On Christmas Day in 1831, "dearest Polly," his wife of forty-nine years, had died. Such was the depth of his sorrow that even a year following her death he would write, "I have lost her! And with her I have lost the solace of my life!" Rarely, Marshall told his friend Story, was he able to pass a night without tears. "She must have been a very extraordinary woman to have attached him," wrote Story, "and I think he is the most extraordinary man I ever saw, for the depth and tenderness of his feelings."

Added to Marshall's bereavement was the inexorable toll of age. Asked by a joint committee of the Senate and the House of Representatives to deliver an address on the centennial birthday of Washington, he was forced to decline, saying, "I am physically unable to perform the task I should assume. My voice has become so weak as to be almost inaudible even in a room not unusually large." He, who had known vibrant health nearly all his life, had come to reflect, *Could I find the mill which would grind old men, and restore youth, I might indulge the hope of recovering my former vigor and taste for the enjoyment of life. But as that is impossible, I must be content with patching myself up and dragging on as well as I can.*

It was also a time when Marshall found the authority of the Supreme Court flaunted by the State of Georgia, and by the president of the United States who declared that he would do nothing to prevent Georgia from violating Indian treaty

rights. "Well, John Marshall has made his decision, now let him enforce it," said President Jackson.

Appointed to the Court by John Adams, Marshall was an unlikely choice as far as academic credentials were concerned. His education was no more than two years in length—a year spent at the Reverend Archibald Campbell's Classical Academy and another year at home under a Scottish tutor. A few weeks' attendance at George Wythe's law lectures at the College of William and Mary was the limit of his formal legal education. But this self-educated son of a small Virginia planter had an acute mind and common sense. Rufus King, who heard him argue his first and only case before the Supreme Court in 1796, noted that "his head" was "one of the best organized of anyone that I have known." Years later, when he was on the bench with the Harvard-educated and encyclopedically minded Joseph Story, Marshall would say, "That, Story, is the law. Now you find the precedents."

The coming together of the man and the job could hardly have been more fortunate. Marshall, a warm, convivial man who loved eating, drinking, and conversing with other men, found the clubby atmosphere of the Supreme Court made to order for his particular genius. The Court was in session for twelve or thirteen weeks a year, at most, and the members came to Washington without their families. They lived and ate together in the same boarding-house, "very harmoniously and familiarly," wrote Justice Story. "Indeed, we are all united as one, with a mutual esteem which makes even the labors of jurisprudence light." Something of the jovial nature of the gathering is suggested in a report that Story gave of the Court's adopting a rule that its members would take wine at meals only in wet weather. He reported to his wife: *But it does sometimes happen that the Chief Justice will say to me, when the cloth is removed, "Brother Story, step to the window and see if it does not look like rain." And if I tell him that the sun is shining brightly, Judge Marshall will sometimes reply, "All the better, for our jurisdiction extends over so large a territory that the doctrine of chances makes it certain that it must be raining somewhere."*

Marshall, who as the oldest of fifteen children had learned early the knack of "putting his own ideas into the minds of others, unconsciously to them"—dominated them all. Story, a fervent Jeffersonian, was won over at the first meeting. "I love his laugh—it is too hearty for an intriguer." A few years later, when he was Marshall's closest associate on the bench, he wrote impulsively, "I am in love with his character, positively in love." Marshall's cousin, Thomas Jefferson, one of the few men who disliked the chief justice, was well aware of his charisma. In 1810, when the Republican had, for the first time, an opportunity of getting a majority on the Supreme Court, Jefferson wrote to President James Madison that "it will be difficult to find a character of firmness enough to preserve his independence on the same Bench with Marshall." Such proved to be the case and, even after five out of the seven justices were Republican-appointed, it continued to be the "Marshall Court." In his years on the Court, Marshall wrote almost half of all the decisions (519 out of 1,106), and only in nine cases did he fail to carry the majority with him. The Marshall Court, in landmark rulings such as those reached in *Marbury* v. *Madison*, the "Dartmouth College case," *McCulloch* v. *Maryland*, and *Gibbons* v. *Ogden*, enlarged the powers of the federal government at the expense of the states and firmly established the principle of judicial review. John Marshall's influence can hardly be overestimated.

William Wirt, who had first known Marshall when he was a young lawyer in Richmond, and who in subsequent years watched him many times in the courtroom, wrote: *This extraordinary man, without the aid of fancy, without the advantages of person, voice, attitude, gesture, or any of the armaments of oratory, deserves to be considered as one of the most eloquent men in the world; if eloquence may be said*

to consist in the power of seizing the attention with irresistible force, and never permitting it to elude the grasp, until the hearer has received the conviction which the speaker intends.

Marshall was "antique in his dress and altogether negligent," his contemporaries agreed. To the end of his days he wore knee breeches. Story noted that he dressed "in the garb—but I would not say in the mode—of the last century." He looked, said his friend, as if he had gotten his clothes "from the wardrobe of some antiquated slopshop of second-hand raiment."

Thomas Jefferson spoke sneeringly of John Marshall's "lax lounging manners" which, he said, "have made him popular with the bulk of the people of Richmond, and a profound hypocrisy with many thinking men of our country." But the "lax lounging manners" were not an affectation. This conservative Federalist, this staunch defender of property rights, this opponent of universal suffrage, looked and acted (save for the knee breeches) the very image of the Jacksonian Democrat.

Hubard has painted a magnificent head, but the body beneath is ungainly and awkward. While one might be inclined to blame the ill-proportioned body on Hubard, judging from contemporary descriptions it seems fair to say that the artist has captured the physical structure of John Marshall. Marshall's body, said Story, "seemed as ill as his mind was well compacted." He was, observed his friend, "without proportion," and his arms and legs dangled, looking "half dislocated." William Wirt described him as "tall, meagre, emaciated, his muscles relaxed, and his joints so loosely connected . . . his black eyes possess an irradiating spirit which proclaims the imperial powers of mind that sits enthroned within." His eyes, most observers agreed, were his most striking feature. It was remarked in his eulogy that they were "dark to blackness, strong and penetrating, beaming with intelligence and good nature."

Baker, Leonard. *John Marshall, a Life in Law.* New York: Macmillan, 1974.

Dunne, Gerald T. *Justice Joseph Story.* New York: Simon & Schuster, 1970.

McCormack, Helen G. *William James Hubard 1807–1862.* Richmond, Va.: Valentine Museum, Virginia Museum of Fine Arts, 1948.

Mason, Frances Norton. *My Dearest Polly.* Richmond, Van Garrett & Massie, 1961.

Rodell, Fred. "The Great Chief Justice." *American Heritage,* December 1955, p. 10.

Edwin Forrest 1806–1872
By Frederick Styles Agate 1807–1844
Oil on canvas
62.2 x 48.9 cm
Unsigned
Circa 1832
NPG.66.20

Retained by the artist and inherited by his nephew, Thomas Agate Carmichael. Gift of Kathryn and Gilbert Miller Fund in Memory of Alexander Ince

Frederick Styles Agate has painted neither Edwin Forrest the man nor Metamora the Indian chief. The portrait is most correctly described as "Mr. Forrest in the character of Metamora."

Metamora, a romantic tragedy based loosely on King Philip's futile uprisings, in 1675, against the English settlers, made its debut on December 15th, 1829. Forrest himself had commissioned the play. As America's first native-born and native-trained tragedian, he was notable even in a time of rampant cultural nationalism for his "spread-eagle" sentiments. In the interests of securing dramas based on what he considered to be peculiarly American themes, the popular young actor had sponsored a contest offering $500 and half of the third night's receipts for the "best Tragedy, in five acts, of which the hero or principal character shall be an aboriginal of this country." The winner was not a writer, but an actor, John Augustus Stone, who had worked with Forrest and who was familiar with his acting style. Together Stone and Forrest created an action-filled spectacle expressly tailored to Forrest's taste for heroic postures and bellowing delivery and full of opportunities for showing off the magnificent body he had assiduously exercised into fearsome strength.

The audience thrilled to Forrest as the noble Indian chief who fought valiantly and died heroically, cursing the white man with his last histrionic breath. People had, wrote one critic, never heard anything so "tremendous in its sustained crescendo swell and the crashing force of utterance" as Forrest's voice which *surged and roared like the angry sea; as it reached its boiling seething climax, in which the serpent hiss of hate was heard, at intervals amidst its louder, deeper, hoarser tones, it was like the falls of Niagara, in its tremendous downsweeping cadence; it was a whirlwind, a tornado, a cataract of illimitable rage.*

It was as real as it was strenuous. Forrest, a perfectionist who studied all his roles with the greatest of care, prided himself on his realism, and in the matter of an Indian portrayal was guided by impressions formed when he was eighteen and spent two months living with Indian friends just outside New Orleans. "So accurate had been his observations," a contemporary theatregoer observed, that he "caught the very manner of their breathing." At one performance a visiting delegation of Indians was so carried away by his dramatic realism that they rose from their seats to chant a dirge in honor of the dying chief.

Forrest continued to play *Metamora* for forty years, and even though he knew greater artistic successes in his Shakespearean roles, most notably King Lear, his role of the Indian chief was most popular with the public. Although he might, as his younger colleague Joseph Jefferson reported, come to detest the part, the money-conscious Forrest never failed to put it on the boards when the audiences flagged or he had a particular need for more funds, as he often did following his notorious, and very expensive, divorce. Jefferson, in speaking of *Metamora*, wrote: *Forrest was always in a state of intense irritation during the rehearsal and performance of this drama. Irregularities that he would have overlooked under ordinary circumstances were now magnified to an enormous size, so that when he donned the buckskin shirt, and stuck the hunting-knife of the American savage in his wampum belt, he was ready to scalp any offending actor who dared to cross his path. The copper-colored liquid with which he stained his cheeks might literally have been called "war paint."*

Harpers, reporting on Forrest as Metamora late in his career when the taste for roaring physical histrionics had waned among the sophisticated, sneered, *There he is—the neck, the immemorial legs, the ah-h-h-h-h in the same hopeless depth of guttural gloom. We may call it the muscular school; the brawny art; the biceps aesthetics; the tragic calves; the bovine drama, pant, roar, and rigamarole; but when then; and what then? Metamora holds his mighty arms and plants his mighty legs, and with his mighty voice sneers at us "Look there!" until the very ground thrills and trembles beneath our feet.*

Henry Cabot Lodge, recalling *Metamora* as one of the most pleasant and vivid

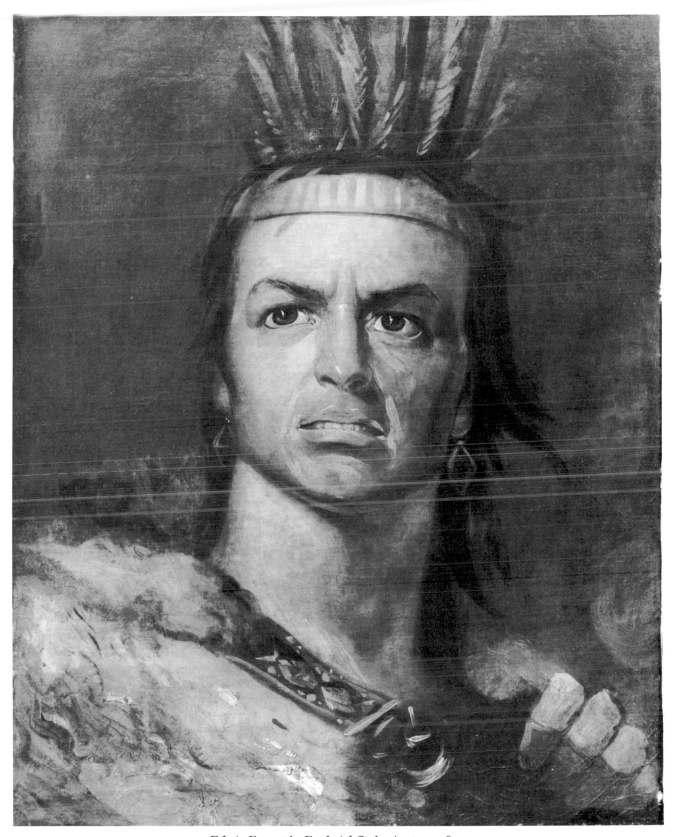

Edwin Forrest by Frederick Styles Agate, c. 1832

memories of his boyhood, reflected more nearly the attitude of the thousands who continued to delight in the vibrant Forrest. Lodge wrote in *Early Memories* that Forrest *impressed me deeply in the part of the noble savage, and I did not mind his rant or his marked mannerisms. He was a very striking-looking man, large, powerful, with a voice of great depth and compass. His faults were obvious enough, in fact everything about him was obvious, and he was generally condemned by my elders, to whose opinion I deferred and from whom I concealed my admiration for the chief of the Wampanoags. But when I saw him in later years, although he was then an old man, I perceived that despite his ranting and his crudity, due to lack of training, he was really a great actor of unusual force and power.*

Forrest, who had wanted to be an actor as long as he could remember, and who continued to act even as the excruciating tortures of gout, rheumatism, and sciatica made it almost impossible for him to stand or move, gave the American theatre a lifetime of professional dedication.

A young painter of history scenes and portraits, searching for an arresting subject for an exhibition picture, could hardly have chosen better.

Agate, an upstate New York boy who had, when very young, shown "a fondness for drawing figures of horses, ships, cattle," went to New York City to study drawing and painting under John Reubens Smith, one of the best teachers of his time. Under Smith's tutelage he became "a very careful and correct draughtsman." Later he worked under Samuel F. B. Morse and learned to copy Morse's pictures with such fidelity that it was said that the copies could not be distinguished from the originals. In 1827 he opened his own studio in New York and soon earned a reputation as a painter of faces which were "cleverly colored and always faithful likenesses." Instrumental in founding the National Academy of Design, he contributed paintings each year to the annual exhibition. The portrait of Forrest in the role of Metamora is apparently a finished study for a large full-length portrait he entered in the exhibition of 1833. Of the latter it was said that "there are few rooms in this country where works of this character can be located permanently." When the portrait was exhibited two years later at the Pennsylvania Academy of the Fine Arts, it was noted as being for sale, and was still available in 1839 when shown at the American Academy of Fine Arts exhibition in New York.

As it happened, not long after the portrait was finished, both artist and sitter went for the first time to Europe—Forrest in July of 1834 and Agate the following autumn. Forrest, at the top of his profession in America, had earned the luxury of a grand tour and, following that, was ready, as an established American star, to make his debut in England. One the eve of his departure, his many friends in New York's literary and artistic world arranged a testimonial dinner and presented him with a gold medal (New-York Historical Society), featuring his bust in profile encircled with the inscription "Historiom Optimo, Eduino Forrest, Viro Praestanti." For his part, Agate, who had now earned enough money to study in Europe, planned to be away for three years, spending time in Paris, Italy, Germany, Holland, and England. Unfortunately, shortly after his arrival in Italy, he suffered a severe illness "arising out of his intense devotion to his studies," and was forced to return to New York in the fall of 1835.

Ahead for Forrest were nearly forty years of fame and fortune. Agate's career, on the other hand, was virtually over. He continued to send an occasional picture to the Academy exhibitions, but, *with the loss of health, he seemed to have lost that ambition so essential to great effort; indeed we are persuaded he never sufficiently recovered from that attack to grapple with the difficulties which present themselves in painting large historical pictures.* By the age of twenty-seven, he was dead from consumption.

Edmonds, Francis W. "Frederick S. Agate." *Knickerbocker, New York Monthly Magazine,* vol. XXIV, 1844.

Jefferson, Joseph. *Autobiography.* Edited by Alan S. Downer. Cambridge, Mass.: Harvard University Press, Belknap Press, 1964.

Moody, Richard. *Edwin Forrest, First Star of the American Stage.* New York: Alfred A. Knopf, 1960.

Parry, Ellwood. *The Image of the Indian and the Black Man in American Art 1500–1900.* New York: George Braziller, 1974.

Wilson, Garff F. A *History of American Acting.* Bloomington: Indiana University Press, 1966.

Noah Webster 1758–1843
By James Herring 1797–1867
Oil on panel
81.3 x 69.8 cm
Unsigned
1833
NPG.67.31

Gift of Mrs. William A. Ellis, great-great-granddaughter of Noah Webster

"The name of Noah Webster is familiar to almost the entire population of our country, as associated with the period of their first instruction in the rudiments of knowledge." Thus began the biography of the prominent educator, editor, polemicist, and lexicographer, as it appeared in Volume II of *The National Portrait Gallery of Distinguished Americans,* published in 1835 by James Barton Longacre and James Herring. Clearly Webster—the author of A *Grammatical Institute of the English Language,* Part I, commonly known as the "blue backed speller," a book which sold all over the country at the rate of a million copies a year at a time when the population was only about ten million—through this endeavor alone deserved to be included in such a work. It was expressly to secure a likeness for this publication that James Herring journeyed to New Haven in 1833 to paint Webster's portrait. Webster, writing to his daughter on September 21st of that year, noted in a postscript, *I ought perhaps to add that Mr. Herring of N. York is publishing memoirs of distinguished me[n] in this country, with engravings of their portraits done in elegant style. He has seen fit to request my portrait & is now engaged in painting it himself. The picture is not finished. When it is you will have the opinions of your friends here as to the likeness.*

Noah Webster was seventy-four when Herring painted him, seated in the high-backed armchair that stood by the fireplace in his parlor. He would live ten more active years, but his greatest achievements had been consummated. The major work of his life—the compilation of *An American Dictionary of the English Language,* the "babe he had dandled twenty years and more," finally had been published in 1828. It was a remarkable accomplishment—seventy thousand words, twelve thousand of them and between thirty- and forty-thousand definitions the product of Webster's original scholarship. And the whole, because Webster had been unable to afford secretarial help, was transcribed in his own hand.

Webster's dictionary fast became the standard work in America, adopted by the Congress and in various courts of law. It was not long before it was accepted likewise

in England. In the wake of American independence, Webster had crusaded fervently for an independent national character. "Nothing can be more ridiculous than a servile imitation of the manners, the language, and the vices of foreigners. . . . nothing can betray a more despicable disposition in Americans than to be the apes of Europeans," he had written. American ladies might continue to "dress like a dutchess in London" and every shopkeeper might continue to be "as great a rake as an English lord," but Webster had the satisfaction of knowing that the American standard of language had become the standard of the English-speaking world.

At the time Webster was portrayed by Herring, he was busily engaged in the last major project of his life, a revision of the King James Bible, modernizing obsolete language and sanitizing words and phrases "offensive to delicacy." The authors of *The National Portrait Gallery* took note of his labors, saying, *His revisions have met with the approbation of many persons who have examined the work; and if there is any name in our country which will give currency to such an amendment of the common version, it is that of the author of the American Dictionary of the English language.* The underlying note of skepticism was well founded; the new edition never received popular acceptance; but Webster, who had undergone a Calvinist conversion in 1808 and who was ever after fanatical about his religious work, nevertheless considered his Biblical work the most important labor of his life.

The English-born Herring had come to America with his family in 1805 when he was ten years old. His father operated a brewing and distillery business in the Bowery area of New York City, and Herring was bred to that trade. The economic dislocations which came about as a result of the War of 1812, however, caused the business to fail. Herring, in search of a new means of livelihood, found employment coloring prints depicting the sea battles of the war that had brought him economic ruin. Soon he branched into the tinting of maps, and with his wife set up a successful business in Philadelphia. Being a man of "uncommon energy," a characteristic he shared with Webster, Herring decided to put a talent for drawing to professional use. He began with watercolor profiles but soon taught himself to do full-face portraits in oils. After a period spent traveling about northern New Jersey, he opened, in 1822, a studio in his old New York neighborhood. William Dunlap reports that "a fit of sickness caused him to reflect on the helpless situation of his wife and children if he should die," and out of this foreboding came a plan for a lending library. The Enterprise Library, which Herring began in a small way in 1830, grew within a few years to a collection of about a thousand books. This combined interest in literature and art led him to think about publishing a book of fine engravings. Mr. Longacre, a Philadelphia engraver, "having the same idea," noted William Dunlap, "they decided to collaborate."

Sometime in the early 1830s the two had heard about a project then under way in London, *The Gallery of Portraits: With Memoirs*, a five-volume publication of biographies of famous men of the world illustrated with engraved portraits. Longacre and Herring proposed to publish a like work, but limited to persons born in or primarily associated with the United States, to be called *The National Portrait Gallery of Distinguished Americans*.

A similar project undertaken by Joseph Delaplaine in 1815 had proved to be a financial failure. However, Herring and Longacre felt that, "with the advancement of art, a more auspicious era had dawned, and the American people now display a becoming solicitude for the preservation of the relics of their own glory." On March 1st, 1833, the partners issued a prospectus in which they noted that "the value of such a publication cannot fail to be appreciated by all who feel an interest in the preservation of the most essential ingredients in the history of their country."

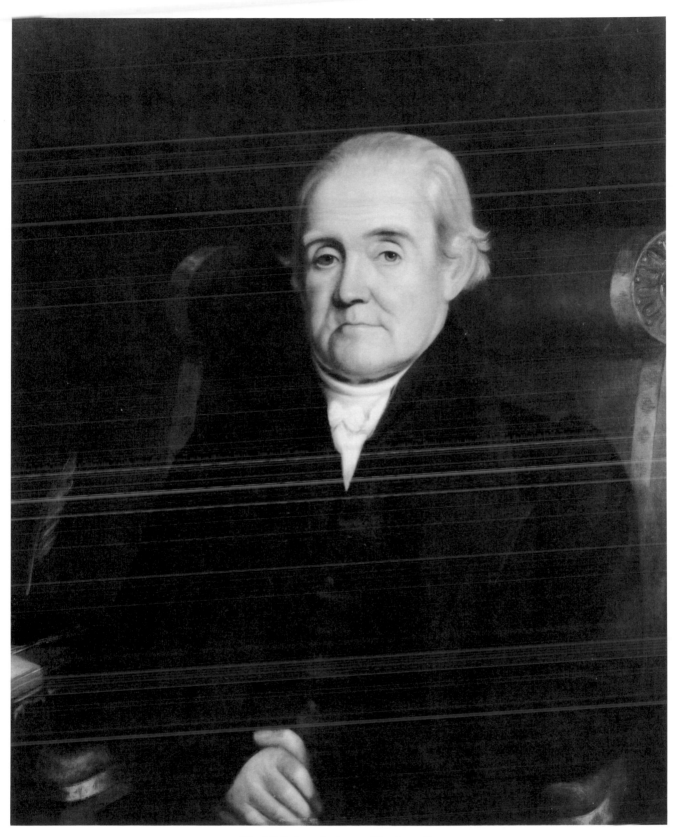

Noah Webster by James Herring, 1833

Certainly Webster must have been happy to cooperate with such a project. Over half a century earlier he himself had done his utmost to see to it that every school-child should be familiar with American history and American heroes, packing his textbooks with patriotic materials even unto footnotes in grammars and spellers. As soon as a child opens his lips, Noah Webster had said, "he should lisp the praises of liberty and of those illustrious heroes and statesmen who have wrought a revolution in his favor."

Herring has pictured Webster in what was an active old age. Asked to account for his remarkable physical vigor and intellectual sharpness, Webster replied: *In the first place . . . I always accustomed myself to retire at an early hour, and to make it a point to lay aside my cares with my clothes. In the second place, though I had but a feeble constitution I have made it an invariable rule to rise with the lark. In the third place, I have, even to my present advanced age, uniformly combined mental labor with considerable bodily exercise, without remitting it even for a day. And in the fourth and last place, I have studiously endeavored to keep a conscience void of offense toward God and man.*

Journalist Anne Royall, who saw him about the time of the portrait, described him as a "low chubby man with a haughty air." His face, she went on, *was round and red and by no means literary looking. He was dressed in black broadcloth, in dandy style; in short, he comes nearer the description of a London cockney than any character I can think of. He eyed me with ineffable scorn and scarcely deigned to speak at all. I am sorry for his sake I ever saw the man, as it gave me infinite pain to rescind an opinion I had long entertained of him.*

Webster looked to be, as he was in fact, a lineal descendant of Puritan fathers and Yankee farmers. "Strait-laced" and "dour" were words frequently used to describe him. But those who knew him intimately regarded him as a sweet and gentle man whose eyes were always filled with sentiment and good humor. His granddaughter, Emily Ellsworth Fowler Ford, remembered that "he often became very animated in discussing principles, or past history, but his common mood was grave, reticent, though kindly, and his refinement of nature and innate modesty were feminine." The slightest vulgarity made him wince. Coarse and impertinent language, reported Mrs. Ford, moved him to anger as almost nothing else did. When a member of his own family ventured an off-color remark, the rebuke was so severe that one of his little girls said, "Pap makes me siver [shiver] like a top." It was recalled that "his speech was straight-forward and strong rather than elegant, he spoke to the point without circumlocution and without detail, so that his refinement seemed to be of tempera-ment, while his intellect was robust rather than graceful." One contemporary ob-served that the man most responsible for that "remarkable uniformity of pronuncia-tion in our country, which is so often spoken of with surprise by English travellers," retained a severe New England pronunciation, saying 'lecter' for 'lecture' and 'edurd' for 'Edward.'

Webster never retreated from his "untiring efforts and labours." He continued to lecture, and to work on revisions of his earlier work. His letters to newspapers "were frequent and very strong in their expression of Federal opinions." Sometimes he sounded like a testy schoolmaster, and to the public he gave the appearance of vanity and arrogance. His enemies called him "The Monarch."

In the age of Jackson, he looked at America and found that it was too much in a hurry: *The excitements which exist in this country drive our people, in their under-takings, to do everything in a hurry. The abolitionists are in a hurry for the emancipa-tion of the slaves in the South. The missionary societies are in a hurry to Christianize all nations, and urge their operations too fast for their resources, making no allow-*

ances for unforeseen disappointments. Men are everywhere in a hurry to get rich, and this hurry often drives them into folly, excess, and poverty. From five hundred to a thousand lives are annually sacrificed to hurry in making and managing railroads and steamers. Even learning and education can not escape the contagion.... Children are no longer to learn the first rudiments of language; they are to bound over their horn-books at a leap, and plunge at once into geometry, trigonometry, conic sections, botany, chemistry, mineralogy, geology, logic, intellectual philosophy, and other sciences. Instead of learning to spell, they are to learn the properties of matter. This leaping over the elements of language, or only giving them a brush, is the principal cause of the inferiority of American scholars in the languages to European scholars. Our characteristic hurry in learning is well adapted to fill the country with smatterers, and it is very successful.

Babbidge, Homer D., Jr. *On Being American, Selected Writings, 1783–1828.* Washington, D.C.: Frederick A. Praeger, Publishers, 1967.

Dunlap, William. *History of the Rise and Progress of the Arts of Design in the United States* (2 vols.). New York: Dover Publications, 1969 (first published 1834).

Shoemaker, Ervin C. *Noah Webster: Pioneer of Learning.* New York: AMS Press, 1966.

Skeel, Emily Ellsworth Ford, ed. *Notes on the Life of Noah Webster compiled by Emily Ellsworth Fowler Ford* (2 vols.). New York: Burt Franklin, 1971 (first published 1912).

Stewart, Robert G. *A Nineteenth-Century Gallery of Distinguished Americans.* Published for the National Portrait Gallery, Smithsonian Institution. Washington, D.C.: Smithsonian Institution Press, 1969.

Warfel, Harry R. *Noah Webster: Schoolmaster to America.* New York: Octagon Books, 1966.

Osceola ("The Black Drink") circa 1800–1838
By George Catlin 1796–1872
Oil on canvas
78.2 x 65.5 cm
Unsigned
1838
L/NPG.7.70

On indefinite loan from the Department of Anthropology, The National Museum of Natural History, Smithsonian Institution

When in late 1837 George Catlin heard about the capture of the famous Seminole warrior Osceola, he abruptly terminated a successful New York exhibition of his Indian pictures and hurried to Charleston, South Carolina, to paint the intrepid leader's portrait. Since that day in Philadelphia in the 1820s, when the lawyer-turned-self-taught-painter had been strongly affected by the sight of a "noble and dignified" delegation of Indians "arrayed and equipped in their classic beauty," Catlin had determined that he would devote his life to "rescuing from oblivion the looks and customs of the vanishing races of native man in America." He had subsequently, in the years between 1830 and 1836, traveled throughout the West, painting the Indians of the Great Plains, the Southern Plains, and the Upper Mississippi Valley. The fruits of these labors, portraits of Indians posed in their best clothes, paintings of tribal dances, buffalo hunts, and religious ceremonies, together with costumes, weap-

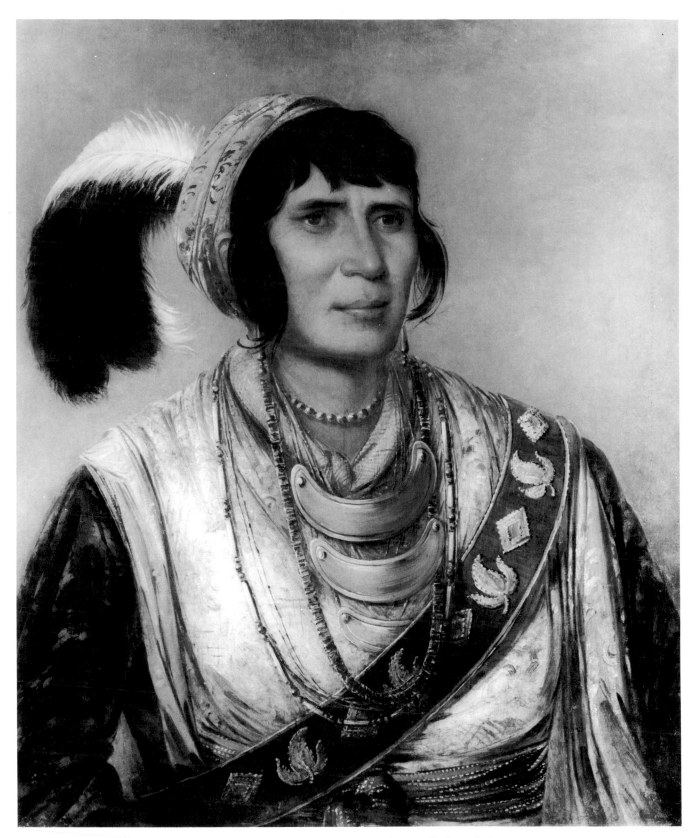

Osceola ("The Black Drink") by George Catlin, 1838

ons, pipes, ornaments, and other artifacts, were now assembled for exhibition and "explanations in the form of a Lecture." A mass audience flocked to "Catlin's Indian Gallery," America's first Wild West show.

The "bold and dashing Osceola," who had roused the Seminoles to guerilla resistance against removal from their Florida lands, had eluded four generals of the United States Army and seized the public imagination. The circumstances of his capture, under a flag of truce (the war could go on forever, said General Thomas Jesup in justifying his action, unless drastic measures were taken) made him a *cause célèbre*. The portrait of such a man would be a conspicuous coup for the Catlin collection. "It will be important to his Gallery as it will bring thousands of visitors," said his father.

Catlin wrote of Osceola: *This young man is, no doubt, an extraordinary character, as he has been for years reputed, and doubtless looked upon by the Seminoles as the master spirit and leader of the tribe, although he is not a chief. From his boyhood, he had led an energetic and desperate sort of life, which had secured for him a conspicuous position in society; and when the desperate circumstances of war were agitating his country, he at once took a conspicuous and decided part, and in some way, whether he deserved it or not, acquired an influence and a name that soon sounded to the remotest parts of the United States, and amongst the Indian Tribes, to the Rocky Mountains.*

Osceola, the son of a Creek mother, and with some Scottish blood in his veins, came from an uncertain background. An anonymous letter to *Niles' Weekly Register* on February 2nd, 1838, related: *From a vagabond child he became the master spirit of a long and desperate war. He made himself—no man owed less to accident. Bold and decisive in action, deadly but consistent in hatred, dark in revenge, cool, subtle, and sagacious in council, he established gradually and surely a resistless ascendancy over his adoptive tribe, by the daring of his deeds, and the consistency of his hostility to the whites, and the profound craft of his policy. In council he spoke little—he made the other chiefs his instruments, and what they delivered in public, was the secret suggestion of the invisible master. Such was Osceola, who will long be remembered as the man that with the feeblest means produced the most terrible effects.*

Osceola and some two hundred of his followers were held at Fort Moultrie, awaiting transfer to an area about seven hundred miles west of the Mississippi. The living accommodations were civilized. Osceola's two wives and children had been summoned to join him, and the Indians had been given the freedom of the fort. Nevertheless Osceola, who had been fighting Andrew Jackson since he was a small boy, and who had spent the last seven years denouncing and even killing those Indians who had signed away their land, was consumed with bitterness. The defiant warrior who in 1835, according to legend, plunged his great knife into the treaty designed to remove the Seminoles west of the Mississippi, did not take easily to captivity. His spirit chafed; he also suffered from chronic malaria.

Catlin, arriving at Fort Moultrie on January 17th, 1838, saw Osceola as a "gallant fellow" who was "grieving with a broken spirit, and ready to die, cursing white man, no doubt, to the end of his breath." The artist recounted: *In stature he is about at mediocrity, with an elastic and graceful movement; in his face he is good looking, with rather an effeminate smile; but of so peculiar a character, that the world may be ransacked over without finding another just like it. In his manners, and all his movements in company, he is polite and gentlemanly, though all his conversation is entirely in his own tongue; and his general appearance and actions, those of a full-blooded and wild Indian.* In the course of the next two weeks, Catlin observed "a rapid decline in his face and flesh."

One who had seen Osceola during the Florida campaign noted that: *When conversing on topics agreeable to him, his countenance manifests more the disposition of the white than of the red man. There is a great vivacity in the play of his features, and when excited, his face is lighted up as by a thousand fires of passion, animation, and energy. His nose is Grecian at the base, and would be perfectly Phidean, but that it becomes slightly arched. There are indomitable firmness and withering scorn in the expression of his mouth—though the lips are tremulous from intense emotions, which seem ever boiling up within him. About his brow care and thought and toil have traced their channels, anticipating on a youthful face the work of time.* The same writer added, "He was the best runner, hunter, ball-player, and athlete of his tribe."

The Indian whose blood-curdling yell sent chills of fear through the bravest of troops, had, noted many of his contemporaries, "a mild sweet expression." One observer recorded that "a continuous smile played over his face, particularly when shaking hands with the officers."

Osceola and others of his party posed willingly for the several artists, including Robert J. Curtis (Charlestown Museum), who converged on the fort. Catlin painted Osceola, he noted, precisely in the costume in which he posed "even to a string and a trinket. He wore three ostrich feathers in his head, and a turban made of vari-coloured cotton shawl—and his dress was chiefly of calicos, with a handsome bead sash or belt around his waist."

Catlin's involvement with his subjects went beyond the formal sittings. "After painting all day at their portraits," he conversed with the Indians in his room until a late hour at night, "where they have taken great pains to give me an account of the war and the mode in which they were captured, of which they complain bitterly." He later wrote, in his *Letters and Notes on the Manners, Customs, and Condition of the North American Indians,* that "I am fully convinced from all that I have seen, and learned from the lips of Osceola, and from the chiefs who are around him, that he is a most extraordinary man, and one entitled to a better fate."

The sympathy Catlin felt for Osceola was a major factor in the success of the portrait. In addition, Catlin's twelve days of residence at the fort had given this artist, who usually sketched "on the run," the time to give the portrait a careful finish. The painting of Osceola shows Catlin at his best.

The sittings were concluded on January 26th. The following day Osceola was seized with a "violent quinsy." Catlin and the officers of the post watched over him through the nights of the 27th and 28th. Told that Osceola was near death, Catlin hoped to be with him at the end, but was forced to leave for New York on January 29th. Osceola died the next day. At the Indian's request, his last moments were reported to his friend George Catlin. Osceola had died, arrayed in full dress, including the turban decorated with three ostrich plumes and with his face, neck, throat, and wrists painted vermillion as a symbol of an irrevocable oath of war and destruction. At the very end, Catlin was told, "he . . . slowly drew from his war-belt his scalping-knife, which he firmly grasped in his right hand, laying it across the other on his breast, and in a moment smiled away his last breath without a struggle or groan."

Back in New York, Catlin lost no time in drawing a lithograph of his full-length portrait of Osceola, which he sold at $1.50 each. The half-length oil was added to "Catlin's Indian Gallery" and was exhibited in Europe from 1839 to 1852. This traveling extravaganza initially met with much success in England and later in France, but audiences grew jaded, and Catlin was overwhelmed with the expense of the undertaking and went heavily into debt. He had hoped, even before he took the pic-

tures to Europe, that the United States Government would purchase the "Indian Gallery." In 1853 a bill to buy the collection for $50,000 was passed in the House of Representatives. Daniel Webster urged Senate concurrence, saying: *These tribes . . . that have preceded us, to whose lands we have succeeded, and who have no written memorials of their laws, their habits, and their manners, are all passing away to the world of forgetfulness. Their likeness, manners, and customs are portrayed with more accuracy and truth in this collection by Catlin than in all the other drawings and representations on the face of the earth. . . . I go for this as an American subject— as a thing belonging to us—to our history—to the history of a race whose lands we till, and over whose obscure graves and bones we trod, every day.* Jefferson Davis who, as a young army officer stationed in the West, had witnessed a number of the portraits in the painting, believed that Catlin was the only artist who had ever been able to portray the Indians in an authentic manner. Nevertheless, since his constituents were interested in Indian lands for the creation of additional slave states, Senator Davis voted against the bill "on principle," and his vote alone prevented passage.

Catlin was bitterly disappointed. In a desperate financial plight, he mortgaged his gallery several times over. Finally Joseph Harrison, a wealthy locomotive builder, paid off liens amounting to $40,000 and whisked the pictures off to storage in Philadelphia before European creditors could seize and disperse the collection.

The impecunious Catlin returned to America in 1870, bringing with him his "Cartoon Collection" (American Museum of Natural History, New York)—paintings on cardboard which were revisions of his earlier work and others based on his later travels in South America and the Far West. Taking pity on an esteemed friend, Smithsonian Secretary Joseph Henry invited Catlin to exhibit his work and offered him living accommodations in a turret room. There Catlin stayed and painted until his last illness struck in 1872. He died at a relative's house in New Jersey, crying out at the very end, "What will become of my Gallery! What will become of my Gallery!"

As it happened, if the federal government had acquired the collection when Catlin intended, it would likely have been destroyed in the disastrous fire which gutted the Smithsonian's picture gallery in 1865. Instead they languished unpacked, neglected, and forgotten in the basement of the Harrison Boiler Works in Philadelphia. Of the original 507 pictures, 450 survived two fires, water, and generally deleterious storage conditions. In 1879 the collection was given to the National Museum by Harrison's heirs. "And so," wrote Thomas Donaldson (a lawyer from Idaho Territory who made a personal appeal that the Harrison estate "donate the Gallery in interest of history of our American aborigines"), thirty-five years after Catlin first offered his Gallery to the Smithsonian, "it found a permanent lodgment in the same Institution after vicissitudes and misfortune hardly equaled."

Catlin, George. *Letters and Notes on the Manners, Customs and Condition of the North American Indians.* Minneapolis: Ross & Haines, 1965 (first published 1841).

Ewers, John C. "George Catlin: Painter of Indians of the West." *Annual Report of the Smithsonian Institution,* 1955, pp. 483–528.

Hartley, William, and Ellen. *Osceola.* New York: Hawthorn Books, 1973.

McCracken, Harold. *George Catlin and the Old Frontier.* New York: The Dial Press, 1959.

Mahon, John K. *History of the Second Seminole War 1835–1842.* Gainesville: University of Florida Press, 1967.

Roehm, Marjorie Catlin. *The Letters of George Catlin and His Family.* Berkeley: University of California Press, 1966.

Frederick Douglass 1817?–1895
Attributed to Elisha Hammond 1779–1882
Oil on canvas
69.8 x 57.1 cm
Unsigned
Circa 1844
NPG.74.45
A copy was inherited by the sitter's great-granddaughter

Frederick Douglass, drawing up his will in August of 1886, bequeathed to his wife, Helen Pitts Douglass, "all my writings, books, papers, pictures, paintings, horses, carriages, harness and each and every description of property in and about my house in Anacostia; except a certain portrait of myself, painted more than forty years ago by Mr. Hammond of Florence, Massachusetts." This he left to his eldest child, Rosetta D. Sprague. The portrait shows the young Douglass, six years out of bondage and when still a fugitive from his legal master. "Gath," the Washington correspondent for the *Cincinnati Enquirer*, noticed it hanging in the parlor when he visited the home of Douglass's late Washington years, "Cedar Hill," in April 1886. He wrote, "In another place in the room was Mr. Douglass' portrait when he was a young man about twenty-five years old. One could see looking at it the observant lines in the face, eyes wide apart and the individual resisting nature."

The portrait must have had a special meaning for Douglass, recalling, as it did, the early days of his antislavery career and his first visit to that extraordinary community in Florence, Massachusetts. Florence, adjacent to Northampton, was in 1844 the site of the Northampton Association of Education and Industry, a communal society of middle-class New Englanders. The society at Florence was a heterogeneous one—of various occupations and religious persuasions, but held together by a common conviction "that the rights of all are equal without distinction of sex, color, or condition, sect or religion." The atmosphere of tolerance was almost unique in the America of the 1840s—rare indeed was the community that awarded true equality not only to blacks, but to women as well.

When, in the 1890s, Charles A. Sheffeld was compiling the history of Florence, he asked Frederick Douglass for his recollections of the community. Douglass responded, and his chapter, "What I Found At The Northampton Association," was included in the history which was published the year of his death. The Community was, Douglass remembered, "a protest against sectism and bigotry and an assertion of the paramount importance of human brotherhood." He wrote: *I visited Florence almost at its beginning, when it was in the rough; when all was Spartan-like simplicity. . . . The place and the people struck me as the most democratic I had ever met. It was a place to extinguish all aristocratic pretensions. There was no high, no low, no masters, no servants, no white, no black.* He went on to say, *My impressions of the Community are not only the impressions of a stranger, but those of a fugitive slave to whom at that time even Massachusetts opposed a harsh and repellent side. The cordial reception I met with at Florence, was, therefore, much enhanced by its contrast with many other places in the commonwealth.*

It was here that Douglass first met with Soujourner Truth, whom he described as "that strange compound of wit and wisdom, of wild enthusiasm and flint-like common sense, who seemed to feel it her duty to trip me up in my speeches and to ridicule my efforts to speak and act like a person of cultivation and refinement." He recalled that *she cared very little for elegance of speech or refinement of manners. She seemed*

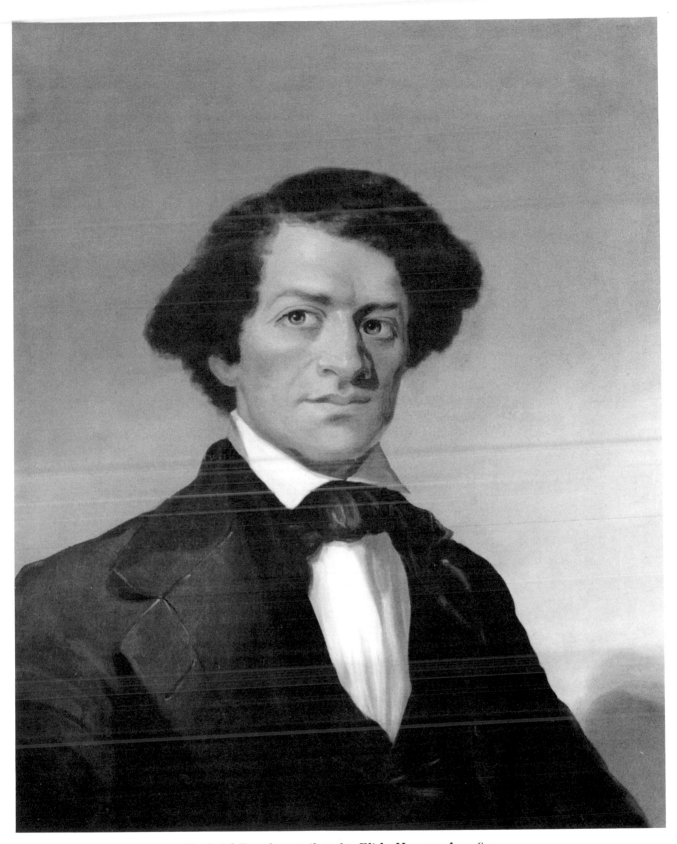

Frederick Douglass attributed to Elisha Hammond, c. 1844

to please herself and others best when she put her ideas in the oddest forms. She was much respected at Florence, for she was honest, industrious, and amiable. Her quaint speeches easily gave her an audience, and she was one of the most useful members of the Community in its day of small things.

There was a reunion, too, with his old friend David Ruggles. Ruggles, one of the primary black conductors in the Underground Railroad system, had helped Douglass on his road to freedom. At Ruggles's New York home Douglass had waited for the freewoman Anna Murray to join him, and it was here that they were married. Ruggles, who deemed New York to be unsafe for Douglass, pressed upon him a $5 bill and sent him off to New Bedford, a place of likely employment for one who had been hired out by his master to work in the Baltimore shipyards. But now Ruggles, who in his time had helped over six hundred runaway slaves, had grown blind. Destitute, he had been brought to Florence, where he was cared for by members of the Community.

Among those whom Frederick Douglass met in what he refers to as this "very high society" of Florence was Elisha Livermore Hammond, farmer and artist. Hammond, first a stucco worker, plied his trade in Boston until about 1835. In his mid-forties, he decided to become a portrait painter and took some instruction from Chester Harding. Perhaps heeding the same advice Harding had given to another student, that embryo artists were just as likely to do well in some of the country towns of Vermont or New Hampshire as in the larger cities, Hammond left Boston for his second wife's home town, New Ipswich, in New Hampshire. Once there he combined painting and farming and also, say the local histories, tavern-keeping. Given Hammond's fervent views on abstinence, his hostelry must have been a temperance establishment. At the age of sixty-five, hearing of the formation of the "Northampton Association of Education and Industry," which sounded to him like "the beginning of the reign of heaven upon earth, universal brotherhood," Hammond sold his farm to "follow, as he thought, the teachings of the greatest reformer the world has ever known." A contemporary recalled that "more than any man I ever knew, he tried to follow Christ's teachings literally." Hammond, like many of his fellows in this hotbed of abolitionist sentiment, was an active member of the Underground Railroad and often personally conducted the fugitives to the next stop north. He wrote in his journal, "My investments in silver and gold have not been successful, but my investments in humanity have been yielding a percentage quite satisfactory and remunerative."

As it was with most of the Utopian communities of the 1840s, the Northampton Association was short-lived, and was disbanded in 1846. Nevertheless, Florence remained a center of free thought and tolerance, "a haven of refuge for original minds." Hammond built a little cottage, where he lived for about thirty-five years with his "adored and adoring wife," and became one of the founders of the Free Congregational Society, an organization of unorthodox liberals who sponsored lectures by— among others—Ralph Waldo Emerson, Bronson Alcott, Louisa May Alcott, Julia Ward Howe, Lucy Stone, Susan B. Anthony, Elizabeth Cady Stanton, William Lloyd Garrison, and Wendell Phillips. Frederick Douglass came often to speak and lingered to visit the friends he had first met in 1844.

Douglass's initial sojourn in Florence had been occasioned by an antislavery rally in Northampton, held on the 30th of April in 1844. The five Hutchinsons, famed singers of abolitionist songs, were there also. John W. Hutchinson wrote later of the two happy days that the family had spent in Florence and reminisced that *Frederick Douglass, then so recently 'chattel personal,' who the following year went with us to Europe, to promulgate the gospel of freedom, was there, and spoke to the communists. . . . At night we rode to Northampton where we sang at the great anti-slavery*

meeting in the town hall. I remember Douglass talked three hours. An old man from Northampton recalled going to the lecture as a youth and seeing Douglass as "a finely formed athletic young man." He noted that there was preserved "a stone which was thrown at him while trying to speak in the Northampton town hall."

Douglass was by this time a seasoned lecturer and was well used to both adulation and brickbats. It had been only some three years earlier, in the summer of 1841, that he had risen at the antislavery convention in Nantucket and, trembling in every limb, made his first public address. "My speech on this occasion," he later wrote, "is the only one I ever made, of which I do not remember a single connected sentence." To William Lloyd Garrison the effect was electrifying. *I shall never forget his first speech at the convention—the extraordinary emotion it excited in my own mind—the powerful impression it created upon a crowded auditory, completely taken by surprise—the applause which followed from the beginning to the end of his felicitous remarks. I think I never hated slavery so intensely as at that moment. . . . There stood one, in physical proportion and stature commanding and exact—in intellect richly endowed—in natural eloquence a prodigy—in soul manifestly "created but a little lower than the angels"—yet a slave, ay, a fugitive slave,—trembling for his safety, hardly daring to believe that on the American soil a single white person could be found who would befriend him at all hazards, for the love of God and humanity!* When Douglass concluded, Garrison turned to the audience, asking, "Have we been listening to a thing— a piece of property, or a man?" With deep emotion came the unified response, "A man!"

"The public have itching ears to hear a colored man speak, and particularly a slave," the abolitionists knew. It was immediately obvious, to Garrison and others, that this tall, dramatic-looking black with the rich baritone voice was exactly what the anti-slavery forces had been seeking. Douglass quickly became the "prize exhibit" of the Massachusetts Anti-Slavery Society, and was introduced as a "graduate from an institution whose diploma was written upon his back." Douglass's very look and bearing gave lie to the notion of black inferiority; his developing skill as an orator "the appropriateness of his elocution and gesticulation and the grammatical accuracy of his sentences"—were dramatic proof of Charles Sumner's thesis of the perfectability of the Negro.

By the fall of 1841, the editor of the *Hingham Patriot* reported, *He is very fluent in the use of language, choice and appropriate language, too: and talks as well, for all we could see, as men who have spent all their lives over books. He is forcible, keen and very sarcastic; and considering the poor advantages he must have had as a slave, he is certainly a remarkable man.* Another editor recognized that Douglass *was a living, speaking, startling proof of the folly, absurdity and inconsistency (to say nothing worse) of slavery. Fluent, graceful, eloquent, shrewd, sarcastic. . . . He seemed to move the audience at his will, and they at times would hang upon his lips with staring eyes and open mouths.*

John A. Collins, the agent of the Massachusetts Anti-Slavery Society, who traveled with him to "upwards of sixty towns and villages," reported that Douglass's "descriptions of slavery are most graphic, and his arguments so lucid, and occasionally so spiced with pleasantry, and sometimes with a little satire, and his addresses, though long, are seldom tedious, but are listened to with vast respect."

At first Douglass contented himself with a simple description of his life as a slave. But this became, he said later, "a task altogether too mechanical for my nature." "It was impossible for me to repeat the same old stories month after month and keep up my interest in it." Consequently, he began to move from a simple description of slavery to a denunciation of the institution, berating the churches for their silence

on the issue, demanding the abolition of slavery in the District of Columbia, and opposing the annexation of Texas. He began to speak out also against discrimination in the North. "You degrade us and then ask why we are degraded—you shut our mouths, and then ask why we don't speak—you close your colleges, and seminaries against us, and then ask why we don't know more," he told his audiences.

Douglass's "Heroic figure . . . dilating in anti-slavery debate" had made "color not only honorable but enviable." He was established now as an orator whom "the listener never forgot." Elizabeth Cady Stanton, who came to know Douglass well years later when the two were joined in the common struggle for woman's suffrage, recalled that she had first heard him speak when she was a girl. "He stood there like an African prince, conscious of his dignity and power, grand in his proportions, majestic in his wrath, as with keen wit, satire and indignation he portrayed the bitterness of slavery."

By the time Douglass spoke in Northampton, it was being openly asked "how a man, only six years out of bondage and who had never gone to school a day in his life could speak with such eloquence—with such precision of language and power of thought." His friends told him, "People won't believe you were a slave, Frederick, if you keep on this way. Be yourself and tell your story. Better have a little of the plantation speech than not; it is not best that you seem to be learned." They suggested that he confine his remarks to his experience as a slave. "Give us the facts, we will take care of the philosophy." Rejecting this advice, Douglass determined instead to prove his credibility by writing a book which would document his story, revealing places and names, including that of his old master. The book was begun during the winter of 1844, and Garrison and Wendell Phillips, who had no faith in the power of Massachusetts to protect Douglass from repossession by his master, were horrified at the dangers of disclosure. *The Narrative of the Life of Frederick Douglass* was nonetheless published in May 1845, just about a year after Douglass's appearance in Florence. The author was by then in England where he remained for eighteen months. The book proved to be one of the best of the slave narratives; Douglass himself had written every line, and its authenticity was manifest. One of the Florence group said, after reading it, that it "entered so deep into the chambers of my soul as to entirely close the safety valve."

The portrait of Frederick Douglass came to the Rhode Island Historical Society in 1901 from the estate of Alphonso Janes (1804–1892). Janes, well known in Providence for his abolitionist views, was for many years treasurer of the Rhode Island Anti-Slavery Society, and was for one year vice-president, under William Lloyd Garrison, of the American Anti-Slavery Society. It is likely that he first came to know Douglass when, late in 1841, the fugitive came into Rhode Island to help defeat the proposed state constitution which included a provision denying suffrage to free blacks.

Janes, it might well be believed, was on the platform with Douglass the night he spoke in Providence. The publishers of the local *Herald of Freedom* wrote of that occasion: *This is an extraordinary man: he was cut out for a hero. In a rising for Liberty, he would have been a Toussaint or a Hamilton. . . . A commanding person over six feet, we should say, in height, and of most manly proportions. . . . Let the South congratulate herself that he is a fugitive. It would not have been safe for her if he had remained about the plantations a year or two longer.*

During his weeks in Rhode Island Douglass found himself subjected to constant discrimination on trains, steamboats, and eating and sleeping establishments. He who had resolved never to accept segregation without protest was dragged from railway cars and subjected to foul eggs and foul words. The Rhode Island antislavery people tried to make up, as best they could, for the incivility and inhumanity of their fellow citizens, and in consequence Douglass made, among their numbers, many life-

long friends. Just previous to his appearance in Northampton, he had been back in Rhode Island, where he had spent the greater part of three months lecturing and raising funds for the Rhode Island Anti-Slavery Society.

In 1892, when Alphonso Janes died after a long illness, it fell to his son Lewis to inform Frederick Douglass of the death of his old comrade in arms. "My Father," wrote the younger Janes, "was very much gratified at your recent call. He spoke of it to me, within the last week, and of his pleasure at seeing you." Had Douglass been nearer, "it would be very grateful to us if you could be present and speak a word at the funeral—but we can hardly expect you to come so far."

Within three years Douglass too would be dead, felled by a massive stroke which he suffered just after returning from addressing a woman's suffrage meeting.

"I do not wish it to be imagined by any that I am insensible to the singularity of my career," he had written in his autobiography published in 1892, *or to the peculiar relation I sustain to the history of my time and country. I know and feel that it is something to have lived at all in this Republic during the latter part of this eventful century, but I know it is more to have had some small share in the great events which have distinguished it from the experience of all other centuries. No man liveth unto himself, or ought to live unto himself. My life has conformed to this Bible saying, for, more than most men, I have been the thin edge of the wedge to open for my people a way in many directions and places never before occupied by them. It has been mine, in some degree, to stand as their defense in moral battle against the shafts of detraction, calumny, and persecutions, and to labor in removing and overcoming those obstacles which, in the shape of erroneous ideas and customs, have blocked the way to their progress. I have found this to be no hardship, but the natural and congenial vocation of my life.*

Douglass, Frederick. *My Bondage and My Freedom.* New York: Dover Publications, 1969 (first published 1855).

Foner, Philip S. *Frederick Douglass.* New York: The Citadel Press, 1963.

Sheffeld, Charles A. *The History of Florence, Massachusetts.* Florence: 1895.

John Collins Warren 1778–1856
By Francis Alexander 1800–1880
Pastel on paper
55.9 x 47.6 cm (oval)
Unsigned
Circa 1845–50
NPG.69.41

In the second quarter of the nineteenth century, John Collins Warren was the leading surgeon in Boston if not in the whole country. Francis Alexander, a generation younger than Warren, was one of Boston's most successful portrait painters.

Alexander's pastel portrait of Dr. Warren was done in the late 1840s, near the end of the doctor's life and near the end of his own career as an artist. As is the case with most of Alexander's work, the portrait is not signed or dated although the name Alexander is printed on the back of the old panel, on which the pastel is mounted, in pencil in two separate places.

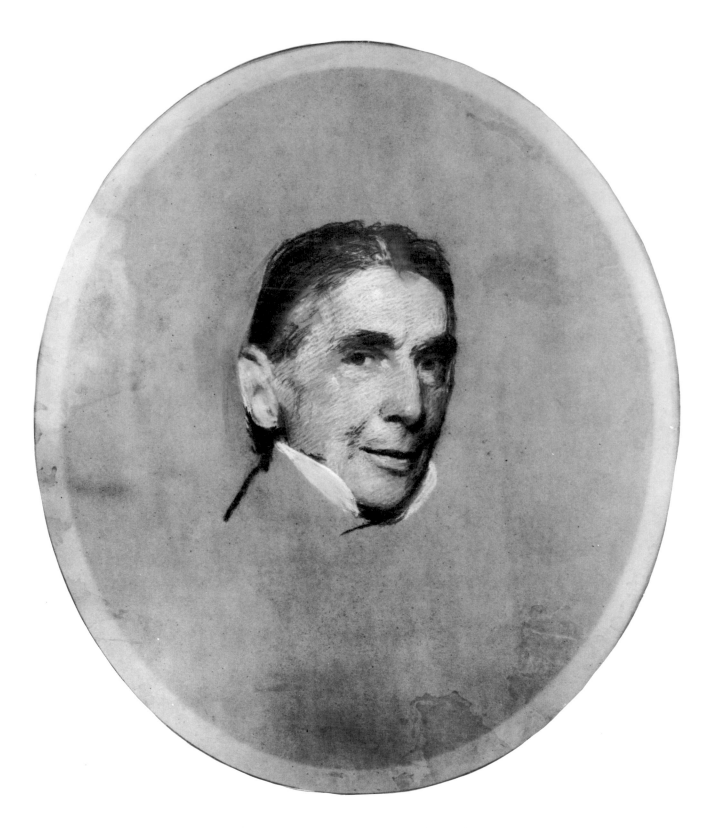

John Collins Warren by Francis Alexander, c. 1845–50

In contrast to his sitter—the son of a prominent doctor, who had entered life, it was said, "with singuler advantages"—the artist who was born in Killingly, Connecticut, went "through all the perplexities and privations incident to the life of a poor farmer's son." Whereas Warren, whose uncle was Dr. Joseph Warren of Bunker Hill fame and whose father was one of the founders of the Harvard Medical School, came naturally to his choice of a profession, Alexander came upon his vocation by chance. Finding that he could paint realistic-looking fish with no great effort, Alexander decided that it would be easier to make a living at sign painting than at farming. He later confessed to William Dunlap that "indeed, my reading had been so limited, and my birth so obscure, that I thought sign painting the highest branch of painting in the world." Warren, sent to study in Edinburgh, London, and Paris, received the best medical training then available; Alexander made his way to New York where Alexander Robertson, who ran an Academy, gave him some slight instruction, and several established artists, including John Trumbull and Samuel Waldo, lent him paintings to copy. Dr. Warren returned from Europe, plunged into his father's medical practice, and soon took over the dissections for his father's anatomy course at Harvard. Francis Alexander came back to Connecticut and found that none of his neighbors had taste enough to hire him to ornament their walls with landscapes but, thunderstruck by his ability to capture a likeness, were willing to pay $1.00 a day to have their portraits painted. His fame, Alexander recounted, "spread half a mile in one direction." The 1820s brought particular successes to both men. To Warren it was the opening of the community hospital he had been working for a decade to establish, the Massachusetts General, and the publication of his landmark book, *Surgical Observations on Tumours with Cases and Operations*. As for Alexander, the 1820s saw him set up in a studio in Boston and accepted by the many who were clamoring to have their likenesses recorded. In the 1830s both men went to Europe. Dr. Warren, ostensibly on vacation, spent the time visiting hospitals, observing autopsies, making detailed notes of ways he might improve his own techniques. Alexander spent a year and-a-half abroad, most of it in Italy, where he absorbed the art of the Old World and painted landscapes as well as portraits. Warren continued in his profession until the end of his life, seeing patients to within a few days of his death in 1856. Alexander, who in 1836 had married a wealthy woman, found the necessity for earning a living removed and was, by the late 1840s, apparently executing few commissions. In 1843 he gave up painting as a profession and moved to Europe where he spent the next twenty-seven years collecting Italian primitives (some were in storage in Boston and presumably destroyed in the great fire of 1873, and fifteen were sold at auction in 1884), and teaching drawing and painting to his only child. "What's the use of painting," he once told the sculptor Thomas Ball, "when I can buy a better picture for a dollar and a half then I can paint myself."

At the time Alexander came to paint him, Warren was close to seventy and had been a major force in American medicine for thirty years. At the instigation of his son, Dr. Mason Warren, he had agreed in 1846 to participate in the first public demonstration of a substance that dentist W. T. G. Morton claimed would produce insensitivity to pain during surgical operations. On October 16th, before an audience of eminent doctors, Warren operated on a patient anesthetized by ether, thus lending his name and reputation to the legitimization of a revolutionary new procedure. An eyewitness recounted, "The operation was successful; and when the patient recovered he declared he had suffered no pain. Dr. Warren turned to those present and said, 'Gentlemen, this is no humbug.'" In the words of the official hospital report, "the results of this operation led to the repetition of the use of ether in other cases, and

in a few days its success was established and its use resorted to in every considerable operation in the city of Boston and its vicinity." It would prove to be America's major contribution to medicine.

In retrospect, it seems almost out of character for a man like Warren, conservative in nature and, as his biographer has noted, "enough of a social and intellectual snob to be uninterested in William T. G. Morton," to have risked his prestige in such a cause. As Oliver Wendell Holmes put it, *When we remember that none of Harvey's contemporaries past middle age would accept his new doctrine of circulation [of the blood] we confess it to have been a noble sight when an old man was found among the foremost to proclaim this new fact—strangely unwelcome as well as improbable to some who should have been the foremost to accept it—that pain was no longer the master, but the servant, of the body.*

Warren was described as being tall, almost painfully thin. His bright piercing eyes under shaggy brows never missed seeing something wrong, even, it was said, when the doctor appeared to be looking the other way. He tolerated no weakness in others, particularly the members of his own family. His son John he expunged not only from the family bosom, but also from the family genealogy, accusing him of being "so far habituated to vicious courses, that there is no hope for you in this life or another." He wrote to his other son, Mason, then studying medicine in Europe, that "I would not allow myself much light reading. It is not only a loss of valuable time, but it weakens our powers of reflection. When you require relaxation go into the society of friends who will promote your interest."

Dr. Henry I. Bowditch called Warren "an autocrat enragé" and exploded on the margin of one of his books that Warren's "own will was law for all, not only for those immediately in contact with him." His brother Edward said that Warren believed that "man is formed, not for happiness but . . . warfare with himself. He is never satisfied with himself; he is never perfectly satisfied with others." To many it appeared that he had no human side.

Yet, when it came to his profession, he was the most passionate of men. When he was twenty-one and studying medicine in London, he wrote to his father, "now I see a good operation with the pleasure I used to feel at the successful solution of Euclid's problems—a pleasure greater than almost any I know . . . and am only surprised that I was so long blind." Exuberantly he wrote to his mother, *I am the luckiest dog in life! I was called away . . . to a dislocated shoulder, which I have reduced in very handsome style. Within the first three days of my week, I have had one fracture, and one injury of the cranium; one fractured leg and another that we thought fractured at first; one fracture of the ribs, and this dislocation; besides two or three trifling accidents. I have been extremely fortunate in every way, and I verily begin to think I shall be famous.* This enthusiasm stayed with him his entire professional life. Edward Everett said, "At a time when, under the overwhelming pressure of his various duties he habitually allowed himself but five hours sleep out of twenty-four. . . . I never saw the slightest disposition to economize his time at the expense of the patients's welfare or comfort." Even Dr. Bowditch conceded the "neat, curt and *effective incisiveness* of the Doctor's own *rapid hand* when wielding the knife or lancet."

Characteristic of the man was his will, in which he specified that his "bones be carefully preserved, whitened, articulated and placed in the lecture-room of the Medical College near my bust; affording, I hope, a lesson useful, at the same time, to morality and science." And so they hang, to this day, inside a rosewood cabinet at the Warren Anatomical Museum, Harvard Medical School, where they are viewed once a year, as the doctor stipulated, by members of his family.

Dunlap, William. *History of the Rise and Progress of the Arts of Design in the United States* (2 vols.). New York: Dover Publications, 1969 (first published 1834).

Packard, Francis. *History of Medicine in the United States.* New York: Hofner Publishing Co., 1963.

Pierce, Catharine W. "Francis Alexander." *Old-Time New England,* vol. XLIV, no. 2, October–December 1953, pp. 29–46.

Truax, Rhoda. *The Doctors Warren of Boston.* Boston: Houghton Mifflin Co., 1968.

Dolley Payne Madison 1768–1849
By William S. Elwell 1810–1881
Oil on canvas
76.2 x 63.5 cm (feigned oval)
Signed: *w.s. Elwell pinxt* [lower left]
Inscribed on the back by William Winston Seaton, editor of the
National Intelligencer, who commissioned the portrait: *Mrs. Madison
aged 83 painted by W. S. Elwell in 1848. A Faithful portrait W. W. S.*
(Mrs. Madison was seventy-nine, but since she had always been purposely vague about her age, Seaton's mistake is understandable.)
1848
NPG.74.6

*Descended in the Seaton family until acquired by the National
Portrait Gallery*

William S. Elwell has afforded us a last look at one of the most memorable women in American history, Dolley Madison. "There are few ladies who retained their powers over the heart of mankind so long as she has through the winning attraction of her manner and conversation," observed Mrs. John Quincy Adams. Dolley Madison was, when Elwell painted her in February 1848, just short of eighty and little more than a year away from the end of her life.

In the autumn of 1837, the year following her husband's death, Mrs. Madison had returned to Washington, taking up residence in a house on Lafayette Square, just across from the White House. "What a difference twenty years make in society," she said. "Here are young men and women not yet born when I left the capital, whose names are familiar, but whose faces are unknown to me." It made no difference, however, in the welcome she received. Her reputation as the one who had "administered the hospitalities of the White House with such discretion, impartiality, and kindliness, that it is believed she gratified every one and offended nobody" had made her a national legend. In a spontaneous gesture of recollection and affection, the crowds who came to President Martin Van Buren's open house on New Year's day, 1838, proceeded across the square to pay their respects to Mrs. Madison. The processions continued, on every New Year's day and Fourth of July, until her death. For a decade the city watched with satisfaction as Mrs. Madison promenaded on the arms of each successive president "with the appearance of almost youthful agility." Philip Hone, who saw her in 1842, described Dolley as "a *young* lady of fourscore years and upward, goes to parties and receives company like the Queen of this new world."

John Quincy Adams made haste to call on her soon after her arrival back in Washington, and confided in his diary, *This morning I visited Mrs. Madison, who has*

Dolley Payne Madison by William S. Elwell, 1848

come up to take up her residence in this city. I had not seen her since March 1809. The depredations of time are not so perceptible in her personal appearance as might be expected. She is a woman of placid appearance, equable temperament, and less susceptible to lacerations of the scourges of the world abroad than most others.

Thus she continued to appear before her public. Despite her seeming equanimity, Dolley Madison's days were not untroubled. She had been, throughout her life, superbly successful in all her personal relationships save one—that with her only child, the son of her first marriage. Whatever the reason, Payne Todd turned out to be, in the view of those who loved Dolley, "a notoriously bad character." Addicted to drink and dissipation, he lived an aimless and debt-driven life. "His misconduct," reported Martha Jefferson Randolph, "was the sorrow of his mother's life." "It has been too long since I was cheered with a line from you—What are you about that prevents you from communicating with your Mother?" was Dolley Madison's cry as she struggled with her maze of financial problems. Nonetheless she loved her son deeply and was quick to defend his erratic behavior. "My poor boy, forgive his eccentricities—his heart is right."

What with her son's spendthrift ways and her own lavish hospitality, she was, within a few years of James Madison's death, heavily in debt. By 1842 she was forced to take out a mortgage on her Washington house; by 1844 she was compelled to sell Montpelier. But, even as she wrote to her son, "We are without funds and those we owe are impatient," she continued to entertain in the best Virginia tradition, never giving a sign of her private troubles. Her former slave, then working for her friend and neighbor, Senator Daniel Webster, wrote in his reminiscences that *in the last days of her life, before Congress purchased her husband's papers, she was in a state of absolute poverty, and I think suffered for the necessities of life. While I was a servant to Mr. Webster, he often sent me to her with a market-basket full of provisions, and told me whenever I saw anything in the house that I thought she was in need of, to take it to her. I often did this, and occasionally gave her small sums from my own pocket, though I had years before bought my freedom from her*

The May following the Elwell sitting, in time for her eightieth birthday, Congress, ending four years of hesitation, finally agreed to the purchase of James Madison's papers. Shortly after his death, the government had acquired Madison's notes on the Constitutional Convention. It was obvious to all that these papers, providing the only firsthand account of the making of the Constitution, had an overriding national importance. The remaining documents were viewed with less reverence. Andrew Johnson of Tennessee, for one, maintained that money spent for historic or scientific acquisition was a misappropriation of public cash, and opposed the Madison bill for the same reasons he opposed the funding of the Smithsonian Institution. In the end the Madison presidential papers were acquired for the people of the United States, not so much for their historic importance, but because Madison's much-beloved widow was known to be in desperate circumstances. Mrs. Madison was awarded $25,000 for the papers, and the Congress, in paternalistic regard for "their lady," saw to it that the money was held for her in trust, assuring her of an annual income but keeping the principal out of the hands of Payne Todd.

Certainly she must have been relieved, for literally the roof over her head had been saved. But even more, she had finally discharged what had been the central mission of her later years, the safe disposition of the Madison papers. In retirement at Montpelier, she had helped her husband, at the expense of her chronically irritated eyes, in the sorting and transcription of this great chunk of American history. After his death, she was dogged in her determination that the collection be saved for posterity.

It would seem as if she could now rest easy. Her nephew, Richard Cutts, congratulating her on the final passage of the Madison bill, wrote, "I shall expect to find you ten years younger than when I left you." Almost immediately, however, her peace of mind was shattered by conflicting loyalties. Her son, outraged by the terms of the purchase, threatened suit against the trust the Congress had set up. She wrote to him in agitation, "Your mother would have no wish to live after her son issued such threats which would deprive her of her friends who had no other view in taking charge than pure friendship." Looking about for some way to help her son meet his debts, she determined, as Jefferson had done before her, to hold a raffle, offering her silver and paintings, including four Gilbert Stuart paintings of Washington, John Adams, Jefferson, and Monroe as prizes. Only the intervention of James Buchanan, one of her government trustees, prevented this lottery.

Publicly she carried on, good-natured and kind-hearted as ever. At the behest of Mr. and Mrs. William Seaton she posed for William S. Elwell. William Winston Seaton, editor of the *National Intelligencer* and mayor of Washington, was distantly related to Dolley Madison through the Virginia Winstons. Seaton and his wife, rare survivors from the capital's earliest days, were two of Mrs. Madison's oldest and closest friends. Mrs. Seaton, herself a prominent Washington hostess, first met Dolley at a White House reception in the autumn of 1812, and as a young bride was immediately put at her ease by the considerate First Lady. Mrs. Seaton wrote in admiration, *I could describe the dignified appearance of Mrs. Madison, but I could not do her justice. It is not her form; it is not her face. It is the woman altogether whom I should wish you to see . . . her demeanor is so removed from the hauteur generally attendant on royalty that your fancy can carry the resemblance no further.* Two years later, describing in great detail Dolley Madison's splendid New Year's reception attire, she observed that "'Tis here the woman who adorns the dress, and not the dress that beautifies the woman."

William S. Elwell had advertised as a portrait painter in the Richmond, Virginia, *Compiler* in December 1847. Seaton, a member of an old Virginia family, had attended school and started his newspaper career in that same city. It is likely, therefore, that he had heard of the artist through Richmond connections. Elwell had been born in Brimfield, Massachusetts, and worked in the Connecticut River Valley until 1845. He has been characterized as a self-taught itinerant artist who "never went through the primitive period, but by instinct started out following along conventional lines." At some stage of his career he studied under Chester Harding. In 1840 he exhibited a portrait entitled *The Young Student* at the National Academy of Design. The Dolley Madison portrait is probably his finest work.

In her long life, Dolley Madison sat to many artists. Eastman Johnson, who sketched her in crayon (Essex Institute) just three years previous to the Elwell sitting, described his experience thus: *She comes in at 10 o'clock in full dress for the occasion, and, as she has much taste she looks quite imposing with her white satin turban, black velvet dress and a countenance full of benignity and gentleness. She talks a great deal and in such quick beautiful tones. So polished and elegant are her manners that it is a pleasure to be in her company.*

Undoubtedly she indulged, during portrait sittings, in her well-known habit of taking snuff. Aaron Burr, who had know her as a young widow in Philadelphia and who had arranged a meeting with "the great little Madison," received a report from his daughter in 1803, "Mrs. Madison is still pretty; but oh, that unfortunate propensity to snuff-taking." She never gave it up, and the tips of her elegant white fingers were stained by the long use of tobacco. Mrs. Seaton remarked, "You are aware that she

snuffs; but in her hands the snuff-box seems only a gracious implement with which to charm."

Elwell shows her elegantly, but not fashionably, dressed. Her white silk turban, high fashion in the days when she was First Lady, had been long out of vogue. In her last years she was frequently pictured as she is here, in a black velvet gown which she seems to have regarded as her best dress. This, described as having leg-of-mutton sleeves, was almost ten years out of date, but the old-fashioned sleeves were always covered by splendid shawls. Her neck was habitually draped round with a soft white material because, as she told an old friend, it has become "scraggy." She rouged her cheeks and wore a set of false curls of glossy black. She, who never forgot her Quaker days when "our Society used to control me entirely and debar me from so many advantages and pleasures," determined that she would look as attractive as she could to give pleasure to her friends.

She left wonderful memories for the young. Her grand niece recalled her "Levee-Day" and the "very sweet-looking lady, tall and very erect." She wrote, many years later: *I thought her turban very wonderful, as I never saw any one else wear such a head-dress. It was made of some soft silky material and became her rarely.*

There were two little bunches of very black curls on either side of the smooth white brow; her eyes were blue and laughed when she smiled and greeted the friends who seemed so glad to see her. I wondered at her smooth, soft skin, as I was told that she was over seventy, which at that time was a great age to me.

Mrs. Anne Royall, who journeyed to Richmond in 1829 to meet the "lady of whom I had heard more anecdotes than any family in Europe or America," was surprised to find "her face is not handsome, nor does it ever appear to have been so. It is diffused with a slight tinge of red, and rather wide in the middle." She added, however, that "her power to please, the irresistible grace of her every movement shed such a charm over all she says and does that it is impossible not to admire her." Mrs. Royall concluded, "No wonder she was the idol at Washington."

Few of Mrs. Madison's contemporaries had the perception of Harriet Martineau, who visited her at Montpelier in 1835 and saw her as "a strong-minded woman, fully capable of entering into her husband's occupations and cares; and there is little doubt that he owed much to her intellectual companionship, as well as to her ability in sustaining the outward dignity of his office." It was this aspect of Dolley Madison that began to show in her face as she grew older. The William Elwell portrait shows a face slightly masculine in its strong contours, fully revealing her strong character.

"Toward the close of the evening," wrote President James Knox Polk, recording his last White House reception in February of 1849, "I passed through the crowded rooms with the venerable Mrs. Madison on my arm." Thus ended Dolley Madison's long reign as democracy's social queen. She continued to receive her friends as usual until within a few weeks of her death. She died on the 12th of July, some seventeen months after Elwell had captured her likeness.

Anthony, Katharine. *Dolly Madison.* Garden City, N.Y.: Doubleday & Co., 1949.

Arnett, Ethel Stephens. *Mrs. James Madison: The Incomparable Dolley.* Greensboro, N.C.: Piedmont Press, 1972.

Goodwin, Maud Wilder. *Women of Colonial and Revolutionary Times.* New York: Charles Scribner's Sons, 1896.

Sears, Clara Endicott. *Some American Primitives: A Study of New England Face and Folk Portraits.* Boston: Houghton Mifflin Co., 1941.

Charlotte Cushman 1816–1876
By William Page 1811–1885
Oil on canvas
69.8 x 55.9 cm
Unsigned
1853
NPG.72.15

In Miss Cushman's family until acquired by the Gallery

"Mr. Page's portrait of Miss Cushman is really something wonderful—soul and body together," wrote Elizabeth Barrett Browning after seeing the celebrated painting by William Page which was the talk of Rome's English-speaking colony. Indeed, almost everyone agreed, in ecstatic terms, that the "American Titian" had captured the quintessence of America's most powerful actress. To those who claimed it was as good as Titian, others responded, "Did Titian produce anything like it!" Robert Browning said that he had never seen such "modern art." Sculptor and letter-writer *extraordinaire* William Wetmore Story, no great admirer of Charlotte Cushman, found the portrait to be "wonderfully fine—the best portrait, I think, I *ever* saw."

The Albany-born Page, who had studied with James Herring and Samuel F. B. Morse, arrived in Italy in 1849, his reputation already assured by an admiring and influential New York and Boston clientèle. He counted James Russell Lowell, William Wetmore Story, and Nathaniel Hawthorne among his boosters. Emerson had pronounced his figures real enough to bleed. Fanny Kemble had written that his portraits were "among the best modern pictures I have ever seen." Although many contemporary critics disapproved of his work, scores of notable admirers found him to be a most remarkable painter and were unstinting in their praise of the "noble Page."

His only fault, as they saw it, was a propensity to experiment with pigments, which led often to disastrous results. Within a very short period of time, some of his canvases turned red, some spotted, some "slid off the canvas and all—gone as if by spontaneous combustion." Most often they turned black. "May all Boston rather turn black," exclaimed Mrs. Browning. The portrait of Miss Cushman, fortunately, escaped deterioration.

When Page arrived in Rome in October of 1852, to make analytical drawings of antique sculpture and to continue turning out copies of Titians, Charlotte Cushman was quick to commission a portrait. Miss Cushman "had . . . found it possible, by the simple aid of intelligent art, the austere charm of 'thoughtful acting' . . . to have amassed in no great compass of time a considerable fortune." After seventeen years of very hard work, she felt she had earned the right to the good life and had, in 1852, retired from the stage. Along with her several female protegées, including the aspiring author Grace Greenwood and the aspiring sculptor Harriet Hosmer, she was spending the winter of 1853 in Rome, enjoying a life of *dolce far niente*. The days were passed reading books, writing letters, shopping, riding on the Campagna, and touring wealthy American visitors through the studios of the "sisterhood" of artists then at work in Italy. She was an active participant in the bustling social life of Anglo-Rome. Story, every ready to sneer at "the emancipated females" of the colony, reported, "The Cushman sings savage ballads in a hoarse manny voice, and requests people recitatively to forget her not. I'm sure I shall not."

Sitting for her portrait was nothing new to Charlotte Cushman. During her "brilliant and triumphant" success in London in 1845, she took time out to sit for no less than five different painters. Page, an artist who worked out his portraits carefully,

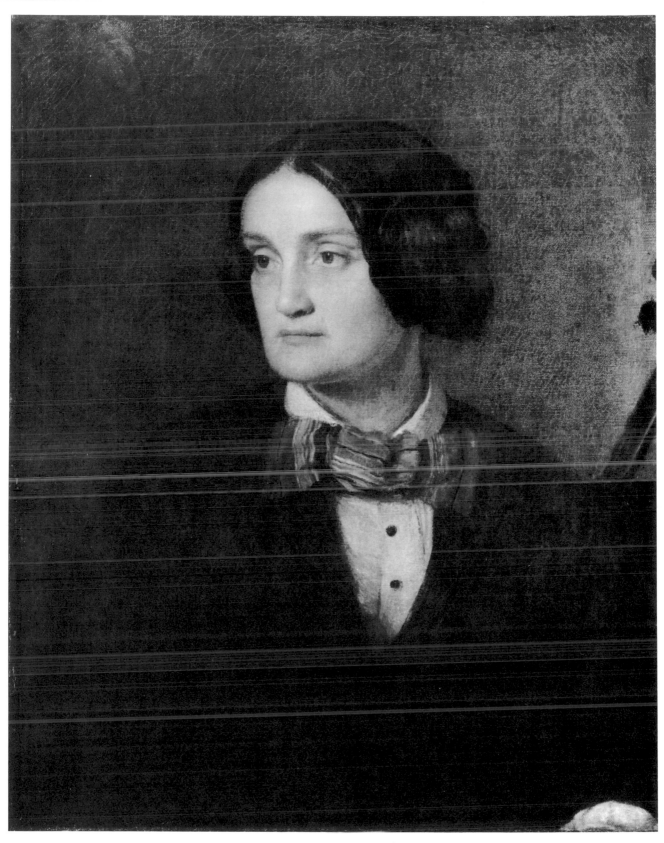

Charlotte Cushman by William Page, 1853

painstakingly making a life-size drawing (Page family) before beginning the painting in oil, required weeks of daily sittings. He would fret, erase, and then suddenly dash down something inspired. As with all his subjects, Page was determined that Miss Cushman should look like herself and not like an artist's model.

The two became, during the sessions, warm personal friends. Later she would write to Page, "How often, how very often, I wish I saw you, have I felt the good it would be to me to see you, hear you talk, and look at you while you painted and talked." For his part, in the difficult year after his young wife ran off with her Italian lover, Page wrote to Charlotte that "I long to have a *long talk* with you again." She continued also to patronize him as an artist, buying his copies of Titians and Raphaels and commissioning a portrait of her companion, Catherine Hayes.

Thomas Sully, who had painted Cushman ten years before (Library Company of Philadelphia), had softened the lines of her chin and cheeks and, as she said, established in her mind as a settled fact "that I am beautiful." However, Story, who called her, in his usual astringent fashion, "markedly destitute of beauty or of the feminine-attractive," was closer to the truth. Charlotte Cushman never was a beautiful woman, and acknowledged as much in modeling her acting style after that fact. She moved around the stage in an intense restless manner because, she said, not being beautiful she had to keep her audience through action and movement. Even after she achieved international fame and was hailed in America as "Our Charlotte," she was once heard to say, "I would rather be a pretty woman than anything else in this wide, wide, world."

Page did not make her pretty. He shows her as a plain woman, looking all of her thirty-six years. Her features are heavy; her square jaw is obvious as is the wart on her cheek. The fashionable but severe Victorian daytime costume heightens her somewhat masculine appearance. In the age of female helplessness, Cushman looks strong, determined, and commanding. It can well be believed that she performed best in the "character of a woman where most of the softer traits of womanhood are wanting." She looks indeed like one who would sooner play Romeo than Juliet, and who could bring down the house as Hamlet and as Cardinal Wolsey. It can well be believed that she did not woo her audience, but seized them. One can envision her saying, in her fabled husky voice, as she did in her final farewell to the stage on November 7th, 1874, just two years before her death: "I found life sadly real and intensely in earnest . . . and my watchword—to be thoroughly in earnest, intensely in earnest, in all my thoughts and in all my actions, whether in my profession or out of it, became my one single idea."

But whatever it was that Charlotte Cushman saw in her portrait she liked. Moreover, she was especially delighted with the acclaim it evoked. Back in London a few months after the likeness was completed, and already planning a return to the stage, she wrote to Page, "Your picture of me is more admired than I can describe to you. Some of the finest critics in Paris have seen and pronounced most enthusiastically upon it, and only the other day Ruskin sent me a message . . . to say he wanted to see it."

One of the tributes that pleased her most came in an 1861 article written by sculptor Paul Akers for the *Atlantic Monthly*. This piece, ostensibly a paean to Page—America's finest contemporary portraitist, he was called—described Charlotte Cushman's portrait at length but without mentioning the sitter by name. Speaking of the portrait as "somewhat miraculous," Akers wrote: *It is a face rendered impressive by the grandest repose,—a repose that pervades the room and the soul—a repose not to be mistaken for serenity, but which is power in equilibrium. No brilliancy of color, no elaboration of accessories, no intricacy of composition attracts the attention of the*

observer. There is no need of these. But he who is worthy of the privilege stands suddenly conscious of a presence such as the world has rarely known.

"What he says of me is wondrous," Charlotte Cushman wrote after she had seen the piece. "Do you think," she asked, "that an Editor's note might put my name at the bottom of the page?"

James, William. *William Wetmore Story and His Friends* (vol. I). Boston: Houghton, Mifflin & Co., 1903.

Leach, Joseph. *Bright, Particular Star*. New Haven: Yale University Press, 1970.

Taylor, Joshua C. *William Page: The American Titian*. Chicago: University of Chicago Press, 1957.

Harriet Beecher Stowe 1811–1896
By Alanson Fisher 1807–1884
Oil on canvas
86.4 x 67.9 cm
Unsigned
1853
NPG.68.1

Descended in the Howard family, members of which played the original roles in the George L. Aiken dramatization of Uncle Tom's Cabin.
Replica left to the Rhode Island Historical Society by Charles L. Pendle ton in 1896 and acquired by the Stowe-Day Foundation in 1955

"I am utterly incredulous of all that is said; it passes by me like a dream," wrote Harriet Beecher Stowe amid the clamor of adulation and abuse that came in the wake of the 1852 publication of *Uncle Tom's Cabin*. Among the incredulities of life as an instant celebrity was the fact that this daughter, sister, and wife of Calvinist preachers agreed, at the behest of Mr. Alexander Purdy, owner of the National Theatre in New York, to sit for a portrait intended to hang in the theatre where a stage version of her book was then playing. Alanson Fisher, an Associate of the National Academy of Design described in the *New York Sunday Atlas* as "the celebrated artist," traveled to Andover, Massachusetts, late in 1853 to execute the commission. The result, the newspaper commented, "is remarkable for its fidelity to the original."

Harriet Beecher Stowe had a natural bent for storytelling, a talent she put to good use early in her marriage "to a man rich in Greek and Hebrew, Latin and Arabic, and, alas! nothing else." When the family accounts just "wouldn't add up," she dashed off "sketches" which she sold to newspapers and magazines. It was recognized, even among the extraordinarily brilliant and articulate Beecher family (Lyman Beecher, father of seven sons and four daughters, was said to be "the father of more brains than any other man in America") that "Sister Hattie" had a special literary genius. In 1850, at a time when the New England antislavery people were seething at the abominations of the recently passed Fugitive Slave Law, her brother Edward's wife wrote, "Hattie, if I could use a pen as you can, I would write something that will make this whole nation feel what an accursed thing slavery is." Harriet Beecher Stowe, after eighteen years of exile in Cincinnati, had just returned to the East, and was living in Brunswick, Maine, where her husband was teaching at Bowdoin College. She had recently given birth to her seventh child. Her children recalled in later years

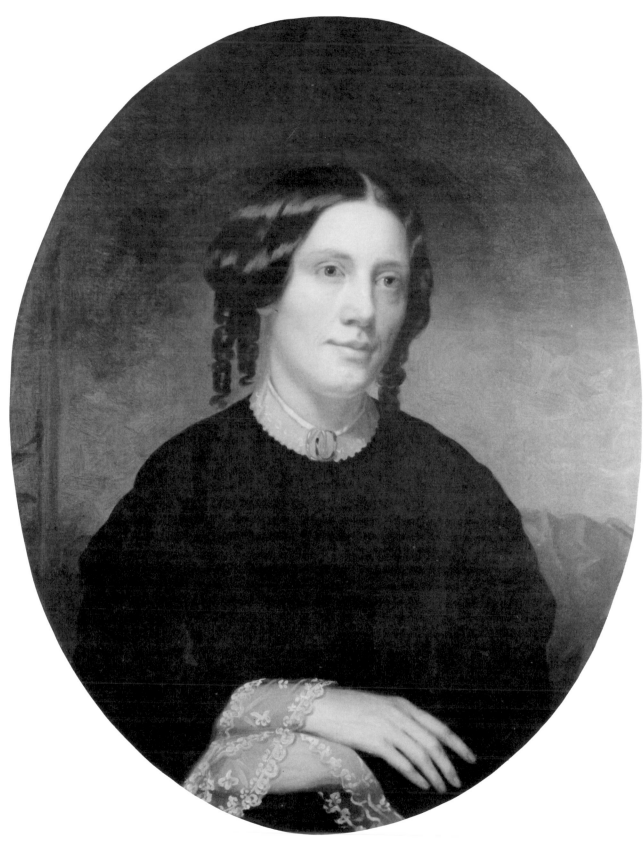

Harriet Beecher Stowe by Alanson Fisher, 1853

that, upon reading her sister-in-law's letter, she clinched it to her bosom and with eyes flashing declared, "I will write something. I will—if I live!" The Beechers were all given to drama as well as to hypochondria.

In the agreeable atmosphere of the Bowdoin community, in one of the happiest periods of her life, Harriet Beecher Stowe began to mull over the story which she would come to write "with my heart's blood." Precipitously, during a February church service, a vivid picture of a black man being whipped to death flashed before her. It was like the unrolling of a picture scroll, she said later.

More pictures, of things she had seen or heard about while she was living in Ohio on the border of slavery, came into her mind. In March she wrote to Dr. Gamaliel Bailey, editor of the Washington, D.C.-based antislavery *National Era*, asking him if he would be interested in publishing "a series of sketches which give the lights and shadows of the 'patriarchal institution.'" She intended "to show the *best side* of the thing, and something *faintly approaching the worst*." She added, *Up to this year I have always felt that I had no particular call to meddle with this subject, and I dreaded to expose even my own mind to the full force of its exciting power. But I feel now that the time is come when even a woman or a child who can speak a word for freedom and humanity is bound to speak.* Dr. Bailey agreed to publication and offered to pay her $300 for the series. Before she was finished it ran for about fifty installments—June 5th, 1851 to April 1st, 1852—and devoured all her writing time.

Long before the series concluded, questions of its publication in book form arose. Most publishers, however, felt that the Compromise of 1850 had settled slavery matters and, except for the abolitionists, *Uncle Tom's Cabin* would have no sale. Mrs. Jewett, the wife of the owner of a small publishing house, persuaded her husband, John Punchard Jewett, to read the story, and he somewhat reluctantly agreed to publish an edition of ten thousand. Mrs. Stowe was advised that she would do well if she got enough money out of it to buy a silk dress. Within two days of publication, Jewett was completely sold out, and Harriet Beecher Stowe was transformed from obscure housewife to national luminary. Longfellow wrote in his journal, "How she is shaking the world with UTC. At one step she has reached the top of the staircase up which the rest of us climb on our knees year after year. Never was there such a literary coup-de-main as this."

Her brother Edward worried that all the praise would work harm to her Christian character. But she noted that he needn't be troubled, because the Lord, not she, had written the book. "It all came to me in visions, one after another, and I put them down in words."

This belief kept her ego in check and also helped to sustain her when the tirade of criticism and abuse set in. The first attack came from financial interests in the North, when the *New York Journal of Commerce* attacked the book as a completely untrue picture of slavery. The *New York Herald* denounced "our nine days' literary wonder," calling it "a new field of fiction, humbug and deception, for the more extended agitation of the slavery question—than any that has heretofore imperiled the peace and safety of the Union." The *Southern Literary Messenger* termed the book "a criminal prostitution of the high function of imagination." The woman who wrote *Uncle Tom's Cabin*, said the *Alabama Planter*, "must be either a very bad or a very fanatical person." Anonymous letters, filled with fury and obscenity, poured in on Mrs. Stowe. A package arrived containing the severed ear of a slave.

She had said, when she finished writing the story, that "the indignation, the pity, the distress, that had long weighed upon her soul seemed to pass off from her, and into the readers of the book." By nature she was not a crusader. She had set forth the

wrongs and sufferings of the slaves and was ready now to move on to something else. She planned, as soon as she had gotten her family settled at her husband's new post at Andover Theological Seminary, to work on a novel concerning Maine's island fishermen. However, the recurring charges that *Uncle Tom's Cabin* was not based on fact outraged her. In December of 1852 she put aside her Maine novel and began a defense of her story. When she wrote *Uncle Tom's Cabin*, she had not, as J. F. Rhodes put it in his *History of the United States*, "the facts which a critical historian would have collected," but "she used with the intuition of genius the materials gained through personal observation, and the result was what she desired." Now, however, she had documentation after the fact. In the months since the publication of her novel, it had all come to her unbidden—clippings, handbills, letters detailing personal experiences. Using selections from this "mountain of material," buttressed wth judicial records and statutes, she wrote *The Key to Uncle Tom's Cabin.*

While she was still in the throes of writing *The Key*, Glasgow's two antislavery societies invited "Mrs. and Professor Stowe" to visit Scotland and England. She accepted, saying, in her usual way, "Should God spare my life till April," and raced to complete the book just barely in time to keep her sailing date.

Her two months in the British Isles made the commendation which she had received in America pale by comparison. Calvin Stowe wrote home that *the speeches that are constantly poured into poor wife's ears from all quarters, are enough to turn the strongest head. Lord Palmerston, the judges, the bishops, the literati, all speak the same language; and every distinguished man of every grade makes it a point to see her.* They all called on her, her husband reported dryly, "with great apparent rapture." He concluded, "Wife bears it all very well. She is gaining in health. She is meek, humble, pious, and loving, the same that she ever was."

Following her triumphal tour of the British Isles, Mrs. Stowe spent the summer on the Continent. She returned to the United States in September, full of plans for a travel book on "Sunny Memories." She returned also with the $20,000 given her in the British Isles for use in the abolition movement and with the weighty responsibility of leadership. "Yours for the cause," she signed her letters now. At the time she sat to Fisher, she was just getting her new role in hand.

It is unlikely that Mrs. Stowe paid much heed to the dramatization of her book. All of the theatrical productions were undertaken without her consultation. The first stage presentation, written by G. W. Taylor and produced in New York by Alexander Purdy, lasted only two weeks. On July 18th, 1853, Purdy opened with a new version written by actor George L. Aiken, which had been previously produced with great success by George C. Howard in Troy, New York. Aiken, a cousin of Howard's wife, had written the play at the request of the producer, who saw in Topsy and Eva characters ideally suited to the talents of his wife and daughter. Howard himself played the role of St. Clair. In the Aiken version Purdy had a hit, a play which enjoyed an unprecedented run, continuing into 1854.

So well did the plot of *Uncle Tom's Cabin* lend itself to dramatization that Purdy soon found that he had local competition. P. T. Barnum produced a version at his American Museum, which he advertised as "the only honest and sensible dramatic version of Mrs. Stowe's book." The Bowery Theatre opened a production featuring the popular minstrel performer T. D. "Daddy" Rich as Uncle Tom. In an all-out effort to counter these rivals, Purdy spent $2,000 on redecorating the theatre and improving the scenery. On January 16th, 1854, to celebrate the play's two hundredth performance, he held a "Grand Uncle Tom Jubilee" complete with brass band and fireworks.

It is interesting to speculate just how Purdy persuaded Harriet Beecher Stowe to

sit for the picture. Dramatic though the Beechers might be, none of them approved of the theatre. Had not her famous brother, Henry Ward, proclaimed that "it is notorious that the Theatre is the *door* to all sinks of iniquity"? Perhaps Purdy, in advertising that the play was attracting "eager multiudes, comprising the piety, morality, intelligence and fashion of the city and surrounding country," made the stage production more palatable to her.

In 1854, Francis Underwood, founder of the *Atlantic*, prevailed upon Mrs. Stowe to see the Howards' play in a Boston production. Underwood, describing her reaction for his readers, reported: *I asked Mrs. Stowe to go with me to see the play. She had some natural reluctance, considering the position of her husband as a preacher, but she also had some curiosity as a woman and as an author to see in the flesh and blood the creation of her imagination. I think she told me she had never been in a theatre in her life. I procured the manager's box. . . . She watched the play attentively. I never saw such delight upon a human face as she displayed when she comprehended the full power of Mrs. Howard's "Topsy." She scarcely spoke during the evening; but her expression was eloquent—smiles and tears succeeding each other through the whole.* Underwood observed that Mrs. Stowe never said what she thought of the play.

Ironically, the story of *Uncle Tom's Cabin* has come down through the years in the distorted image of the stage version. Long after the book ceased to be read, the play flourished. In the 1870s it became a standard vehicle for hundreds of touring companies. By the 1890s, the high point of "Tomming" was reached, with four hundred to five hundred companies traveling by wagon, railway, and boat, playing in tents, churches, halls, theatres, and opera houses all across the country. The plot was pure melodrama, the characters overdrawn caricatures, the original message lost. Most painful of all, the character of Uncle Tom, whom Harriet Beecher Stowe had created as a man of strength and dignity, was misinterpreted so badly that his name became synonymous with submission and servility.

None of this could have been foretold when Harriet Beecher Stowe posed for Alanson Fisher. The portrait was complete by early December 1853, and the *New York Evening Post* reported, on January 6th, 1854: *There has just been placed on exhibition at the National Theatre in this city a portrait of Mrs. Harriet Beecher Stowe, executed by Mr. Fisher, at the request of Mr. Purdy. According to the picture the distinguished writer is quite a good-looking woman, apparently about forty-five years of age. She is dressed in a high necked black dress. A splendid gilt frame incloses the portrait, and another frame of polished mahogany about four feet high and three feet wide, with a plate glass front, protects it from injury. The cost of the portrait and frames was five hundred and sixty dollars, and the manager of the National incurred the expense in consequence of the great success of Uncle Tom's Cabin at his place of amusement.* Another newspaper account noted that the portrait was intended for Mr. Purdy's parlor, but that "he has, however, assented to universal desire, and the portrait will remain in the lobby of the theatre for a few weeks." An accompanying inscription assured the viewers that the "Authoress of Uncle Tom's Cabin" had been painted from life.

Only a scant two years previous the idea, to say nothing of the expense, of having her likeness recorded had seemed preposterous to Harriet Beecher Stowe. At the time when *Uncle Tom's Cabin* was still being serialized in the *National Era*, Sara J. Hale, editor of *Godey's Lady's Book*, asked for a daguerreotype and biographical facts for inclusion in a book about "distinguished women writers of the earth." Mrs. Stowe responded, saying that she was wholly innocent of any pretensions to rank among "distinguished women." She went on, "The idea of the daguerreotype especially was quite droll, and I diverted myself somewhat with figuring the astonishment of the

children, should the well known visage of their mother loom out of the pages of a book before their astonished eyes."

After her first book was published, however, she did have a daguerreotype likeness taken by Stevens of Andover. By the time she arrived in England, she found lithographs of herself on display in shop windows everywhere. She wrote, "I should think that the Sphinx in the London Museum might have sat for most of them. . . . There is a great variety of them, and they will be useful, like the Irishman's guide-board, which showed where the road did not go." Nonetheless, she found that the "horrid pictures do me a service, and people seem relieved when they see me; think me even handsome." She once remarked, "As beauty has never been one of my strong points, I am open to flattery upon it."

Mrs. Stowe's friends often commented that her photographs, which showed her to be lackluster in expression, were "painfully untrue." Mrs. Annie Fields, the wife of her publisher, accompanying the author to a reception in Boston, was chided by the hostess for not having given notice that Mrs. Stowe was beautiful. Mrs. Fields recounted, *Indeed when I observed her, in the full ardor of conversation, with her heightened color, her eyes shining and awake but filled with great softness, her abundant curling hair rippling naturally about her head and falling a little at the sides . . . I quite agreed with my hostess.*

Some months before Fisher painted Mrs. Stowe's portrait, she described herself in a letter to a fellow author as "a little bit of a woman—somewhat more than forty, about as thin and dry as a pinch of snuff; never very much to look at in my best days, and looking like a used up article now."

As far as we know, Harriet Beecher Stowe made no public comment on the Fisher portrait. Her husband, however, testified as to his approval. In a letter of December 10th, 1853, addressed to Mr. Purdy and exhibited along with the portrait, he wrote, *I am better satisfied with Mr. Fisher's portrait of Mrs. Stowe than with any other attempt of the kind which I have seen. Every feature is very exactly copied, and the general expression is pleasing, life-like and natural. On the whole, to my eye, it is a handsome picture and a good likeness.*

Fields, Annie, ed. *Life and Letters of Harriet Beecher Stowe.* Detroit: Gale Research Co., 1970 (facsimile of 1897 edition).

Groce, G. C., and David Wallace. *New-York Historical Society's Dictionary of Artists in America.* New Haven: Yale University Press, 1957.

Johnston, Johanna. *Runaway to Heaven.* Garden City, N.Y.: Doubleday & Co., 1963.

Moody, Richard. "Uncle Tom, the Theater and Mrs. Stowe." *American Heritage,* October 1955, pp. 29 ff.

Stowe, Charles Edward. *Life of Harriet Beecher Stowe.* Boston: Houghton, Mifflin & Co., 1889.

Wagenknecht, Edward. *Harriet Beecher Stowe: The Known and the Unknown.* New York: Oxford University Press, 1965.

Wilson, Forrest. *Crusader in Crinoline.* Philadelphia: J. B. Lippincott Co., 1941.

George Peabody 1795–1869
By George Peter Alexander Healy 1813–1894
Oil on canvas (probably cut down)
158.8 x 101.6 cm
Unsigned
circa 1854
NPG.68.26

*Painted to hang in the Peabody Institute at South Danvers (renamed
Peabody in 1868). Came into possession of the sitter's niece, Mrs. Joseph
Outhwaite, and descended in her family*

By the spring of 1854, international banker George Peabody had arrived at a stage
in life when he was "almost tired of making money without having time to spend it."
In a few months, however, his new partner, Junius Spencer Morgan, would be on
hand to help with the burdens of business, thus allowing Peabody to concentrate
more of his attention on philanthropy and plan for a visit to America, the first since
he had settled in London in 1837. At the request of the citizens of his native town
of Danvers, Massachusetts, Peabody took time to sit for his portrait, and insisted on
paying the bill. The artist selected was George Peter Alexander Healy, well known
as the painter of French royalty, English nobility, and American presidents.

Danvers had good cause to want the portrait of its most famous son. Unable to
be present in 1852 when the town celebrated its centennial, Peabody sent a letter to
the citizens, in which he proclaimed that "to the principles there inculcated in child-
hood and early youth, I owe much of the foundation for such success as Heaven has
been pleased to grant me during a long business life." He went on to announce his
first major philanthrophy, a grant of $20,000 for a lyceum and a permanent fund to
support a continuing series of free lectures—a system for dispensing knowledge that
mid-nineteenth-century New Englanders regarded with the utmost enthusiasm. This
substantial act of generosity, one of the first of its kind in America, brought the Pea-
body name to public attention. As his friend William Wilson Corcoran commented,
Peabody was now becoming a "national man."

By the time of his death, the philanthropist, whom most people thought unobtru-
sive, would have given his name to thirteen separate institutions. William Lloyd
Garrison was almost alone among his contemporaries to suggest publicly that vanity
was the prime motive for his beneficence.

Peabody himself told the townfolk of Danvers, when he came to see what his
money had wrought, that he was still at heart "the humble boy who left yonder un-
pretentious dwelling, many—*very* many years ago." No doubt he considered that his
likeness, hanging in the lecture hall of a "stately edifice of brick," would serve as an
object lesson to the rising generations, an eloquent testimony to the rewards of dili-
gence. As he told his audience, "There is not a youth within the sound of my voice
whose early opportunities and advantages are not much greater than were my own,
and I have since achieved nothing that is impossible to the most humble boy among
you."

Everything Peabody had accomplished was through his own exertions. He had
been working since he was eleven years old. Indeed, as the son of a poor Massachu-
setts farm family, the third of eight children, Peabody could claim to have been
working for as long as he could remember. His formal education never went beyond
the four or five years he had spent in Danvers's one-room schoolhouse, a fact that he
never ceased to lament.

In 1807 Peabody was apprenticed to learn the storekeeper's trade. Six years later, at the age of fifteen a qualified journeyman, and possessed of two suits of apparel and $25, he set out to make his fortune. He was hardworking, wrote a good hand, and was attentive to detail. Moreover he had a face and manner which inspired confidence, no small consideration when it came to establishing a line of credit. In partnership with his uncle, he set up a drygoods store in Georgetown (in the District of Columbia) in 1812, traveling about as a pack peddler to increase the business. In 1815, now with a new partner, Elisha Riggs, he moved to Baltimore and, in the next twenty-two years, thanks to his reputation for absolute integrity, he built up a considerable business in transatlantic commerce. By 1829, when Riggs retired, Peabody's assets were in excess of $85,000. The years in Baltimore had given him the foundation for a fortune that would soon be extended into the millions, and Baltimore, Peabody would later note, "shares with my native town in my kindest feelings." It would receive a good share, also, of his generosity. Even as he sat for his portrait he was deep in planning for a gift that would net that city a library, an academy of music, and an art gallery.

George Peabody was a sentimental man, and the pattern of his giving in the years to come would reflect this nature. Not only were Danvers and Baltimore generously remembered but also Thetford, Vermont, where he had spent a happy year with his maternal grandfather; Georgetown, Massachusetts, where his mother had lived; and Georgetown, D.C., where he had had his first business. His affection and pride in his nephew Othniel Charles Marsh, professor of geology and paleontology at Yale, was responsible in part for the Peabody Museum of Archeology there. Nor was London, the city in which he would remain until his death, to be forgotten. As a mark of appreciation to the English, he established the Peabody Donation Fund, a grant of $2.5 million for a model housing project for London's working poor.

In 1837 Peabody moved permanently to London and the world of international finance. It was said: *You may always find him at his business during the hours devoted to it in London. He knows no such thing as relaxation from it. At 10½ o'clock, every morning, you may notice him coming out from the Club Chambers, where he keeps bachelor's hall, taking a seat in the passing omnibus, and riding some three miles to his office in Wanford Court, a dingy alley in Throgmorton Street; and in that office, or near by, day after day, year in and out, you may be sure to find him, always cheerful, always busy.*

He labored not only at the making of money but at the furthering of Anglo–American relations as well. In 1851, when the Congress failed to appropriate money for an American contribution to the Crystal Palace Exhibition, he singlehandedly salvaged the honor of American industry by a personal loan which underwrote the cost of a stunning display of his country's technology. Typically, he himself was so busy, he told a friend, that he was able to pass but one hour in the exhibition.

In a gesture symbolizing the common humanity of the English-speaking countries, he contributed a large sum to help finance the American Elisha Kent Kane's search for the British antarctic explorer, Sir John Franklin. Peabody Bay, off the coast of Greenland, is, as a consequence, named for him.

The most famous of Peabody's Anglo–American friendship endeavors was his instigation of the Fourth of July celebration—a concert, dancing, and elegant supper. "No other man," said one of his home town admirers, "could have assembled on the Fourth of July with the stars and stripes decorating the hall, the aristocracy of Great Britain, to commemorate with Americans the birth day of republican institutions."

A bachelor, and ungregarious by nature, Peabody nevertheless entertained with great élan, using hotels and private clubs, insisting upon the best in food, drink, and

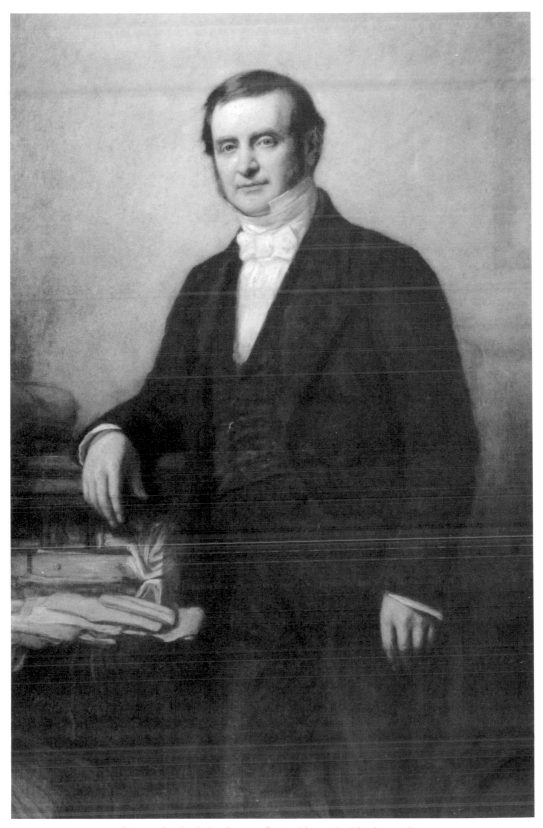

George Peabody by George Peter Alexander Healy, c. 1854

decoration. He gave to his social obligations the same kind of meticulous attention as he gave to his business affairs. He never forgot a name; he knew the likes and dislikes of each of his guests. He sent flowers to the ladies, accompanied by charming little notes. With his well-developed sense of public relations, Peabody was always pleased with the publicity his parties engendered.

He traveled extensively on the Continent, but his time was devoted exclusively to business. His biographer, Franklin Parker, noted that he was not known to spend any time in museums or art galleries. He told James Read Lambdin, who painted his portrait in 1857 (Maryland Historical Society), that "you may be surprised when I tell you that, although I have lived twenty years within pistol shot of the Royal Academy and National Gallery in London, I have never been within their walls." Likewise the man who endowed a half-dozen libraries had no interest in reading anything other than newspapers. He did, however, enjoy the opera.

Peabody was a large man, just over six feet tall, with light blue eyes and, until he was in his sixties, dark black hair which, he confessed to one of his close friends, he dyed with African balm. His complexion was florid. He had a pointed chin, a small mouth, a rather large nose, and a forehead described as "fine and bold." He was fastidious about his appearance, taking great care that his dress reflected his station in life, sparing no expense when it came to personal adornment. Otherwise he lived frugally, occupying rented rooms and subsisting, when he was not entertaining, on cheese and mutton chops.

Through all of his years in London, Peabody maintained a finely tuned American consciousness. He said of his enterprise, *I have endeavored in the constitution of its members and the character of its business, to make it an American House, and to give it an American atmosphere, to furnish it with American journals; to make it a center for American news, and an agreeable place for my American friends visiting London.* When looking around for a partner, a major consideration had been that the man be American. So it was, too, that when he came to have his portrait painted he chose an American artist.

George Peter Alexander Healy was forty-one and in the prime of his career when Peabody summoned him to London early in 1854. Like Peabody, Healy was self-made. His father was an improvident Irish sailor, and early in life Healy had the responsibility of helping to support his mother and younger brothers and sisters. He remarked in his reminiscences that there had been nothing in his childhood to indicate that he would become an artist. He was sixteen before he ever held a paintbrush. On the dare of his sister's friend he attempted to color an amateur drawing. After that, he reported, "I would do nothing else." He resolved to become a painter, and the only way he knew how was by copying all the prints he could find and making likenesses of anyone who could be persuaded to sit to him. He soon became skilled enough to pay the butcher bill with a portrait of the butcher. Gilbert Stuart's daughter, Jane, taken with "little Healy's" "attempts" at painting, introduced him to Thomas Sully. Sully, in turn impressed by Healy's copies of Gilbert Stuart and John Singleton Copley portraits, encouraged the eighteen-year-old to look to painting as a profession. On the strength of Sully's recommendation, Healy rented a studio which he paid for by painting the portraits of his landlord's son and son-in-law. Shy though he was, he ventured to ask Mrs. Harrison Gray Otis, Boston's "queen of fashion," to sit for him (Illinois State Museum, Springfield). The portrait made his reputation in Boston, and by 1834 he had earned enough money to fulfill his ambition to study in Europe at "a regular art school." He arrived in France without contacts or letters of introduction, only, as he put it, with "a great stock of courage, of inexperience—which is sometimes a great help,—and a strong desire to do my very best." Entering

the atelier of the neoclassical painter Baron Gros, he "went to work with a will, doing my best to understand my master and my comrades, and quickly catching up enough French to make my way." A little more than a year later, Gros drowned himself in the Seine, and Healy was back to learning on his own once again, this time copying old master paintings at the Louvre. Thus engaged, he first met Sir Arthur and Lady Faulkner, an English couple who invited him to England in 1836 to paint their portraits. As would be the case with Healy throughout his life, one satisfied customer would lead him on to new contacts, and so it was that he had occasion to return often to England to execute portrait commissions.

Back in Paris he painted the portraits of Lewis Cass, United States minister to France, and his wife (The Detroit Historical Museum). Cass subsequently commissioned a portrait of King Louis-Philippe, and the latter was so struck by this twenty-six-year-old artist's talent that he employed him to copy some of the paintings at Windsor Castle for the galleries at Versailles. This accomplished, Louis-Philippe sent him to America to paint portraits of distinguished Americans, including all the presidents of the United States.

In the next nine years, Healy was back and forth across the Atlantic many times, executing individual portraits and working on the nearly 150 life portraits for *Webster Replying to Hayne* (Faneuil Hall, Boston), a canvas designed to hang at Versailles along with his life-sized *Benjamin Franklin at the Court of Louis XVI* (American Philosophical Society, Philadelphia). The fall of Louis-Philippe in 1848 brought but a momentary lull in Healy's fortunes. Well known by now in both Engand and America as a "capital portrait painter," he did not lack for commissions. He continued to maintain his studio in France, finding the facilities in Paris best for his large-size canvases.

Healy was a sociable man who seemed genuinely to like people. Almost without exception his patrons found the sittings pleasant. Normally he demanded six sessions of two hours each. He always measured the face—much to the horror of Louis-Philippe's attendants who took the compass to be an assassin's weapon.

It might be assumed that Peabody and Healy, both equally devoted to the Puritan work ethic, would have had a natural compatibility. The story of the portrait, as elucidated through the Healy correspondence in the Peabody Papers, at the Essex Institute, is, however, fraught with unanswered questions.

On the 29th of March, 1854, Healy wrote to Henry Stevens, Peabody's friend and adviser, saying that it would give him great pleasure to paint the portrait of "our friend," George Peabody, to hang in the Peabody Institute in South Danvers (now Peabody), and offered to arrange his engagements for the next two months so as to be free to come to London for this purpose. He added that he hoped, if he were selected as the artist, that the portrait might be completed in time for exhibition at the Royal Academy. The price would be his usual one for a full-length portrait, $1,000. Stevens, in passing on Healy's letter to Peabody, found it necessary to assure the millionaire that the price was not "high for a full length life size portrait." He went on to say that "no English painter of good standing would execute such a commission for less than £300 to £500. Besides I think this a good opportunity to let Healy try for the Royal Academy. It could do him good and you too." Healy had in fact exhibited at the Royal Academy as early as 1838, but he never became a member.

Healy was awarded the commission and arrived in April, determined, he told Peabody, to "exert myself to the utmost to do yourself & native town justice."

By the 14th of June, Healy was back in Paris awaiting delivery of the portrait to his atelier. (For one reason or another the portrait was never shown at the Royal Academy). The artist was personally overseeing the framing, and reported to Peabody

that he had gone to the Louvre with his framemaker and decided upon a carved frame in Renaissance style. It would cost 1,800 francs to copy. The penurious financier was aghast and had to be reassured that, although "18 hundred francs is a large sum for a frame," it was "cheap for what is offered." Peabody, a man who recognized quality, agreed to go ahead with the expensive wood frame rather than make do with one in plaster which could be had for half the sum. The portrait, along with its enormous richly carved frame, was shipped from Paris to Boston on the 16th of August. After being briefly exhibited in Boston, it was sent on to the Peabody Institute in South Danvers where it was hung in its intended place.

Healy was well pleased. His wife liked the portrait. His friends were complimentary. Peabody had ordered two copies of bust length, for presentation to his business associates. Healy proceeded with plans to have the portrait engraved, humbly asking Peabody in what way he might be permitted to sell the plates. His ambition, he told Peabody, "is more that a work alike creditable to the subject, and the artist, might be produced, than to make money by it." He had found a young man "of first rate talents" who, like Healy, "had his reputation in view" and consequently had agreed to work very cheaply. Healy had made "a beautiful copy in small which was to go into the engraver's hands." Peabody wrote Healy kind letters, let him draw money for the underwriting of the engraving, and promised letters of introduction to contacts in Chicago, where Healy planned to settle "if I like the people & they like me." The artist was euphoric, saying, "Everything has prospered with me since the success of your picture." He added obsequiously, "I feel I may say of you what Mr. Corbin said the other day, he exclaimed God Bless him, when I speak of him my heart expands."

The first hint that Peabody was not altogether pleased with the portrait came when he saw the engraving proofs and desired alterations. When he arrived in Danvers on October 9th, 1856, he saw the finished full-length portrait for the first time. It was reported in the "Proceedings at the Reception and Dinner in Honor of George Peabody Esq. of London by the Citizens of the Old Town of Danvers" that *over the rostrum hangs a full-length portrait of Mr. Peabody, by Healy, which has been pronounced by connoisseurs to be a chef d'oeuvre of that artist. It was set for by him at the request of the citizens of the town, but, at its completion, was presented to them.*

Sometime later it became known that Peabody did not like the portrait. The records of the Trustees of the Peabody Institute of Peabody show that Mr. Peabody was unhappy with it and had it removed from the massive frame. It was replaced by another portrait painted by "British artists of London" which Mr. Peabody approved.

Healy seems not to have known of Peabody's dissatisfaction. In July of 1858, he wrote to Peabody saying that last autumn he had sent him a letter and a "small whole length portrait of yourself" and had received no acknowledgment. "I have attributed your silence to your great press of occupation. I would beg you to be so kind as to inform me if the picture has reached you, if it is approved of, & if not I beg you to have it returned." Oblivious to any cooling of their relationship, Healy chatted on, telling Peabody that he had "painted for Congress, Fillmore, Van Buren, Pierce, J. Q. Adams and shall try to paint that of Polk within the coming month." Peabody's reply, if any, is not known.

A bust portrait, which Healy executed for his own collection, he took with him to Chicago. Late in 1859, at a time when he was in financial straits and wished to buy some property, he sold the painting to his old friend Judge Thomas B. Bryan of Chicago. On May 3rd, 1879, William H. Corcoran, another close friend of Healy's, wrote, "I have recently purchased from our friend Judge Bryan, for the Art Gallery, your collection of portraits of the Presidents, with that of Mr. Peabody and others, which

we value very highly." This bust portrait of Peabody has been in the collection of the Corcoran Gallery of Art ever since.

The Portrait Gallery's three-quarter-length Peabody was owned by the sitter's niece Ellen, the daughter of his younger brother Jeremiah who had gone West to farm near Zanesville, Ohio. She married Joseph Outhwaite, one-time Congressman from Ohio, and the portrait descended in the Outhwaite family. A recent examination indicates that the canvas has been cut down, and it is therefore likely that this is the original full-length portrait which Healy noted in his correspondence measured eight feet by four feet ten inches. "I hope it pleased you as much as it does those who have seen it here," wrote the artist to his sitter.

DeMare, Marie. *G. P. A. Healy: American Artist*. New York: David McKay Co., 1954.

Healy, George P. A. *Reminiscences of a Portrait Painter*. Chicago: A. C. McClung & Co., 1894.

Parker, Franklin. *George Peabody*. Nashville. Vanderbilt University Press, 1971.

Virginia Museum of Fine Arts. *Healy's Sitters*. Richmond: 1950.

Thomas Jonathan ("Stonewall") Jackson 1824–1863
By an unidentified daguerreotypist
Daguerreotype
8.3 x 7.1 cm
Unsigned
1855
NPG.77.57

One of the rarities in the National Portrait Gallery collection is the daguerreotype of the great master of strategic warfare, Thomas Jonathan "Stonewall" Jackson. Made in Parkersburg, Virginia (now West Virginia), in August of 1855, it is the only known survivor of four daguerreotypes and one ambrotype for which the short-lived Jackson posed. Other than a sketch in the Virginia Military Institute and an original photographic print in the Museum of the Confederacy, in Richmond, no other life portraits of the famed Confederate hero have been uncovered.

At the time of the portrait, Jackson, professor of Artillery Tactics and Natural Philosophy at Virginia Military Institute, in Lexington, was vacationing at the home of his aunt and uncle, Mr. and Mrs. Alfred Neale. Thanking his Aunt Clementine for an agreeable visit, he wrote, on September 4th, 1855, "Though I have reached home, yet the pleasures enjoyed under your hospitable roof, and in your family circle, have not been dissipated." The daguerreotype remained with Mrs. Neale and descended in her family.

Miss Anna Morrison, who would later become Jackson's second wife, meeting him two summers before the daguerreotype, described him at twenty-nine: *My first impression was that he was more soldierly-looking than anyone else, his erectness . . . being quite striking but, upon engaging in conversation, his open, animated countenance, and his complexion, tinged with a ruddy glow of health, were still more pleasing. . . . His head was a splendid one, large and finely formed, and covered with soft dark brown hair, which, if allowed to grow to any length, curled; but he had a horror of long hair for a man, and clung to the conventional style, a la militaire, of wearing very close-cut hair and short side-whiskers. . . . His forehead was noble and*

expansive. . . . His eyes were blue-gray in color, large and well-formed, capable of wonderful changes in varying emotions. His nose was straight and finely chiseled, his mouth small and his face oval. His profile was very fine. All his features were regular and symmetrical, and he was at all times manly and noble-looking, and, when in robust health, he was a handsome man. Jackson, she added, "always wore citizen's dress when off duty."

It was often remarked, by those who saw Jackson in pre-Civil War days, that "he always sat bolt upright in his chair, never lounged, never crossed his legs, or made an unnecessary movement." And even then, as it would be later on in the battlefield, "every movement was quick and decisive."

The Reverend Robert Dabney, who knew Jackson first in Lexington and who later served as his wartime chief of staff, remembered: *The remarkable characteristic of his face was the contrast between its sterner and its gentler moods. As he accosted a friend, or dispensed the hospitalities of his own house, his serious constrained look gave place to a smile so sweet, so sunny in its graciousness that he was another man. And if anything caused him to burst into a hearty laugh, the effect was a complete metamorphosis. Then his eyes danced and his countenance rippled with a glee and abandon literally infantile. This smile was indescribable to one who never saw it. Had there been a painter with genius subtle enough to fix upon his canvas, side by side, the spirit of a countenance with which he caught the sudden jest of a child romping on his knees, and with which, in the crisis of battle, he gave the sharp command, "sweep the field with the bayonet!" he would have accomplished a miracle of art, which the spectator could scarcely credit as true to nature.*

In the privacy of his home, Jackson was affectionate and playful. His second wife, describing what she called his "sportiveness," wrote, "He would often hide himself behind a door at the sound of the approaching footstep of his wife, and spring out to greet her with a startling caress."

At the time Jackson sat to the daguerreotype artist, the great drama of his life was still in the future. Nonetheless the prosaic-looking professor's past had not been without excitement. Within eighteen months from the time Jackson had graduated from West Point in 1846, his "gallant and Meritorious conduct" under fire during the Mexican War had earned him the rank of brevet major. The shy Jackson early found that he had a taste for the heroic, and reported that "the only anxiety of which I was conscious during the engagements was a fear lest I should not meet danger enough to make my conduct conspicuous." Once the excitement of war was over, he was flattered to be offered a coveted teaching post at the Virginia Military Institute, a situation which afforded him the chance to continue a military style without the transience and uncertainties of regular army life.

Inflexible in his meticulous habits, devoid of imagination and humor, stiff and unbending in social intercourse, Jackson was ill-suited to the teaching of young men. "Hickory," the cadets called the rigid Jackson, or "Square Box," a derision prompted by the enormous size of his feet. One of the cadets, in a letter home, said that he was "taught by such a hell of a fool, whose name was Jackson." A former student said in retrospect: "No one recalls a smile, a humorous speech, anything from him while at the barracks. He was not sullen, or gloomy, or particularly dull. He was simply a silent, unobtrusive man doing his duty in an unentertaining way—merely an automaton." But whether the cadets liked or disliked their teacher was of no particular concern. Singlemindedly and intensely in earnest, Jackson performed his duty.

"One may do whatever he resolves to do," Jackson had written at the time he came to West Point, totally unequipped, by reason of a desultory education, to undertake

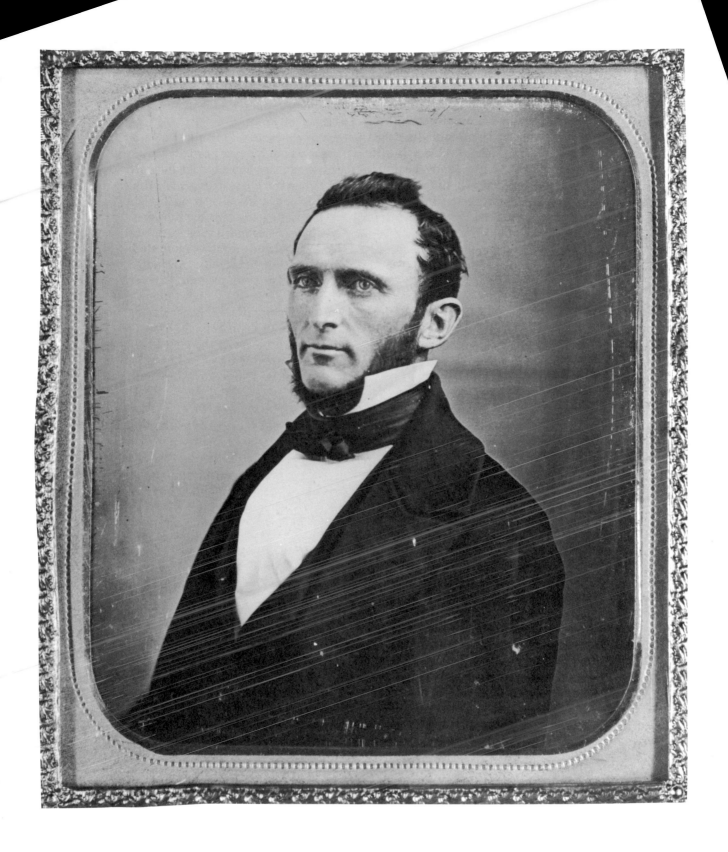

Thomas Jonathan ("Stonewall") Jackson by an unidentified daguerreotypist, 1855

the rigorous curriculum. "I am very ignorant," he admitted as he asked family friends to help him secure the West Point appointment, "but I can make it up in study. I know I have the energy and I think I have the intellect." With this determination he persevered through his course at the military academy, rising steadily in rank each year and finally graduating seventeenth out of a class of fifty-nine.

His diligent habits and well-developed powers of concentration continued to be exercised at the Virginia Military Institute. A weakness in his eyes prevented study by artificial light. Consequently, he utilized the early morning hours to memorize the next day's lecture material. In the evening he spent some two hours standing or sitting rigidly upright (he suffered from chronic dyspepsia and believed that an upright position was beneficial to his digestion), face to the wall, going over the morning's reading in his mind. Even after he had been teaching the same courses for several years, his wife, then a new bride, complained that her husband "is rather more studious than I would like him to be as I see nothing of him in his study hours." She noted, in a letter to her sister-in-law, "You know he always makes every pleasure give way to duty."

In his singular way Jackson had settled into a satisfactory life. Of particular significance to him was his strong religious orientation. An orphan, he had grown up without church affiliation but with a strong affinity for theology. At the close of the Mexican War he had joined the Episcopal Church, but after his arrival in Lexington he became a member, and soon a deacon, of the Presbyterian Church, and his youthful pleasures—dancing, the theatre, and the like—were banished forever. He explained simply, "I know it is not wrong, *not to do it*, so I'm going to be on the safe side." He never read or wrote a letter on Sunday or posted one if he risked its traveling to its destination on the Sabbath. One who knew Jackson in Lexington remarked that he lost sight of the perspective of things. "Not drawing the distinction that men generally do between small and great, he laid as much stress upon truth in the most insignificant words or actions of his daily life as in the most solemn and important."

A year or two before Jackson presented his daguerreotype likeness to Mrs. Neale, he had written to her: *The subject of becoming a herald of the Cross has often seriously engaged my attention, and I regard it as the most noble of all professions. It is the profession of our divine Redeemer, and I should not be surprised were I to die upon a foreign field, clad in ministerial armor, fighting under the banner of Jesus. What could be more glorious? But my conviction is that I am doing good here, and that for the present I am where God would have me.*

Half soldier, half deacon, Jackson lived the dichotomy without conflict. Only once, when he was forced by military exigency to fight a battle on Sunday, did his duty as a soldier and his duty as a Christian clash. He wrote apologetically to his wife: *You appear much concerned at me attacking on Sunday. I was greatly concerned, too; but felt it my duty to do it, in consideration of the ruinous effects that might result from postponing the battle until the morning. So far as I can see my course was a wise one; the best that I could do under the circumstances, though very distasteful to my feelings; and I hope and pray to our Heavenly Father that I may never again be circumstanced as on that day. I believed that so far as my troops were concerned, necessity and mercy both called for the battle. I do hope the war will soon be over, and that I shall never again have to take the field. Arms is a profession that, if its principles are adhered to for success, requires an officer to do what he fears might be wrong, and yet, according to military experience, must be done, if success is to be attained.*

In 1853 Jackson had married his first wife, Elinor Junkins, the daughter of the president of Washington College, but fourteen months later she died very suddenly

and with Jackson's unborn child. In his agony he wrote to Mrs. Neale, *I can hardly realize yet that my dear Ellie is no more—that she will never again welcome my return—no more soothe my troubled spirit by her every kind, sympathizing heart, words, and love. . . . Oh, do you not long to leave the flesh and go to God, and mingle with the just made perfect?*

By the time he visited his Aunt Clementine the following August, the freshness of his grief had abated, and he was keeping busier than ever with his Christian work—methodically collecting contributions for the American Bible Society even unto pennies from the free blacks, a solicitation which he felt had the added moral advantage of keeping the money from being spent on drink or tobacco.

That fall he initiated a Sunday school for blacks, a controversial undertaking in a society that had laws circumscribing assemblies of blacks. Certain that slaves had souls to be saved, Jackson waved away local opinion and proceeded with his duty. At first he had to conduct the sessions alone, a difficult task for a man who found public speaking to be one of life's most painful experiences. Having "neither ear nor voice for singing," Jackson nonetheless began each session with a hymn, usually "Amazing Grace," and then went on, in military precision, with prayers and lessons. Monthly he reported to the slaveowners on the Christian progress of each of his pupils.

Even in the midst of war, the Sunday school remained an important concern. Following the first Battle of Bull Run, he wrote back to Lexington, "My dear pastor, in my tent last night, after a fatiguing day's service, I remembered that I had failed to send you my contribution for our colored Sunday-school. Enclosed you will find my check for that object."

Reading in his Bible that slavery had been ordained by Providence, Jackson found nothing immoral in the South's "peculiar institution." Although too much a product of his society to have considered blacks in other than a paternalistic light, he had an honest affection for the slaves in his household. When he was a homesick cadet at West Point, he wrote, in regard to one long-time family servant, "Give my respects to Selly if you should see her and tell her that there is not a day that passes without my thinking of her." His wartime cook testified, "I would go through all kinds of weather to do anything for him, because I loved him."

"I am very confident," wrote his wife, in her memorial to her slain husband, *that he would never have fought for the sole object of perpetuating slavery. . . . He found the institution a responsible and troublesome one, and I have heard him say that he would prefer to see the negroes free, but he believed that the Bible taught that slavery was sanctioned by the Creator Himself, who maketh all men to differ, and instituted laws for the bond and free. He therefore accepted slavery, as it existed in the South, not as a thing desirable in itself, but as allowed by Providence for ends which it was not his business to determine.*

Jackson, however, had long been aware that the spectre of slavery threatened the stability of the Union. One purpose of his 1855 visit to Parkersburg was the settlement of his half-brother Wirt, who had been brought up by the Neales, and who was then ready to go out on his own. Upon his return to Lexington, Jackson warned, "I do not want him to go into a free state if it can be avoided, for he would probably become an abolitionist; and then in the event of trouble between North and South he would stand on one side, and we on the opposite."

In January of 1861 Jackson expressed the views held by many in the South when he wrote: *I desire to see the state use every influence she possesses in order to procure an honorable adjustment of our troubles, but if after having done so the free states, instead of permitting us to enjoy the rights guaranteed to us by the Constitution of our country, should endeavor to subjugate us, and thus excite our slaves to servile*

insurrection in which our families will be murdered without quarter or mercy, it be-
comes us to wage such a war as will bring hostilities to a speedy close.

There was no question as to where Jackson would stand. On the eve of war, he told the secession-minded cadets, "Gentlemen, I am a man of few words; when the time for fighting comes, I will draw the sword, and throw away the scabbard." And so he did. "Duty is ours, consequences are God's."

The outbreak of hostilities transformed Thomas Jonathan Jackson, the much-lampooned college professor, into Stonewall Jackson, the adored leader of Confederate forces. The legend of Stonewall Jackson had its inception early in the war, during the first Battle of Bull Run. General Barnard E. Bee, in command of a fleeing South Carolinian brigade, turned to Jackson with the anguished cry of "General, they are beating us back." "Sir," replied Jackson, a conspicuous figure as he rode with arm upraised to reduce the bleeding from a bullet-splintered finger, "we'll give them the bayonet." The sight of the resolute Jackson inspired Bee to exort his troops: "Look, there is Jackson standing like a stonewall! Rally behind the Virginians!" The day after the battle Jackson wrote to his wife, "Whilst great credit is due to other parts of our gallant army, God made my brigade more instrumental than any other in repulsing the main attack. This is for your information only—say nothing about it. Let others speak praise, not myself." Others did, and Jackson was soon the most famous of Lee's lieutenants. "The Revolution has at last found a great Captain. He is Stonewall Jackson," proclaimed the Macon (Georgia) *Daily Telegraph.*

Jackson's subsequent success in bedeviling the Union forces in the Shenandoah Valley and preventing their deployment for an assault on Richmond did much to keep up Confederate morale at a time when there was little else to cheer about. Jackson became "the idol of the people," "the object of greater enthusiasm than any other military chieftain of our day."

Jackson imbued his troops with his own self-confidence: with God's help they could do anything. "His men loved him. They would go anywhere he ordered them, for they believed, as I have often heard them say, that when he took them in he could take them out," said one who rode with him.

In the "delightful excitement" of battle, the phlegmatic Jackson became a different man: "His spirits never rose higher," said a fellow-officer, "than when danger and death were rife about him." His brother-in-law, General D. H. Hill, remembered that *the muscles of his face would twitch convulsively when a battle was about to open, and his hand would tremble so that he could not write. This only indicated weak nerves and not timidity. I think that he loved danger for its own sake, and though his nervous system was weak, he gloried in battle and never shrank from its dangers or responsibilities.* General Robert E. Lee, watching Jackson survey the enemy lines just before the Battle of Chancellorsville, noted "a brilliant glow lighting his sad face."

General Richard Taylor, commander of the jaunty Louisiana Creole brigade, was with Jackson during most of the Shenandoah Valley campaign. Jackson, he remembered, "sucked lemons, ate hard-tack, and drank water, and praying and fighting appeared to be his idea of the 'whole duty of man.'" Only once did Taylor catch "a glimpse of the man's inner nature. It was but a glimpse. The curtain closed, and he was absorbed in prayer. Yet in that moment I saw an ambition boundless as Cromwell's, and as merciless." Taylor added: *I have written that he was ambitious; and his ambition was vast, all-absorbing. Like the unhappy wretch from whose shoulders sprang the foul serpent, he loathed it, perhaps feared it; but he could not escape it— it was himself—nor rend it—it was his own flesh. He fought it with prayer, constant and earnest—Apollyon and Christian in ceaseless combat. What limit to set to his*

ability, I know not, for he was ever superior to occasion. Under ordinary circumstances it was difficult to estimate him because of his peculiarities—peculiarities that would have made a lesser man absurd, but that served to enhance his martial fame, as those of Samuel Johnson did his literary eminence.

Jackson's field service to the Confederacy was less than twenty-five months in duration but was marked by a skillfullness almost unparalleled in the annals of American warfare. "I have but to show him my design," said General Robert E. Lee, "and I know that if it can be done it will be done. No need for me to send or watch him. Straight as the needle to the pole he advances to the execution of my purpose." While Jackson lived, Confederate hopes burned bright. "I know not how to replace him," sighed Lee after Jackson, severely wounded by gunfire from his own lines, died of pneumonia in May of 1863.

Arnold, Thomas Jackson. *Early Life and Letters of General Thomas J. Jackson ("Stonewall" Jackson).* New York: Fleming H. Revell Co., 1916.

Cook, Roy Bird. *The Family and Early Life of Stonewall Jackson.* Charleston, W.Va.: Education Foundation, 1967 (first published 1924).

Henderson, Colonel G. F. R. *Stonewall Jackson and the American Civil War.* London and New York: Longmans, Green & Co., 1936.

Riley, Elihu S. *"Stonewall Jackson": A Thesaurus of Anecdotes of and Incidents in the Life of Lieut-General Thomas Jonathan Jackson, C.S.A.* Annapolis, Md.: 1920.

Vandiver, Frank E. *Mighty Stonewall.* New York: McGraw-Hill Book Co., 1957.

Henry David Thoreau 1817–1862
By Benjamin D. Maxham (dates unknown)
Daguerreotype
6.3 x 4.9 cm
Signed: *B. D. Maxham* [stamped on double-elliptical mat]
1856
NPG.72.119

Gift of an anonymous donor

In June of 1856, Henry David Thoreau, while visiting in Worcester, Massachusetts, stopped by Maxham's Daguerrean Palace at 16 Harrington Corner to have his picture taken. Three almost identical portraits were made; two were given to his Worcester friends, H. G. O. Blake (Berg Collection, New York Public Library) and Theo. Brown (Thoreau Society Archives at Concord). The third was sent to Calvin H. Greene, an admirer in far-away Michigan who had commissioned the sitting. Thoreau is dressed in garments "assimilated" to his frame. "Beware of all enterprises that require new clothes," he said.

Greene, Thoreau's exact contemporary, had been sent to Oberlin College to study for the ministry. He first heard of Thoreau late in 1855 when he read a review of *Walden* in Horace Greeley's *New York Tribune* and promptly bought the book. So taken was Greene with Thoreau's account of his two-year residence in the Concord woods that he looked for the author's first book, *A Week on the Concord and Merrimack Rivers,* published in 1849. This work had met with so little success that it had completely disappeared from the bookstores. The determined Greene wrote directly to Thoreau, who replied that a copy of *A Week* could be had for $1.25. In response

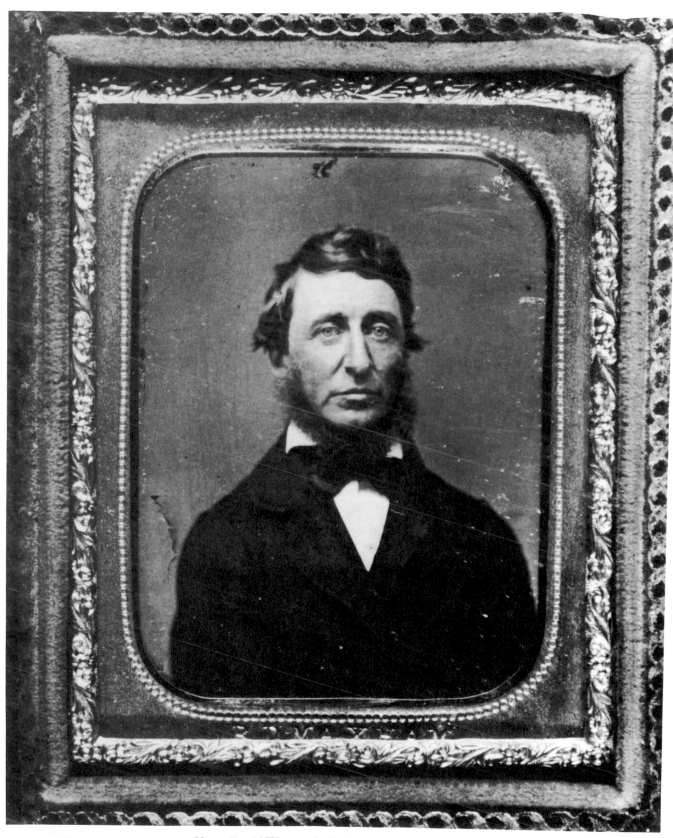

Henry David Thoreau by Benjamin D. Maxham, 1856

to Greene's enthusiastic compliments, Thoreau wrote, "I am glad to hear that my 'Walden' has interested you—that perchance it holds some truth still as far off as Michigan. I thank you for your note." In reply to his fan's question about future books, Thoreau said, *As for the 'more' that is to come, I cannot speak definitely at present, but I trust that the mine—be it silver or lead—is not yet exhausted. At any rate, I shall be encouraged by the fact that you are interested in its yield.*

There was no difficulty in supplying Greene with a copy of *A Week*. Thoreau himself had paid for the printing, and the publisher, despairing of ever getting rid of the edition, had packed the lot off to him, and he noted in his journal, "I now have a library of nearly nine hundred volumes, over seven hundred of which I wrote myself."

Happily, *Walden*, whose publication had been postponed for five years because of the onus attached to the failure of *A Week*, was selling surprisingly well. In a letter of February 10th, 1856, Thoreau told Greene that *Walden* had "found an audience of excellent character, and quite numerous, some 2000 copies having been dispersed. I should consider it a greater success to interest one wise and earnest soul, than a million unwise and frivolous."

The Walden period, the two years Thoreau spent living in self-sufficient existence by the pond in the Concord woods, was now in the past, but the experience had provided him with material for a popular lecture, and with the book which would be forever synonymous with his name. "I went to the woods," he wrote, "because I wished to live deliberately, to front only the essential facts of life, and see if I could not learn what it had to teach, and not, when I came to die, discover that I had not lived." Stripping life of its nonessentials, Thoreau was able to live on $.27 a week, proving, he said, not how to live cheaply but "to live as I could, not devoting much time to getting a living." His detractors said he would have starved to death without the pies and doughnuts sent regularly by his family, and no one denied that he walked often to the Emerson's house for dinner. In any case, Thoreau found that, other than the time consumed tending his subsistence garden, the major share of his days and evenings could be spent watching the progress of the seasons, taking long tramps in the woods, playing his flute, writing in his journal, and incidentally entertaining his friends (although his small hut was intentionally kept religiously free of superfluous items, Thoreau allowed three chairs for sociability). "Going to see Henry [is] one of Concord's first recreations," wrote one of his aunts. The recluse, who preferred woodchucks over people, who found enough in an oak tree "to keep one man happily busy all his life," and who wrote, "I cannot spare my moonlight and my mountains for the best of man I am likely to get in exchange," nonetheless took a lively interest in village gossip.

On September 6th, 1847, Thoreau left Walden. He wrote, "I left the woods for as good a reason as I went there. Perhaps it seemed to me that I had several more lives to live, and could not spare any more time for that one." More mundanely, Emerson was going to Europe, and there was a place for Thoreau once again as the caretaker of the Emerson home and family. Henceforth he remained in society, returning, after his stint with the Emersons, to live with his family.

Shortly after he left the woods, Thoreau responded to an inquiry from the secretary of his Harvard Class of 1827, writing, "I am a Schoolmaster—a Private Tutor, a Surveyor—a Gardener, a Farmer—a Painter, I mean a House Painter, a Carpenter, a Mason, a Day-Laborer, a Pencil-Maker, a Glass-paper Maker, a Writer, and sometimes a Poetaster." He went on, *My present employment is to answer such orders as may be expected from so general an advertisement as the above—that is, if I see fit, which is not always the case, for I have found out a way to live without what is com-*

monly called employment or industry attractive or otherwise. Indeed my steadiest employment, if such it can be called, is to keep myself at the top of my condition, and ready for whatever may turn up in heaven or on earth.

Thoreau didn't add, as others would later, that he never married, never went to church, never voted, and had spent the night in jail when he refused to pay a poll tax as a symbol of protest against the Mexican War. Who among his fellow class-mates could have foretold that this ne'er-do-well nonconformist, the author of a little-noticed essay on civil disobedience, would prove to be among the most influential of all the graduates of Harvard, inspiring both Gandhi's drive for Indian Independence and the American Civil Rights Movement of the 1960s.

Thoreau had told Greene, *You may rely on it you have the best of me in my books, and that I am not worth seeing personally, the stuttering, blundering clod-hopper that I am. Even poetry, you know, is in one sense an infinite brag and exaggeration. Not that I do not stand on all that I have written—but what am I to the truth I feebly utter!*

Greene, however, was not content with Thoreau's deprecatory description of him-self, and, in a letter asking that *A Week* and *Walden* be sent to his brother in Cali-fornia, also requested that Thoreau have his picture taken. Greene enclosed $5 and told Thoreau to keep whatever change remained for his trouble.

So it was that to oblige a faithful reader, Thoreau sought out one of the many "Daguerreotype Artists" then working in Massachusetts. On July 21st he wrote to Greene from Concord, "While in Worcester this week I obtained the accompanying daguerreotype—which my friends think is pretty good—though better looking than I." The books and postage came to $2.64, the daguerreotype $.50, and the postage $.16. Thoreau enclosed $1.70 change "with my shadow."

Thoreau and Greene never met, although the correspondence continued over the years. Greene hoped that Thoreau might come West on a lecture tour, and Thoreau replied, "The West has many attractions for me, particularly the lake country and the Indians. . . . I have once or twice come near going West a-lecturing, and perhaps some winter may bring me into your neighborhood." He added, "Yet lecturing has commonly proved so foreign and irksome to me, that I think I could only use it to acquire the means with which to make an independent tour another time."

The midwesterner, ever thirsty for more of Thoreau's prose, made constant inquiry as to work in progress, and the author replied, on July 8th, 1857, "Though my pen is not idle, I have not published anything for a couple of years at least. I like a private life, and cannot bear to have the public in my mind." (During his lifetime Thoreau's total literary output was but two books and a few magazine articles.)

In the fall of 1859, Greene read an account of the lectures Thoreau had given upon the capture and trial of John Brown, and asked for a copy of his remarks. Thoreau responded on November 24th: *The lectures which you refer to were reported in the newspapers, after a fashion. The last one in some half dozen of them, and if I pos-sessed one or all, I would send them to you, bad as they are. . . . I am glad to know that you are interested to see my things, and I wish I had them in printed form to send to you. I exerted myself considerably to get the last discourse printed and sold for the benefit of Brown's family—but the publishers are afraid of pamphlets, and it is now too late.*

One who was present on October 30th, 1859, when Thoreau called the people of Concord to the Town Hall to "do his part to correct the statements of newspapers, and of my countrymen generally, respecting the character and actions of John Brown," reported: *Henry spoke of him in terms of the most unqualified eulogy. I never heard him before speak so much in praise of any man, and did not know that his sympathies were so strong in favor of the poor slave. He thinks Capt. Brown has*

*displayed heroic qualities that will cause him to be remembered wherever and when-
ever true heroism is admired. The lecture was full of Henry's quaint and strong ex-
pressions: hitting the politicians in the hardest manner, and showing but little of
that veneration which is due to our beloved President and all the government offi-
cials, who are laboring so hard and so disinterestedly for the welfare of the dear people.
The church also, as a body, came in for a share of whipping, and it was laid on right
earnestly.* Interestingly enough, Bronson Alcott, writing in his journal, remarked
upon the similarity between Thoreau and Brown. "The men have much in com-
mon—sturdy manliness, straightforwardness, and independence."

As a man of singular and eccentric genius, or "racy individuality of character," as
the writer of his obituary put it, Thoreau was closely scrutinized by his contempo-
raries, and an inordinate number of them took the trouble to record their impressions.
"His face," said Ellery Channing, "once seen could not be forgotten." "He is as ugly
as sin; long-nosed, queer-mouthed, and with uncouth and somewhat rustic manners,"
wrote Nathaniel Hawthorne upon first meeting the twenty-five-year-old Thoreau.
Thoreau's eyes, it was remarked, were "big, round, sharp and piercing, looking out
searchingly through his hair which hung over them"; his prominent nose was called
"a sort of interrogation mark to the universe"; he walked with a "long, ungainly,
Indian-like stride." "His whole figure had an active earnestness, as if he had no mo-
ment to waste."

The year before he sat to Maxham, Thoreau had grown a beard—not, we can be
sure, because chin whiskers were coming into fashion, but probably because the
growth of hair provided some protection against the cold. The beard was "worn nat-
ural but not untrimmed," corresponding with the "full growth of rather dark hair
somewhat carelessly brushed after no particular style."

Thoreau's resemblance to Emerson was much remarked upon. Frank Sanborn,
describing Thoreau as he appeared in May of 1855, just a year before the Maxham
sitting, wrote: *He is a sort of pocket edition of Mr. Emerson, as far as outward ap-
pearance goes, in coarser binding and with woodcuts instead of the fine steel-engrav-
ings of Mr. Emerson. He is a little under size, with a huge Emersonian nose, bluish
gray eyes, brown hair, and a ruddy, weather-beaten face which reminds one of that
of some shrewd and honest animal, some retired philosophic woodchuck or mag-
nanimous fox. He dresses very plainly, wears his collar turned over like Mr. Emerson,
and often an old dress-coat, broad in the skirts, and by no means a fit. He walks about
with a brisk rustic air, and never seems tired. He talks like Mr. Emerson and so spoils
the good things which he says; for what in Mr. Emerson is charming, becomes ludi-
crous in Thoreau, because an imitation.*

Daniel Ricketson, another of those who admired *Walden* and immediately started
a correspondence with the author, invited Thoreau to visit him at his home in New
Bedford. Thoreau, engaged to lecture in that city on December 26th, 1854, arrived
the day previous, and Ricketson later put down his initial impressions of the man he
took to be a peddler. *I perceived a man walking towards me bearing an umbrella in
one hand and a leather travelling-bag in the other. So unlike my ideal Thoreau, whom
I had fancied, from the robust nature of his mind and habits of life, to be a man of
unusual vigor and size, that I did not suspect . . . that the slight, quaint-looking per-
son before me was the Walden philosopher. There are few persons who had previ-
ously read his works that were not disappointed by his personal appearance.* Ricket-
son's initial disillusionment soon passed, and he related, *In fact, I soon began to see
that Nature had dealt kindly by him, and that this apparently slender personage was
physically capable of enduring far more than the ordinary class of men, although he
had then begun to show signs of failure of strength in his knees.*

Ricketson, who afterwards made several excursions with Thoreau, said, *I do not*

remember of ever seeing him laugh outright, but he was ever ready to smile at anything that pleased him; and I never knew him to betray any tender emotion except on one occasion, when he was narrating to me the death of his only brother, John Thoreau, from lockjaw, strong symptoms of which, from his sympathy with the sufferer, he himself experienced.

There was in Thoreau, nonetheless, a certain gay abandon. Ricketson recalled him singing and dancing, "executing some steps more like Indian dances than the usual ball-room figures." The performance "was earnest and spontaneous but not particularly graceful." Nathaniel Hawthorne's daughter, Rose, remembered watching Thoreau skate, "figuring dithyrambic dances and Bacchic leaps on the ice—very remarkable, but very ugly, methought."

Walt Whitman met Thoreau in New York in 1856 at the time the latter had traveled to Eaglewood, a communal village near Perth Amboy, New Jersey, to survey the property and to lecture. "Thoreau's great fault," Whitman found, was *disdain for men (for Tom, Dick and Harry): inability to appreciate the average life—even the exceptional life: it seemed to me a want of imagination. He couldn't put his life into any other life—realize why one man was so and another man was not so: was impatient with other people on the street and so forth. We had a hot discussion about it—it was a bitter difference: it was rather a surprise to meet in Thoreau such a very aggravated case of superciliousness. It was egotistic—not taking that word in its worst sense. . . . Yet he was a man you would have to like—an interesting man, simple, conclusive.*

Another contemporary, obviously not well disposed toward the "Sylvan philosopher," characterized Thoreau as "an odd, shy recluse man, an intense egotist, who thoroughly believed in himself and his own ideas. He was an Indian in his nature, with the advantages of Harvard library and Plato's philosophy."

Emerson, who knew Thoreau as well as anyone, said, after his death, *Henry was homely in appearance, a rugged stone hewn from the cliff. I believe it is accorded to all men to be moderately homely; but he surpassed sex. He had a beautiful smile and an earnest look. . . . One could jeopard anything on him. A limpid man, a realist with caustic eyes that looked through all words and shows and bearing with terrible perception! . . . His fault was that he brought nothing near to his heart; he kept all influences toward his extremities.* Once, musing about his "Spartan-Buddhist Henry," Emerson remarked, "He had no temptations to fight against,—no appetites, no passions, no taste for elegant trifles."

Thoreau was thirty-nine when Maxham made his picture, and is seen here before the ravages of tuberculosis had taken their toll. Less than a year before his death, he posed for an ambrotype by E. S. Dunshee, a portrait which, said one who knew him, "lacked the 'clear-eyed courage and directness,' qualities so dominant in his personality."

Thoreau, reporting on himself at the time of the Maxham sitting, wrote: *I got "run down" they say, more than a year ago, and have not yet got fairly up again. It has not touched my spirits however, for they are as indifferently tough, as sluggishly resilient, as a dried fungus. . . . I dwell as much aloof from society as ever: find it just as impossible to agree in opinion with the most intelligent of my neighbors; they not having improved one jot, nor I either. I am still immersed in nature, have much of the time a living sense of the breadth of the field on whose verge I dwell.*

Harding, Walter, ed. *Thoreau: Man of Concord.* New York: Holt, Rinehart & Winston, 1960.

——— and Carl Bode, eds. *The Correspondence of Henry David Thoreau.* New York: New York University Press, 1958.

Meltzer, Milton, and Walter Harding. *A Thoreau Profile*. New York: Thomas Y. Crowell Co., 1962.

Stern, Philip Van Doren, ed. *The Annotated Walden*. New York: Clarkson N. Potter, 1970.

Stephen Arnold Douglas 1813–1861
By an unidentified artist
Polychromed wood
45.7 cm height
Unsigned
Date unknown
NPG.71.59

Gift of Richard E. Guggenheim

In the late summer and fall of 1858, thousands came by train, farm wagon, horse, mule, and on foot to hear the opposing candidates for the United States Senate, Stephen A. Douglas and Abraham Lincoln, debate the crucial issue of the extension of slavery in the territories. One of those who came to witness the historic, yet typically western-style canvass, may have carved this eighteen-inch-high statue of Douglas, the incumbent senator from Illinois. Like a similar piece of Abraham Lincoln, now owned by the Missouri Historical Society, it is a rare example of portraiture in American folk sculpture. It seems particularly appropriate that Douglas, who had served an apprenticeship to a cabinetmaker and who had created his political image as a man of the frontier, should be represented in wood and through the whittling technique which was a natural pastime in the hinterlands.

Douglas's name has been painstakingly carved into the figure's base, but even without the inscription the identification is unmistakable. The unidentified artist has captured "The Little Giant" "to the life." He stood five feet four inches and, although his body was not unduly short, his lower limbs were much truncated. His head was large and connected by a short neck to strong, square shoulders and an extraordinarily full chest. His face was round. His eyes, under an overhanging brow, were intense and "with a deep, dark, scowling, menacing horizontal wrinkle between them." "His figure," said one observer, "would be an unfortunate one were it not for the animation which constantly pervades it." In compensation for his lack of physical stature, he had developed a "boisterous and exuberant manner." He reminded some of a "squat bouncing bull." Harriet Beecher Stowe, observing him at the time of the passage of the Kansas–Nebraska Act in 1854, when he boasted he "had the authority and power of a dictator throughout the whole controversy," saw him as "the very ideal of vitativeness. . . . every inch of him has its own alertness and motion."

Although New England-born, Douglas had, at the age of twenty, bid farewell to his friends and started alone for the "great West." Six months later, in December of 1833, he wrote to his family, "I have become a *Western* man, have imbibed Western feelings principles and interests and have selected Illinois as the favorite place of my adoption." Almost immediately he became immersed in the great recreation of the frontier—politics—and became a consummate master of political organization. "I live with my constitutents, eat with my constituents, drink with them, lodge with them, pray with them, laugh, hunt, dance and work with them; I eat their corn

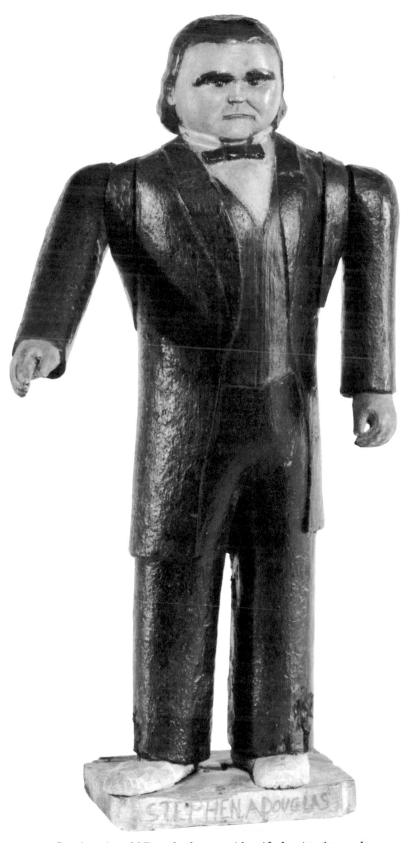

Stephen Arnold Douglas by an unidentified artist, date unknown

dodgers and fried bacon and sleep two in a bed with them." In less than two years he was in Congress.

In Washington, he became a conspicuous figure. John Quincy Adams, writing in his diary, described the freshman Congressman in debate: *His face was convulsed, his gesticulation frantic, and he lashed himself into such a heat that if his body had been made of combustible matter it would have been burnt out. In the midst of his roaring, to save himself from choking, he stripped off and cast away his cravat, unbuttoned his waistcoat, and had the air and aspect of a half-naked pugilist.*

Douglas's marriage in 1847 to Martha Martin, the daughter of a North Carolina plantation owner, and, following her death, his second marriage, in 1856, to Adele Cutts, the grand-niece of Dolley Madison, had done much to improve his appearance and civilize his manners. Nevertheless, behind the facade of good tailoring remained the soul of a backwoods Illinois politician, and he frequently reverted to the use of coarse language, to whiskey, and to what has been called "the band of brotherhood of the western men"—chewing tobacco. His bearing contained, said one, "a dash of rowdy." Another, even more blunt, said that "his manners smacked of the bar room." Mrs. Anne Royall, surprisingly, wrote that "his neat modest brow gives a sweetness and innocence to his countenance that words can't convey." Most others would be inclined rather to agree with the reporter who observed that Douglas "looks like a prize fighter, though I am not sure as his arms are long enough for that. He has excellent prize fighting qualities. Pluck, quickness and strength; adroitness in shifting his position, avoiding his adversary's blows, and hitting him in unexpected places in return."

In 1858 Douglas was forty-five years old, four years younger than Lincoln. He was also one of the best-known personalities in public life. The previous April, in defiance of President James Buchanan, he had successfully led the fight against the admission of Kansas under the proslavery Lecompton Constitution, basing his opposition not on the slavery question but rather on the grounds that it had not been submitted to popular referendum. As a consequence, he went into his reelection campaign with the opposition of both the Republicans and the pro-administration Democrats. "Illinois is from this time forward until the Senatorial question shall be decided, the most interesting political battle-ground in the Union," said the *New York Times*, and it was the candidacy of Stephen A. Douglas that made it a campaign of national significance. Newspapers from around the country came to cover the fate of this man who, if reelected, would be a leading candidate for the presidency of the United States.

Douglas radiated confidence and vigor when he returned to Illinois in July and opened his campaign with a speech from the balcony of the Tremont House in Chicago. The crowds applauded with frenzy, the band played Yankee Doodle, and a large fireworks display spelled out the keynote of his campaign, "Popular Sovereignty." The whole scene was "glorious beyond description."

Douglas's itinerary for stumping the whole state had already been drawn up by the time he received from Lincoln, in late July, the challenge that the two men "canvas the State together." There was little in this suggestion to benefit Douglas. He wrote to a campaign worker, *The whole country knows me and has me measured. Lincoln, as regards myself, is comparatively unknown, and if he gets the best of this debate—and I want to say he is the ablest man the Republicans have got—I shall lose everything. Should I win I shall gain but little.* But in the realization that Lincoln intended to stick to him like a burr, following him around from place to place, addressing the same audiences and thereby gaining "the concluding speech," Douglas agreed to accommodate Lincoln "so far as it is in my power to do so."

Seven joint debates were agreed to. In addition, Douglas went ahead with his previously planned campaign appearances. In the course of three months, he traveled by stagecoach, steamboat, and, wherever possible, by rail, up and down the vast state of Illinois. His private railroad car, covered with bunting and banners and supplemented by an empty freight-car platform from which a six-pound cannon announced his impending arrival, dramatized his progress. In addition, the arrangement gave him a convenient place to entertain local politicians, and see to the vitally important matters of fence-mending and fund-raising. Most importantly, the comforts of a private railroad car enabled Douglas to husband his strength. Although his nervous energy was a wonder to all, this "steam engine in britches" was not robust in constitution.

Douglas, accompanied by his wife (the presence of such a "sweet and beautiful woman" at his side "would encourage his supporters and restrain his enemies," it was believed), several stenographers, and campaign advisers; and his wife's cousin Leonard Volk, who was along for the odd moments when the candidate might be free to pose for a full-length statue, traveled over 5,200 miles by rail and uncounted miles by other means. Before the state legislature came to make its choice between the two candidates, Douglas had delivered fifty-nine set speeches, each of two or three hours' duration, seventeen shorter speeches in response to serenades, and thirty-seven speeches in reply to addresses of welcome. Most of these were made in the open air, and seven of them took place in the pouring rain. He was greeted everywhere with "great demonstrations of public sentiment"—which usually included maidens dressed as goddesses of Liberty, torchlight parades, band music, loud hurrahs from the men, and a gentle waving of handkerchiefs from the ladies. In part it was a spontaneous outpouring of excitement, but it was also the result of good advance work. What with everything, it is estimated that Douglas spent $50,000—an enormous sum for a mid-nineteenth-century senatorial race.

On the day before the joint appearances, crowds swarmed in from the surrounding countryside, ringing the towns with campfires as they awaited the next day's events. Although most were aware of the crucial issues that threatened to tear the Union apart, few could have guessed that they were participating in the making of a Republican president. They came, some twelve- to fifteen-thousand strong, above all because they expected to be entertained; the excitement of any election was a break in the loneliness and monotony of their isolated lives, and this one in particular offered the added fillip of two colorful personalities. *There was no end of cheering and shouting and jostling. . . . But in spite of the excitement created by the political contest, the crowds remained very good-natured, and the occasional jibes flung from one side to the other were uniformly received with a laugh,* wrote one eyewitness. Reporters, their job made easier by the newly developed system of shorthand, stood poised to telegraph verbatim reports to newspapers all over the country.

As befitting a man with presidential aspirations, Douglas looked "rather natty and well groomed in an excellently fitting broadcloth and shining linen." An unfriendly observer reported that "his face seemed a little puffy, and it was said that he had been drinking hard with some boon companions. . . . The deep horizontal wrinkle between his keen eye was unusually dark and scowling." Douglas, taking some pains to minimize his dwarf stature, generally stood behind a table, but sometimes strode back and forth across the stage for dramatic effect. At other times he "tossed his mane with an air of overbearing superiority, of threatening defiance, as if to say: How dare anyone stand up against me?"

Douglas spoke without notes, apparently spontaneously, but his speeches were carefully organized. He carried with him a small notebook of reference materials

from which he read from time to time, quoting particularly from Lincoln's "House Divided" speech which he regarded as a call to sectional warfare. "I hold that under the Constitution of the United States, each State of this Union has a right to do as it pleases on the subject of slavery," Douglas said. He refused to argue the morality of servitude, stating that *I hold that the people of the slave-holding States are civilized men as well as ourselves, that they bear consciences as well as we, and that they are accountable to God and their posterity and not to us. It is for them to decide, therefore, the moral and religious rights of the slavery question for themselves within their own limits.*

The newspaper accounts of the debates were heavily colored by partisan prejudice. One reporter called Douglas's speech a "calm and logical argument" and noted that the people listened with the same calmness. At the same debate, another, of different political sentiments, wrote that "Douglas' face was livid with passion and excitement. . . . He resembled a wild beast in looks and gesture, and a maniac in language and argument."

Damon Wells, in his account of Douglas's last years, has noted of the debates that *Douglas' delivery was more heated, more emotional, but its fundamental appeal was to the minds of those who heard him; Lincoln was calmer, more deliberate, almost detached, but his words spoke to the heart, and the response they evoked was basically a sentimental one.* One who attended the debates, and who knew both men well, reflected in later years that "Lincoln had two advantages over Douglas: he had the best side of the question and the best temper."

The antislavery advocate Carl Schurz, who admitted that he detested Douglas, was present at the debate in Quincy, Massachusetts, and described the event in detail when he came to write his autobiography. He spoke of Douglas thus: *His voice, naturally a strong baritone, gave forth a hoarse and rough, at times even something like a barking, sound. His tone was, from the very start, angry, dictatorial, and insolent in the extreme. In one of his first sentences he charged Lincoln with "base insinuations," and then he went on in that style with a wrathful frown upon his brow, defiantly shaking his head, clenching his fists, and stamping his feet. No language seemed to be too offensive for him, and even inoffensive things he would sometimes bring out in a manner which sounded as if intended to be insulting; and thus he occasionally called forth, instead of applause from his friends, demonstrations of remonstrance from the opposition.* But Schurz conceded, nonetheless, that "his sentences were well put together, his points strongly accentuated, his argumentation seemingly clear and plausible."

Schurz, a German immigrant who had fled his native country after the failure of the liberal revolution of 1849, was deeply impressed by the democratic character of the spectacle which, he said, on the whole had strengthened his faith in the virtue of the democratic principle, although it made him more sensible of some dangers attending its practical realization. In his reminiscences Schurz wrote: *Here were two men, neither of whom had enjoyed any of the advantages of superior breeding or education. . . . Neither of the two men had received any regular schooling calculated in any manner to prepare a person for the career of a statesman. Neither of them had in any sense been particularly favored by fortune. Neither of them had, in working his way upward from a low estate, any resource to draw on but his own native ability and spirit. But here they were, in positions before the country in which their ambitions could, without any overleaping, aim at the highest honors of the Republic. . . . Each had won his remarkable eminence because each had, in his way, by his own effort, deserved it.*

The voters turned out on November 2nd in heavy numbers. Even though the Lin-

coln candidates, taken together, received a heavier popular vote than did the Douglas candidates, the apportionment of the legislature was such that Douglas won the election. In overcoming both the Buchanan forces and the Republican party, Douglas had achieved what the *New York Times* called "one of the most wonderful personal victories ever achieved by a public man." He emerged triumphant but strained in health, and finances, and alienated from many elements of the Democratic party. Douglas lived just barely long enough to be a defeated presidential candidate and to hold Lincoln's hat as the latter was sworn in as president of the United States. Three months later he died, giving as his last message the admonition to his young sons "to obey the laws and support the Constitution of the United States."

Johannsen, Robert W., ed. *The Letters of Stephen A. Douglas.* Urbana: University of Illinois Press, 1961.

——. *Stephen A. Douglas.* New York: Oxford University Press, 1973.

Milton, George Fort. *The Eve of Conflict: Stephen A. Douglas and the Needless War.* New York: Octagon Books, 1969 (first published 1934).

Schurz, Carl. *The Autobiography of Carl Schurz.* New York: Charles Scribner's Sons, 1961 (first published 1906–1908).

Sigelschiffer, Saul. *The American Conscience: The Drama of the Lincoln–Douglas Debates.* New York: Horizon Press, 1973.

Stone, Irving. *They Also Ran.* Garden City, N.Y.: Doubleday & Co., 1943.

Wells, Damon. *Stephen Douglas: The Last Years 1857–1861.* Austin: University of Texas Press, 1971.

John Brown 1800–1859
By Ole Peter Hansen Balling 1823–1906
Oil on canvas
76.2 x 63.5 cm
Signed: *H. Balling* [lower left and lower right]
circa 1859
NPG.74.2

Originally owned by James Sutton, the New York publisher of Aldine *(a topographic art journal), who moved to Tacoma, Washington, about 1890. Following Sutton's death, sold at auction in 1905 and presented to the Ferry Museum, the predecessor to the Tacoma Art Museum, and then went into the possession of the Washington State Historical Society, from which it was acquired by the National Portrait Gallery*

John Brown, wrote a journalist who saw him many times in Kansas, "is a strange, resolute, repulsive, iron-willed inexorable old man. He stands like a solitary rock in a more mobile society, a fiery nature, and a cold temper, and a cool head—a volcano beneath a covering of snow." Franklin A. Sanborn, one of those who underwrote Brown's guerrilla warfare against slavery, remembered that *his eyes were those of an eagle,—piercing blue-gray in color . . . and were alternately flashing with energy, or drooping and hooded like the eyes of an eagle. His hair was dark-brown, sprinkled with gray, short and bristling, and shooting back from a forehead of middle height and breadth; his nose was aquiline; his ears large; his frame angular; his voice deep and metallic; his walk positive and intrepid, though commonly slow. . . . His figure was tall, slender, and commanding; his bearing military.* This is the John Brown that

the Norwegian artist Ole Peter Hansen Balling saw when he painted the portrait of the man who called himself "an instrument of God."

On the night of October 16th, 1859, Brown, with a band of twenty-one men, five of them black, seized the government arsenal at Harpers Ferry, the first step in his plan for the liberation of slaves. Within thirty-six hours the scheme was aborted, and Brown had surrendered to a force of marines under the command of Colonel Robert E. Lee. Ten of Brown's men had been killed, including two of his sons. The insurgents had killed five, the first, ironically, a free black.

When it was over, the officials converged on Brown to learn what was behind it all before the old man, wounded by saber and bayonet, should die. John Rosengarten, a friend of Virginia Governor Henry Wise, was present and later, in *Atlantic Monthly*, wrote, *Wounded, bleeding, haggard and defeated, and expecting death, John Brown was the finest specimen of a man that I ever saw. His great gaunt form, his noble head and face, his iron-gray hair and patriarchal beard, with the patient endurance of his own suffering and his painful anxiety for the fate of his sons and the welfare of his men, his reticence when jeered at, his readiness to turn away wrath with a kind answer, his whole appearance and manner, all impressed me with the deepest sense of reverence.* Governor Wise, certain of a widespread abolitionist conspiracy, asked Brown who had given him the idea of taking over the Harpers Ferry arsenal. He readily replied: *It was you, Governor. I read of a speech you had made in '56 at the time of the Presidential canvas in which you said if Fremont was elected Virginia would forcibly leave the Union and obtain the arms and munitions of war at Harper's Ferry.*

Through it all, Brown was defiant and unrepentant. The reporter from the *New York Tribune* noted that "his conversation bore the impression that whatever he had done to free slaves was right and that in the warfare in which he was engaged, he was entitled to be treated with all the respect of a prisoner of war."

Within a week Brown was put on trial, charged with murder, treason, and conspiracy to incite slave rebellion. His trial took place at Charlestown, then in Virginia, and until he was hung on December 2nd, the attention of the nation was riveted on the "flinty old man." Journalists from New York, Baltimore, Washington, and Richmond newspapers, writers and illustrators from *Harper's Weekly, Leslie's Illustrated News*, and the *Atlantic Monthly* all arrived to cover the spectacle.

The courtroom was jammed every day with four to five hundred people, including possibly Ole Peter Hansen Balling. On the verso of the portrait is inscribed—perhaps in Balling's own hand—the statement that it was painted from life. If indeed this was the case, Balling must have traveled to Charlestown either for the trial itself, or in the month following, when visitors came from all over the country to see the condemned man.

Balling, born in Christiania (now Oslo) and trained at the Royal Academy in Copenhagen and the Berlin Academy, had been in America for only four years. His command of the English language was less than perfect. Living in Brooklyn, he made his living copying paintings and coloring photographs. In his autobiography, written in Norwegian and published the year before he died, he points out that in the period before the Civil War he read no newspapers and took no interest in American politics. If, in fact, he traveled to Harpers Ferry, it must have been at someone else's instigation. James R. Sutton, a New York publisher who ultimately owned the painting, may have commissioned it.

Writing his memoirs when he was a very old man, Balling said nothing about John Brown, but the artist may have been attracted by the excitement of the Harpers Ferry affair since all his life he was inclined toward adventure. During the Schleswig–Hol-

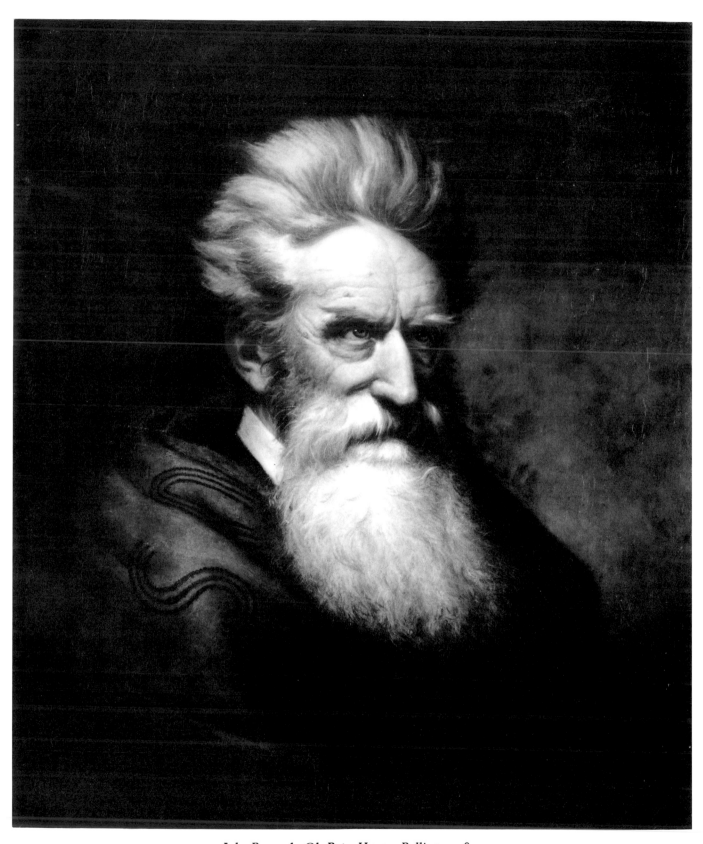

John Brown by Ole Peter Hansen Balling, c. 1859

stein War of 1848–50, he joined the Danish army and won attention with his sketches of military activities. On the scene in Paris during the revolution of 1848, he was commissioned to draw pictures of the street fighting. Hearing the news that Fort Sumter had been fired upon, Balling immediately enlisted, serving as a captain in the Scandinavian regiment and later as a lieutenant colonel in the 145th regiment. Exasperated with the problems of giving commands in his still-faltering English, restless and dissatisfied with camp life without battle action, he resigned his commission in January 1863. Returning to painting, Balling was commissioned by Benona Howard, a wealthy New York merchant, to paint *Grant and His Generals* (National Portrait Gallery), an exhibition piece designed to raise funds for the Sanitary Commission of the Union Army. He spent five weeks with Grant at the height of the campaign against Richmond in the autumn of 1864. Balling, using watercolors, customarily sketched his subjects from life, and executed the finished portraits in oil later in his studio.

John Brown was born in Torrington, Connecticut, and grew up migratory and unschooled, though immersed in the Old Testament. In a restless search for economic stability, Brown worked successively as a drover, tanner, land speculator, raiser of sheep, and broker of wool. In the first fifty years of his life he had gone through seventeen business failures in four states, leaving behind a trail of bankruptcies and lawsuits. He had twenty children by two wives—at times having as many as twenty-three mouths to feed. He lived most of his life under the weight of debt, "like a toad under a harrow," as he expressed it. Before 1855 he had known the loss of nine children and his first wife. It was during this period that he wrote, "I feel considerable regret by turns that I have lived so many years, & have in reality done so very little to increase the amount of human happiness."

Brown's father had been an abolitionist before him, and Brown himself had been aiding the escape of fugitive slaves since 1825. His eldest son, John Brown, Jr., vividly remembered the moment in 1839 when his father first informed the family of his *determination to make war on slavery . . . war by force and arms. After spending considerable time in setting forth, in most impressive language, the hopeless condition of the slave, he asked who of us were willing to make common cause with him, in doing all in our power to "break the jaws of the wicked, and pluck the spoil out of his teeth". . . . Receiving an affirmative answer from each, he kneeled in prayer, and all did the same. This position in prayer impressed me greatly, as it was the first time I had ever known him to assume it. After prayer, he asked us to raise our right hands, and he then administered to us an oath, the exact terms of which I cannot recall but in substance it bound us to secrecy and devotion to the purpose of fighting slavery, by force and arms, to the extent of our ability.*

Frederick Douglass, who first met Brown in Springfield, Massachusetts, in 1847, recalled that *He denounced slavery in look and language fierce and bitter, thought that slaveholders had forfeited their right to live, that the slaves had the right to gain their liberty in any way they could, did not believe that moral suasion would ever liberate the slave, or that political action would abolish the system.*

Douglass, who would refuse to join Brown at Harpers Ferry because the "attack upon the Federal Government . . . would array the whole country against us" said, in retrospect, *His zeal in the care of my race was far greater than mine—it was as the burning sun to my taper light—mine was bounded by time, his stretched away to the boundless shores of eternity. I could live for the slave, but he could die for him.*

Richard Henry Dana, becoming lost in the Adirondacks in 1849, was afforded refuge at John Brown's Elba, New York, farm. Dana, who recorded his impressions on the spot, affords us a rare look at Brown uncolored by the weight of history. Dana

described Brown as *a thin, sinewy, hard-favored, clear-headed, honest-minded man, who had spent all his days as a frontier farmer. On conversing with him, we found him well informed on most subjects, especially in the natural sciences. He had books and evidently made a diligent use of them.* Afterwards Dana noted: "It would have been past belief had we been told that this quiet frontier farmer, already at or beyond middle life, with no noticeable past, would, within ten years, be the central figure in a great tragic scene."

The repeal of the Missouri Compromise, reopening the whole question of slavery in the territories, made Kansas a battleground and gave John Brown his ticket to fame. He went to Kansas at the behest of his sons, five of whom had moved there in 1855 to take up land and assist in the fight to keep slavery out. Stern Calvinist father though Brown was, whipping his children even as he wept, his family was an extraordinarily close-knit unit; and it was in patriarchal fashion that he directed them in guerrilla warfare. As captain of the local militia company he routed the proslavery forces at Osawatomie. At Pottawatomie he instigated the hacking to death of five innocent men in retaliation for an enemy raid. Dogmatic in his crusade against evil, he felt no guilt. Called upon in the last days of his life to justify the murders, he dismissed the matter, saying, "Time and posterity will approve every act of mine to prevent slavery from being extended in Kansas. I never shed the blood of any man except in self-defense or in the promotion of a righteous cause."

Affecting disguises and assuming aliases, courting violence, gambling with danger—Brown was in his element. Once the Kansas excitement had settled down, an occasional foray, such as the descent on a plantation across the Mississippi and the safe portage of eleven slaves to freedom in Canada, kept the interest of his financial backers, but the resulting death of the slaveowner brought a price upon his head. Defiantly, he continued to speak in public, feasting on the guilt of those who could serve the cause only with money.

Fresh from his exploits in "bloody Kansas," Brown toured the North to raise funds for his antislavery activities and also, not incidentally, to provide for his still large family. Seizing center stage in New England, he dazzled intellectuals, merchants, and industrialists. Bronson Alcott wrote in his journal, *He does not conceal his hatred of slavery, nor his readiness to strike a blow for freedom at the proper moment. . . . I think him equal to anything he dares, the man to do the deed if it must be done, and with the martyr's temper and purpose.* Alcott went on to say, "Our best people listen to his words—Emerson, Thoreau, Judge Hoar, my wife—and some of them contribute something in aid of his plans without asking particulars, such confidence does he inspire with his integrity and abilities."

George B. Dill, who knew Brown well in 1858–59, later characterized him as *very superstitious, very selfish and very intolerant, with great self-esteem. His immense egotism coupled with a love of approbation and his god-idea begat in him a feeling that he was the Moses that was to lead the Exodus of the colored people from their Southern taskmasters.*

Many thought Brown insane. In the midst of the trial, friends in Ohio gathered an impressive number of affidavits to prove that his blood lines were replete with insanity, but he would have no part in this attempt to save his life.

After interviewing Brown, Governor Wise declared, *They are themselves mistaken who take him for a madman. He is a bundle of the best nerves I ever saw, cut and thrust, and bleeding and in bonds. He is a man of clear head, of courage, fortitude and simple ingeniousness. He is cool, collected and indomitable, and it is but just for him to say that he was humane to his prisoners . . . and he inspired me with a great trust in his integrity, as a man of truth.*

Certainly his northern backers never thought Brown insane. The group known as the "Secret Six," Unitarian ministers Thomas Wentworth Higginson and Theodore Parker, wealthy manufacturer George Luther Stearns, Julia Ward Howe's husband Dr. Samuel Gridley Howe, Emersonian disciple Franklin Sanborn, and wealthy New Yorker Gerritt Smith were all willing to fund his "secret services and no questions asked." Thoreau found him to be "a New England farmer, a man of great common sense, deliberate and practical as that class is and tenfold more so, like the best of those who stood at Concord Bridge once, on Lexington Common and Bunker Hill."

The trial was swift. Virginia was worried about attempts to rescue Brown, as in fact several were plotted; was concerned about possible mob action; and above all was obsessed with slave insurrection. The jury deliberated for three-fourths of an hour and found him guilty on all three counts: murder, treason, and conspiring with slaves to commit treason. He was sentenced to be hung thirty days later, on the 2nd of December.

Brown stood for the verdict, picking his teeth, *Harper's* reported, as it was rendered. He then returned to his cot, adjusted his blanket, and rolled over.

During that last month, as the abolitionists and others, too, lauded his approaching martyrdom, Brown was besieged by admiring visitors and deluged with sympathetic mail. He wrote to his wife, "*I have enjoyed remarkable cheerfulness and composure of mind* ever since my confinement, and it is great comfort to *feel assured* that *I am permitted* to die (for a *cause*) not merely to pay the debt of nature (as all must)."

The old man went unflinchingly to his death, while bells tolled and memorial meetings were held all over the North.

Abolitionist Wendell Phillips said, *John Brown has loosed the roots of the slave system . . . it does not live, hereafter. Insurrection was a harsh, horrid word to millions a month ago, John Brown went a whole generation beyond it, claiming the right for white men to help the slave to freedom by arms.*

The day of the execution, troops lined the streets, isolating the prisoner from the public. There would be, ruled the authorities, no farewell speech from the gallows. But the "sly old veteran" had his way to the last. Asked by his jailer for his autograph he gave the world his final message. "I John Brown am now quite *certain* that the crimes of this *guilty land: will* never be purged *away*; but with blood. I had *as I now* think vainly flattered myself that without *very much* bloodshed: it might be done."

Abels, Jules. *Man on Fire: John Brown and the Cause of Liberty.* New York: Macmillan Co., 1971.

Boyer, Richard O. *The Legend of John Brown.* New York: Alfred A. Knopf, 1973.

Cramer, Richard S. "Ole P. Balling: Painter of Civil War Heroes." *American Scandinavian Review,* Summer 1966, pp. 138 ff.

Edelstein, Tilden G. *Strange Enthusiasm: A Life of Thomas Wentworth Higginson.* New Haven: Yale University Press, 1968.

Nelson, Truman. *The Old Man John Brown at Harper's Ferry.* New York: Holt, Rinehart & Winston, 1973.

Stutler, Boyd B. "An Eyewitness Describes the Hanging of John Brown." *American Heritage,* February 1955, pp. 4 ff.

Villard, Oswald Garrison. *John Brown.* Gloucester, Mass.: Peter Smith, 1965 (first published 1910).

Nathaniel Hawthorne 1804–1864
By Emanuel Gottlieb Leutze 1816–1868
Oil on canvas
63 x 50.8 cm (oval)
Signed: *E Leutze* [lower right]
1862
NPG.65.55

In possession of the artist until his death. Sold at auction in 1869 to artist John F. Kensett (1816–1872) for $22.50. Reappeared in 1894 when it was reproduced in Century *magazine. Exhibited at the Panama-Pacific Exposition in 1915. Acquired by Thomas B. Clarke in 1923 and on loan to the Philadelphia Museum of Art 1928–31. Purchased by Andrew Mellon in 1936 and, by indenture of the A. W. Mellon Education and Charitable Trust, dated August 1942, held "for exhibition in a National Portrait Gallery," if such a gallery should be established within a period of twenty years*

Nathaniel Hawthorne, the nineteenth-century symbol of the Puritan tradition, sat to Emanuel Leutze under what can only be described as the most hedonistic of circumstances. The author of gloomy tales of sin and guilt wrote to a friend from Washington, April 2nd, 1862, saying, *I stay here while Leutze finishes a portrait which I think will be the best ever painted of the same unworthy subject. One charm it must needs have,—an aspect of immortal jollity and well-to-doness; for Leutze, when the sitting begins, gives me a first-rate cigar, and when he sees me getting tired, he brings out a bottle of splendid champagne; and we quaffed and smoked yesterday, in a pleasant state of mutual good-will, for three hours and a half, during which the picture made a really miraculous progress. Leutze is the best of fellows.*

Certainly this was a marked contrast to his 1847 sitting, at the request of his friend Franklin Pierce, to George Peter Alexander Healy (New Hampshire Historical Society). At that time Hawthorne posed so self-consciously that the artist despaired of getting a natural expression. Only through the stratagem of having Mrs. Healy read aloud during the sessions was Hawthorne's shyness overcome.

In March 1862 Hawthorne, under the care of his friend and publisher, William D. Ticknor, had journeyed to Washington to visit his old Bowdoin classmate Horatio Bridge, and to get a look at a war which he said he approved as much as any man, "but I don't quite see what we are fighting for." Hawthorne, who had previously enjoyed exceptionally good health, had been suffering for the past year or so with an "indefinite ailment" which sapped his zest for life and made him infinitely weary. It was hoped that a change of scene would revive his spirits. Wartime Washington did, at least temporarily, provide the needed tonic. He attended sessions of Congress and a presentation ceremony at the President's House, and made excursions to Harpers Ferry, Fortress Monroe, and some of the neighboring battlefields. Days when rain prevented sightseeing were spent at Willard's Hotel, the nerve center of Union activity. In a letter of March 16th, he wrote to his daughter, "I have shaken hands with Uncle Abe, and have seen various notabilities, and am infested by people who want to exhibit me as a lion. I have seen a camp, and am going in a few days to Manassas, if the mud of the Sacred Soil will permit." By the 1st of April, he wrote to his wife, "I have now seen almost everything of interest in and about Washington, and begin to long for home. It has done me a great deal of good, this constant activity of mind and body; but being perfectly well, I no longer need it as a medicine." Haw-

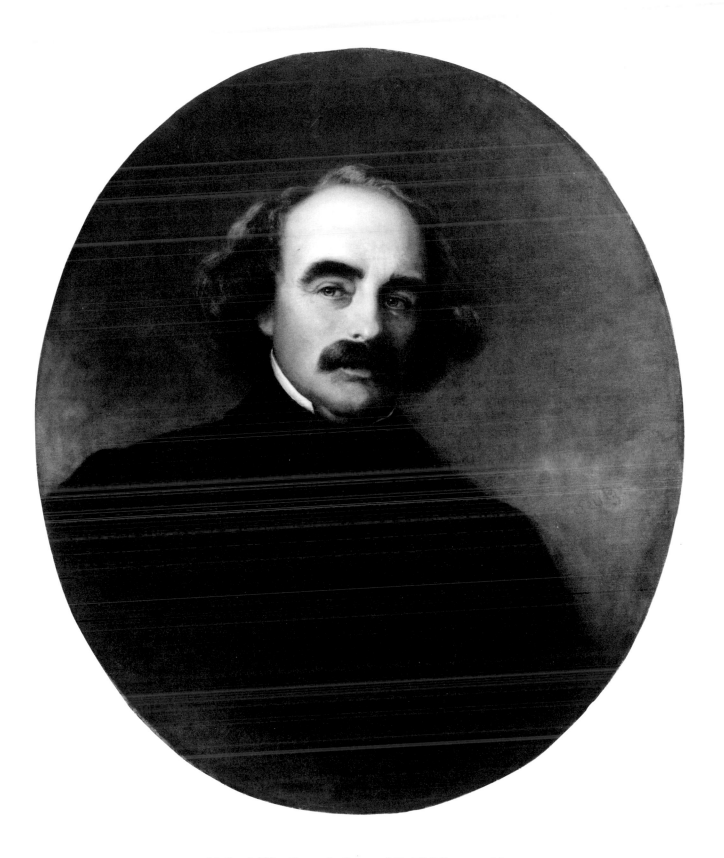

Nathaniel Hawthorne by Emanuel Gottlieb Leutze, 1862

thorne lingered, however, a few days longer because, as he told his wife on the 1st of April, "Leutze wishes to paint a portrait of me, and is to have the first sitting to-day. Three or four sittings will finish it, no doubt, so I expect to start for home early next week." The portrait was apparently finished by the 6th of April, and the writer returned to Concord.

Hawthorne, in an article written for the July issue of the *Atlantic Monthly,* "Chiefly About War Matters," describes the Washington encounter with Leutze. The artist, who had previously painted a historical work based on Hawthorne's *Scarlet Letter,* was then working at the Capitol on the mural for the West Staircase of the House of Representatives, *Westward the Course of Empire.* Hawthorne wrote, *At last we came to a barrier of pine boards, built right across the stairs. Knocking at a rough, temporary door, we thrust a card beneath; and in a minute or two it was opened by a person in his shirt sleeves a middle aged figure, neither tall nor short, of Teutonic build and aspect, with an ample beard of a ruddy tinge and chestnut hair. He looked at us, in the first place, with keen and somewhat guarded eyes, as if it were not his practice to vouchsafe any great warmth of greeting, except upon sure ground of observation. Soon, however, his look grew kindly and genial (not that it had ever been in the least degree repulsive, but only reserved), and Leutze allowed us to gaze at the cartoon of his great fresco, and talked about it unaffectedly, as only a man of true genius can speak of his own works. Meanwhile the noble design spoke for itself upon the wall. A sketch in color, which we saw afterwards, helped to form some distant and flickering notion of what the picture will be, a few months hence, when these bare outlines, already so rich in thought and suggestiveness, shall glow with a fire of their own,—a fire which I truly believe, will consume every other pictorial decoration of the Capitol, or, at least, will compel us to banish those stiff and respectable productions to some less conspicuous gallery. The work will be emphatically original and American, embracing characteristics that neither art nor literature have yet dealt with, and producing new forms of artistic beauty from the natural features of the Rocky-Mountain region, which Leutze seems to have studied broadly and minutely.... But it would be doing this admirable painter no kind office to overlay his picture with any more of my colorless and uncertain words; so I shall merely add that it looked full of energy, hope, progress, irrepressible movement onward, all represented in a momentary pause of triumph; and it was most cheering to feel its good augury at this dismal time when our country might seem to have arrived at such a deadly stand-still.*

Hawthorne, who saw "no reason to think hopefully of the final result of this war," found that *it was an absolute comfort, indeed, to find Leutze so quietly busy at this great national work, which is destined to glow for centuries on the walls of the Capitol, if that edifice shall stand, or must share its fate, if treason shall succeed in subverting it with the Union which it represents. It was delightful to see him so calmly elaborating his design, while other men doubted and feared, or hoped treacherously, and whispered to one another that the nation would exist only a little longer, or that, if a remnant still held together, its center and seat of government would be far northward and westward of Washington. But the artist keeps right on, firm of heart and hand, drawing his outline with an unwavering pencil, beautifying and idealizing our rude, material life, and thus manifesting that we have an indefensible claim to a more enduring national existence. In honest truth, what with the hope-inspiring influence of the design, and what with Leutze's undisturbed evolvement of it, I was exceedingly encouraged.*

The artist, incidentally, was to have received $30,000 for the mural, but a government in the throes of war paid him $20,000 and asked that he wait for better times

for the balance. Leutze wrote a receipt for the full amount, saying the final $10,000 would represent his contribution to the war chest.

Leutze, born in Germany, had been brought to America as a child. He studied drawing in Philadelphia with John Rubens Smith, and thereafter set out as an itinerant portrait painter, traveling through Maryland and Virginia. Like most ambitious young American artists, he was avid for the European training which would equip him to paint large historical canvases. In 1840, with some financial backing from a number of Philadelphia merchants, he enrolled at the Düsseldorf Academy. A year later he established his own atelier in that city and soon achieved considerable reputation for his "dramatically conceived" historical pictures, such as *Columbus Before Ferdinand and Isabella* and *The Landing of the Norsemen in America*. His series dealing with events of the American Revolution—including *News from Lexington, Mrs. Schuyler Firing the Wheat Fields*, and the most famous of all, *Washington Crossing the Delaware*—gave generations of American schoolchildren well-remembered, albeit mythical, impressions of their country's past.

After twenty years of European success, Leutze returned to America, where he found, other than *Westward the Course of Empire*, no opportunities for history pictures. He turned, therefore, once more to the painting of portraits. These were, said art critic Henry Tuckerman, writing in 1867, "remarkable for vigorous expression and individuality of character." Chief Justice Roger B. Taney (Harvard Law School) and Secretary of State William Seward (New-York Historical Society) were among those who sat to him.

Leutze had portrayed Hawthorne two years (lacking a month) before the author's death. Hawthorne's writing life was essentially over—the novels he still hoped to complete would be published after his death in fragmentary form. He was only fifty-eight, but on the verge of old age. Photographs taken by Mathew Brady the same month revealed an old man. Hawthorne protested that "my hair is not really so white as this photograph makes me; the sun seems to take an infernal pleasure in making me venerable—as if I were as old as himself."

His portrait gives no hint of physical failure. Vitality emerges from this man. His hair and mustache show only the slightest suggestion of distinguishing grey; the eyes that so many had called "magnificent" are alert and interested. The face that women thought handsomer than Byron's is here to be seen. The man that Leutze has painted looks to be at the height of his powers.

Bridge, Horatio. *Personal Recollections of Nathaniel Hawthorne*. New York: Harper & Brothers, 1893.

Fields, James T. *Yesterdays with Authors*. Boston: Houghton, Mifflin & Co., 1900.

Groseclose, Barbara S. "Emanuel Leutze: Portraitist." *Antiques*, November 1975, pp. 986–91.

Hawthorne, Julian. *Nathaniel Hawthorne and His Wife* (Vol. II). Cambridge: University Press, 1884.

Hoeltye, Hubert H. *Inward Sky*. Durham, N.C.: Duke University Press, 1962.

Lathrop, Rose Hawthorne. *Memories of Hawthorne*. Boston: Houghton, Mifflin & Co., 1897.

Ticknor, Caroline. *Hawthorne and His Publishers*. Boston: Houghton, Mifflin & Co., 1913.

Tuckerman, Henry T. *Book of the Artists*. New York: James F. Carr Publisher, 1966 (first published 1867).

Wagenknecht, Edward. *Nathaniel Hawthorne: Man and Writer*. New York: Oxford University Press, 1961.

Isaac Merritt Singer 1811–1875
By Edward Harrison May 1824–1887
Oil on canvas
130.2 x 97.8 cm
Signed: *May*/1869 [lower center]
1869
NPG.75.37
Gift of the Singer Company

Isaac Merritt Singer, the inventor, promoter, and manufacturer of the first practical sewing machine, contributed as much as any single individual to the democratization of clothing in America. When he came to have his portrait painted in Paris by the American artist Edward Harrison May in 1869, the flamboyant Singer chose a costume which unmistakably indicated wealth and position. In the post-industrial world when most men posed stiffly in sober black, the six-foot-four Singer, who had been an actor and stage manager as well as an inventor and businessman, fairly swaggers in his resplendent red velvet dressing gown trimmed with yellow satin. Not since the days when rich colonial merchants posed in their formal undress of banyan and cap had an American male afforded the viewer such a spectacle of elegance.

One who came to know Singer a year or two after the portrait was painted remembered: *He was most impressive in appearance: a handsome old gentleman . . . with a white "Father Christmas" square cut beard and, when dressed in his party attire, he was to us children magnificent. He felt the cold very much . . . and usually wore an overcoat, but for a party this overcoat was of velvet-lined satin. I remember a large garden-party . . . of children and grown-ups. He was immaculately dressed in morning attire but with a long coat of royal-blue velvet lined with primrose satin. It had a striking effect but it seemed to suit him and looked quite in order—for him—and on other occasions he wore similar coats in different colours.*

Singer was not to the manner born. The eighth child of poor German immigrants, he grew up in western New York State. Apprenticed as a machinist, he early showed a remarkable mechanical bent, but his consuming passion was the theatre. Singer, who ever believed in the instant gratification of his desires, ran away to appear on the stage. In subsequent years, he wandered around the country, appearing in Shakespearean productions (although he was almost illiterate, he could recite Shakespeare by the yard) and temperance plays—Singer himself did not drink. When at liberty he worked at odd jobs.

Singer had an uncanny ability to figure out an easier way of doing things, and in 1839 patented a rock-drilling machine. With the $2,000 realized from his first invention, he formed an acting company, called the Merritt Players, which toured the country with a divergent repertoire that included *Richard III* and *The Stumbling Block or Why a Deacon Gave Up His Wine*. By the time the group reached Fredericksburg, Ohio, the money had run out, and Singer was forced to rely once more on his mechanical skills. He got a job in a plant that manufactured wooden printer's type, and shortly he invented and patented an improved type-carving machine which, in search of financial backing, he took to New York.

In bookseller George B. Zieber, Singer found a patron. The two went to Boston, where they rented demonstration space in the workshop of Orson B. Phelps, a manufacturer of sewing machines. Phelps, struggling with the production of machines that, when they worked at all, sewed only a few inches at a stretch, remarked to Singer that there was a fortune to be made in the invention of a truly workable sewing machine.

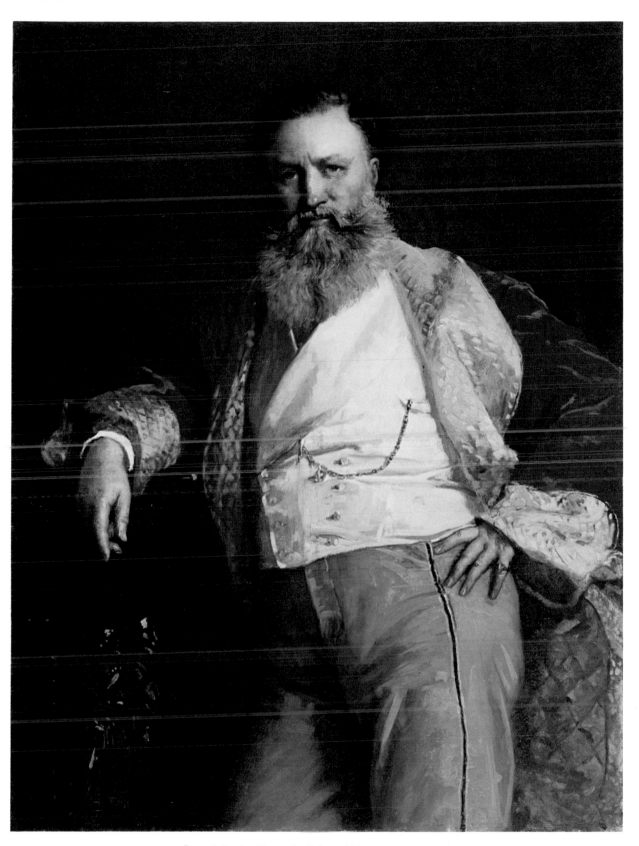

Isaac Merritt Singer by Edward Harrison May, 1869

Singer, ever on the lookout for the main chance, concentrated his attention on the deficient machines, and within twelve hours had sketched an improved version capable of continuous stitching.

In partnership with Zieber and Phelps, Singer went forward with his design. Later, in the course of his legal battle over the patent rights, he described how the Singer sewing machine had come to be invented. *Phelps and Zieber were satisfied that it would work. I had no money. Zieber offered forty dollars to build a model machine. Phelps offered his best endeavors to carry out my plan and make the model in his shop; if successful we were to share equally. I worked at it day and night, sleeping but three or four hours a day out of twenty-four, and eating generally but once a day, as I knew I must make it for the forty dollars or not get it at all.*

The machine was completed in eleven days. About nine o'clock in the evening we got the parts together and tried it; it did not sew; the workmen exhausted with almost unremitting work, pronounced it a failure and left me one by one.

Zieber held the lamp, and I continued to try the machine, but anxiety and incessant work had made me nervous and I could not get tight stitches. Sick at heart, about midnight, we started for our hotel. On the way we sat down on a pile of boards, and Zieber mentioned that the loose loops of thread were on the upper side of the cloth. It flashed upon me that we had forgot to adjust the tension on the needle thread. We went back, adjusted the tension, tried the machine, sewed five stitches perfectly and the thread snapped, but that was enough. At three o'clock the next day the machine was finished.

Whether time was as short, or the circumstances as dramatic, as the theatrically minded Singer described them matters not at all. The fact remains that Singer had indeed put together all the necessary ingredients for a successful sewing machine. He applied for a patent, and even before it was received on August 12th, 1851, the machines were in production.

The manufacture of the Singer sewing machines had no sooner gotten under way than Elias Howe, who in 1846 had patented a sewing machine which used the principles of the eyepointed needle and the lock stitch, demanded that Singer pay royalties. Singer let the matter come to litigation. To fight the legal battle, he and Zieber (Phelps had been bought out and Zieber soon would be) took as their new partner Edward Clark, a junior associate in a prominent New York law firm. In the end Singer was forced to pay Howe $15,000, but the so-called "war of the sewing-machines," in which a half-dozen or so sewing-machine manufacturers, bombarding the public with claims and counter-claims, constantly kept the concept of a machine that could sew before the public. By 1856, when Howe, Singer, and the other manufacturers had entered into the great Sewing Machine Combination for the purpose of granting licenses and collecting royalties for all machines produced, the revolutionary new product had won public acceptance. And Singer, with an astute partner (who originated the hire-purchase plan, providing for the purchase of a $125 machine with only $5 down), was in a position to capitalize on the potential market.

James Parton, writing the "History of the Sewing Machine" for *Atlantic Monthly* in May of 1867, recalled the first years of the Singer operation: *We well remember his [Singer's] early efforts, when he had only the back part of a small store in Broadway, and a little shop over a railroad depot; and we remember also the general incredulity with regard to the value of the machine with which his name was identified.* Parton noted that Singer "advertised, he travelled, he sent out agents, he procured the insertion of articles in newspapers, he exhibited the machine at fairs in town and country." Parton concluded, *Even after hearing him explain it at great length, we were very far from expecting to see him, one day, riding to the Central Park in a French*

diligence, *drawn by five horses, paid for by the sewing-machine. Still less did we anticipate that, within twelve years, the Singer Company would be selling a thousand sewing-machines a week, at a profit of a thousand dollars a day.*

At last Singer had the means to gratify his expensive appetites. Residing at a fashionable Fifth Avenue address with his common-law wife, he simultaneously engaged in liaisons with several other women, supporting in all some four households and close to twenty children. His most conspicuous extravagance was a fantastic coach which he himself designed and patented. The *New York Herald* of December 5th, 1859, described it as *a regular steamboat on wheels, drawn by six and sometimes nine horses, three abreast.... The carriage is a monster, having all the conveniences of a modern brownstone front, with the exception of a cooking department. It weighs about 3,800 pounds and will seat, inside and out, thirty-one persons. The inside is arranged with convenient seats for full sized persons with a nursery at the back end for the nurse and children, with beds to put the dear ones to sleep, and all the other necessary arrangements. This apartment is also used as a smoking-room when there are any gentlemen in the party who wish to enjoy their Havanas. There are seats on the outside for the accommodation of sixteen persons, these furnishings means for carrying a small band of music, with guards enough to keep off all outside barbarians.... The body is painted a canary bird color, edged with black.* Whether, concluded the *Herald*, "this eccentric turnout is intended for speed, comfort or advertisement, the reader must judge."

The world was Singer's oyster until the fatal afternoon in August of 1860 when, driving in state with one of his mistresses, he was encountered by his common-law wife. The latter, who had borne him ten children, was in especially bad temper because Singer, divorced at last from his first wife, had shown no intention of keeping his long-pledged promise of marriage. She made a public scene. Singer, enraged, followed her home, and the upshot was that it was soon reported by *Frank Leslie's Illustrated Weekly* that *Mr. I. M. Singer, the great sewing machine manufacturer, who resides at No. 14 Fifth Avenue, New York, was arrested on complaint of his wife, who accuses him of having beaten and choked her in a violent manner. He was put under bonds to keep the peace for six months.* The public notoriety was particularly unfortunate at a time when the Singer Company was actively soliciting the patronage of ministers and other community leaders by offering them machines at half price. Singer, in the company of his mistress's nineteen-year-old sister, hastily departed for Europe.

Singer returned to New York in 1861, and was promptly sued by his common-law wife, who called him "a most notorious profligate" and claimed that "a more dissolute man never lived in a civilized country." The arrogant Singer was embarrassed enough to address a humble note to his partner, saying: "Mr. Clark, dear, sir, My private affairs (though justly merited) hangs heavily upon me and my soul sicends at the prospects befor me and for the well fare of all concerned try to make my load of grief as light as posabl."

Edward Clark, a former Sunday school teacher, a decorous man of education and breeding, had from the beginning found the earthy Singer personally incompatible. Increasingly embarrassed by Singer's philandering ways and distressed that his partner's reputation was jeopardizing the credit of the company, Clark moved for a termination of the relationship. In July of 1863 the partnership was dissolved, with Singer and Clark each maintaining forty percent of the stock. At Singer's insistence neither was to assume the presidency so long as the other should live. I. M. Singer became the Singer Manufacturing Company and continued on its prosperous way.

Singer, extraordinarily enough, settled down to the joys of monogamy, marrying a

French lady he had brought to America. Building an ostentacious house, known as The Castle, in Yonkers, he planned to dazzle the countryside with his lavish entertainments. The local gentry, however, refused his invitations, and so, after enduring two years of social ostracism, the Singers moved to Paris.

Isaac Singer, at fifty-eight and in retirement, radiated the exuberance of one who savors life. His French wife had given him five children (soon there would be six), and he enjoyed periodic visits from the others in his numerous brood—it was said that he loved them all no matter who the mother. Spending his money with imagination, he was never bored. James Parton reported to Americans that "Isaac Merritt Singer who has . . . so often astonished the Fifth Avenue . . . is now amusing Paris, by the oddity and splendor of his equipages." In the glory of his Paris days, he decided to commission a portrait.

The artist he chose was a fellow expatriate, Edward Harrison May. May had been born in England but came to America when his clergyman father was called to a pastorate in New York. First trained as an engineer, he soon studied painting under Daniel Huntington, and was only twenty when he exhibited two portraits at the National Academy of Design in New York. By 1845 he had added history painting to his repertoire, showing *Cromwell Refusing the Crown* at the American Art-Union exhibition. During the next five years he continued to show portraits at the National Academy and history paintings at the Art-Union.

At just about the time Singer was applying for his sewing-machine patent, May went to Europe and entered Thomas Couture's Paris studio. By 1855 he was exhibiting in the Salon, and it was not long before he became well known for his elaborate historical canvases. The French critics lauded the "exactitude and firmness of his drawing, the harmony and depth of his color, and his striking veracity of expression." His portraits, noted Samuel Isham in his pioneer work, *The History of American Painting*, "were also commended."

May traveled to England to execute portrait commissions and came back to America for visits, but regarded Paris as his principal address. He continued to send paintings back to America for exhibition at the Pennsylvania Academy and the National Academy of Design, where he had been elected to Associate membership in 1850. At the time he was painting Singer, May's *Louis XIV at Marley* was being seen in New York.

In the year following the portrait sitting, the Franco-Prussian War disrupted the lives of both artist and subject. May volunteered for duty in an American hospital corps, and was awarded a medal from the French government for his service at the front line. Singer moved to England, briefly to London and then to Torquay on the South Devon coast, where he spent the last years of his life designing what was described as "a rather florid French villa" which "does not possess any marked architectural features, but it is capacious." Its amenities included a theatre and a circular coach house big enough for fifty carriages. Singer called it "The Wigwam." One of his sons later wrote, "Our dear Father, Isaac Merritt Singer, *never for a moment failed to claim and insist* (no matter where he happened to be temporarily) that he was an American citizen and always in fact an American. That is why he named his Paignton home 'The Wigwam,' an Indian name for home."

Here he lived in splendor, giving grand parties for the whole neighborhood without a care in the world for those who worried that "he wasn't quite a gentleman." But, six years after May painted his portrait, Singer was dead. He was survived by a great fortune and some twenty-three squabbling heirs. So ended the life of the man who had perfected, as Godey's publisher phrased it, "next to the plough . . . perhaps humanity's most blessed instrument." Back in America, the men in the sewing machine

factory would long remember him as "companionable . . . a good story teller . . . his genius for acting came into good play. The world was made brighter by his presence."

Brandon, Ruth. *A Capitalist Romance: Singer and the Sewing Machine.* Philadelphia: J. B. Lippincott Co., 1977.

Cooper, Grace Rogers. *The Invention of the Sewing Machine.* Washington, D.C.: Smithsonian Institution, 1968.

Lyon, Peter. "Isaac Singer and His Wonderful Sewing Machine." *American Heritage*, October 1958, pp. 9 ff.

Parton, James. "History of the Sewing-Machine." *Atlantic Monthly*, May 1867, pp. 527–44.

Tuckerman, Henry. *Book of the Artists.* New York: James F. Carr Publisher, 1966 (first published 1867).

Horace Greeley 1811–1872
By Thomas Nast 1840–1902
Watercolor on paper
30.8 x 18.4 cm
Signed: *Th. Nast 1872* [lower left]
1872
NPG.64.2

*One of four original Vanity Fair drawings, given by the oldest national
portrait gallery in the English-speaking world to the youngest "as a
token of good wishes and greeting to the sister institution in America."
Gift of the Trustees, National Portrait Gallery, London*

This portrait caricature of Horace Greeley, the Liberal Republican candidate for the presidency of the United States, was drawn by Thomas Nast, *Harper's* premier illustrator, for the British humor magazine *Vanity Fair*. Commissioned for chromolithographic reproduction in the July 20th, 1872, issue, it appeared shortly after the Democratic convention which, in the spirit of "anything to defeat Grant," had also endorsed the Greeley candidacy. Greeley grew "dizzy," he said, at the thought of being supported by the party he had heatedly opposed for the last forty years. "All Democrats may not be rascals but all rascals are Democrats," he had once declared.

Nast, satirizing Greeley fairly early in what would rapidly become a campaign marked by personal vilification on both sides, pictured the editor of the *New York Tribune* in the eccentric image Greeley himself had created. Near the beginning of Greeley's career, a rival publisher noted that "the editor of the *Tribune* seeks for notoriety by the strangeness of his theories and practices. . . . He lays claim to greatness by wandering through the streets with a hat double the size of his head, a coat after the fashion of Jacob's of old, with one leg of his pantaloons inside and the other outside of his boot." In truth, this apparition of a rustic sage, this poor country boy "who never had a dollar from a relative," consciously cultivated an image which would serve as an advertisement for his newspaper. A flapping white duster became the particular Greeley trademark. "People suppose I wear the same old coat but I don't," he once remarked with glee. "The original white coat came from Ireland. I bought it from an emigrant who needed money and I needed the coat. I paid him $20 for it and it was the best coat I ever wore."

Added to the picturesque negligence of Greeley's dress was a peculiarity of physical feature. His head was egg-shaped and outsized. "He seemed to have to walk fast

just in order to keep it balanced on top," said one observer. Greeley described himself as "slouching in dress, goes bent like a hoop, and so rocking in his gait that he walks down both sides of the street at once." He was a recognizable figure, not only in New York but, since he lectured widely, at every crossroads in America. One who saw him as he was campaigning on behalf of Republican presidential candidate John C. Frémont recalled: *The appearance of Mr. Greeley was unique: his broad shoulders clad in a coat too large for him; a limp, unlaundered turnover collar; heavy spectacles on nose, with a head of a giant, bald at the dome, and abundant uncombed locks on either side, a clean-shaven face, luxuriant whiskers beneath his chin and cheeks, a smile on his beaming features, childlike and bland. A more open countenance one never saw, a countenance on which candor and sincerity were most legibly stamped. On looking at him you thought of a full, round harvest moon.*

Greeley's personal pulpit, the *New York Tribune* which he founded in 1841, was intended to be "a journal removed alike from servile partisanship on the one hand, and from gagged, mincing neutrality on the other." Lively but not sensational, it proved to be a landmark in the history of responsible journalism. Read everywhere in America outside of the South, it was easily the most influential newspaper of its day. "Greeley does the thinking of the whole West for $2 per year for his paper," Ralph Waldo Emerson remarked. Greeley's robust and pungent editorials, signed "H. G.," gave a singular stamp to his unequivocal views. Using strong and clear language, he was a master of "the art of putting things," able to hold the attention of his readers through countless iterations of his favorite topics. His sincerity transcended frequent inconsistencies, and his pronouncements carried with them an aura of infallibility. For thirty years he crusaded for a whole variety of causes, including antislavery, westward expansion, free homesteads, women's rights, high tariffs, vegetarianism, temperance, and spiritualism. "He was a true knight errant," one of his early biographers noted, "because his lance was always at the service of the weak, the downtrodden and the wronged."

Through long association, Americans had come to think of Greeley as their "Uncle Horace" and, even when he appeared to be "wrongheaded," they continued to regard him with amusement and affection. Only when he signed the bail bond for the release of Jefferson Davis did his readers fall off in any great numbers. But then as ever, Greeley, it was said, "never counted the cost of his words; he never inquired what course would pay or what would please his subscribers." Characteristic was his reply to Republican criticism voiced by the Union League Club. Greeley wrote: *You evidently regard me as a weak sentimentalist, misled by a maudlin philosophy. I arraign you as narrow-minded blockheads, who would like to be useful to a great and good cause, but don't know how. Your attempt to base a great, enduring party on the hate and wrath necessarily engendered by a bloody Civil War, is as though you should plant a colony on an iceberg which had somehow drifted into a tropical ocean.*

Greeley was chosen by the Liberal Republicans because, of all the potential nominees, he alone had a national reputation. In the words of the editor of the *Springfield Republican*, a partisan newspaper: *He is probably the best-known man in the country. For the better part of two generations, he has been one of the most prominent figures in the public eye until both his features and his foibles have become public property. And it is hardly too much to say that he is as widely liked as known. Those who laugh at him oftenest and loudest, generally have a warm spot for him in their hearts.*

John Bigelow, former associate editor of the *New York Evening Post*, observed with cool logic that *Greeley is an interesting curiosity which everyone likes to see and to show and in whom we all feel a certain amount of pride, but I do not think anyone*

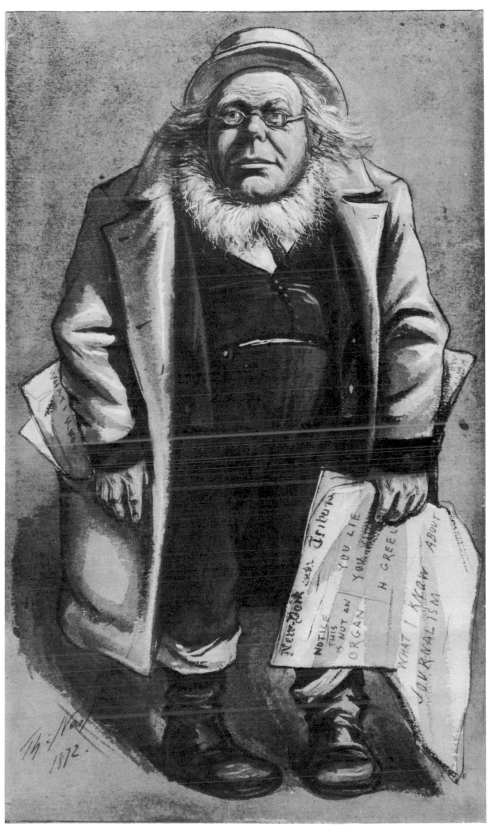

Horace Greeley by Thomas Nast, 1872

can seriously believe in his fitness for any administrative position whatever. If they do, they know as little of him as he knows of himself.

Harper's Weekly, admittedly anti-Greeley, was nevertheless not misreading majority sentiment when it stated that his "nomination struck the country at once with amusement and astonishment. It was probably the only nomination for president ever made which was received with a good-humored laugh." The editor went on to say, "If there is one quality which is indispensable in a President, it is sound judgment. If there is one public man who is totally destitute of it, it is Horace Greeley. A certain kindly feeling with which he is regarded will not blind the country to his natural unfitness for the office to which he has been nominated."

"A fussy old man in a white hat and linen duster, it was hard to think of him as President," noted one of Grant's biographers. Seldom has the political cartoonist been afforded a more vulnerable target. Thomas Nast, watchdog of the Reconstruction, made the most of it.

Greeley, pictured by Nast as a floundering old buffoon, holds a copy of his *Tribune* on which is written, "This is not an Organ." The allusion is to Greeley's statement, made as he removed himself from the editorship of the paper for the duration of the campaign, that the *Tribune* was no longer a "party organ." "You Lie You Villain," was an expression the high-pitched Greeley sometimes used to punctuate his editorial comments. Seen stuffed in his pocket is a paper lettered "What I Know About Politics," referring to Greeley's fondness for beginning his editorials with the phrase "What I know about . . ." and taking particular sarcastic notice, perhaps, of his pamphlet published the previous year, entitled "What I Know About Farming." The "What I Know About" label became an ever-present feature in all of Nast's depictions of Greeley, reading, variously, "What I Know About Politics," "Honesty," "Warfare," "Clasping Hands Over Bloody Chasms," "Getting Votes," etc.

At the time the caricature was being published in London, the campaign was just getting under way. Greeley, at this juncture, canvassed in what was then the accepted American campaign style; he stayed home and greeted his supporters on his own front porch. So it was that in mid-July a trainload of well-wishers arrived at Chappaqua, the Greeley farm about thirty miles north of New York City. "The vigorous form of the philosopher himself with his broad white hat slammed on the back of his caput, his head up and gold spectacles glittering in the sun, was discerned coming in his jerky trot down the hill," said one participant in recording Greeley's arrival. The assemblage made a thorough tour of the farm, feasted on lobster salad, potted pigeon pie, ice cream, and fruits, washed down by lemonade, and listened to Greeley give an oration on the improvement of agriculture, a subject very dear to his heart.

Later in the campaign, following in the footsteps of Henry Clay, the presidential candidate he most revered, Greeley took to the hustings, traveling in New England and the West. For these swings around the country, the aspirant to the highest office in the land carefully revised his appearance, setting out in black frock-coat and trousers, black velveteen vest, and white muslin string tie. He even took care to groom his whiskers. A member of the *Tribune* staff, astonished at the transformation, saw this new image as an artificiality symbolic of the whole campaign.

Greeley, who had been deeply immersed in politics since he helped ballyhoo William Henry Harrison into the presidency with the campaign weekly *The Log Cabin*, had long had a hankering for political office. He was confident, at least during that summer, that he could defeat Ulysses Grant. "The money and office-holding power arrayed against us are fearfully formidable but we *ought* to win, so I guess we shall," he wrote to a friend.

In the other camp, any criticism of Grant was attributed to those who "can not forgive his victory over the rebellion." To this view Thomas Nast subscribed with a

vehemence equal to Greeley at his most impassioned. Nast, who worshipped Grant as the saviour of the Union, and who truly admired him as a person, was blind to the corruption of the Grant regime. Like Greeley, Nast was a man of strong convictions, never allowing that there might be another side to a decided opinion. Further, his loyalty had recently been reinforced by a trip to Washington, where he had been lionized by the president and the whole administration. The German-born, self-made Nast wrote to his wife, describing a party given "for the Great men of Washington to meet me, and I can tell you they came. . . . the power I have is *terrible*." And so Horace Greeley, who had been a leading public force almost as long as Nast had been alive, found it to be as the young illustrator came at him with all the might of his commitment. No one knew better how "to hit the enemy between the eyes and knock him down."

Greeley, the man who had been one of the founders of the Republican party and in no small way responsible for the nomination of Abraham Lincoln, and who had campaigned vigorously for the emancipation of the slaves, became not merely an "old humbug" but a traitor and Confederate sympathizer as well. One of the main themes of the Greeley campaign, "Let us clasp hands over the bloody chasm," was seized upon by Nast, and Greeley was shown clasping hands with John Wilkes Booth over the grave of Lincoln. "Let us bind up the wounds of our country," Greeley said, and Nast portrayed him extending a hand of friendship over the coffins of the Andersonville prison dead. "Theirs is a lost cause, but they are not a lost people," said Greeley, and Nast pictured him handing blacks over to the Ku Klux Klan. Ironically *Harper's*, in reporting Greeley's death, acknowledged that "No single force in educating the nation for the terrible struggle with slavery was so powerful as the Tribune."

Before the campaign was over, Greeley confided in a letter to a friend that he wondered whether he was running for the presidency or for the penitentiary. He was dead before December, when the electoral vote was counted, some say helped to his grave by the cruelty of Nast's barbs. As it happened, however, his whole world fell apart at one time. In the midst of an exhausting campaign trip, where in a period of ten days he spoke twenty or more times a day, he was called home to the bedside of his dying wife. Haphazard though his marriage to the long neurasthenic Mrs. Greeley had been, Greeley's devotion to "Mother" was emotionally intense, and he maintained a sleepless vigil for most of October. Ignoring the campaign, he wrote, "I am glad that the election will soon be over. My home troubles are enough to make me forget it." Two days before the election, his wife died, and he wrote, "I am not dead but I wish I were. My house is desolate, my future dark, my heart is a stone. I could not shed tears; they would not come; they would not bring relief." When the votes were counted, he had carried only six border and southern states. Although he had said he should not shed one tear on any possible result of the election, the knowledge that he was "the worst beaten man who ever ran for high office" must have been a bitter humiliation for one who had long thirsted after both political office and popular acclaim. The final blow came when, upon his return to the *Tribune*, he found that his editorial control had been taken over by his associates. His mind snapped, apparently as it had earlier when his cry of "On to Richmond" had pressured unprepared Union troops into the disaster at Bull Run. He had written then to Lincoln, "This is my seventh sleepless night . . . yet I think I shall not die, because I have no right to die. I must struggle to live, however bitterly." This time there was no struggle to live, and the man whose whole life had been "a fevered march" died insane on the 29th of November 1872.

Thirty-nine years later, his fellow editor William Dean Howells, in responding to an invitation to attend the celebration of the Greeley centenary, said simply, "Greeley was one of the best of us, and we ought to keep his memory green."

Gillette, William. "Election of 1872." *History of American Presidential Elections*. Edited by Arthur M. Schlesinger, Jr., New York: Chelsea House, 1971.

Hale, William Harlan. *Horace Greeley*. New York: Harper & Brothers, 1950.

Keller, Morton. *The Art and Politics of Thomas Nast*. New York: Oxford University Press, 1968.

Stoddard, Henry Luther. *Horace Greeley*. New York: G. P. Putnam's Sons, 1964.

The University of the State of New York, Division of Archives and History. *Proceedings at the Unveiling of a Memorial to Horace Greeley at Chappaqua, N.Y. February 3, 1911*. Albany: 1915.

Van Deusen, Glyndon G. *Horace Greeley: Nineteenth-Century Crusader*. Philadelphia: University of Pennsylvania Press, 1953.

Chief Joseph 1840–1904
By Cyrenius Hall 1830–post 1885
Oil on canvas
56.5 x 45.7 cm
Inscribed: *In-matuyahlat-cut/thunder Cloud travelling over the Mountain/Indian name of Chief Joseph/Fort Levenworth/June 1878/by Cyrenius Hall* [on back of canvas]
1878
NPG.68.19

Joseph, one of the last Indian chiefs to resist removal from his ancestral lands, was painted by Cyrenius Hall in June of 1878. Nine months previous, the leader of the Nez Percés had surrendered to the United States Army and was now held prisoner at Fort Leavenworth, Kansas. One who saw him in captivity reported: *Physically Joseph is a splendid looking man. He is fully six feet high in the prime of life—about 35, has a splendid face and well formed head. His forehead is high, his eyes bright yet kind, his nose finely cut, and his mouth, though determined, rather too sad looking for actual beauty.*

The Nez Percés (pierced noses) were called such by the French-Canadian trappers, who observed many of them wearing a single shell of wampum through the nose. The name continued long after the custom died out. Lewis and Clark found them to be hospitable in 1805, and for almost seventy years the Nez Percés remained the "faithful friend of the white man." A reservation was set aside for them in 1855, and official reports continually called them "peaceable," "industrious," "prosperous," and "altogether one of the most promising tribes west of the Rocky Mountains." The discovery of gold in their mountains in the 1860s brought the seeds of inevitable conflict, as an influx of white settlers soon grew to ten thousand and more. Faced with pressures from this added population, the government negotiated a new treaty with the Nez Percés, greatly contracting the land previously guaranteed. Some members of the tribe signed this new agreement in 1863; others refused to cede their land.

Joseph, whose Indian name, Hin-Mah-Too-Yah-Laht-Ket, means "thunder rolling in the mountains," succeeded to tribal leadership upon his father's death in 1871 and became the most prominent leader of the "non-treaty" Nez Percés. The land "has always belonged to my people," he said. "It came unclouded to them from our fathers, and we will defend this land as long as a drop of Indian blood warms the hearts of our men." Joseph and his band held firm and refused to withdraw to the intended Lapwai Reservation in Idaho. In 1875 the Commission of Indian Affairs noted that

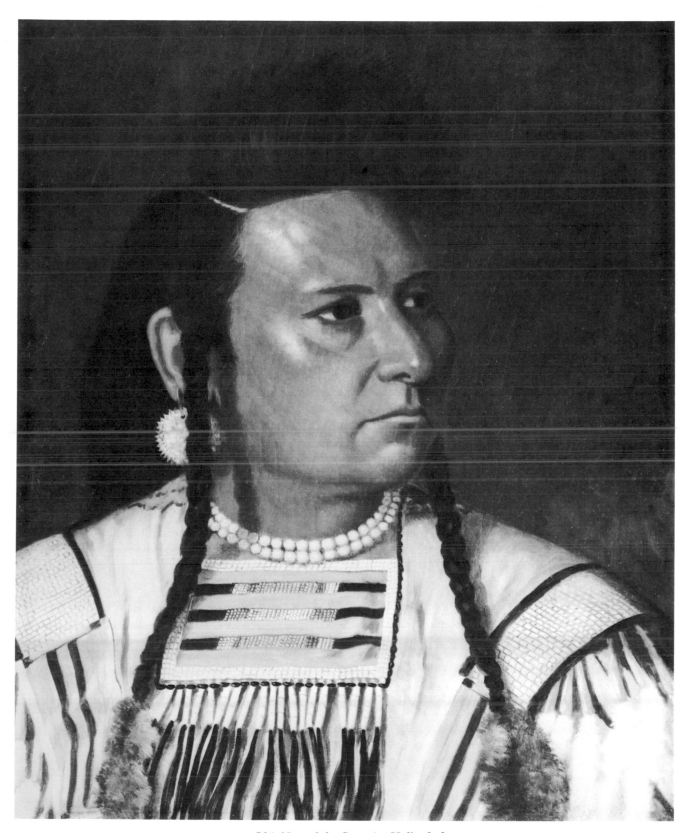

Chief Joseph by Cyrenius Hall, 1878

the settlements made in the Wallowa Valley, which has for years been the pasture-ground of the large herds of horses owned by Joseph's band, will occasion more or less trouble between this band and the whites, until Joseph is induced or compelled to settle on his reservation. The potential for trouble between the aggressive white settlers and angry young Indians was soon realized—Indian cattle were stolen; an Indian was killed by a white squatter. By the spring of 1877 the government had decided that the issue had to be forced. The Indians were called to conference after conference, but no amount of persuasion could shake Joseph from the conviction that "the earth is part of our body," and they would never give it up. Emily Fitz-Gerald, the wife of an army surgeon stationed at Fort Lapwai, reported in a letter to a friend, "We heard . . . that Joseph will make no terms or acknowledge any authority. . . . This Joseph will admit no boundary to his lands but those he chooses to make himself. I wish somebody would kill him before he kills any of us." The official report of the conference noted about Joseph that "an alertness and dexterity in intellectual fencing was exhibited by him that was quite remarkable."

With the United States cavalry occupying the Wallowa Valley, it was apparent to Chief Joseph that the alternative to removal was war. He recalled later, "I said in my heart that, rather than have war, I would give up my country. I would give up my father's grave. I would give up everything rather than have the blood of the white men upon the hands of my people."

The band of some seven-hundred-fifty men, women, and children prepared to move to Lapwai. They were given thirty days. "If you let the time run over one day," General Oliver Otis Howard said, "the soldiers will be there to drive you onto the reservation, and all your cattle and horses outside of the reservation, at that time will fall into the hands of white men." There could hardly have been a worse season for the exodus. It was June, and the waters of the Snake River were high from the spring runoffs. Cattle were drowned in the attempt at crossing; horses were stolen by white men. Exasperation turned to anger, and a small band of young braves found their revenge in the killing of four whites who had been particularly obnoxious to the Indians. Seventeen warriors, ignited by firewater, terrorized the countryside, and over a period of two days killed about fifteen more white settlers. Joseph said, in a retrospective interview he gave to the *San Francisco Chronicle,* that "captured whiskey was usually at the bottom of all murders, the Indians getting almost crazy with it and utterly beyond his influence." The Indian leaders had not intended war—a truce party was sent out displaying a white flag. The Mount Idaho volunteers fired; the war was on. Joseph recalled later, *I would have given my own life if I could have undone the killing of white men by my people. I blame my young men and I blame the white men. . . . I would have taken my people to the buffalo country without fighting, if possible . . . but the soldiers attacked us and the first battle was fought.* The Indians won, but their only course now was flight to Canada.

What followed was an epic chase, lasting for some three months over 1,700 miles of mountainous terrain. Three major battles and countless skirmishes later, the Indians were finally brought to heel at Bear Paw Mountain in Montana, only thirty miles from the Canadian border.

Joseph's role in what has been described as one of the great strategic retreats in military history, has been a matter of some dispute. It would seem that throughout the campaign the leadership was shared, and that all important decisions were made by a tribal council dominated by others. Only when the military leaders had been killed did Joseph, as the spokesman for civilian matters, come to the fore.

With the Nez Percés under siege, Joseph came into the opposing camp. He was seen by one observer as *a man of splendid physique, dignified bearing and handsome*

features. His usual expression was serious, but occasionally a smile would light up his face, which impressed us very favorably. . . . Joseph appeared very sad; he was inclined to surrender, but did not have control of the entire camp.

After five days it became clear that the Indians were faced with the choice of escaping by abandoning their wounded, their old, and their women and children, or accepting capture. Chief Joseph, speaking through an interpreter, replied to the surrender demand: *I am tired of fighting. . . . The old men are all dead. . . . He who led on the young men is dead. It is cold and we have no blankets. The little children are freezing to death. My people, some of them, have run away to the hills, and have no blankets, no food; no one knows where they are—perhaps freezing to death. . . . Hear me, my chiefs. I am tired; my heart is sick and sad. From where the sun now stands I will fight no more forever.*

In accordance with this pledge, Joseph, riding on horseback, his hands crossed on the pommel of the saddle, his head bowed on his breast, and accompanied by five warriors on foot, came within the Army lines to offer his rifles as "the token of submission." An eyewitness reported him to be *dressed in a woolen shirt of dark slate color, with a blanket of red, yellow and blue stripes around his hips, and a pair of beadless moccasins. His front hair was tied straight back from his forehead with a small strip of otter skin, making a . . . "top-knot," and the hair at the sides was braided and held back, with the waving loose locks behind, by longer pieces of the same fur.* It was sunset, and *the Indian camp lay in the lengthening shadows and as the little group came up from the darkening valley into the higher light which showed their wretchedness, Joseph lifted his head, and with an impulsive gesture, straightened his arm toward General Howard, offering his rifle, as if with it he cast away all ambition, hope and manly endeavors leaving his heart and his future down with his people in the dark valley where the shadows were knitting about them a dusky shroud.*

Joseph had surrendered in the belief that his band would be returned to the Lapwai Reservation. General Nelson A. Miles, he wrote, "promised that we might return to our country. I believed General Miles, or I never would have surrendered." He "could not have made any other terms with me at that time. I could have held him in check until my friends came to my assistance, and then neither of the generals nor their soldiers would ever have left Bear Paw Mountain alive."

Joseph ever after believed that Miles would have kept his word if he could have done so. Others, most importantly Generals William Tecumseh Sherman and Philip Henry Sheridan, did not want the Nez Percés back in Idaho. The white people of Idaho, who remembered the murders that set off the war, would, it was feared, kill any returning Indians, thus beginning the conflict all over again. Local opinion wanted the Indians sent "so far away that they can never return." Joseph's band would never be allowed to go home.

The four hundred or so survivors, treated as prisoners of war, were shipped to Fort Leavenworth. Here they were detained at a squalid campsite built on swampy bottom land. An Indian agent wrote in retrospect, "The bad effect of their location at Fort Leavenworth manifested itself in the prostration by sickness at one time of two hundred and sixty out of the four hundred and ten; and 'within a few months' in the death of 'more than one quarter of the entire number.' "

It was in these circumstances that Cyrenius Hall came to paint Chief Joseph. The Indian leader was near the depths of despair. He remembered later: *Many of my people sickened and died, and we buried them in this strange land. I cannot tell how much my heart suffered for my people while at Leavenworth. The Great Spirit Chief who rules above seemed to be looking some other way, and did not see what was being done to my people.* Not only had his people lost their ancestral valley, but "we gave

up all our horses, over eleven hundred, and all our saddles, over one hundred, and we have not heard from them since."

Joseph was near the beginning of what would be a lifelong campaign to seek redress for his tribe. For the next quarter of a century, he would continue to plead his cause with the leaders in Washington "who all say they are my friends, and that I shall have justice." He had *heard talk and talk, but nothing is done. Good words do not last long unless they amount to something. Words do not pay for my dead people. They do not pay for my country, now overrun by white men. . . . It makes my heart sick when I remember all the good words and broken promises. . . . You might as well expect the rivers to run backward as that any man who was born a free man should be contented when penned up and denied liberty to go where he pleases. . . . I have asked some of the great white chiefs where they get their authority to say to the Indian that he shall stay in one place, while he sees white men going where they please. They cannot tell me. Let me be a free man—free to travel, free to stop, free to work, free to trade where I choose, free to choose my own teachers, free to follow the religion of my fathers, free to think and talk and act for myself—and I will obey every law, or submit to the penalty.*

The month following the execution of the portrait, the Nez Percés were moved from Fort Leavenworth to an Indian reservation in Oklahoma. Finally, in 1885, Joseph won a victory of sorts when the band was allowed to return to the Northwest, though to Washington and not to their valley in Idaho.

Of Cyrenius Hall little is known. He was born in the East and began a life of peregrination when he traveled overland to California in the early 1850s, sketching all the way. After ten years on the West Coast, where he painted a panorama of the plains and of California, twenty-six rods long (unlocated), he returned briefly to Westminster, Ontario, where he assisted his father in the management of business affairs. Before he arrived at Leavenworth, he had lived and worked in Peru, Chile, Argentina, England, France, Bavaria, and New York. He specialized in both landscapes and portraits. A number of Hall's western landscapes are in the collection of the Wyoming State Gallery, Cheyenne. His last known work, a portrait in the Chicago Historical Society, is dated 1885.

In 1968 Hall's portrait of Chief Joseph was chosen as the subject of a commemorative stamp, saluting the American Indian and marking the dedication of the National Portrait Gallery.

Brown, Dee. *Bury My Heart at Wounded Knee.* New York: Holt, Rinehart & Winston, 1970.

Brown, Mark H. *The Flight of the Nez Percé.* New York: G. P. Putnam's, 1967.

Hall, Rev. David B. *The Halls of New England.* Albany, N.Y.: Joel Munsell's Sons, 1883.

Jackson, Helen Hunt. *A Century of Dishonor.* Edited by Andrew F. Rolle. New York: Harper & Row, Torchbooks, 1965 (first published 1881).

Utley, Robert M. *Frontier Regulars: The United States Army and the Indian 1866–1891.* New York: Macmillan Co.; and London: Collier-Macmillan, 1973.

Ralph Waldo Emerson 1803–1882
By Daniel Chester French 1850–1931
Bronze (derived from 1879 life sitting)
57.1 cm
Signed: *D. C. French 1879/Henry Bonnard Bronze Co./Mt. Vernon, N.Y. 1901*
NPG.74.13

One of seven known bronze replicas from the original plaster (which also was reproduced in plaster copies offered for sale at $30 each). Two marble versions were executed, one for the Concord Free Library and the other for Harvard University

"Some day when you don't expect it Mr. Emerson will die. Those lights often go out so suddenly," wrote Pamela French to her stepson, Daniel Chester French, in January of 1879. Urging him to put aside other commissions and begin a bust of Ralph Waldo Emerson which would "be a great feather in your cap," she warned that "you must do it this winter. I'm afraid Mr. Emerson won't keep."

French had spent his adolescence in Concord, Massachusetts, and knew Mr. Emerson (in Concord it was always *Mr.* Emerson) as a neighbor. He was used to seeing Emerson's "slender figure, slightly stooping, a shawl about his shoulders, standing patiently in line with the rest at the post-office wicket." French himself recalled the philosopher as a "tall figure walking the village street, enveloped in a long black cloak or shawl, and looking as I imagine Dante must have looked as he walked the streets of Florence."

When he first saw Mr. Emerson in 1867, French was seventeen, and he wrote, years later: *Young as I was, I was impressed, as every one was, with his dignified, serene presence. . . . Emerson seemed as great as he really was. . . . all who approached him aware that they were in the presence of a demigod. Perhaps it was the soul that shone out upon you from his face, or the deep, full, beautiful voice with its matchless enunciation and perfect diction; or the clear, piercing eyes; or the courtesy towards man or child, high or lowly, which was unfailing.*

As a member of the committee charged with commissioning an appropriate memorial to commemorate the hundreth anniversary of "the shot heard round the world," Emerson had approved French's design for a statue of the Minute Man. The twenty-one-year-old sculptor had had some training in art and anatomy but, as he wrote to his brother, "Of course, I have never made a statue. I wonder whether I can do it. This time next year I shall *know.*" In the spirit, it was said, of Emerson's Concord, whose citizens did whatever was expected of them, French executed a statue that pleased everyone. At the urging of Emerson, the town, instead of just paying expenses, as originally agreed, awarded the embryo sculptor an additional $1,000. "If I ask an artist to make a silver bowl and he gives me one of gold, I can not refuse to pay him for it if I accept it," Emerson had said. And when the statue was unveiled before an audience that included President Ulysses S. Grant and most of his cabinet, French's father was able to report to his son, then abroad, "This is Fame Dan!"

His reputation as the sculptor of the Minute Man statue further buttressed by a year's study in Italy with Thomas Ball, French set up a studio in Concord ready to begin his career in earnest. His most important commission was for a group of marbles representing Law, Prosperity, and Power intended for the Philadelphia Court House. Since Emerson's daughter-in-law was the model for the head of Law, French's desire to portray the famous writer was easily brought up. It was soon arranged. By

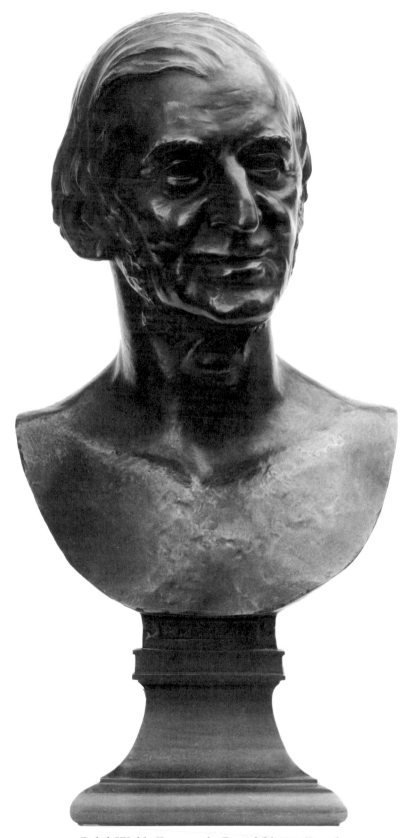

Ralph Waldo Emerson by Daniel Chester French

mid-January French's father wrote with satisfaction, "Your interview with the Philosopher was excellent. How good he is always."

The sittings began in March, Emerson posing in the first-floor library of the Old Manse. French worked slowly and deliberately, taking countless measurements and making close observations by eye. The artist recounted that Mr. Emerson "kindly gave me as many sittings as I required—perhaps twenty in all." Emerson did not seem to mind. "This is as easy as sleeping," he said.

By the end of April, the bust was finished in clay and shortly thereafter put into plaster. The family held a "ceremonious unveiling" and mounted it on a pedestal. Mrs. Emerson pronounced it a perfect likeness. Bronson Alcott saw it as "the man as he now is, touched with age yet youthful in his manly features and expression. It is the form in which we wish to perpetuate our friend."

"The bust certainly should be valuable," French later wrote, as a "topographical survey of Emerson's face." He noted, "I took no liberties with it whatever and it is as nearly a record of his contours as I could make. I did try to choose an expression and to get some of the illuminated look of Emerson's face." The philosopher's countenance, said French, "in spite of the boldness of the general plan, had an infinity of detail, the delicacy of which evinced the refinement of the soul that evolved it." There was nothing slurred, nothing accidental in that face; "it had been like the perfection of detail in great sculpture—it did not interfere with the grand scheme." Here was "an almost childlike mobility that admitted of an infinite variety of expression and made possible that wonderful lighting up of the face so often spoken of by those who knew him." French recalled how hard he had worked "to put into the eyes that something which made people say of the philosopher that he looked as if he had seen God," only to have Emerson pronounce, "That is the face that I shave."

Emerson's biographer, Bliss Perry, in describing his subject, wrote: "Seen from one side [his] was the face of a Yankee of the old school, shrewd, serious, practical. . . . Seen from the other side, it was the face of a dreamer, a seer, a soul brooding on things to come, things as yet very far away."

Years later this sculptor, who had created the statue for the Lincoln Memorial in Washington, would look back and say that his portrait of Emerson was the piece of work which had given him the most enjoyment. French, wrote his daughter, felt that to have known Emerson and to have been the recipient of his beneficence had been one of the greatest privileges of a privileged life.

Pamela French had suggested that the sculptor take notes on whatever Emerson said during the course of the sittings. "They would add much to the value of the bust," she said. But by this time Emerson, one of the most seminal influences in all of American history, was saying little that was worth recording. For over ten years he had been drifting into a serene and dignified senility. The year 1867, reported his son, was about the end of his creative life. The short speech he composed for the unveiling of French's Minute Man statue in April of 1875 was the last he wrote himself. He ceased writing letters to his friends; he made no further entries in his journal.

Emerson continued to lecture, and crowds flocked to listen with reverence long after he had anything to say, and even after he himself forgot why it was he had come there. John Burroughs, hearing him speak in Baltimore in 1872, noted that "Nothing can be more irrelevant or pitiful than those lectures he is now delivering." Emerson was, however, an American institution, and even those who never really understood a word he uttered continued, in the words of his Concord neighbor, to "like to see him stand up there and look as if he thought every one was as good as he was."

The *Boston Journal*, describing Emerson during the years when he was hurling the epigrammatic "thunderbolts" which excited, and sometimes shocked, his audiences,

wrote: *There is no other man in America who can, by the mere force of what he says, so enthrall and dominate an audience. Breathless attention is given, although now and then the voice falls away so that those seated farthest off have to strain every nerve to catch the words. The grand condensation, the unfaltering and almost cynical brevity of expression, are at first startling and vexatious; but presently one yields to the charm, and finds his mind in the proper assenting mood. The loving tenderness with which Emerson lingers over a fine and thoroughly expressive phrase is beyond description.*

But even when Emerson was in his prime, Oliver Wendell Holmes remembered that he *was apt to hesitate in the course of a sentence, so to be sure of the exact word he wanted; picking his way through his vocabulary, to get at the best expression of his thought, as a well-dressed woman crosses the muddy pavement to reach the opposite sidewalk.* Now, as "the evening mists gathered around him," the words for common objects tended to escape him altogether—chair became "that which supports the human frame," plough was the "implement that cultivates the soil," umbrella became "something people carried away."

His memory, Emerson said, "hid itself." He forgot old friends. "Strange that kind Heavens should keep us upon earth after they have destroyed our connection with things!" he was heard to muse.

Outwardly he changed little, his visage retaining the look of "active inquiring intelligence." At about the time he sat to French, one visitor described him as "strangely beautiful." Another remarked that his eyes were bright and "the old clear-peering aspect quite the same." Young Henry Cabot Lodge, who saw him at a meeting of the Massachusetts Historical Society, remembered: *When I saw him I watched him with the deepest interest, although I was then far from realizing what a truly great man he was and that I was in the actual presence of one of the remarkable minds of the century; poet, thinker, creator of ideas, planter of thoughts which were to grow up and flower in alien soils to which the very name of him who sowed the seed was unknown. Tall, thin, with a face full of intellect, unscarred by passion, in a way remote in look and yet with such human sympathy and feeling in the regard that no one could call it ascetic, he seemed to me a man whose mere appearance must have impressed the most careless gazer.* Prophetically, Emerson had said years before, "I have so little vital force that I could not stand the dissipation of a flowing and friendly life. . . . I husband all my strength. . . . no doubt shall be a well-preserved old gentleman."

Adams, Adeline. *Daniel Chester French.* Boston: Houghton Mifflin Co., 1932.

Bode, Carl, ed. *Ralph Waldo Emerson.* New York: Hill & Wang, 1968.

Cresson, Margaret French. *Journey into Fame.* Cambridge, Mass.: Harvard University Press, 1947.

French, Mrs. Daniel Chester. *Memories of a Sculptor's Wife.* Boston: Houghton Mifflin Co., 1928.

Richman, Michael. "Daniel Chester French." *Metamorphoses in Nineteenth-Century Sculpture.* Edited by Jeanne L. Wasserman. Cambridge, Mass.: Harvard University Press, 1975.

———. *Daniel Chester French: An American Sculptor.* New York: The Metropolitan Museum of Art, for the National Trust for Historic Preservation, 1977.

Russell, Phillips. *Emerson: The Wisest American.* New York: Brentano's Publishers, 1929.

Wagenknecht, Edward. *Ralph Waldo Emerson: Portrait of a Balanced Soul.* New York: Oxford University Press, 1974.

Mary Cassatt 1844–1926
Self-portrait
Watercolor on paper
33 x 24.1 cm
Signed: *M.C.* [lower center]
circa 1880
NPG.76.33

Mary Cassatt, the only American member of the avant-garde French impressionist group of painters, was in her mid-thirties and vigorously striding toward the full maturity of her art when she painted her own portrait in watercolors. As far as we know, this and a gouache done two years earlier (Metropolitan Museum of Art) are the only self-portraits she did. A determined woman of strong face, Cassatt looks capable of anything she might wish to undertake.

Louisine Havemeyer, who had had the benefit of Mary Cassatt's advice since 1873 when the artist had urged her to spend her teenage allowance on a Degas pastel, described her friend as having *large eyes whose glance came frankly to meet yours, a wonderfully flexible mouth and a nose . . . remarkable in its modelling and with those sensitive flaring nostrils which I always said made her an artist in spite of herself. Miss Cassatt's tall figure, which she inherited from her father, had distinction and elegance, and there was no trace of artistic negligence or carelessness which some painters affect. Once having seen her, you could never forget her, from her remarkably small foot to the . . . hat . . . upon her head . . . without which she was never seen.*

Viewed through the eyes of a non-compatible sister-in-law, Mary was harshly de picted in the summer of 1880. Her brother Alexander's wife wrote: *The truth is I cannot abide Mary and never will. I cannot tell why but there is something to me utterly obnoxious about that girl. I have never yet heard her criticize any human being in any but the most disagreeable way. She is too self-important and I can't put up with it. The only being she seems to think of is her Father. She tries to be polite to me however, and so we get on well enough. The children all seem to prefer her to the others, strange to say.*

Whether or not Mary Cassatt was as overbearing as her sister-in-law implied, the naturally assertive artist had reason enough to exude self-confidence. The reviews of the "Independent" artists' exhibition of 1879 had made favorable mention of her pictures, overcoming once and for all her father's reservations about her unfeminine career. Writing home to Philadelphia, her parent bragged that *she is now known to the Art world as well as to the general public in such a way as not to be forgotten again as long as she continues to paint! Everyone of the leading daily French papers mentioned the Exposition and nearly all named Mame—most of them in terms of praise.* A week later he reported, "Mame's success begins to bore her. Too much pudding! she says."

Ostensibly it would seem as if a proper Victorian lady of well-off family was miscast as a member of the bohemian art world of Paris. But as George Biddle, a much younger Philadelphia artist, later explained, Mary Cassatt "drew that almost impossible line between her social life and her art, and never sacrificed an iota to either. Socially and emotionally she remained the prim Philadelphia spinster of her generation." She never mingled with her fellow impressionists. She resided with her parents and went about living much as she might have, had she never left Philadelphia. The one difference was incessant work, for Mary Cassatt was first and foremost a profes-

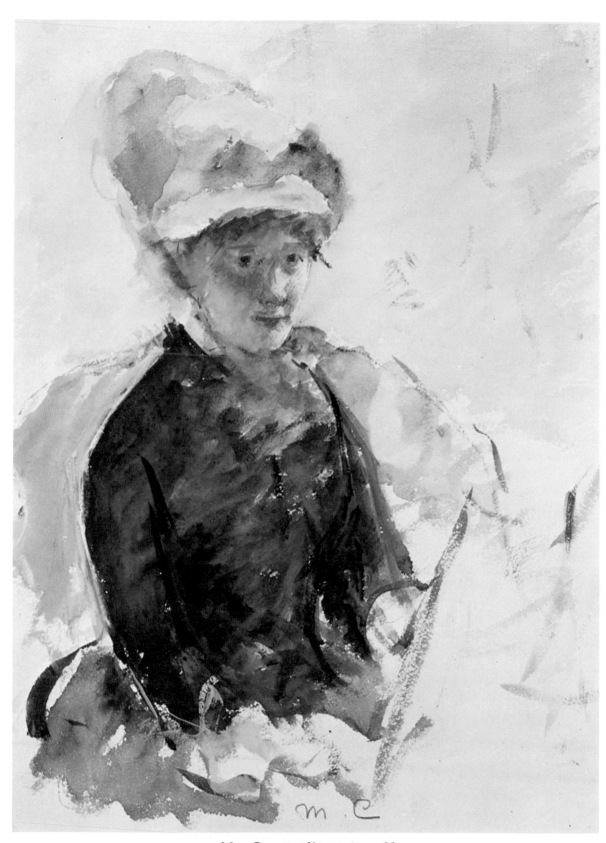

Mary Cassatt, self-portrait, c. 1880

sional artist. Even as a student she scoffed at girls of her social strata who saw art as a genteel pastime, writing of one dilettantish friend, "She is only an amateur and you know we professionals despise amateurs."

Dedication to her profession meant long days—from early morning to dusk—spent at her easel, and evenings in experimentation with graphic techniques. Save for family demands, which until the death of her parents were constant and her first obligation, she was relentless in a high-minded devotion to art.

Cassatt, her family reported about the time of the self-portrait, was "working like a beaver." It was a gladsome time. "We can surmise this from the many delightfully bright, happy paintings and pastels of that period," wrote Adelyn D. Breeskin, the leading authority on Mary Cassatt's work.

Exposed to European art galleries since she was seven, trained in the copying of plaster casts at the Pennsylvania Academy of the Fine Arts, immersed in the old master paintings of France, Spain, Belgium, and Italy, enrolled in the Paris studio of Charles Chaplin, an establishment portrait painter, Mary Cassatt had had a prolonged art education. Looking back upon her experiences, she dismissed her formal instruction as largely useless and claimed that the opportunity to copy a masterpiece was worth far more than the instruction of the best of teachers. Happily Cassatt herself would play an important role in bringing great art to her native country, persuading family and friends to buy impressionist paintings, many of which eventually came to American museums. As the advisor to the H. O. Havemeyers, she was instrumental as well in the acquisition of great canvases by such earlier artists as Goya, Velasquez, El Greco, and others for the collection which ultimately came to the Metropolitan Museum of Art.

Settling down in Paris, Cassatt won modest recognition when, beginning in 1872, her pictures were accepted for exhibition in the Salon. In 1875 she was chagrined when the jury rejected her entry because her palette was considered to be too bright. The following year, toning down the colors to meet the expectations of the establishment, she submitted the very same picture. It was admitted. In 1904, angrily declining the Lippincott Prize from the Pennsylvania Academy, she berated America's "slavishly copying all the evils of the French system." She wrote to the director of the Academy, "Liberty is the first good in this world and to escape the tyranny of a jury is worth fighting for, surely no profession is so enslaved as ours." The following year when the Academy, ignoring her clearly enunciated sentiments, asked her to serve on a jury for its Hundredth Anniversary Exhibition, she wrote: *That is entirely against my principles. I would never be able to forgive myself if through my means any pictures were refused . . . I know too well what that means to a young painter and then why should my judgment be taken? Or anyone else's for that matter in the hasty way in which pictures are judged . . . I abominate the system and think entire liberty the only way.*

Cassatt here enunciated the creed of the "independents," or impressionists as they had become known, those artists who, in protest against the government Salon, banded together to exhibit in a society in which there were to be no juries, no medals, no awards. Invited by Edgar Degas to show with the group in 1877, Cassatt accepted with alacrity. She later wrote: *Degas persuaded me not to send my work to the Salon any longer and to show with his friends in the group of Impressionists. I accepted with joy. Finally I could work with absolute independence without concern for the eventual opinion of a jury. Already I had recognized those who were my true masters. I admired Manet, Courbet, and Degas. I detested conventional art. I began to live.*

Even before she came to know Degas, Cassatt had admired his work. She recalled seeing a small pastel of his exhibited in a store window, and said, "I used to go and

flatten my nose against that window and absorb all I could of his art. It changed my life. I saw art then as I wanted to see it."

During the next decade, Cassatt, with Degas at her elbow offering criticism and advice, realized her full powers as an artist. No one was more aware than she how much she owed to the "magnificent" but "dreadful" Degas. Writing to Mrs. Potter Palmer, concerning the problems she was having in executing her mural for the Columbian Exposition of 1893, she agonized, *I have been half a dozen times on the point of asking Degas to come and see my work, but if he happens to be in the mood he would demolish me so completely that I could never pick myself up in time to finish for the exposition. Still he is the only man I know whose judgment would be a help to me.*

Despite frequent estrangements, there was between Degas and Cassatt a mutual admiration that endured for forty years. During Degas's final months, Cassatt took it upon herself to see that his niece was brought to take care of him, and when he died in 1917 she wrote, "His death is a deliverance but I am sad. He was my oldest friend here and the last great artist of the nineteenth century. I see no one to replace him." Louisine Havemeyer once asked Mary Cassatt how she managed to put up with the misanthropic Degas. The spirited Cassatt replied, *Oh, I am independent! I can live alone and I love to work. Sometimes it made him furious that he could not find a chink in my armor, and there would be months when we just could not see each other, and then something I painted would bring us together again and he would go to Durand-Ruel's and say something nice about me, or come to see me himself.*

To be sure, the quick-tempered, sharp-tongued Cassatt must have been capable of holding her own even against the crushingly cynical Degas. Miss Cassatt's elegance, it was said of her in later life, had its limitations, and she resorted at times to the most inelegant language. One who referred to Woodrow Wilson as "a syphilitic son-of-a-bitch" must have been able to equal, if she so deigned, the master of verbal vitriol.

The exact nature of the relationship between Cassatt and Degas was much speculated upon during their lifetimes and beyond. When Cassatt was old and blind, a relative asked directly if she had had an affair with Degas. "What, with that common little man; what a repulsive idea!" she reportedly replied. Art Critic Forbes Watson, dining with an ill and nearly sightless Degas, heard him say of Mary Cassatt, "I would have married her, but I could never have made love to her."

Assuredly, if one is to judge Mary Cassatt's personality by the themes of her paintings, she would seem to have been the most conventional of women. Everything she painted was out of her own familiar world, and a well-bred and respectable world it was. Her sitters often were family members who willingly posed to save her the expense of hiring a model. Most often she painted ladies, showing them engaged in the pleasant diversions of sheltered womanhood—drinking tea, sewing, reading, taking the air in sunlit gardens. Repeatedly she chose to depict children—her many nieces and nephews and, after 1893, the youngsters from the neighborhood of Beaufresne, the country chateau she bought with her earnings. Almost never, with the exception of her father and two brothers, did she portray men, although she got on better with them than she did with most members of her own sex.

Just about the time of the self-portrait, Mary Cassatt had turned to the theme with which she would become most closely identified, that of mother and child. Degas is said to have suggested the motif to her as a lode untouched since the days of the Renaissance Madonnas. From 1880 until blindness closed out her career more than a decade before her death, "maternity pictures" ("the Infant Jesus with his English nurse," quipped Degas) remained her specialty. These gentle portrayals satisfied the contemporary critics' sense of the fitness of things. "Only a woman can paint infancy," wrote one of them. "There is a special feeling that a man cannot achieve, at

least they are not especially sensitive, their fingers are too heavy not to leave a clumsy imprint, only a woman can pose a child, dress it, adjust pins without pricking themselves." Mary Cassatt, she who to the awed admiration of Jean Renoir "even carried her easel like a man," was too much a product of her own times to have disagreed. Certainly it is no surprise to find, in the accounts of her lonely old age, the statement that "there's only one thing in life for a woman, it's to be a mother." Nonetheless, one hardly believes it: for Mary Cassatt, there had been only one thing in life and that was to have been an artist. Maternity was to her a professional concern and not a matter of sentiment. Writing to Mrs. Havemeyer in 1909, she crisply noted, "I had several portraits to do, but it is not worth while to waste one's time over little children under three who are spoiled and *absolutely refuse* to allow themselves to be amused, and are very cross like most spoiled children. It is not a good age, too young and too old, for babies held in the arms pose very well."

To anything beyond her frame of reference, the opinionated Mary Cassatt reacted with prejudice, and, when it came to a matter of art, with extreme prejudice. Taken in 1908 to the Paris salon of her fellow Pennsylvanian, Gertrude Stein, Cassatt peered in disgust at the Matisses and Picassos and announced, "I have never in my life seen so many dreadful paintings in one place. I have never seen so many dreadful people gathered together, and I want to be taken home at once."

Although Mary Cassatt returned to America for only three short visits, her brothers and their families came often to Europe, thus helping her keep up her American ties. Philadelphia remained her legal residence, and she was firm about her nationality. "I am American ... clearly and frankly American," she told her French biographer A. F. Jaccaci. It bothered her that recognition came hard in the land of her birth. "I am very much disappointed that my compatriots have so little liking for any of my work," she wrote after an unsuccessful exhibition of her prints in New York in 1905. When in 1914 she presented the Pennsylvania Academy of the Fine Arts two portraits by Courbet, the letter of acknowledgment aroused her ire. "And do you know what the Academy had the audacity to write me?" she jeered. *They thanked me and added that, by the way, they noticed that the Academy had no examples of my own work, and would I send them something, hi! hi! hi! I told them I had been exhibiting for years at the Academy and they had never asked my prices, although they had funds for buying contemporary American art.*

At the height of her European fame, she returned to America for her first visit since she had settled in France in the 1870s. The hometown newspaper reported her arrival in 1898: "Mary Cassatt, sister of Mr. Cassatt president of the Pennsylvania Railroad, returned from Europe yesterday. She has been studying painting in France and owns the smallest Pekingese dog in the world." Is it any wonder she concluded, "Give me France. Women do not have to fight for recognition . . . if they do serious work."

To Mary Cassatt is universally conceded the title of America's foremost woman painter. Forbes Watson, writing in 1954, put her reputation into proper focus when he added, "Much more interesting and revealing would be a list of the men who painted better than Mary. It would be a very short list."

Breeskin, Adelyn Dohme. *Mary Cassatt: A Catalogue Raisonné of the Oils, Pastels, Watercolors, and Drawings.* City of Washington: Smithsonian Institution Press, 1970.

Hale, Nancy. *Mary Cassatt.* Garden City, N.Y.: Doubleday & Co., 1975.

Lowe, David. "Mary Cassatt." *American Heritage,* December 1973, pp. 11 ff.

Sweet, Frederick A. *Miss Mary Cassatt: Impressionist from Pennsylvania.* Norman: University of Oklahoma Press, 1966.

Henry Cabot Lodge 1850–1924
By John Singer Sargent 1856–1925
Oil on canvas
127 x 86.3 cm
Signed: *John S. Sargent* [upper left]
1890
NPG.67.58

Gift of the Honorable Henry Cabot Lodge, grandson of the sitter

During the summer of 1890, Henry Cabot Lodge, the scholar in politics (as he liked to be called), was painted by John Singer Sargent. Lodge at forty was in his second term as a Massachusetts congressman and was looking eagerly to the time when he might ascend to the Senate seat of Daniel Webster and Charles Sumner. Sargent, his junior by six years, was, as described by Henry James, "the slightly uncanny spectacle of a talent which on the very threshold of its career has nothing more to learn." The brilliant and successful portrait painter had just been engaged to do the mural decoration for the Boston Public Library and was, like his sitter, looking to new fields of conquest. Although both had long and distinguished careers stretching before them—Lodge in fact reaching the zenith of his influence in 1920—the 1890s was a time of satisfaction for them both.

The world of Lodge and Sargent encompassed both sides of the Atlantic, but it was nevertheless a small world peopled by an intertwining network of friends and relatives. It was still almost the same place it had been when Lodge was a boy, and "it was possible to grasp one's little world and to know and to be known by everybody in one's own fragment of society." Not only was it fitting, but well nigh inevitable, that Henry Cabot Lodge be painted by John Singer Sargent.

Sargent, born in Italy of American parents, was twenty before he first saw America. He came in 1876 to visit the Centennial Exhibition and, not incidentally, to establish his citizenship. Although he would continue to live in Europe for most of his life, Sargent never thought of himself as other than American, declining a knighthood rather than lose his birthright.

Like Lodge, Sargent came from what might be considered a privileged background. As the son of a Philadelphia doctor who had given up his practice to live in Europe on his wife's annuity, Sargent had spent his childhood immersed in all the cultural advantages of the Old World. But, with his family continually traveling about in search of health and cheaper living accommodations, it was also a rootless and somewhat insecure childhood.

Sargent's innate artistic talents were encouraged by his mother, and his formal art training began when he was twelve. At fourteen he was enrolled at the Academia delle Belle Arti, in Florence, and at eighteen at the Ecole des Beaux-Arts in Paris. Shortly thereafter he entered the studio of the academic painter Carolus-Duran, and within a very few years his bravura brush strokes were as facile as his master's. A period spent in Holland absorbing Frans Hals and some time in Spain where he was influenced by Velasquez enriched his style. His bold portrait of *Madame* X (Metropolitan Museum of Art), perceived as provocative in décolletage and stance when it was exhibited at the Salon of 1884, shocked the lady, her husband, and most of Paris. Somewhat taken aback by the unexpected notoriety, Sargent moved to London where he met with a ready patronage.

Even before he came to America on his first painting trip in 1887, Sargent was well known in Lodge's world. Charles Fairchild, a wealthy Bostonian, had met Sargent

Henry Cabot Lodge by John Singer Sargent, 1890

in Europe and commissioned a portrait of Robert Louis Stevenson (Taft Museum, Cincinnati) to take home to his wife. Other Sargent paintings had likewise found their way to Boston. T. Jefferson Coolidge, seeing *El Jaleo* in the Salon of 1882, bought it to hang in his home at 93 Beacon Street (now in the Isabella Stewart Gardner Museum). The portrait of the daughters of Edward Boit (Museum of Fine Arts, Boston) which Sargent had painted in Paris in 1883, had also found its way to Boston, hanging in the Boit's home at 170 Beacon Street.

Spending the winter of 1887–88 in Boston, Sargent painted seven portraits, including the exasperating and challenging one of Isabella Stewart Gardner (Isabella Stewart Gardner Museum), the head of which he scraped out eight times before he was satisfied with the result. He stayed, while in the city, with his friends the Boits, in the neighborhood of the Lodges who resided at number 31, Beacon Street. It is more than likely that the artist and his future sitter became acquainted during Sargent's first Boston visit.

There can be no question but that Sargent, descendant of the same Eppes Sargent immortalized by John Singleton Copley (National Gallery of Art), fit nicely into Boston's ancestor-conscious society. Sargent's lines, going back to the Winthrops and the Dudleys, gave him an older and more distinguished ancestry than the vaunted Cabots and the post-revolutionary Lodges. Boston could not but take to its bosom this superb artist of sound New England lineage and cultivated English manners. Sargent felt immediately at home, and it is no accident that some of his best portraits are of Bostonians. He came back to the city regularly until the end of his life, in connection with the mural commissions for the Public Library and, later, the Boston Museum and Harvard's Widener Library. He once told a relative that after London he loved Boston best.

Sargent returned to America on a second painting trip in December of 1889. This time he took a studio in New York, where he was caught up for a while in the world of the theatre, doing portraits of Edwin Booth and Joseph Jefferson (The Players, New York), and the Spanish dancer Carmencita (Centre Pompidou, Paris). However, he made several trips to Boston to appear at receptions given by architects McKim, Mead, & White for the purpose of soliciting subscriptions for the Boston Public Library murals.

In August Sargent came to Nahant, the Brahmin summer colony just north of Boston, to vacation at the home of his friends the Fairchilds. Henry Cabot Lodge was in residence just across the way, and so it came to be that the portrait was painted in the Lodge home by the sea, the place, above all others, that Lodge loved best.

The portrait's success was due in no small part to the artist's response to his sitter. There can be no doubt that Sargent liked Lodge. The summer of 1890 was the beginning of a lifelong friendship between the two men. They dined together often in America, and in England, when Lodge and his family paid their annual visit to Europe. And although Sargent seemed to understand Lodge very well, Lodge, whose strong point was never a sensitive perception of others, understood Sargent less well. Nearly thirty years later, Sargent, in Washington to paint the portrait of Woodrow Wilson (National Gallery of Ireland), spent his first evening in town with Henry Cabot Lodge. Sargent, who during the past twenty years had been becoming increasingly bored with "paughtraits," had reluctantly accepted a commission to paint the president only because his $50,000 fee would benefit the Red Cross. Lodge was delighted that an artist, whose abilities he judged to be unsurpassed at capturing the true personality of the sitter, had agreed to paint the portrait of the man he had come to hate more than he had ever expected to hate anyone. Woodrow Wilson would

at last stand revealed before the world. What a splendid opportunity, Lodge told the apolitical and bewildered Sargent, to serve his party. "I do not judge," Sargent once said, "I only chronicle."

Sargent's painting of Lodge is a cogent portrayal of the man Henry Adams called "Boston incarnate." Some thirty summers later, H. L. Mencken, watching Lodge preside over the Republican National Convention of 1919, remarked on Lodge's "unescapable confidence in himself," "his disarming disdain," "his unapologetic superiority." So, too, is the man as Sargent saw him.

Lodge's self-possession was innate. His world of Beacon Street in the winter and Nahant in the summer was agreeable and secure. At the appropriate time he entered Harvard where he planned, he later confessed, to take his degree "with as little effort as possible, and so arranged my recitations as to give myself the largest possible spaces of uninterrupted time for my own amusements." He belonged to the Hasty Pudding Club and engaged enthusiastically in their theatrical performances, sometimes donning wig and skirt to play female leads. The theatre, he said, was "a field which had always held for me a strong fascination."

In his senior year he "stumbled into Henry Adams' course in medieval history," an event which he regarded as the turning point of his life. He wrote, "Mr. Adams roused the spirit of inquiry and controversy in me. . . . In just what way Mr. Adams aroused my slumbering faculties I am at a loss to say, but there can be no doubt of the fact."

An equally happy event in Lodge's life was his marriage, on the day following his graduation from Harvard, to Anna Davis, a woman of great warmth and wit. She provided a much-needed balance for an imperious husband who always regarded himself with the utmost seriousness. Lodge, a consistent opponent of votes for women, discussed all political matters with her and routinely submitted his speeches for her approval. Wishing to keep his ego in check, his wife might at first dismiss his efforts as "quite impossible" and then gaily concede, after much reworking, "I suppose it is as good as you can do, my poor boy."

On the advice of Henry Adams, Lodge began to study the early law of the Germanic tribes, a "doleful business" but a course satisfying his passion for mental discipline. His dissertation on this topic earned him Harvard's first doctorate in political science. In addition he entered Harvard Law School and took a law degree. He became an assistant editor of Henry Adams's *American Review*; he taught a history course at Harvard. With the publication of the biography of his grandfather, George Cabot, an important figure in Federal New England, Lodge was well on his way to becoming a Boston "literary lion."

Nevertheless he was still restless, looking for new outlets for his ambition. An appointment to the State Board of Library Trustees brought him into contact with the world of practical politics. "When I came to the conclusion I would like to hold office," he recounted, "I did not wait to be requested by friends, but I went out and told the men who had much to do with elections that I would like to run." At the end of the college year in 1879, he resigned his Harvard instructorship and began to campaign for the state legislature. He chose to run from his summer home at Nahant, a district whose population was centered in the manufacturing city of Lynn. He was ridiculed as "Lah-de-dah Lodge," the dude of Nahant who "parted his name and his hair in the middle." (If only his adversaries had known that, because of his rosy complexion, his intimates called him "Pinky".) As it happened, the 150 liquor dealers in the district, fearing the prohibition propensities of his opponent, threw their support to the "silver spoon young man." Thus, at the age of twenty-nine, Lodge was

launched on his political career. Characteristically his first piece of legislation was a bill offered on behalf of the Massachusetts Historical Society for the better protection of old burying grounds.

His early political career was not without reverses. After serving two terms in the Massachusetts lower house, he was defeated when he ran for the state senate. In 1882 he tried, and failed, to gain the Republican nomination for Congress. He retreated temporarily back to the literary world, turning out *A Short History of the English Colonies in America* and, for the American Statesman Series, the lives of Alexander Hamilton, Daniel Webster, and George Washington.

As a delegate to the Republican National Convention in 1884, he worked along with his new friend Theodore Roosevelt to prevent the nomination of the morally tainted James G. Blaine. His devotion to the party of his father and his grandfather received its greatest test when the forces of reform failed, and Blaine became the party nominee. Proper Boston was appalled when Lodge put party loyalty above principles. Old friends crossed the street to avoid him; he was cut dead at his club; he failed to be reelected to the Harvard Board of Overseers. But, once he had made the decision to support Blaine, he never doubted that he was right. His Harvard classmate, Bishop William Lawrence, recalled, "He held himself so aloof, and was apparently so well satisfied that his decision was the right one, that he seemed to assess us as ignorant and short-sighted." Lodge himself was a candidate for a seat in the United States House of Representatives. He went down to defeat with Blaine, losing by only 265 votes out of some 30,000 cast.

Win or lose, however, Lodge was in politics for life. He became acquainted with every political leader in the state and the votes they controlled. In 1886 he was finally elected to a seat in the United States House of Representatives, a position he would hold until the Massachusetts legislature awarded him, at the age of forty-two, the long-coveted seat in the United States Senate. "He ought to have been professor at Harvard College, as I meant him to be when I educated him," sighed Henry Adams as his protégé went on to become chairman of the Foreign Relations Committee and one of the most powerful men in the nation.

Lodge was a hard-working congressman, sedulous in constituent services, taking care of pension claims, seeing that the Civil War veterans received cannons for the decoration of their posts, and occasionally, even though he was in the forefront of those fighting for Civil Service reform, making use of "accursed patronage." He looked out for the economic interests of his district, voting in favor of high tariffs, defending the rights of New England fishermen to the waters off the Grand Banks, seeing to it that the Brooklyn Navy Yard was not built up at the expense of the Charlestown Navy Yard, advocating restriction of immigration. As a member of the Naval Affairs Committee he fought hard to build up a navy. Theodore Roosevelt later would say of Lodge that "more clearly than almost any other man he understood the vital fact that the efficiency of our navy conditioned our national efficiency in foreign affairs."

Just a few months before Sargent painted his portrait, Lodge delivered one of the most dramatic speeches of his House career on behalf of the "Federal Elections Bill of 1890," a measure designed to counteract the disfranchisement of black voters. Speaking on June 26th, Lodge declared, "The Government, which made the black man a citizen of the United States, is bound to protect him in his rights as a citizen, and it is a cowardly government if it does not do it." The bill died in the Senate, the victim of a tradeoff for votes in favor of the McKinley tariff, but Lodge's efforts won him plaudits. "Thy manly speech," wrote John Greenleaf Whittier, "has the ring and is worthy of the best days of Massachusetts—of Webster and Sumner and John Quincy Adams."

Gross, Ellen, and James Harithas. *Drawings of John Singer Sargent in the Corcoran Gallery of Art.* Alhambra, Calif.: Borden Publishing Co., 1967.

Hatch, Alden. *The Lodges of Massachusetts.* New York: Hawthorn Books, 1974.

Hoopes, Donelson F. *Sargent Watercolors.* New York: Watson-Guptill Publications, 1970.

Lodge, Henry Cabot. *Early Memories.* New York: Charles Scribner's Sons, 1913.

McKibbin, David. *Sargent's Boston.* Boston: Museum of Fine Arts, 1956.

Mount, Charles Merrill. *John Singer Sargent.* London: The Cresset Press, 1957.

Ormond, Richard. *John Singer Sargent.* New York: Harper & Row, 1970.

Schriftgiesser, Karl. *The Gentleman from Massachusetts: Henry Cabot Lodge.* Boston: Little, Brown & Co., 1944.

Bertha Honoré Palmer 1849–1918
By Anders Zorn 1860–1920
Etching
32.8 x 25.5 cm (paper); 23.9 x 16 cm (plate)
Signed: *zorn* [in pencil, lower right]; *zrn* [in plate, lower left]
1896
NPG.74.35

The Swedish painter, etcher, and sculptor Anders Zorn first came to America in 1893 as commissioner for the Swedish Art Exhibition of the World's Columbian Exposition in Chicago. Bertha Honoré Palmer was chairman of the Board of Lady Managers. She served, she said, as "the nation's hostess and the nation's head woman servant." She and the artist crossed paths in their official capacities. Zorn was frequently a guest at the many functions Mrs. Palmer held in her "million dollar castle" on Lake Shore Drive, including the famous party in honor of the highest-ranking visitor to the exposition, the difficult Eulalia, Infanta of Spain. The guest of honor attended in a mood of high dudgeon, saying that she did not "wish to meet the Innkeeper's Wife." Mrs. Potter Palmer, the wife of the owner of the famed Palmer House, the palace-hotel that Chicagoans thought to be "the finest hotel in the finest city on God Almighty's earth," remained poised as always and handled the sulky Infanta with dignity and grace.

Mrs. Palmer was an organized woman and an experienced hostess; there was little with which she could not cope. Born into an old Louisville, Kentucky, family, she came to live in Chicago when a small child. Her father, like her future husband, had made a fortune in Chicago real estate, and admission to the highest circles of Chicago society was part of her heritage. Married in 1870 to the forty-four-year-old Potter Palmer, who was twenty-three years her senior and worth close to seven million dollars, she rose instinctively to leadership in the social and cultural life of the midwestern metropolis. She entertained lavishly, filling her house not only with society but also with people of achievement from all walks of life—civic leaders, politicians, reformers, and crusaders.

Among the first of the very rich to take an interest in the lot of the working woman, Mrs. Palmer held meetings in her house for factory girls and pressed for legislation which would improve their working conditions. Following the Haymarket riots and during the Pullman strike, she welcomed representatives of the opposing factions to mediation sessions held in her drawing room. She ran the Charity Ball; she was a leading figure in the Chicago Women's Club and the National Civic Federation;

Bertha Honoré Palmer by Anders Zorn, 1896

she was a fervent supporter of Jane Addams and Hull-House—until they became too controversial. To every cause she contributed not only her name and her funds but her indefatigable energy as well.

Bertha Palmer was, in 1889, the first to introduce French impressionism to the Midwest. Advised by Mary Cassatt, she covered the walls of a seventy-five-foot-long gallery with three tiers of the avant-garde paintings, and it was her social position that enhanced the art and not the other way around.

No doubt about it, in the 1890s Mrs. Potter Palmer was the most influential woman in Chicago. A ficticious character based blatantly on her was made to say, in a novel of 1894, "Keep up with the procession is my motto, and head it if you can. I *do* head it, and I feel that I'm where I belong."

Her appointment, in 1891, to the chairmanship of the Board of Lady Managers gave her a perfect opportunity for the exercise of her particular talents. She set to work with her usual vigor. Traveling to Europe, she visited distaff members of royalty, arousing their interest in the exhibition and enlisting official cooperation. Later, when promised federal money appeared to be in jeopardy, she helped the city of Chicago to entertain a trainload of congressmen. As one of them put it, "We took no note of the time at a reception given by Mrs. Potter Palmer." The $5 million appropriation was secured.

Certainly no one would deny that Bertha Palmer had all the social prerequisites for the job. However, although she was reasonably educated for a woman of her day— she had spent two years being finished at the Convent of the Visitation in Georgetown—she seemed hardly a match for the many "new women" on her committee— doctors, lawyers, teachers, artists, suffrage and temperance leaders. But the rich dilettante surprised them all. From the beginning it was clear who was in command. With tact and an incredible managerial ability she welded the disparate group of 115 women into a formidable force that contributed greatly to the success of the whole fair. "Oh, how she could drive us, day and night," recalled one committee member. "She not only worked herself but made others labor, too. As a committee chairman, I've never seen her equal." Through it all she remained, in the words of her niece, "calm, amiable, quick and capable."

The Women's Building of the fair, designed by Sophia Hayden of Boston, decorated with murals of Mary Fairchild MacMonnies and Mary Cassatt, filled with entries from women throughout the world, was one of the most popular attractions of the exhibition. The display could not but draw attention to women, and Mrs. Palmer succeeded in publicizing their conditions and genteelly ("without touching upon politics, suffrage or other irrelevant issues") underlining their rights. In her speech dedicating the building, she noted, "Even more important than the discovery of Columbus . . . is the fact that the General Government has just discovered woman." Later, at the opening of the Exposition itself, she hit upon what she hoped would be one of the main messages of the female display, equal pay for equal work. It was neither "unfeminine" nor "monstrous" to "take a place beside or to compete with men in the various lucrative industries," she said. "Freedom and Justice for all are infinitely more to be desired than pedestals for a few." Mrs. Palmer went on to say, *I beg leave to state that, personally, I am not a believer in the pedestal theory—never having seen an actual example of it—and that I always suspect the motives of any one advancing it. It does not represent the natural and fine relation between husband and wife or between friends. They should stand side by side, the fine qualities of each supplementing and assisting those of the other.*

"Women," said Mrs. Palmer firmly, must be permitted to work on equal terms with men, to "participate in the industries of the world and find out by experiment

in what classes of work they are fitted by nature to excel." She herself had "a private theory that when the sexes have equal opportunity, and each seeks the direction most congenial to its tastes, the minds of women will be found to turn in more practical directions, and men will prove to be the poets and dreamers of the race." Mrs. Palmer would prove to be a prime example of women's practical turn of mind when, after her husband's death, she exercised a business acumen that doubled his estate.

Mrs. Palmer advocated, on behalf of her committee, *the thorough education and training of woman to fit her to meet whatever fate life may bring; not only to prepare her for the factory and workshop, for the professions and arts, but, more important than all else, to prepare her for presiding over the home. It is for this, the highest field of woman's effort, that the broadest training and greatest preparation are required.* She hoped, she said, in the address delivered at the closing of the fair, that "such a sentiment has been created that from this time forward no woman will be forced to conceal her sex and her identity in order to secure just treatment." Mrs. Palmer said privately that she doubted that men could generally admire "the stupid, superficial fools they have trained us to become." "I suppose it is Mrs. Palmer's French blood that gives her the . . . determination that women should be *someone* and not *something*," her friend Mary Cassatt remarked.

Mrs. Palmer, dedicated though she might be to the cause of woman's rights, had never been one, as the saying went, "to wear the bloomer costume." She believed that women should play up their God-given assets. In the light of her time, she was a stunning figure of fashion, dressed by Worth of Paris and, well aware of the role the spectacular could play in the assertion of leadership, outdoing them all in diamonds and pearls. "There she stands," her husband once remarked, "with $200,000 worth of jewels on her." Below average in height, she nonetheless always managed to look commanding. So unforgettable was she, that James McNeill Whistler, writing of his first visit to Rome in 1891, remembered the city only as "a bit of an old ruin alongside of a railway station where I saw Mrs. Potter Palmer."

Mrs. Palmer's committee, in appreciation of her leadership, presented her with "a large wreath of silver to place over the ostrich tips of her bonnet." Moreover, they commissioned a portrait. Anders Zorn, who had already delighted a number of prominent Chicago women with portraits done in the fashionable, fluent style which had made him a favorite of European society, was an obvious choice for the commission. Even though he had recently broken his collarbone in a fall from a horse, and had the use of but one arm, he continued to paint. Mrs. Palmer was told that Zorn "places himself and his left hand at your disposal to begin your portrait when you will!" This portrait, now in the Art Institute of Chicago, shows her in evening dress and jeweled tiara, holding her ivory gavel as the regal symbol of her office.

In the autumn of 1896, Zorn returned to America, and was welcomed again by Mrs. Palmer's Chicago. During this visit he made a pencil sketch of Bertha Honoré Palmer, depicting her in fashionable daytime dress, a stylish suit with leg-of-mutton sleeves. From this drawing an etching was made.

Mrs. Palmer was forty-seven, and described as "radiant, with fresh skin and brilliant eyes, in the prime of her great beauty." As a result of the publicity generated by the fair, she was a public figure and inundated with letters and requests of every description. The demands on her time were such that a staff of twenty-seven isolated her from the world; even her most intimate friends had to write for an appointment. Once reached, however, she was gracious. Those who knew her well maintained that she was able to brush off flattery as easily as she did criticism. Her experience at running the fair had left her more decisive and authoritative than ever. Without so much as raising her low-pitched voice, she managed things her way, which, she was sure, was the best way.

Bertha Palmer had been, in the year in which Zorn sketched her, looking for new worlds to conquer. Adlai E. Stevenson, the Democratic vice-president, proposed that Potter Palmer be appointed ambassador to Berlin, and his wife campaigned to secure the assignment. However, President Cleveland decided that the post should go to a professional diplomat, and Mrs. Palmer suffered what was one of the very few defeats of her life. Somewhat ironically, shortly before her death, *Hampton's Magazine*, in summarizing her brilliant career in society, business, and philanthropy attributed her success to her diplomatic talents. The author concluded: *If Mrs. Palmer were a man she would make an ideal ambassador. The same qualities that have made her so successful as a mother, as a wife, as a social queen and as a business woman, would make her a successful ambassador. She is democratic, cordial, frank, yet never says a thing she does not want to say and seldom a thing she should not say. Her mental vision extends beyond the present moment, and her keen insight into human nature enables her to tell far in advance what effect a certain speech or a certain act will have. Her poise is perfect.*

Asplund, Karl. *Zorn's Engraved Work.* Stockholm: A. B. H. Bukowskis Konsthandel, 1920.

Chicago, World's Columbian Exposition, 1893, Board of Lady Managers. *Addresses and Reports of Mrs. Potter Palmer.* Chicago: Rand, McNally & Co., 1894.

Farr, Finis. *Chicago.* New Rochelle, N.Y.: Arlington House, 1973.

Ross, Ishbel. *Silhouette in Diamonds: The Life of Mrs. Potter Palmer.* New York: Harper & Brothers, 1960.

Saarinen, Aline B. *The Proud Possessors.* New York: Random House, 1958.

William Dean Howells 1837–1920 with his daughter Mildred
By Augustus Saint-Gaudens 1848–1907
Bronze
20.9 x 33.7 cm
Inscribed: MILDRED. AND WILLIAM.DEAN HOWELLS/
NEW YORK M.D.C.C.C.VIII [upper left]; FROM.
AVGVSTVS.SAINT-GAVDENS [upper right]
1898
NPG.65.65

Presented by artist to sitter. Mildred Howells, who considered it to be the best portrait of her father, gave it to the National Gallery of Art in 1949, from where it was transferred to the National Portrait Gallery. The plaster original is at the Saint-Gaudens National Historic Site, Cornish, New Hampshire; the master bronze is unlocated. Other castings of the reduction are at the Saint-Gaudens National Historic Site and the Musée National du Luxembourg. The double portrait served as a model for smaller individual portrait medallions of Howells and his daughter. One of Howells is at Cornish; one of Mildred is at the Isabella Stewart Gardner Museum; and another is in a private collection

Augustus Saint-Gaudens modeled his friend the popular man of letters, William Dean Howells, in 1897 "for fun," reported the artist's son Homer, "in happy relaxation from the series of important commissions." That year the statue of Peter Cooper was finally completed, almost ten years after it had been commissioned by the "Citi-

William Dean Howells with his daughter Mildred by Augustus Saint-Gaudens, 1898

zens of New York." Chicago's statue of General John A. Logan, ordered seven years earlier, was finished also. Most importantly, on May 31st, the memorial to Colonel Robert Gould Shaw, commander of the black Civil War regiment, the Massachusetts Fifty-Fourth, was unveiled. This last, erected on Boston Common opposite the Massachusetts State House, had been twelve years in the making, and would prove to be Saint-Gaudens's most important work. The sculptor now was primarily concerned with the completion of what would turn out to be the greatest equestrian statue in American art, the Sherman Central Park monument. Already that piece was four years behind schedule, but Saint-Gaudens readily excused delays in his major works, saying that *a sculptor's work endures for so long that it is next to a crime for him to neglect to do everything that lies in his power to execute a result that will not be a disgrace. There is something extraordinarily irritating, when it is not ludicrous, in a bad statue.*

Saint-Gaudens had been, ever since the completion of his realistic statue of Admiral David Glasgow Farragut in 1881 (which stands in Madison Square, New York City), overwhelmed with requests for his services, not only for large public commissions but also for portrait medallions. He had recently turned aside a request to do a bas-relief of his friend Mrs. Jack Gardner, with the observation that *I invariably pass a great deal more time on these serious portraits than I have contemplated and that, unless well paid, it is not worthwhile to undertake them. My interest increases and they always develop far beyond my original intention. That's the way I'm constructed.*

The Howells's bas-relief, however, was something he really wanted to do. Author and artist had been acquainted since the 1880s, when Howells began to forsake Boston in favor of New York. As the editor of *Harper's Weekly* and also as the brother-in-law of Rutherford Mead of the architectural firm McKim, Mead & White for whom Saint-Gaudens was a consultant, Howells moved in the same circles as Saint-Gaudens. The author recalled that their friendship began in earnest at a dinner in 1890, when Saint-Gaudens stilled the chatter of others and said he wanted to hear what Mr. Howells had to say. "What more was needed to make me love him?" wrote Howells in his reminiscences. Two years later, Howells, in his *Harper's* "Editor's Study," praised the bust of General William Tecumseh Sherman, saying that "it seems to express the grandeur of a whole people, a free people, friendly, easy, frank and very valiant." "So in appreciation of that," Saint-Gaudens recounted in his *Reminiscences,* "as well as the deep admiration which I have for his achievement, his principles, and his delightful personality, I begged that he allow me to make his portrait and that of his daughter Miss Mildred Howells." On the 2nd of May, 1897, he wrote to Howells: *I dreamed last night that I was modelling your medallion, probably because my designs on you have matured within the last week. I should like to make a study of you and Miss Mildred, a sketch in clay which would require two or three long sittings from each of you. If you can come and pose I shall be delighted, if not please be perfectly frank with me for I fully understand how you may feel that it would be a too serious loss of time for an uncertain result.*

Howells, a printer's son who couldn't remember a time when he didn't know how to set type, was, in the 1880s and 1890s, with the possible exception of Mark Twain, the most widely read author in America. His was the literary voice of post-Civil War America, dealing with "common American lives" and understanding them "so much better than they understand themselves." Each of his annual novels was a literary event. Published in the influential mass-circulation magazines of his time—*Harper's Weekly, Atlantic Monthly, Century, Scribner's,* and the *North American Review*—his novels, poems, plays, reviews, and editorials were read aloud in family circles all over America. So familiar was this "gentle, quiet, unnoticing-looking little man" that

a Chicago manufacturer begged and received permission to use his name and portrait "on a handsome Cigar Box Label."

Howells was frequently described as "contented looking," an appearance, particularly during the decade of the portrait, which masked frustration and conflict. As he said in a letter to Henry James, "After fifty years of optimistic content with 'civilization' and its ability to come out all right in the end, I now abhor it, and feel that it is coming out all wrong in the end unless it bases itself anew on real equality." The socialist Howells then concluded, "Meantime, I wear a fur-lined overcoat and live in all the luxury my money can buy."

The year 1897 was for Howells characteristically prolific and profitable. In addition to his regular contributions to *Harper's Weekly*, he published *Stories of Ohio* for a juvenile audience, *An Open-Eyed Conspiracy*, and a major novel, *The Landlord at Lion's Head*. The latter, based on a country boy's progress at Harvard, was undertaken by the self-educated Howells in the conviction that his twelve years' residence in Cambridge and his son's recent years at Harvard had given him a sufficiently reliable "intimacy with the university moods and manners." In his Introduction to this novel, in the Library Edition of 1909, he recalled what a difficult task writing it had been. "It made me feel at times as if I should never learn my trade, but so did every novel I have written; every novel, in fact, has been a new trade."

In addition to his writing, Howells had in 1897 undertaken a lecture tour, a lucrative offshoot of his profession but something he ventured only when he suffered the need to feel "safe from poverty." He had just returned from an evening at Smith College, where he *had a very joyous time giving my lecture at Northampton to 500 girls, but it left me terribly exhausted, and resolved not to lecture again. The fact is I find that I hate compliments, and thanks, and tributes. If I could take them ungraciously, all right, but I hang out a grateful grin, which I find stereotyped on my face when I go to bed, and which tires me almost to death.*

The prestigious Howells was still the dean of American letters, but just barely. Within a very few years America would come to find his fiction too commonplace and his criticism too prudish. He would soon be viewed, in the words of H. L. Mencken, as the "Maiden Aunt of American literature."

Twenty-five-year-old Mildred, called "Pil" by the family, was the youngest of the three Howells children and the only surviving daughter. Her sister Winifred, said to have been Howells' favorite child, died in 1889, and from this tragedy her mother never recovered. Mildred from that time was often her father's companion, and he thought it good "to get her surfeit of society early, so that she will know it means nothing and can come to nothing." Earlier, when she was ten, her precocious reactions to Venetian paintings had prompted Howells to write a book around her sketches, *A Little Girl Among the Old Masters*. Later, when Howells was four months short of eighty, she would prompt him to march up Fifth Avenue on behalf of votes for women.

The sittings took place in Saint-Gaudens's small studio on West Thirty-sixth Street, and, although it was only May, Saint-Gaudens recalled "the stifling heat of the tropical summer, which vastly increased my admiration for him and his patience." On his part, Howells remembered that Saint-Gaudens was "perpetually entertaining with stories and reminiscences," talking about "his boyish life in New York, and especially about the old cameo-cutter to whom he was apprenticed, dramatizing him at his polishing wheel, and in his moments of rage." Watching the artist begin with a flat clay tablet on his easel and modeling the surface until a face gradually appeared, Howells found it "most interesting to watch the working of his mind as well as his hand. He changed the position of one of my arms, but changed it back, thoughtfully, almost ruefully." The writer observed that Saint-Gaudens, *like all artists . . . had a*

difficulty in keeping his own portrait out. He especially kept giving my daughter's profile his noble leonine nose. He could not see that he did this, but when he was convinced of it, he forced himself to the absolute fact, and the likeness remained perfect.

In the course of sitting, Saint-Gaudens showed Howells his model of an allegorical figure of Victory which he intended as the lead for Sherman's horse. Howells, the champion of realism, recalled later, "I own I did not like the introduction of the ideal in that group and the Shaw monument, but he defended it strongly, and I have no doubt effectively."

The Howells's double portrait was, however, real enough to have pleased the crusading critic who had proclaimed, "Let fiction cease to lie about life; let it portray men and women as they are." Like the horses in the Shaw memorial, the figures here "seemed almost to breathe." The costumes are modeled with an accuracy of detail that makes them superb documentation for dress of the late 1890s. The furniture might have come out of a Sears, Roebuck catalogue. Howells, Henry James had said, "adores the real, the natural, the colloquial, the moderate, the optimistic, the domestic and the democratic." The writer must have been delighted with this homey vignette of the father reading aloud from his latest manuscript, while the daughter listens with critical attention. A scene, incidentally, which, in the tradition of the Renaissance bronzes, also symbolized Howells's profession.

Commonplace though the medallion may have been in theme, it was far from commonplace in execution. Low-relief carving, an ancient technique, was one that Saint-Gaudens came particularly to admire when, on his first trip to Rome in 1870, he had seen the portrait medals of the Italian Renaissance. The process has been described as something between sculpture and drawing. The artist Kenyon Cox called it "the most delicate and difficult of any of the arts that deal with form alone." He explained, "The lower the relief the more subtle and tender must be the variation of the surface which produces them and therefore success in relief is one of the best attainable measures of any sculptor's skill." A double portrait presents a special challenge, since both faces must be constructed to contrast with each other, depending on the light in which they are viewed. Saint-Gaudens, by building the face of Mildred out of shadow and by emphasizing the highlights of her father's visage, has been successful with both heads. Criticizing his own work some years later, the artist observed, "When I made this medallion I felt very happy about his portrait and unhappy about that of Miss Mildred. Now, ten years later, I see that the reverse would be the proper state of mind."

Once their features were captured in clay, the Howellses, who never spent the summer in New York, were off to Europe. But, after seeing Saint-Gaudens so constantly—a face, said Howells, which was "full of a most pathetic charm, like that of a weary lion"—father and daughter were, Howells told the artist's son, constantly "finding sculptured lions all over Europe that looked like Saint-Gaudens."

Cady, Edwin Harrison. *The Realist at War: The Mature Years 1885–1820 of William Dean Howells*. Syracuse, N.Y.: Syracuse University Press, 1958.

Hough, Robert L. *The Quiet Rebel*. Lincoln: University of Nebraska Press, 1959.

Howells, Mildred, ed. *Life in Letters of William Dean Howells*. Garden City, N.Y.: Doubleday, Doran & Co., 1928.

Kirk, Clara Marburg. *W. D. Howells and Art in His Time*. New Brunswick, N.J.: Rutgers University Press, 1965.

Lynn, Kenneth S. *William Dean Howells: An American Life*. New York: Harcourt Brace Jovanovich, 1970.

National Portrait Gallery, Smithsonian Institution. *Augustus Saint-Gaudens: The Portrait Reliefs*. Washington, D.C., 1969.

Saint-Gaudens, Homer, ed. *The Reminiscences of Augustus Saint-Gaudens.* New York: Century Co., 1912.

Tharp, Louise Hall. *Saint-Gaudens and the Gilded Era.* Boston: Little, Brown & Co., 1969.

Wagenknecht, Edward. *William Dean Howells: The Friendly Eye.* New York: Oxford University Press, 1969.

Edward Hopper 1882–1967
Self-portrait
Charcoal on paper
47 x 30.5 cm
Signed: *E. Hopper Nov. 1903* [lower left]
1903
NPG.72.42.77
Owned by Hopper's friend and neighbor, Reverend Arthayer Sanborn of Nyack, New York

Edward Hopper, who long before his death at the age of eighty-four would be classed in the league of John Singleton Copley, Winslow Homer, and Thomas Eakins, was twenty-one when he drew this self-portrait. Looking fashionably collegiate in his casual attire, Hopper corroborated the impression left on art critic John Canaday, who, eons later, described the octogenarian Hopper as "a rangy, big-boned man whose appearance suggests that he might have been a member of his college crew around the year 1900."

A detailed description of Hopper's personal appearance has been given by Brian O'Doherty, who interviewed the artist several times over a period of four years. Writing in 1964, O'Doherty said: *Physically, Mr. Hopper is made, like Lincoln, for myth. Both he and his wife are exceptionally handsome people with no qualification necessary for age. Mr. Hopper has a global and magnificent head, partly and grandly bald, almost geologically weathered. His blue eyes are set firmly and deep. They stare easily, then slip away deliberately when they have provided the necessary information. His mouth is wide-lipped and generous, connected to a blunt nose by two deep wrinkles that in the other direction zigzag into two spare jowls framing a square, definite chin.* The six-foot-four-plus Hopper, continued O'Doherty, *stands from a sitting position like an Erector set assembling itself, climbing up to higher and higher heights until he passes you and moves on to Alpine altitudes so that one finally looks up at him as one looks at a mountain. Like a mountain, he is difficult to get a perspective on, hovering in the distance, looming up close. In motion he is purposeful and economical as ever. He doesn't waste a thing—a gesture, a brushstroke, a word, a thought.* Added O'Doherty, "His mind seems fundamentally composed of fatalism, detachment and a steady curiosity."

Edward Hopper was a man who didn't change very much—either in appearance, in personality, in life style, or in his art. His "frank and brooding face" looked much as it had at the turn of the century. Ever wedded to elegant sports attire, he habitually dressed in long-wearing but expensive Abercrombie & Fitch clothes, one of his few self-indulgences. Deliberate and taciturn, he remained an exasperating enigma to those who hoped for a verbal exposition of his pictures ("If you could say it in words, there'd be no reason to paint," he once said). When he was forty-two he married

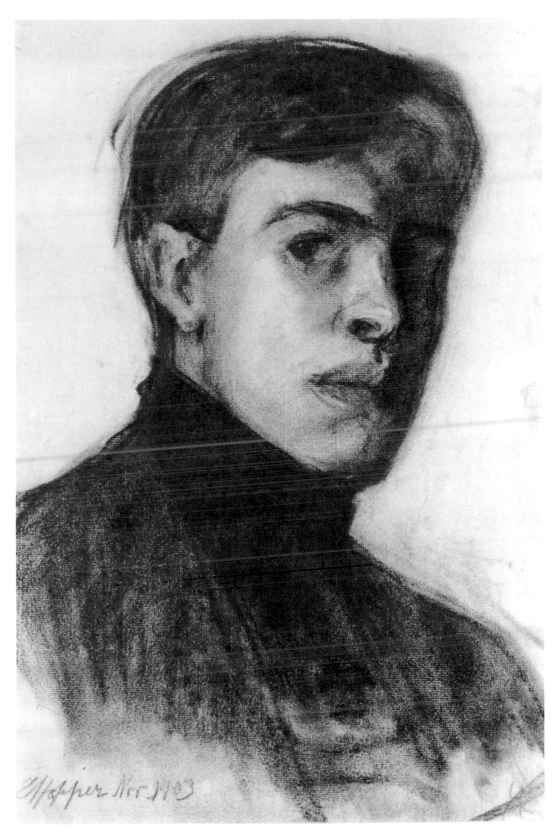

Edward Hopper, self-portrait, 1903

artist Josephine Nivison, and, even after he had achieved considerable financial success, the two continued to live frugally in the Greenwich Village walkup that had been Hopper's home since 1914. After 1930, because Hopper was fascinated by the luminous atmosphere at Cape Cod, they spent six months of the year in the austere home he had designed at South Truro. There were occasional automobile trips—to New Mexico, South Carolina, California, and Mexico, but for the most part the Hoppers' routine was regular and unvaried. For over four decades an active participant in an art world which was in kaleidoscopic change, he never deviated from his set pattern of selective realism.

Hopper, growing up in comfortable middle-class circumstances in Nyack, New York, a Hudson River town not far from New York City, developed two major interests in life, sailing and drawing. After a year spent studying commercial art, he enrolled in what was then called the William Merritt Chase School (now the New York School of Art), where he studied for five years, primarily under the tutelage of Robert Henri. "Few teachers of art have gotten so much out of their pupils, or given them so great an initial impetus as Henri," Hopper later wrote. However, Hopper, who was not interested in sociological message, was always quick to point out that he had never been a member of the "Ash Can School."

In 1906, a few years older than he had been in the self-portrait, Hopper went to Europe for the first of three visits. The ferment then taking place in the world of art—fauvism, cubism, and the beginning of abstraction—"made no particular impression on me." The artists Robert Henri admired—Goya, Manet, and Degas—had a greater impact. Further exposure to the work of the impressionists persuaded Hopper to abandon the dark colors of the Henri days. But, above all, the European experience afforded Hopper the wonderful discovery of a light that "was different from anything I had ever known." By 1910 he had gotten all he needed from Europe; he never went back again. Even this early on, most of the elements of Hopper's style were in place, a style which had been developed relatively free from outside forces. "I've always turned to myself. I don't know if anyone has influenced me much," he said.

Hopper proclaimed, "I paint only for myself. I would like my work to communicate, but if it doesn't, that's all right too. I never think of the public when I paint—never." For a long time he didn't communicate with anybody. Exhibition juries, bewildered by realism untempered by romance, rejected his work. Ironically, he sold his first painting, *Sailing* (Private Collection), at the Armory Show of 1913 which was the clarion call of non-representational art. It would be ten years before Hopper sold anything else. He ceased exhibiting and worked as an illustrator, a job he hated. He wasn't interested, he told Lloyd Goodrich, in drawing people "grimacing and posturing. Maybe I am not very human. What I wanted to do was to paint sunlight on the side of a house."

Hopper's reentry into the world of fine arts came with the success of his etchings, a technique he took up in 1915 and carried on for eight years. "Having done them," his fellow artist Charles Burchfield wrote, "and said what he wanted to so magnificently, Hopper never returned to the medium." In 1922 Hopper painted in watercolors for the first time, and his works in this medium, reported Burchfield, had "a clarity, or better, a chastity of outlook that seems to stem from the New England scene from which so many of them are taken." Two years later Hopper won a showing of his new oils at the Rehn Gallery in New York, and quite suddenly, at forty-two, he was recognized. Beginning with the retrospective exhibition at the Museum of Modern Art in 1933, the rest of his life was crowded with exhibitions, awards, and honors.

Hopper, who was a genuinely modest man, was unimpressed by the stir his art created. To those who proclaimed him one of America's great artists he replied,

"Ninety per cent of them are forgotten ten minutes after they're dead." One "honor," however, delighted him. He told O'Doherty, "One of my paintings was swopped for an Eakins recently." There was a long pause before he added, "That's coming up!'" Eakins, Hopper thought, was "greater than Manet."

In spite of himself Edward Hopper became a public person. He was on the cover of *Time* magazine; he was interviewed on radio; he made appearances on television; on occasion he went to parties. He gave a number of interviews to journalists over the years, but always in the presence of a protective wife who dominated the conversation. O'Doherty remarked that during the sessions with the Hoppers, the artist watched his wife "curiously as if to discover what she thought he thought. When he disagreed with something she said he spoke in a flat monotone from deep in his chest, every syllable as a spondee, falling across the conversation like a roadblock that had to be removed before progressing." Hopper's pessimism, wrote O'Doherty, "is so deep that you can easily get him to agree with you, thus stopping the conversation short of any illumination." Said this interviewer, "I know of no one more secure in his knowledge of the facts, and less convinced of their worth." Lloyd Goodrich found that "a positive statement was usually followed by a partial withdrawal." Even the simplest of statements might be followed by a Hopper qualification. "I like Emerson to read, I guess."

Hopper was a deliberate man and a deliberate painter. It took him a long time to find exactly the right subject, and he never put brush to canvas until the final composition was distinctly formulated in his imagination. During his first trip through New Mexico he could find nothing to paint. Sedulously avoiding the exotic scenery, he finally determined upon a locomotive as the subject for a watercolor. Hopper said, in a 1956 interview in *Time* magazine, *I look all the time for something that suggests something to me. I think about it. Just to paint a representation or a design is not hard, to express a thought in painting is. Thought is fluid. What you put on canvas is concrete, and it tends to direct the thought. I've never been able to paint what I set out to paint.* Hopper told O'Doherty, "So many people say painting is fun. I don't find it fun at all. It's hard work for me."

Asked about his choice of subject matter, the reply was "just things I like to paint." The things were picked from the contemporary American landscape, primarily in New York City and along the New England coast. Early in his career, Hopper, in writing about his colleague Charles Burchfield, reported that Burchfield chose to depict *our native architecture with its hideous beauty, its fantastic roofs, psuedo-Gothic, French Mansard, Colonial, mongrel or what not, with eye-searing colour or delicate harmonies of faded paint, shouldering one another along interminable streets that taper off into swamps or dump heaps.* Hopper often painted the same subjects, but much more simply, adding a glorious interplay of light and shadows. When he worked in watercolors, he painted directly "from the fact," but otherwise his paintings were done in his studio, the elements a composite of observation and memory. "My aim in painting," Hopper said, "has always been the most exact transcription possible of my most intimate impressions of nature." He was not, noted Lloyd Goodrich, "merely an objective realist. His art was charged with strong personal emotion, with a deep attachment to our familiar everyday world, in all its ugliness, banality and beauty."

Hopper's canvases are often peopled with lonely figures who sit in all-night lunch counters, or dress and undress in dingy interiors, or frequent gaudy movie-houses, or stay in seedy hotels or garish motels, or eat in nondescript restaurants, or work in city offices and rural gas stations. They never communicate with each other. They seem, in the words of Thoreau, one of the writers the well read Hopper admired, to be living "lives of quiet desperation."

Katherine Kuh, interviewing Hopper for *The Artist's Voice: Talks with Seventeen Artists*, asked Hopper if loneliness and nostalgia weren't recurring themes in his work. He replied, "If they are, it isn't at all conscious. I probably am a lonely one. As for nostalgia, that isn't conscious either. People find something in your work, put it into words and it goes on forever." "The loneliness thing is overdone," he told another interviewer. "It formulates something you don't want formulated."

"I have no conscious themes," Hopper said. Asked about *Second Story Sun-light* (Whitney Museum of American Art)—which shows two women on a porch, a girl in a bathing suit sunning, and an old lady reading—he said, "This picture is an attempt to paint sunlight as white with almost no or no yellow pigment in the white. Any psychological idea will have to be supplied by the viewer." Queried as to what he was after in *Sun in an Empty Room* (Private Collection), Hopper replied simply, "I'm after ME."

The artist adamantly denied that his pictures were in any way anecdotal. His wife, in describing *Cape Cod Morning* (Sara Roby Foundation), a picture showing a woman at a window, remarked that the figure was looking to see if the weather was good enough to hang out her wash. Hopper quickly contradicted her: "You're making it Norman Rockwell. From my point of view she's just looking out the window, just looking out the window."

Nothing made Hopper crosser than the implication that he belonged to the so-called American Scene painters, the latter-day genre artists who depicted rural midwestern life. He fumed: *The thing that makes me so mad is the American Scene business. I never tried to do the American Scene as Benton and Curry and the midwestern painters did. I think the American Scene painters caricatured America. I always wanted to do myself. The French painters didn't talk about the "French Scene," or the English painters about the "English Scene." It always gets a rise out of me. The American quality is in a painter—he doesn't have to strive for it.* Hopper didn't see why he "must have the American scene pinned on me. Eakins didn't have it pinned on him. Like most Americans I'm an amalgam of many faces. Perhaps all of them influenced me—Dutch, French, possibly some Welsh. Hudson River Dutch—not Amsterdam Dutch."

Among the things Hopper didn't like to paint were self-portraits. "Once—only once—he tried to paint directly his own mirrored face. He couldn't do it," said O'Doherty. In the thousand or so paintings and drawings that Hopper bequeathed to the Whitney Museum, however, two self-portraits turned up, one in oils that he had executed sometime in the 1920s and one in black conte crayon, dated 1945. One other portrait is known from his student days, a pencil sketch done around 1900–1902 (Private Collection). Hopper's very last painting, executed two years before his death, was entitled *Two Comedians* (Private Collection). Two clowns, one of them very tall, take their final bow on a darkened stage. Mrs. Hopper acknowledged, shortly before her death, that the two figures represented her husband and herself.

Burchfield, Charles. "Hopper: Career of Silent Poetry." *Art News*, March 1950, pp. 15 ff.

Canaday, John. *Culture Gulch*. New York: Farrar, Straus & Giroux, 1969.

Geldzahler, Henry. "Edward Hopper." *Metropolitan Museum of Art Bulletin*, November 1962, pp. 113–17.

Goodrich, Lloyd. *Edward Hopper*. New York: Harry N. Abrams, 1971.

Kuh, Katharine. *The Artist's Voice: Talks with Seventeen Artists*. New York: Harper & Row, 1960.

Mellow, James R. "The World of Edward Hopper." *The New York Times Magazine*, September 5, 1971, pp. 14 ff.

O'Doherty, Brian. "Portrait: Edward Hopper." *Art in America*, December 1964, pp. 69–80.

Henry James 1843–1916
By Jacques-Emile Blanche 1861–1942
Oil on canvas
99.7 x 81.2 cm
Signed: *J. E. Blanche*/1908 [lower right]
1908
NPG.68.13

Bequest of Mrs. Katherine Dexter McCormick

"A great masterpiece of civilization was Henry James, a European, altho he remains for us the incarnation and chief type of the cultivated American." Thus spoke the French artist Jacques-Emile Blanche, who had known and painted the master of the psychological novel. The man, like his work, was, as Blanche saw him, "complex and finely shaded in his sensitivity."

Blanche first beheld James in the 1890s in London and Rome, surrounded "by the women who admired him." The two men, both children of privilege, moved in the same fashionable international circles, and it was not long before Blanche would come to observe James as a dinner companion and report that *his face was planned well, with clear-cut features. . . . His hair grizzling already, a little long and silky, was in fine tone with the dull pallor of his face, in which sparkled abnormally acute eyes, a little almond shaped. His finely drawn, ironic and ascetic mouth smiled beneath a nose aquiline as in a Roman medallion.*

One of James's oldest English friends, the poet and literary critic Edmund Gosse, recalled: *I have said that in early life Henry James was not "impressive"; as time went on his appearance became, on the contrary, excessively noticeable and arresting. He removed the beard [in 1900] which had long disguised his face, and so revealed the strong lines of mouth and chin, which responded to the majesty of the skull. In the breadth and smoothness of the head—Henry James became almost wholly bald early in life—there was at length something sacerdotal. As time went on he grew less and less Anglo-Saxon in appearance and more Latin. . . . The beautiful modelling of the brows, waxing and waning under the stress of excitement, is a point which singularly dwells in the memory.*

"No man of letters," said J. M. Barrie, speaking of James, *ever had a more disarming smile than his. . . . It was worth losing a train (and sometimes you had to do that) while he rummaged for the right word. During the search the smile was playing about his face, a smile with which he was on such good terms that it was a part of him chuckling at the other parts of him.*

James's eyes, noted many of his contemporaries, "had a strange power." "They made me feel," said one of his dinner partners, "as if he had read me to the soul—and I rather think he had." Said another, "His eyes were not only age-old and world-weary, as are those of cultured Jews, but they had vision—and one did not like to think of what they saw."

Chance acquaintances were prone to characterize James, in the words of Theodore Roosevelt, as "effete" and "a miserable little snob." The *New York Times*'s London correspondent jeered, after meeting James for the first time, "Henry James is an effeminate old donkey who lives with a herd of other donkeys around him and insists on being treated as if he were the Pope." Those who knew James well, however, were quick to come to his defense. The young Stephen Crane, while conceding that "Mr. James has ridiculous traits," added that "it seems impossible to dislike him. He is so kind to everybody."

"The essential fact," wrote Theodora Bosanquet, James's last secretary, in assess-

ment: *is that wherever he looked Henry James saw fineness sacrificed to grossness, beauty to avarice, truth to a bold front. He realized how constantly the tenderness of growing life is at the mercy of personal tyranny and he hated the tyranny of persons over each other. His novels are a repeated exposure of his wickedness, a reiterated and passionate plea for the fullest freedom of development, unimperilled by reckless and barbarous stupidity.*

At the time Blanche painted James in 1908, the novelist was sixty-five years old, and the three great works which marked him as the master of intricate literary structure and insightful observer of human behavior—*The Wings of the Dove* (1902), *The Ambassadors* (1903), and *The Golden Bowl* (1904)—had been completed. Now that the turmoil and strife associated with his struggle for artistic perfection had been resolved, James himself speaks of having left behind the period of "the passions" and was like, he said, "the quiet Atlantic liner alongside the wharf after the awful days out in the open." He wrote to a friend in anticipation of the New Year, 1908, "No one but myself was ever aware of the unhappy nature of the physical consciousness from which I have been redeemed." Flying, as he expressed it, "in the face of the jealous gods," he blatantly proclaimed, *I am engaged . . . in a perpetual adventure, the most thrilling and in every way the greatest of my life, and which consists of having more than four years entered into a state of health so altogether better than I had ever known that my whole consciousness is transformed by the intense alleviation of it, and I lose time in pinching myself to see if this be not, really, 'none of I.'* He added that "the value of it still outweighs the formidable, the heaped-up and pressed together burden of my years."

The past four years had been strenuous ones, spent in preparing what was to be his literary monument, the collected edition of "all of the author's fiction that he desires perpetuated"—a task that involved the revision of his early works to bring them up to the level of his maturity and the writing of a series of prefaces discussing the history and theory of each work. He wished to call this "The New York Edition," because, as he wrote to his publisher, it "refers the whole enterprise explicitly to my native city—to which I have had no great opportunity of rending that sort of homage." What he came to refer to as "The Nightmare of the Edition," took "such time—*and* such taste—in other words such aesthetic light. No more commercially thankless job of the literary order was (Prefaces and all—*they* of a thanklessness!) accordingly ever achieved." He wrote to his nephew early in April of 1908, saying, *My terror of not keeping sufficiently ahead in doing my part of it (all the revising, rewriting, retouching, Preface-making and proof-correcting) has so paralysed me—as a panic fear—that I have let other decencies go to the wall. The printers and publishers tread on my heels, and I feel their hot breath behind me—whereby I keep at it in order not to be overtaken. Fortunately I have kept at it so that I am almost out of the wood, and the next very few weeks or so will completely lay the spectre.*

The spectre being laid, he was induced to cross the channel yet one more time for a brief visit with his friend Edith Wharton. "Let me come please incognito," he wrote, "masked wholly in motor goggles." James, who shared with Wharton a nostalgia for the past and who constantly bemoaned the new era which "becomes every hour a more impossible century," had nonetheless developed a passion for the greatest of change-bringers, the motorcar. Although he refused to buy a car of his own, he took advantage, to the last drop of petrol, said Edith Wharton, of the vehicles of his friends. There was, however, during this brief fifteen-day stay in mid-April, little opportunity for touring in "the chariot of fire." For, despite James's reluctance to meet the many people of Paris who had been making "those admirable and amiable enquiries for 'cher James,' " he was kept occupied with a full round of social activities,

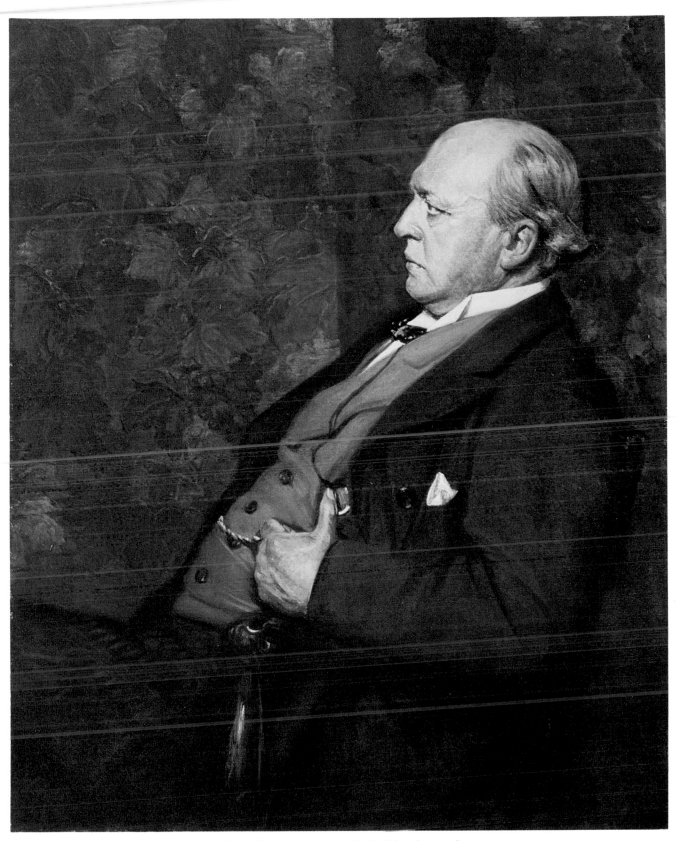

Henry James by Jacques-Emile Blanche, 1908

which included the Sunday open house at Passy hosted by Edith Wharton's new friend, Jacques-Emile Blanche. At Edith Wharton's instigation, James agreed to come back the following week to pose for the artist.

Blanche, writer and, as one art critic had dubbed him, "historian of the artistic and intellectual aristocracy of France," had painted, among others, Edgar Degas (North Carolina Museum of Art), and Claude Debussy (Lyon Museum), and recently, as James wrote, "a rather wonderous thing of Thomas Hardy (Manchester Gallery)—who, however, lends himself." He added that Blanche "does all the billionaires and such like."

The artist, although thoroughly exposed to the artistic influences of both France and England, was essentially self-taught. He claimed that the only serious instruction he had ever received was from James McNeill Whistler, with whom he spent one summer. Despite the fact that he frequented the studios of Degas and Manet and early began to collect the works of the impressionists, he never "became an exponent of broken color, nor has he ever evinced sympathy with the extremes of divisionism and pointillism." He turned, it was noted by the contemporary art critics, to the older masters for inspiration.

As he posed for Blanche, James discoursed at great length in monologue. The novelist was well known for his strong, slow stream of deliberate speech. He talked, said Max Beerbohm, with "great authority," but "there was a great deal of hesitation and gurgitation before he came out with anything; but it was all the more impressive, for the preparatory rumble." Blanche recalled James's "sidesplitting critiques of personality which he risked in the intimacy of my atelier," including depiction of his brother, the eminent philosopher William James. "Dear, dear William," said Henry James, "is so unbelievably, so supremely, so superhumanly and magnificently serene, let him float in the transcendental regions of thought!" "*Je vous envie!*" he told Blanche: it was horrible to write. How much more direct was Blanche's art than his, James said.

James thanked the artist for putting his "decadent features" on canvas; he had been, he apologized, a wretched model because he chattered so much. Later he would write to Blanche, recalling "that happy fortnight of my sittings" and saying that "those delightful hours of mine in your studio affect me as already remote and romantic and as almost fabulous."

In his correspondence to others, however, James worried that his full-face portrait made him look "very big and fat and uncanny and 'brainy' and awful." Although his new amanuensis, Theodora Bosanquet, meeting him for the first time during the previous year, found him to be overwhelming—"more massive . . . much broader and stouter and stronger" than she had expected, James was quick to deny, according to Edith Wharton, that his silhouette had lost firmness and acquired volume. In any case, the artist also was not quite satisfied with the portrait and would have liked more sittings, but wrote that he did not want to worry James about the matter.

The upshot was that when James saw his portrait on display at the New Gallery in London that autumn, it was an altogether different painting. He appeared now in profile, his thumb catching his waistcoat, a characteristic which John Singer Sargent would also note when he came to paint James in 1913 (National Portrait Gallery, London). "The funny thing about it," wrote James, *is that whereas I sat in almost full face, and left it on the canvas in that bloated aspect when I quitted Paris in June, it is now a splendid profile, and with the body (and more of the body) in a quite different attitude; a wonderful* tour de force . . . *consisting of course of his having begun the whole thing afresh on a new canvas after I had gone, and worked out the profile, in my absence, by the aid of fond memory ("secret notes" on my silhouette, he also says surreptitiously taken by him) and several photographs (also secretly taken*

at that angle while I sat there with my whole beauty, as I supposed, turned on. The result is wonderfully "fine" (for me)—considering!

Blanche, however, writing twenty years after the event, said James had no cause to be surprised at the changes because they were made at his own suggestion, with the use of sketches and photographs taken according to the sitter's express wishes; "a carefully studied and endlessly discussed pose."

James, Blanche remembered, did not come right out and say that he wanted "to be painted in the sublime manner," but nevertheless the artist sensed that he would not be displeased to find himself looking like a prime minister. Blanche wrote, *The result is a Poet-Laureate, with a faraway, meditative look, against a William Morris wallpaper of gilded vine leaves and grape clusters—the sort you'd find in the study of an Oxford or Cambridge don. The only imaginative touch I allowed myself—and which ravished James—was a yellow chamois vest which, at his age, he would never have dared wear. I knew that to please him and his admirers, I had to stick to appearances, or at least to moral appearances, and even to accentuate them.* Blanche added that "his moral self also shone from the picture—he had become his own ideal, the paragon of civilization, the English gentleman, politician, man of letters, the spoilt darling and happy, gracious, eternally young man of the world."

In the end Blanche, whom James had earlier characterized as a "do-you-any-way-you-like sort of painter," had pleased both James and Mrs. Wharton, the latter labeling the portrait as "the only one that renders him as he really was." James pronounced final judgment, saying, *I think one sees that it's a chic'd thing, but ever so much less than you'd have supposed. . . . But I really think that (for a certain 'style'—of presentation of H. J.)—that it has, a certain dignity of intention and indication—of who and what, poor creature, he 'is'! It ought to be seen in the U.S.*

The portrait, exhibited at the Salon in 1909, remained in the artist's possession until purchased by Mrs. Katherine Dexter McCormick about 1920. Mrs. McCormick, the daughter-in-law of Cyrus McCormick, was herself a most remarkable woman. A member of the noted Dexter family of Boston, she entered the Massachusetts Institute of Technology in 1896 and graduated with a degree in biology. Within two years of her marriage, her husband Stanley was stricken with a mental illness from which he never recovered. Mrs. McCormick continued the interests she had shared with her husband—art, music, and travel—but in addition began what would become a lifetime crusade for woman's rights. At the time James was sitting for the portrait, she was an active participant in the drive for suffrage.

Mrs. McCormick treasured the Henry James portrait to the end of her life. In June of 1967, regretfully declining to lend it for the opening exhibition of the National Portrait Gallery, she wrote that the picture was "a daily source of pleasure to me. I should not like to have it absent for three months." A little over six months later the ninety-two-year-old Mrs. McCormick died, bequeathing the James portrait to the National Portrait Gallery as "the most appropriate place for it to be hung permanently."

Bell, Millicent. *Edith Wharton & Henry James: The Story of Their Friendship.* Philadelphia: J. B. Lippincott Co., 1972.

Blanche, Jacques-Emile. *Portraits of a Lifetime.* Translated and edited by Walter Clement. London: J. M. Dent & Sons, 1937.

Edel, Leon. *Henry James the Master: 1901–1916.* Philadelphia: J. B. Lippincott Co., 1972.

Hyde, H. Montgomery. *Henry James at Home.* New York: Farrar, Straus & Giroux, 1969.

Lewis, R. W. B. *Edith Wharton.* New York: Harper & Row, 1975.

Lubbock, Percy, ed. *Letters of Henry James* (2 vols.). London: Macmillan & Co., 1920.

Nowell-Smith, Simon. *The Legend of the Master.* New York: Charles Scribner's Sons, 1948.

Belva Ann Lockwood 1830–1917
By Nellie Mathes Horne 1870–?
Oil on canvas
77.2 x 101.6 cm
Signed: *Nellie M. Horne* [lower right]
1913
NPG.66.61

Transfer from the National Collection of Fine Arts; gift of the
Committee of Tribute to Mrs. Belva Ann Lockwood through
Mrs. Anna Kelton Wiley, 1917

Belva Ann Lockwood, teacher, lawyer, for over half a century campaigner for women's rights and world peace, twice candidate for the presidency of the United States, had, in the words of her associates, "won a place with the few who blazed the trail that other women might walk with greater ease and freedom." To honor Mrs. Lockwood, a committee composed of individuals and organizations representative of the causes for which she had worked these many years, raised funds for the commissioning of her portrait in oils. This "enduring memorial" to Mrs. Lockwood was to be executed by "an eminent artist of Boston and New York," and was "to be placed in some national institution which is freely visited by the people of the country." So it was that she took time to sit to Mrs. Nellie Mathes Horne for a portrait which ultimately came to the National Portrait Gallery.

The portrait was unveiled on February 10th, 1913, at a "testimony of esteem" held at the New Willard Hotel. Over three hundred people, friends and co-workers from organizations such as the American Woman's League, the Woman's Professional League, the D.C. Federation of Women's Clubs, the State Equal Suffrage Association, the Woman's National Press Association, the American Penwoman's League, the Woman's Christian Temperance Union, and the Universal Peace Union, were on hand to wave handkerchiefs and small American flags as the portrait was unveiled. In the audience, noted the press, "were many of the famous women of the country, women who are now advocating measures and reforms for which Mrs. Lockwood was ridiculed 40 years ago." Speaker after speaker arose to pay her homage and to recall the achievements of her life. Mrs. Nellie Mathes Horne, the newspapers recounted, was among those who spoke. It can well be imagined that the Maine-born portrait painter shared fully in the glory of this auspicious event.

Mrs. Lockwood, long accustomed to the lecture platform and always in deadly earnest about getting her message across, seized this moment of personal tribute to remind the women present "that if suffrage is granted them, their responsibilities, as well as privileges, will be increased, and that jealousy and gossip must be put aside." She went on to predict that "the vote for women would level classes and make the colored woman as powerful a unit in the government as the white woman."

She also took the occasion to announce her retirement from the practice of law: *I have a great deal of work ahead that I wish to devote myself to. Therefore I shall step out of the practice of law as soon as I can. It's a hard thing to do, you know, once you are in it, but I wish to work on the problems of suffrage, universal peace, temperance and some other reforms in which I have a vital interest.* She concluded by saying that she would soon be traveling to Europe, carrying a peace message to the women there. She was then eighty-three years old.

Shortly after its unveiling, the portrait was put on special exhibition in the lobby of the United States National Museum, the present-day Museum of Natural History

Belva Ann Lockwood by Nellie Mathes Horne, 1913

building. Mounted on an easel, it was prominently displayed at the time of the inauguration of Woodrow Wilson, an event which coincided with the great woman's suffrage parade.

The portrait shows Mrs. Lockwood clad in academic robes with diploma in hand. A few years before, in 1908, she had received an honorary LL.D. from her alma mater, Syracuse University. One cannot help but wonder if the initial suggestion for her costume came from the sitter or the artist. It is tempting to suppose that Mrs. Lockwood may have chosen to be immortalized in academic robes in ironic memory of a graduation ceremony denied her because of her sex. In May 1873, when she had completed the requirements for a Bachelor of Laws degree from the National University Law School, she was refused her diploma because the gentleman graduates feared that their own degrees would be sullied by association. Mrs. Lockwood protested to President Ulysses S. Grant who was, by virtue of his office, president of the National University Law School. She wrote: *You are, or you are not the President of The National University Law School. If you are its President I wish to say to you that I have been passed through the curriculum of study of that school, and am entitled to, and demand my Diploma. If you are not its President then I ask you to take your name from its papers, and not hold out to the world to be what you are not.* Grant offered no reply, but a week later Mrs. Lockwood was summarily handed her degree.

For whatever the reason, the costume was well chosen. There she stands, full of purpose and confidence, determination radiating from every pore, the "National Portia" in all her majesty.

Early in life, Mrs. Lockwood had learned to be self-reliant. Born Belva Ann Bennett to a farming family in upstate New York, she was married by the time she was eighteen to Uriah McNall. At twenty-two, she was left a widow with a child to support. Equipped with a high school education and with some experience at "keeping school," she secured employment in the local Royalston Academy. She earned $3 a week, exactly half of what her male counterparts were paid. Stung by the injustice of the situation, she protested, only to be told that "it was the way of the world." From that time forth she determined to do something about changing the way of the world.

Belva Ann Bennett was ambitious. At a time when few women, least of all those with children, thought about college, she entered Genesee College (later Syracuse University) and in 1857 earned a bachelor of science degree. In the next ten years she was successful as the preceptress in several upper New York State academies, including one that she founded herself in Oswego. Among her innovations was the introduction of gymnastics for the young ladies, a course she personally instructed. She also taught higher mathematics, logic, rhetoric, and botany.

Following the Civil War, she moved to Washington. She came, she later reported, to "this great political centre,—this seething pot" to "learn something of the practical workings of the machinery of government, and . . . see what the great men and women of the country felt and thought." She opened a school for young ladies on Ninth Street, N.W., and immediately became active in the suffrage movement. In March of 1868 she married Dr. Ezekiel Lockwood, a dentist and Baptist preacher who was completely in sympathy with her "advanced views."

At about the age of forty she made up her mind to become a lawyer. Refused admission at Columbian College (later George Washington University) on the ground that the attendance of ladies would be an injurious diversion to the attention of the students, she applied to Georgetown University but again was refused because of her sex. Finally National University Law School agreed to admit her, and she completed the requirements for a Bachelor of Law Degree in 1873.

Even before Belva Lockwood had her degree in hand, she won one of the most important equal rights victories of her career. As a result of her persistent lobbying, a task which involved widespread travel to gain signatures on her petition, the Congress in 1870 passed a bill guaranteeing female government employees equal pay for equal work.

On September 24th, 1873, she was admitted to the Bar of the District of Columbia. However, as a married woman, she was enjoined from practicing before the Court of Claims. Moreover, since there had never been a precedent for admitting a woman to practice before the Supreme Court, she was barred from appearing before that body. In characteristic fashion she launched a vigorous assault against this citadel of male privilege. "I never stopped fighting. My cause was the cause of thousands of women," she later said. "Nothing was too daring for me to attempt. I addressed Senators as though they were old familiar friends, and with an earnestness that carried with it conviction." It took five years of persistent argument, but in 1879, thanks to Belva Lockwood, it became the law of the land that "no person shall be excluded from practicing as an attorney and counselor at law from any court in the United States on account of sex." As a gesture of appreciation, Belva sent bouquets to all the senators who had supported her bill.

She proved to be a competent and successful lawyer, suffering the inevitable sneers, condescensions, and insults with perfect poise. In ways both subtle and obvious she was told, as one judge bluntly put it, "Women are not needed in the courts. Their place is in the home to wait upon their husbands, to bring up the children, to cook meals, make beds, polish pans and dust furniture." Belva brushed aside such remarks as she might flick off a bit of lint from her black velvet suit, and continued her argument in short, clipped sentences, her blue-grey eyes flashing in intensity. She handled cases in equity, divorce, contracts, settlements, and injunctions. She specialized in claims against the government and, as one of the attorneys for the Cherokee Indians, won from the Supreme Court a $5 million claim ($4 million of which was interest) on money owed the Indians since 1835.

Hitting her stride in the high Victorian era, Belva Lockwood was anything but the image of sweet womanhood on a pedestal. Instead, she seized upon the image of Victoria as a ruler of an Empire. "Is not history full of precedents of women rulers?" she asked. Disgusted when the Republican convention of 1884 gave no recognition to the rights of women, she refused to follow when Elizabeth Cady Stanton and Susan B. Anthony urged support for James G. Blaine. When a group of California suffragists organized the National Equal Rights Party, she accepted their nomination and, forty-four years before passage of the Nineteenth Amendment, Belva Ann Lockwood became the first woman to run formally for president of the United States. She reasoned that, although "women in the States are not permitted to vote, there is no law against their being voted for. . . . We shall never have rights until we take them, nor respect until we command it. Reforms are slow but they never go backwards." Lockwood took her candidacy, just as she did everything else in life, very seriously, bringing to bear all of her intellect and vigor. She formulated a forward-looking platform, in which she promised to "seek a fair distribution of the public offices to women as well as men, including the Supreme Court of the United States." She promised to "protect and foster American industries," and to work for an end to the liquor traffic, for uniform marriage and divorce laws, and for citizenship for the Indians. She carried on an active campaign, speaking in New York, Chicago, Cincinnati, and Cleveland. Conscious that her dignified visage would lend credibility to her campaign, she distributed her picture on posters and buttons. These would, it was thought, "have a wholesome effect on the male voters."

Her candidacy generated much publicity, most of it in the form of mockery and

ridicule. The great majority of her colleagues in the suffrage movement were aghast, feeling that Lockwood was bringing on their cause "an abundance of odium and contempt at a time when it was commanding respect and enlisting help. The damage done by her and a little band of eccentric zealots in San Francisco cannot be estimated." Lockwood was accused of self-aggrandizement, and her campaign was seen as an advertisement for her own law practice. She was, however, sincerely convinced that if her party could get one elector, the campaign would have become "the entering wedge—the first practical movement in the history of Woman Suffrage." She never came close, garnering but 4,149 votes of the more than ten million cast. Undaunted, she ran once again in 1888 "to make America conscious of women's right to political equality." Her running mate this time was the pacifist Alfred H. Love, a combination which pleased the press but produced further sighs from the mainstream suffragists. On her part Belva Lockwood maintained, "Women in politics have come to stay."

In her eighties, she looked and acted little differently than she had when running for president in her sixties. She was just as energetic, just as engrossed in public affairs. The only difference was that later in her life she became increasingly absorbed in efforts for world peace. Then she was described as flourishing a banner which said "Woman's Rights" on one side and "Peace" on the other. She never lost her relish for meetings, banquets, lectures, and petition drives. The year in which her portrait was painted, she reported that she had attended sessions of the National Council of Women, the Federation of Women's Clubs, the International Law Congress, and all the woman's suffrage events, including a dramatic parade up Pennsylvania Avenue on the day before Woodrow Wilson's inauguration. She would remain an active participant in the affairs of the nation and the world up until three weeks before her death. Ironically the headlines, on the day that her demise was announced in the *New York Times*, read "President Calls the Nation to Arms; Draft Bill Signed/Regulars Under Pershing to Go to France." Nevertheless Belva Lockwood had the satisfaction of knowing that victory for her other great cause was at hand. She observed, not long before the end of her life, "Suffrage is no longer an issue. It is an accomplished fact. The states which have denied it to women will come around."

Mrs. Lockwood lived not far from the site where her portrait now hangs, at 619 F Street, N.W., where she had a twenty-room house with a large English basement which served as her law office. Her establishment was, for nearly forty years, the meeting-place for those who shared her many concerns. All of the "progressive and advanced" women of her day visited that house, it was said. Sadly, the year after the portrait was painted, she met with financial disaster and, at the age of eighty-four, was dispossessed of her home and belongings by a court ruling.

For all her look of confidence, Lockwood's life had not been without many tragedies. Her second husband had died in 1877, and she lost the only child of that marriage at the age of eighteen months. The child of her first marriage, Mrs. Luna M. Ormes, who had become her mother's law partner, met an untimely death in 1894. Mrs. Lockwood thereupon assumed the responsibility of raising her three-year-old grandson. In after years her grandson would recall his grandmother as a very determined and independent old lady. Most vividly did he recall her riding her three-wheeled bicycle all around the city and up to Capitol Hill.

In 1897 Mrs. Lockwood, in answer to a query as to whether she considered herself to be "a new womam," summed up her life and beliefs: *As a rule I do not consider myself at all. I am, and always have been a progressive woman, and while never directly attacking the conventionalities of society, have always done, or attempted to do those things which I have considered conducive to my health, convenience or*

*emolument. . . . I do not believe in sex distinction in literature, law, politics, or trade;
or that modesty and virtue are more becoming to women than to men; but wish we
had more of it everywhere.*

Nellie Mathes Horne seems to have understood her subject well.

Stern, Madeleine B. *We the Women.* New York: Schulte Publishing Co.,
 1963.

Isadora Duncan 1878–1927
By John Sloan 1871–1951
Etching
35.5 x 27.8 cm (paper); 22.8 x 19 cm (plate)
Signed: *John Sloan* [in pencil, lower right]; *John Sloan 1915*
[in plate, lower left]
1915
NPG.71.12

Gift of Mrs. Helen Farr Sloan

John Sloan first met Isadora Duncan in November of 1909. In honor of the impend-
ing occasion, at the salon of art patron Mary Fanton Roberts, he noted in his diary
under the date of November 11th: "Drew out $25.00 from Saving Fund to buy a suit
of clothes as Mrs. Roberts has invited us to meet Miss Isadora Duncan the famous
interpretive dancer coming Sunday evening. . . . Rushed out at 5:30 and bought a
black suit of clothes at Rogers Peet & Co."

The flamboyant Isadora, now on tour in her native land, was fresh from Europe
where she had won acclaim and adulation. In Paris, "all the well-known artists paid
her homage and made drawings of Isadora," reported the American sculptor Jo David-
son, who, himself, "filled books with sketches made at her performances."

Scornful of the classical ballet, Miss Duncan had created a whole new dance form
based on what she called "natural movement"—improvisation—done to the unlikely
music of Bach, Beethoven, Wagner, and Gluck. "Listen to the music with your soul,"
she told her students. What people called her "Greek dance" had, she said, its origins
in her grandmother's Irish songs and jigs, the "gestures of the Redskins," and perhaps
even the addition of a "bit of Yankee Doodle."

This free spirit, dancing in bare feet, and dressed in body-revealing tunics, shocked
many in early-twentieth-century America. In Washington her "pagan" performance
evoked a storm of protest from the clergy. President Theodore Roosevelt went to see
for himself, and wrote, "What harm can these Ministers find in Isadora's dance? She
seems to me as innocent as a child dancing through the garden in the morning sun-
shine and picking the beautiful flowers of her fantasy."

At their first meeting, John Sloan was less than overwhelmed by this priestess of
the new art form. Two days later, however, he saw her perform and realized that "I
did not know all her art stood for when I met her at Roberts' on Sunday." Enrap-
tured, he began: *Isadora Duncan! It's positively splendid I feel that she dances
a symbol of human animal happiness as it should be, free from the unnatural tram-
mels. Not angelic, materialist—not superhuman but the greatest human love of life.*

Her great big thighs, her small head, her full solid loins, belly-clean, all clean—she dances away civilization's tainted brain vapors, wholly human and holy-part of God. Isadora herself could not have expressed it better.

Two years later, in 1911, Isadora was once more dancing in America and sent the Sloans tickets to her February 15th performance in Carnegie Hall. She danced to music from Wagner's *Tristan and Isolde,* and Sloan recorded in his diary: *It's hard to set down how much I enjoyed this performance. Isadora as she appears on that big simple stage seems like all womanhood—she looms big as the mother of the race. A heavy solid figure, large columnar legs, a solid high belly, breasts not too full and her head seems to be no more important than it should to give the body the chief place. In one of the dances she was absolutely nude save for a thin gauze drapery hanging from the shoulders. In none was she much clothed, simple filmy coverings usually with a loin cloth.*

On March 2nd, Sloan watched her from a lower-tier box seat and experienced that "real ecstatic enjoyment I get from her beautiful work, it's tremendously fine." Sloan, now aged forty and still two years away from selling his first picture, began a painting of the dancing Isadora the next day. He proceeded in the usual way he did his "city pictures": not from life but from memory which, he said, "is the most real." The portrait (Milwaukee Art Center) was finished on March 14th. Later he was to say of it, *No painting that I could possibly produce could express my adoration for Isadora. This attempt made soon after seeing her marvelous dancing goes to prove it, I fear. My excuse must be that I viewed her through a mist of unshed tears. She lifted human movement to the level of the divine. We ne'er shall look upon her like again.*

Sloan attended Miss Duncan's final American performance and *had the pleasure of hearing her give a simple, tender, brave little farewell speech so honest claiming only to have started something an American expression in dance. She hoped that her work would start little girls of America to cultivate that means of human expression. It was fine to hear a real artist make a statement of simple principles.* No doubt this reference to a native American art form was especially appealing to an artist who would never go to Europe and who prided himself on being free of foreign influence.

By the time John Sloan next saw Isadora Duncan, she had known great tragedy. In 1913 her two young children had been drowned in the Seine when the automobile in which they were riding rolled down an embankment. This disaster coming, as Isadora wrote, "in the full power and energy of life," had "completely shattered my forces and powers." The year following, she lost a baby at birth, and at that moment, she said in her autobiography, "I reached the height of my suffering that can come to me on earth." As war broke out in Europe, her school of dance on the outskirts of Paris was turned into a hospital. She embarked, therefore, with all her students in tow, for New York, arriving in October 1914. Shortly thereafter, she danced at the Metropolitan Opera House, her first public performance since the death of her children.

Sloan saw her on a number of occasions during this visit. Years later he recalled, *When this great American and International high priestess of the dance returned from France at the outbreak of World War I for her first appearance in two years after the tragic death of her children, she lacked slenderness, but was still, in my opinion, the greatest dancer on earth.* Isadora, at thirty-seven, was "quite heavy but still beautiful."

He attended her performances, and came also to her studio where she entertained "artistic" New York and attempted to obtain financial backing for an American temple of dance from which children could "come forth with great strides, leaps and bounds . . . to dance the language of our Pioneers." At one of these private perform-

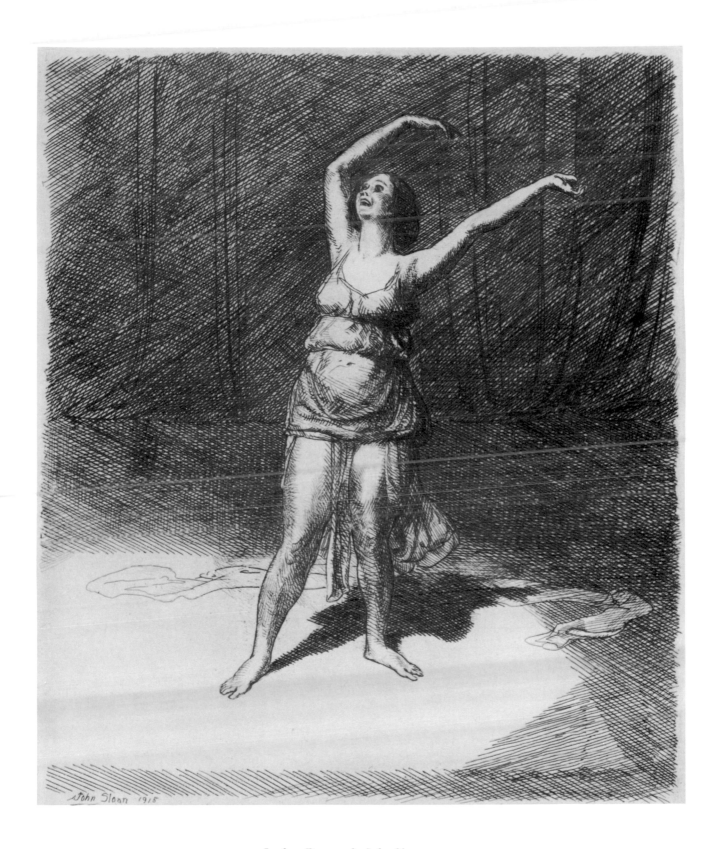

Isadora Duncan by John Sloan, 1915

ances, Sloan reported to her brother Raymond, "I improvised a dance with Isadora,—nearly fell to the floor catching her."

Isadora's visit to America was brief. Outraged by many things, including the financial failure of her production of "Oedipus," the lack of intent in her "college of priestesses" for the religion of the dance, and the eviction of her school by the New York fire department, she departed for Europe on May 9th, 1915, leaving New York to "Philistine darkness."

Before she left, Sloan had portrayed her several times: in monotype, in a drawing done for the Socialist organ, *The Masses*, for which he was briefly the art editor, and in an etching dated (in a proof of the first state) March 17th, 1915.

In the late 1880s, Sloan had taught himself, out of a book, the art of etching. It was a medium he regarded as equal in importance to painting, and he continued to work in this area throughout his life. Every print of an etching, he said in *Gist of Art*, "is a handmade thing, the personal work of the artist, yet it may be put out in great quantity as a means of reproducing the artist's concept."

Sloan afterwards, in lecturing to his students, used the Duncan print to illustrate the pains he took with the etching process. He said: *After the first trial proof there are usually many many states. I don't recall any plate which came off successfully in the first biting. The Isadora Duncan plate has at least forty states, all different, particularly when I was working on the head. I hardly know the difference in many of them myself, just a change of a line here or there, scraping down, pounding up from the back. . . . I am not a skillful craftsman but I have patience, and I always struggle through with a thing.*

To Sloan, Isadora Duncan's movements could be compared to the execution of a well-developed drawing. Follow the technique Isadora used in the dance, he told his students: *Get hold of a theme, not just a recurrent chord, a lot of little repeats and variations. Make a living organization. Go after the big rhythms not the embellishment of the theme, just as Isadora Duncan, when she danced, followed the big movements and paid little attention to the lesser oranamentation of the music.*

Brooks, Van Wyck. *John Sloan: A Painter's Life*. New York: E. P. Dutton & Co., 1955.

Duncan, Isadora. *My Life*. New York: Liberight Publishing Corp., 1927.

Morse, Peter. *John Sloan's Prints*. New Haven: Yale University Press, 1969.

St. John, Bruce, ed. *John Sloan's New York Scene, from the Diaries, Notes and Correspondence 1906–1913*. New York: Harper & Row, 1965.

Seroff, Victor. *The Real Isadora*. New York: The Dial Press, 1971.

Sloan, John. *Gist of Art*. New York: American Artists Group, 1939.

William Merritt Chase 1849–1916
Self-portrait
Monotype
22 16.5 (paper); 19.8 x 15.1 (plate)
Unsigned
Circa 1915
NPG.69.26

Remained in the artist's private collection until his death, and passed into the possession of one of Chase's grandchildren

William Merritt Chase, the most facile and influential painter in turn-of-the-century America, relished painting his own countenance as much as he delighted in painting

glowing brass and glittering fish. Whatever the subject matter—be it landscape, still life, portraits of family and friends—Chase worked with hearty enthusiasm. In this instance he had chosen to draw a self-portrait on an unetched plate and from it pull a unique print, *i.e.* a monotype.

Since the original drawing is removed completely by the paper, the monotype is neither an original drawing nor a print, but something falling between the two. Edgar Degas described the medium as well as anyone, when he called monotypes "drawings done with greasy ink and printed." Giovanni Benedetto Castiglione had utilized this medium in the seventeenth century, and the form had come into vogue again in the last quarter of the nineteenth century. Dr. Charles A. Miller, a member of the National Academy of Design, saw the process demonstrated at one of its meetings in 1879 and soon thereafter gave a presentation for his fellow members of the Art Club in New York. Dr. Miller reported that "Mr. Chase and others experimented with the fascinating possibilities" of this process. Chase, who exhibited a monotype at the New York Academy in 1881, was said to have been the first to show monotypes in America.

In common with many other artists of his time, Chase found the technique exhilarating. Since the printing process could be but partially controlled, chance played a role in determining the values and contrasts of the finished work. The monotype was an ideal vehicle for experimentation and in its nature tended to be a very personal rendition. Chase did several other self-portraits in monotype.

Gilbert Beal, one of Chase's students, recalled that "his dress was always immaculate. I have seen him paint many times in a white flannel suit, holding a palette and brushes, without getting a spot on his clothes!" One is intrigued with the vision of the fastidious Chase working vigorously with the piece of rag which was the indispensable tool of the monotypists. It can well be believed that he rubbed with élan.

There was no question but that Chase was an elegant man with a well-developed stage presence. Another student, Harry W. Watrous, described Chase as his contemporaries remembered him: *I always recall the picture he made, a gallant gentleman, the cynosure of all eyes, with mustache slightly tilted, sauntering down the Avenue wearing a flat brimmed French silk hat, a broad black ribbon hanging from his glasses, and accompanied by a beautiful white Russian wolfhound, that seemed proud of his Master.*

Seeing him thus, it was hard to realize that Chase's roots were in midwestern America. Born in a small town in Indiana, he worked first in his father's dry goods store and later in the expanded business which became "Chase and Cady Ladies' Shoe Store" in Indianapolis. Impressed by his precocious ability for capturing the likenesses of family and friends on scraps of brown wrapping paper, his father indulged him in lessons with a local art teacher. Later, as a restless and romantic adolescent, he signed on as a sailor for a three-month ocean voyage, a traumatic experience for a sensitive boy with no capacity for developing "sea legs." It turned out to be, however, almost the only ill-considered action in an otherwise fortunate life. Rescued by his father, he went to New York to study art with the portrait painter J. O. Eaton. After two years of training, he settled in St. Louis, Missouri, where his family was now living, and set himself up as painter of portraits and still lifes. Four local businessmen, recognizing his already obvious talents, proposed to finance his European art training in return for portraits. In 1872, when Chase was twenty-three, he entered the Royal Academy at Munich and proved to be remarkably adept at the slashing broad brush stroke which was the hallmark of the Munich style. At the end of the six years spent in Europe, primarily in Germany but with nine months in Venice, he was offered a professorship at the Royal Academy. He declined the honor in favor of a return to America, where he established a New York studio and taught at the recently reorganized Art Students' League.

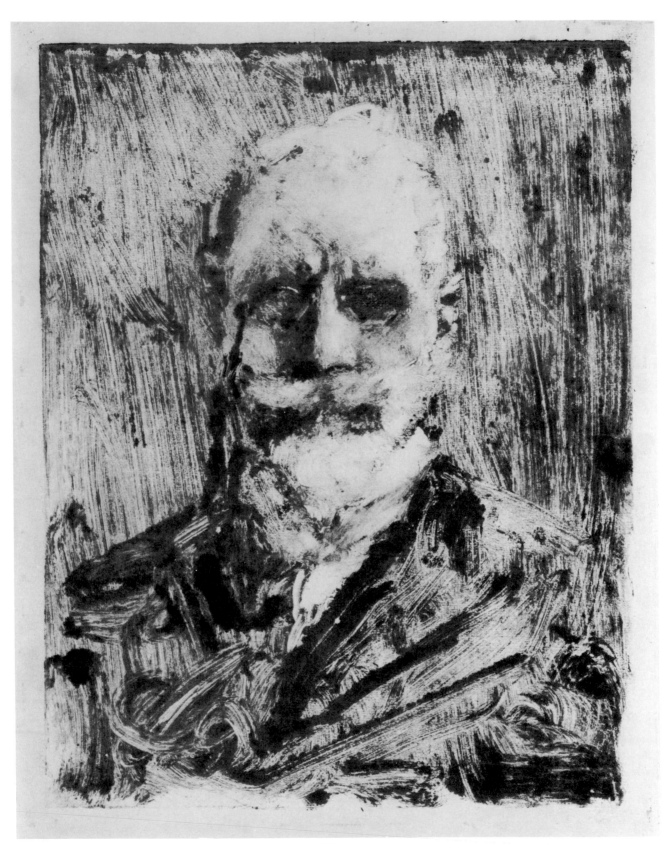

William Merritt Chase, self-portrait, c. 1915

Chase's reputation had preceded him to America. *The Jester,* which he had exhibited at the Centennial Exhibition in Philadelphia (Pennsylvania Academy of the Fine Arts) had won him a medal and recognition as a sound professional. Moreover, he had an engaging personality and a finely honed instinct for attracting attention just short of notoriety. Within a year, by the time he was thirty, he was enveloped in the aura of an old master.

A fellow member of the National Academy recalled: *Mr. Chase, upon returning to New York, virtually took the town by storm, capturing its chief artistic citadel, and. . . . the Tenth Street Studio became the sanctum sanctorum of the aesthetic fraternity, affording midst painting, statuary, music, flowers, and flamingos (stuffed), etc. symposia most unique and felicitous, never to be forgotten by the charmed participants.* Guests to his studio were announced by a servant dressed in gown and fez. At various times his menagerie included, in addition to the dogs, brightly colored jackdaws and white cockatoos. Not since the days of John Wesley Jarvis had the American art world been treated to such a spectacle.

Unlike Jarvis, however, Chase was no bohemian. He dazzled, but always in a dignified way. His carefully cultivated appearance was, noted one of his students, part of his teaching by example. "He hated slovenly technique and sloppy students." The student went on to say that Chase was *one of the men to dignify the profession of painting in this country, and saw no connection between great art and a velvet coat, tam-o-shanter, long hair, and other paraphernalia of the proverbial artist. With him the artist emerged from that particular phase and took on the appearance of other men. His dress was part of art psychology. As students it made us respect him the more and, in turn, respect ourselves.* It was clear, nonetheless, that Chase was never ordinary. He was ever aware, as he often told his students, of the danger of seeing things "in a tiresome way."

Above all, Chase was a great teacher. He once said, in an interview published in the *American Magazine of Art,* that he had more "art children than anyone else in the world." The remark, made in jest, was quite true. He probably taught and inspired more American artists than any other teacher before or since. In 1896 he started the famous "Chase School" and after the turn of the century began his equally famous student trips abroad. Summers not spent in Europe were spent teaching landscape painting at the summer school on Shinnecock Hill on Long Island. In 1906 he began to teach at the Pennsylvania Academy of the Fine Arts, and near the end of his life, the summer of 1914, he held classes in Carmel-by-the-Sea, California. For over thirty-five years, art students sought him out as the best there was. Among his students were Alfred H. Maurer, Marsden Hartley, Gifford Beal, Rockwell Kent, Charles Demuth, Charles Sheeler, Guy Pène du Bois, and Georgia O'Keeffe. They were all taught the dictum of "spontaneity and quick observation" and schooled in the technique of the long quivering brush stroke. Almost all of them were swept along by his overwhelming personality, but the greatest of them nonetheless emerged from Chase's teaching uninhibited and ready to develop their own individual styles.

By the time the monotype was executed, Chase could look back on years of prodigious work and satisfying accomplishment. Eminently successful as a teacher and as an artist, happy as a husband and father of eight children, he had every reason to regard life with affirmation. His attitudes were invariably positive and optimistic; he was chronically cheerful. Typical of him was the oft-repeated remark that he would like to see written over the door of art exhibitions: "These pictures were put here for your pleasure, not your criticism."

Judging from Chase's appearance, the monotype must have been done near the end of his life. He looks much as he does in the self-portrait, dated 1915, inscribed

"To my friend Annie T. Lang" (Corcoran Gallery of Art), and in another, done about the same time and presented by him to the Detroit Institute of Arts, and in still a third, finished in November 1915 for the Art Association of Richmond, Indiana. This last, commissioned as a bust portrait, was executed by Chase who, as his biographer pointed out, "delighted in doing the generous thing" on a large canvas, showing a three-quarter-length figure posed before his easel. A fourth self-portrait, painted around 1916, is in the collection of the Brooks Memorial Art Gallery, in Memphis, Tennessee.

During the summer of 1914, when Chase was teaching summer classes in California, he wrote to his wife, discussing some monotypes he had just made. "I found that impressions could be had with a clothes wringer so I got one. I will send you some to show you what I am doing in that line." In a subsequent letter he wrote: "I made some monotypes in the studio this afternoon. Tomorrow I will send you some. I played a short game of billiards and was beaten." It is altogether possible that the self-portrait was among the monotypes executed during that summer at Carmel-by-the-Sea.

California University, Santa Barbara Art Gallery. *The First West Coast Retrospective Exhibition of Paintings by William Merritt Chase*. Santa Barbara: 1964.

Newhouse Galleries. *Paintings by William Merritt Chase*. St. Louis, Mo.: 1927.
Roof, Alice Gerson. *The Life and Art of William Merritt Chase*. New York: Charles Scribner's Sons, 1917.

Helen Keller 1880–1968
By Onorio Ruotolo 1888–1966
Plaster life mask, painted
38.1 cm height
Unsigned
1916
NPG.75.16.78

Presented by the artist to his son

"I still believe that the welfare of each person is bound up in the welfare of all, but the work for the blind is the only kind that suits my slender capacities, and I can only dream, will and hope for a civilization on which the cornerstones shall be Liberty, Brotherhood, Truth and Service." So wrote Helen Keller on April 4th, 1958, to Onorio Ruotolo, the sculptor who, forty years earlier, had taken her life mask. Sharing a similar concern for the lot of the handicapped, the poor, and the disadvantaged, artist and sitter kept in touch throughout their lives.

Ruotolo regularly sent Helen Keller contributions for the American Foundation for the Blind, regretting, he told her, that he had not a million dollars to give. She replied, "Onorio, as you and I know, caring about human need is the only wealth that can truly lead the poor and hindered out into the light of freedom and equality, and because of that spirit your donation is priceless to me." Keller, who had been studying Italian when she first came to know the sculptor, apologized that she had not kept up with that language well enough to write to him in his native tongue.

In a letter of March 9th, 1945, she shared with her friend the excitement and op-

Helen Keller by Onorio Ruotolo, 1916

timism she felt during her travels around the country to visit the wartime wounded. *Something new under the sun is happening. We witnessed miracles of rehabilitation wrought by surgeons, physicians and scientists that are enabling multitudes of injured servicemen to recover their power to work, communion with normal people and even zest in living. The fortitude even of the most cruelly wounded and their facing the future with a will to victory over all kinds of handicaps is an unanswerable challenge. They are part of the mighty tide setting in to sweep away the enslavement and ignorance which still blight civilization, and give each individual a chance to be understood, developed and encouraged to live creatively.*

Helen Keller was thirty-six when she sat to Ruotolo at his New York studio on East Fourteenth Street. She had been famous since she was ten years old. Although she was born a normal child, a raging fever at the age of eighteen months had left her blind and deaf, and, as a consequence of the latter, mute as well. "Phantom," as she thought of herself during her early years, grew up "wild and unruly, giggling and chuckling to express pleasure; kicking, scratching, uttering the choked screams of the deaf-mute to indicate the opposite." When Keller was a few months short of seven, Anne Sullivan, a young graduate of the Perkins Institute for the Blind in Boston, arrived in Alabama to undertake the formidable task of educating this seemingly unreachable child. By spelling over and over again into her pupil's hand, Miss Sullivan made Helen understand that everything had a name. Helen Keller, writing *The Story of My Life* in 1902, described the moment of breakthrough. Her teacher placed her hand under the well spout, and *As the cool stream gushed over one hand she spelled into the other the word 'water,' first slowly, then rapidly. I stood still, my whole attention fixed upon the motions of her fingers. Suddenly I felt a misty consciousness as of something forgotten—a thrill of returning thought; and somehow the mystery of language was revealed to me.* Within three years, through the use of the manual alphabet and the Braille system, Helen Keller could read and write. By the time she was ten, she determined to learn to talk, and, although she was never able to attain "normal speech," she could be understood well enough by those accustomed to hearing her. With Anne Sullivan at her side, Helen went through the normal course at Radcliffe, graduating *cum laude* in 1904. Miss Sullivan's persistence and imagination, combined with Helen's high intelligence and wonderful curiosity, had wrought what many would call a miracle.

Thanks in no small part to Miss Sullivan, Helen Keller was emotionally, as well as intellectually, prepared to be, as the *New York Times* put it after her death, "in and of the world, a full and happy participant in life." Miss Keller wrote, in tribute to her teacher: *She treated me exactly like a seeing and hearing child, the one exception being that instead of speaking words to me she spelled them into my hand. She never allowed anyone to pity me or adopt the overprotectiveness that can render blindness such a tragedy. She did not allow people to praise anything I did unless I did it well, and she resented it with spirit if anyone addressed himself to her instead of to me as they would do a normal child. She encouraged my family and friends to talk to me freely about everything so that I could acquire language more rapidly.* From the first, Miss Sullivan determined that all of her pupil's questions would be answered, and that they would be answered honestly; the unpleasant was never kept from Helen Keller. When, in 1936, Anne Sullivan was near death, a friend exhorted, "Teacher, you must get well. Without you Helen would be nothing." "That would mean," Miss Sullivan replied, "that I have failed." She hadn't. Helen Keller went on for thirty-two more productive years, writing, lecturing, and traveling the world, sending out a message of triumph over adversity and affliction. "Life," Helen Keller maintained to the end of her eighty-seven years, "is either a daring adventure or nothing."

At the time Ruotolo came to know her, Helen Keller was in her active Socialist phase. Keenly aware that her own accomplishments had been made possible by fortunate circumstances, she was troubled by life's inequities. She joined the Socialist party in 1909. Even as she accepted an annuity from Andrew Carnegie and spent her life soliciting funds for her work for the blind from other capitalists, she remained committed to the principles of Socialism.

Although Keller's mission in life, as she described it succinctly, was "that every blind child have an opportunity to receive an education . . . and that every blind adult, a chance for training and useful employment," she never hesitated to speak out on a gamut of social and political issues, particularly in her earlier years when she had less fear of dissipating her efforts. She fretted that, even though people were "not interested in what I think of things outside myself . . . there are certain subjects about which I feel very deeply." One of these was woman's suffrage, an enthusiasm which Miss Sullivan did not share. In the year of the portrait sitting, Miss Keller wrote: *Anyone that reads intelligently knows that some of our old ideas are up a tree, and that traditions are scurrying away before the advance of their everlasting enemy, the questioning mind of a new age. It is time to take a good look at human affairs in the light of new conditions and new ideas, and the tradition that man is the natural master of the destiny of the race is one of the first to suffer investigation.*

In the cause of righteousness, Helen Keller's pen held a sting that belied the sweetness of her countenance. For example, she minced no words when it came to the then very controversial matter of birth control: *We bar the children of Europe's slums at our gates. Our immigration laws do not permit the weak and unfit to come into our country, but a singular change of sentiment occurs when mothers wish to restrict another kind of immigration far wider and more fateful. Anyone who advocates the limitation of families to a number which their parents can care for in health and decency is frowned upon as a law-breaker. It is not illegal to bring defective children into the world to grow up in soul-destroying poverty, but it is criminal for a physician to tell a mother how to protect herself and her family by birth control! It is a strange, illogical order that makes it a crime to teach the prevention of conception and yet fails to provide decent living conditions for the swarms of babies that come tumbling into the world.*

In fellow Socialist and literary critic John Macy, who as a young Harvard instructor had edited her first book, Helen Keller found a kindred spirit. Macy's marriage to Anne Sullivan in 1905 delighted Helen, and she shared her teacher's unhappiness when it soon became obvious that the union was not going to work out. It was through John Macy that Helen Keller came to meet his close friend, Onorio Ruotolo.

Ruotolo, born near Naples, Italy, had been in America for eight years. Arriving as a fully trained but unknown sculptor, he saw the New World as the land of artistic opportunity. His first six years were disillusioning, as he received few commissions and seemed unable to execute these few to the satisfaction of his clients. Early in his American career, Ruotolo became interested in social realism. John Macy wrote, "While he worships the heroic his sympathies are with those whom life has maimed and oppressed."

Macy, writing about his friend, called him *a man of inexhaustible energy, which glows in his vigorous and abundant work and strikes light and fire from others. . . . He is a natural crusader, a champion of ideals and rights as he conceives them, and is constantly lifting his voice and taking up cudgels in the service of art and life.* His dreams, said Macy, "are limitless."

For Ruotolo, his meeting with Helen Keller became a cherished memory. Forty-five years later, writing in Italian, he recalled:

Even the air in my studio
Was festive on that day
When radiantly you entered
With your friends for the first time.

I stared at you, half a-dream,
While
You explored with your touch
The contours of my head,
The fashioning of my hands

I looked at you dazzled,
While
Your right index hovered
Over my tremulous lips
That stammered their words
Addressed to you, and which you repeated
Magically exact
In a throaty voice
Interrupted by breath-sobs and little laughs

The very clay,
Wet, ready for your image
You blest with your all-wise caressing
And its acrid odor you tried
With your infallible sense of smell

As in a dream I moulded your visage,
Thence with the fluent chalk
I swiftly shaped your mask,
Vibrant, young, pure, smiling

[Translated by Louis Forgione]

Almost thirty years earlier, Anne Sullivan, seeing her charge for the first time, described the young Helen: *She has a fine head, and it is set on her shoulders just right. Her face is hard to describe. It is intelligent, but it lacks mobility, or soul or something. Her mouth is large and finely shaped. You can see at a glance that she is blind. One eye is larger than the other and protrudes noticeably. She rarely smiles.*

The mature Helen smiled a lot. "Animated and graceful, glowing with happiness, she fairly radiated the golden rule and love to all," wrote Mrs. H. O. Havemeyer, who first saw Helen at the time she was about to enter Radcliffe. "The buoyancy of hope beamed from Helen's countenance." Added Mrs. Havemeyer's maid, "What a wonderful face she has! It makes you happy just to look at her." Mrs. Jo Davidson, the wife of the sculptor, toured France and Italy with Helen in 1950 and found, "Every day Helen delights us more and more—her simplicity, her ability to drink in the feel of things, and that spring of joyousness that bubbles up to the surface at the slightest pressure."

Nonetheless, Helen Keller had known, as she confessed in 1927, "bitter moments of rebellion because I must sit at life's shut gate and fight down the passionate impulses of my nature." "If I could see," she once said, "I would marry first of all." Ruotolo, who later chiseled her bust in stone, chose to depict her caressing the face

of a baby, "enfolding the dream child she will never have, in the yearning curve of her arm."

"My life," said Helen Keller, *has been happy because I have had wonderful friends and plenty of interesting work to do. I seldom think about my limitations, and they never make me sad. Perhaps there is just a touch of yearning at times, but it is vague, like a breeze among flowers. The wind passes, and the flowers are content.*

Keller, Helen. *The Story of My Life.* New York: Doubleday, Page & Co., 1904.
———. *Midstream: My Later Life.* Garden City, N.Y.: Doubleday, Doran & Co., 1929.

Whitman, Alden. *The Obituary Book.* New York: Stein & Day, 1971.
Winwar, Frances. *Ruotolo: Man and Artist.* New York: Liveright Publishing Corp., 1949.

William Edward Burghardt DuBois 1868–1963
By Winold Reiss 1886–1963
Pastel on artist board
76.9 x 54.9 cm
Signed: *Winold Reiss* [lower right]
Circa 1925
NPG.72.79

Purchased from the artist's son. Gift of Lawrence A. Fleischman and Howard Garfinkle with a matching grant from the National Endowment for the Arts

The portrait of W. E. B. DuBois was drawn by Winold Reiss as one of the illustrations for Alain Locke's *The New Negro*, published in 1925. Done in the powerfully direct style typical of visual art in America in the 1920s, it shows the father of black consciousness and the progenitor of the Civil Rights movement of the 1960s at the height of his influence and just a bit beyond the midpoint of his life. "I think I may say without boasting," DuBois declared, in looking back on the early decades of the twentieth century, that "I was a main factor in revolutionizing the attitude of the American Negro toward caste. My stinging hammer blows made Negroes aware of themselves, confident of their possibilities and determined in self-assertion."

The Bavarian-born Reiss began his career in Europe, depicting folk characters in Sweden, Holland, the Black Forest of Germany, and his own native Tyrol. In his childhood, his imagination had been stirred by the stories of James Fenimore Cooper, and he came to the United States in 1913 particularly to study the North American Indian. Beginning in 1919, Reiss made many trips to the West, painting the Indian from life, taking great care to be authentic in details of face and dress. Because of his reputation as a delineator of folk types, Reiss was commissioned to do the illustrations for the Harlem issue of *Survey Graphic*, in March 1925. These, which, in addition to the study of DuBois, included portraits of Alain Locke, Jean Toomer, Countee Cullen, Paul Robeson, Roland Hayes, Charles Spurgeon Johnson, James Weldon Johnson, Elise Johnson McDougald, and Mary McLeod Bethune (all now in the National Portrait Gallery), were shortly thereafter incorporated into *The New Negro*.

The book, a collection of essays, stories, poems, and pictures concerning the black experience, included articles by white writers such as Albert C. Barnes, the inventor of Argyrol and noted collector of French paintings who wrote on "Negro Art and

America." Primarily, the anthology featured the work of creative young blacks who were prominent in the flowering of black literature, art, drama, and music, which became known as the Harlem Renaissance.

DuBois, born only five years after the Emancipation Proclamation, was a generation older than most of the major figures in the movement, but he, more than any other single individual, had helped to create the climate that made it possible. Underpinning this extraordinary surge of black creativity were the two major themes of DuBois's life—"pride of race and lineage and self" and a demand for equal rights. Over twenty years earlier, in *The Souls of Black Folk* (1903), a paean in praise of blackness, DuBois was the first to take issue with the unchallenged black leader, Booker T. Washington. He said, *So far as Mr. Washington apologizes for injustice, North or South, does not rightly value the privilege and duty of voting, belittles the emasculating effects of caste distinctions, and opposes the higher training and ambition of our brighter minds—so far as he, the South, or the Nation, does this—we must unceasingly and firmly oppose them. By every civilized and peaceful method we must strive for the rights which the world accords to men.*

Others joined with DuBois at Niagara in 1905 to publicly reject Booker T. Washington's policy of "accommodation," and the following year the group meeting at Harpers Ferry (in honor of John Brown) heard DuBois declare: "We will not be satisfied to take one jot or tittle less than our full manhood rights."

When the National Association for the Advancement of Colored People came into being in 1919, DuBois was appointed Director of Publications and Research. On his own responsibility, he founded an associated but independent monthly magazine, *The Crisis*, called such because prevailing segregation and racial violence marked the era, said DuBois, as "a critical time in the advance of man." Soon its circulation became larger than the NAACP membership. As editor for twenty-five years, DuBois carried on what his successor, Roy Wilkins, described as a "brilliant, vigorous and sustained assault on the citadel of Jim Crow."

Calling upon blacks to protest segregation and injustice, DuBois wrote, "I am resolved to be quiet and law abiding, but refuse to cringe in body or in soul." At a time when "good niggers" were expected to know their place, he told his readers "Agitate then, brother; protest, reveal the truth and refuse to be silent." Lynchings were graphically described, and each issue carried a statistical report of violence done to blacks.

DuBois recognized no sacred cows. He accused the white Christian churches of being "the strongest seat of racial and color prejudice" and denounced particularly those who, he said, prayed in "the church of John Pierpont Morgan and not the church of Jesus Christ." "How long," he asked, "is practical Christianity going to be able to survive its own hypocrisy?" The Negro church, which he acknowledged to be a stabilizing influence upon the family and an effective laboratory for the training of black leaders, nevertheless did not escape his lash. He blasted Negro ministers who condemned dancing and the theatre and who concentrated on raising money for church buildings when the need was for homes and schools.

In a section entitled "As the Crow Flies," DuBois drove home his points in short pithy sentences: *Protestant churches are said to be losing a half million members a year. The wonder is that they are losing so few.*

If you are a railroad you may demand government aid; but if you are merely a starving man, doles are unconstitutional.

What we would really like to live to see would be the three great Races pictured in the nation's geographies by Paul Robeson, Sun Yat Sen and Calvin Coolidge.

In addition to being a gadfly, DuBois worked to build black pride. *The Crisis* regularly dealt with the black contribution to the history of America. Once a year there

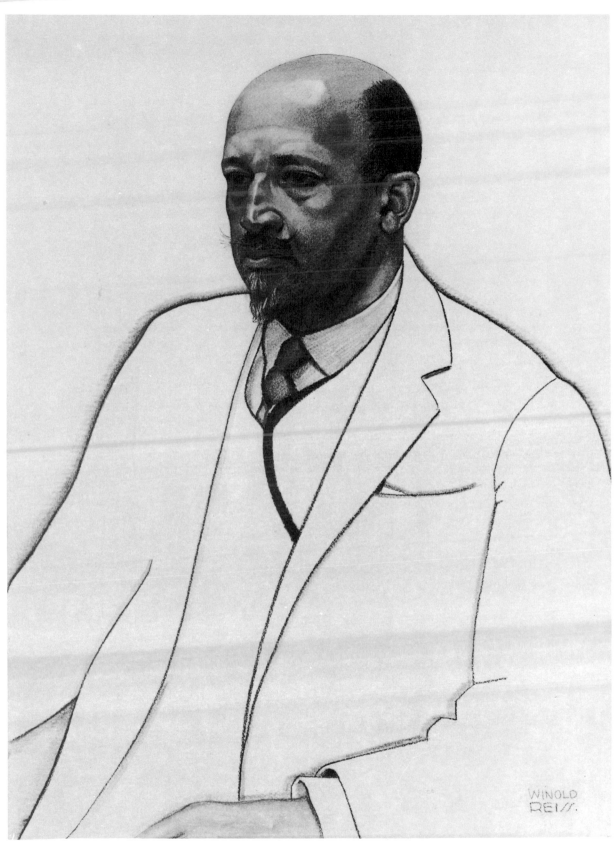

William Edward Burghardt DuBois by Winold Reiss, c. 1925

was a special edition devoted to education, which featured pictures of outstanding black college graduates. The October issue was given over to the concerns of children and included the faces of black babies and stories written around the experience of the black child.

In an effort to give American blacks a sense of their ancestral roots, *The Crisis* carried news and pictures depicting Africans as intelligent human beings rather than as the savages pictured in geography books and missionary magazines. DuBois went first to Africa in 1923, as the American representative to the inauguration of the president of Liberia. In the pages of *The Crisis* he described his feelings: *The spell of Africa is upon me. The ancient witchery of her medicine is burning my drowsy, dreamy blood. This is not a country, it is a world—a universe of itself and for itself, a thing Different, Immense, Menacing, Alluring. It is a great black bosom where the Spirit longs to die.* He concluded, "Africa is the Spiritual Frontier of human kind."

His chapter in *The New Negro*, entitled "The Negro Mind Reaches Out," deals with his passionate interest in Pan-Africanism and reaffirms his 1899 premise that "the problem of the twentieth century is the problem of the color line." Detailing his 1923 travels in Europe and in Africa, DuBois climaxes his story with a description of Liberia. "And now we stand before Liberia; Liberia that is a little thing set upon a Hill;—thirty or forty thousand square miles and two-million folk; but it represents to me the world." One cannot help but note that the man who often described himself as being born "with a flood of Negro blood, a strain of French, a bit of Dutch, but thank God! no Anglo-Saxon," speaks of Liberia as a "little thing set upon a Hill," strangely reminiscent of those Puritans who saw Boston, the "City Upon the Hill," as a Zion in the wilderness.

DuBois saw the encouragement of black artists and writers as an important function of *The Crisis*. His publication sponsored contests, offering prizes for poems, drawings, short stories, and music. Langston Hughes had his first poem, "The Negro Speaks of Rivers," published in DuBois's journal. Jesse Fauset was another notable black writer whom DuBois helped to discover. "Practically every Negro author writing today found his first audience through the pages of *The Crisis*," DuBois said in his 1925 report to the NAACP. In addition, DuBois featured the work of black artists on the magazine's cover.

Professor Harold R. Isaacs, between 1958 and 1961, interviewed a group of eighty blacks, sixty-five of whom were prominent as writers, scholars, educators, businessmen, churchmen, and key figures in important organizations. Isaacs noted that *of all the writers of books who helped to shape the thinking of the members of our panel, none was mentioned more often than DuBois. His name recurred again and again as early memories were summoned up of how each individual discovered his world and the meaning of his place in it as a Negro.*

The influence of DuBois's pen cannot be overestimated. Lorraine Hansberry, author of *A Raisin in the Sun*, speaking at the memorial for Dr. DuBois held at Carnegie Hall in 1964, said: *I do not remember when I first heard the name DuBois. For some Negroes it comes into consciousness so early, so persistently that it is like the spirituals or the blues or discussions of oppression; he was a fact of our culture. People spoke of him as they did the church or the nation. He was an institution in our lives, a bulwark of our culture. I believe that his personality and thought have colored generations of Negro intellectuals, far greater, I think than some of those intellectuals know. And, without a doubt, his ideas have influenced a multitude who do not even know his name.*

Household word though he might have been to upper- and middle-class blacks in

the 1910s, 1920s, and 1930s, DuBois was never a popular leader. He was too scholarly, too remote, too much of a snob. The man "born by a golden river and in the shadow of two great hills" was quickly perceived by the people of Great Barrington, Massachusetts, to be the smartest kid in town. By the time he got to Harvard, by way of Fisk, his self-assurance was manifest. Giving his reason for taking an English course, as taught by Dr. Barrett Wendell, he wrote: "Spurred by circumstance, I have always been given to systematically planning my future. . . . I believe, foolishly perhaps, but sincerely, that I have something to say to the world, and I have taken English 12 in order to say it well." His brilliant success at Harvard, and later in postgraduate work in Berlin, reinforced his sense of superiority. He was brighter than most men and refused to suffer fools willingly. An associate once said that "he had a sort of gentlemanly contempt for the rest of poor mankind." Another recalled. "You couldn't discuss anything with DuBois. You had to listen to him. If you challenged him he became indignant and showed it by becoming manifestly discourteous." Condescending whites he treated with contempt. "Tact," his second wife once remarked, "was never one of his characteristics." Many blacks, although proud of his intellect and his militancy, thought him too aloof, not human enough for ordinary people.

In his autobiography, written when he was ninety, DuBois said, "If, as many said, I was hard to know, it was that with all my belligerency I was in reality unreasonably shy." He did not, he said, seek white acquaintances. *I let them make the advances, and they therefore thought me arrogant. In a sense I was, but after all I was in fact rather desperately hanging on to my self-respect. . . . I wanted to meet my fellows as an equal; they offered or seemed to offer only a status of inferiority and submission.*

Marcus Garvey, the uneducated but charismatic Jamaican, who was, in the 1920s, the only black leader to rival DuBois in influence, once lashed out: *Where did he get this aristocracy from? He picked it up on the streets of Great Barrington, Mass. He just got it into his head that he should be an aristocrat and ever since that time has been keeping his very beard as an aristocrat.*

DuBois did go to great lengths to cultivate his aristocratic appearance. Shirley Graham, who married him when he was eighty-three, saw him first when she was a teenager in 1920. She remembered that *pictures did not do him justice. In all of them he appeared to be very stern, cold and hard. His mustache, with turned-up ends, and pointed goatee did look more as though chiseled into his face instead of . . . to have grown out of it. Later, I learned that the Doctor achieved his fine perfection only with daily and meticulous care. His smooth, sweeping forehead seemed to go right on over the top of his head . . . which, with his thin, high-bridged nose, increased the illusion that his head had been sculptured. These features no doubt explained why his pictures made him seem statuesque. But pictures did not show his eyes! They crinkled at the corners when he smiled. And there was the light that seemed to flicker on and off inside them—a twinkling light that seemed to tell me he was laughing inside. (I was later to realize that his eyes were blue!)*

DuBois, long at odds with various members of the NAACP board, resigned as editor of *The Crisis* in 1934. The last of his life was clouded with controversy and, as he wrote after being labeled "subversive" in the McCarthy era, "The colored children ceased to hear my name." DuBois died a Communist and a citizen of Ghana on the eve of the August 28th, 1963, march to Washington. Roy Wilkins, in announcing his death to the quarter-of-a-million people assembled for the largest civil rights demonstration in American history, said, "Regardless of the fact that in later years Dr. DuBois chose another path, it is uncontrovertible that at the dawn of the twentieth century, his was the voice that was calling you here today."

DuBois, Shirley Graham. *His Day is Marching On*. Philadelphia: J. B. Lippincott Co., 1971.

DuBois, W. E. B. *The Autobiography of W. E. B. DuBois*. New York: International Publishers, 1968.

Foner, Philip S., ed. *W. E. B. DuBois Speaks*. New York: Pathfinder Press, 1970.

Freedomways Associates. *Black Titian: W. E. B. DuBois*. Boston: Beacon Press, 1970.

Huggins, Nathan Irwin. *Harlem Renaissance*. New York: Oxford University Press, 1971.

Lacy, Leslie Alexander. *Cheer the Lonesome Traveler: The Life of W. E. B. DuBois*. New York: The Dial Press, 1969.

Lester, Julius, ed. *The Seventh Son: The Thought and Writings of W. E. B. DuBois* (2 vols.). New York: Random House, Vintage Books, 1971.

Locke, Alain, ed. *The New Negro*. New York: Atheneum, 1968 (first published 1925).

Logan, Rayford W., ed. *W. E. B. DuBois: A Profile*. New York: Hill & Wang, American Century Series, 1971.

Rudwick, Elliott M. *W. E. B. DuBois*. New York: Atheneum, 1969.

George Gershwin 1898–1937
Self-portrait
Oil on canvas board
40 x 29.8 cm
Signed: *George Gershwin, 1934* [lower center]
1934
NPG.66.48

Gift of Ira Gershwin, the sitter's brother and lyricist

George Gershwin, the man who made the whole world realize that there was American music, sometimes proclaimed that if he had chosen to concentrate on painting he could have been as great an artist as he was a musician. He was a self-taught painter. His cousin, artist Henry Botkin, had given him a few pointers, but Gershwin saw no need for art lessons. He "painted well enough," he said. Richard Rogers thought that it was a point of pride with Gershwin to be able to paint as well as he did without any formal training, a natural attitude for one who had developed his musical genius out of Tin Pan Alley rather than the conservatory. He painted as he composed, said one who knew him, in his own happy manner.

Gershwin first began to paint about 1929, the same time he began to collect works of art. Henry Botkin casually suggested one day that in order to appreciate someone else's painting he ought to "do a little shmeering on your own." The next day, reported Botkin, "there was George with the canvas and paints all going. From the very beginning it was amazing! . . . he'd be making a pen-and-ink drawing which almost looked like it was half-Matisse, half-Picasso."

Gershwin took to art with the same gusto and drive he gave to his music. In the midst of life on the run—composing, concerts, parties, sports—he always found time for painting. After he had returned from playing a concert, he sometimes would paint until five in the morning. Wherever he lived, a room would be set aside for his easel, and even with a house full of people (which was usually the case), he would slip away for a few hours of painting. When he traveled, his sketch box and easel were always part of his baggage.

Although to a disinterested observer the quality of his art never approached the sweep and passion of his music, Gershwin took his painting very seriously. There

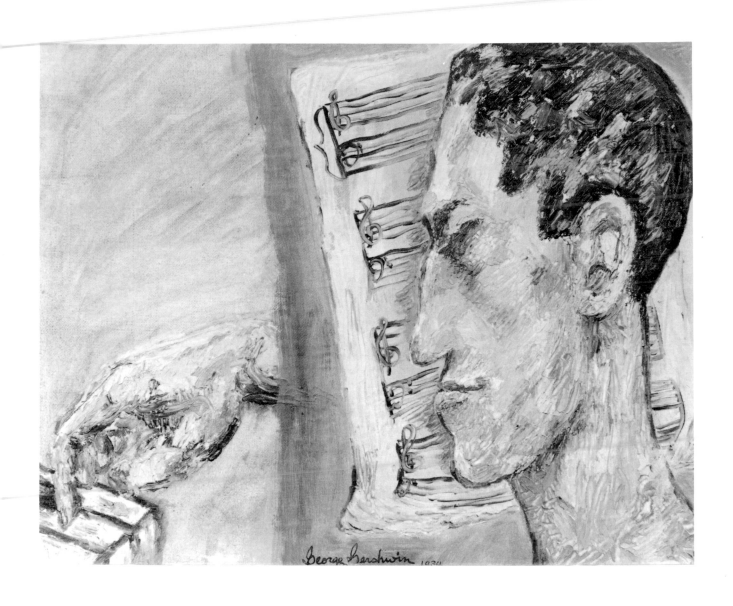

George Gershwin, self-portrait, 1934

were times when he stopped composing to paint and other times when he grudgingly stopped painting to compose. At a dinner party, Gershwin related, "A man told me today that I need never write another note; I could make a fortune with my palette and brush!" "Isn't it amazing," said another guest, "that one man should possess a genius for two of the arts." "Oh I don't know," replied the composer, never known for his modesty, "Look at Leonardo da Vinci!"

The one-man show of his art work, which Gershwin planned in the last year of his life, took place six months after his death. Art critic Henry McBride summed it up by saying, "He was not actually a great painter, but that was merely because he had not yet had the time—but he was distinctly on the way to that goal. He had all the aptitudes." When Gershwin died, just short of his thirty-ninth birthday, he was in the prime of his musical career but had been painting for only about eight years.

Gershwin employed both oils and watercolors, sometimes painting still lifes and landscapes but most often portraits. He was especially interested in people, his cousin said, and was able to capture personality in small, quick sketches. Sometimes he also worked from photographs. His portraits were always realistic—neo-romantic some people would call them, just as Gershwin spoke of himself as being a "modern romantic."

Gershwin's painting and collecting ran parallel courses. In less than a decade, he assembled an impressive collection of contemporary painting, sculpture, drawings, and prints. Like his music—which numbered popular tunes such as *Swanee* and *Fascinating Rhythm*; his musical comedies, to name two, *Girl Crazy, Of Thee I Sing*; his serious concert work, for example *Rhapsody in Blue, Concerto in F*, and *An American in Paris*—his taste in art was equally wide-ranging. It encompassed many movements and schools and included works by Bellows, Benton, Chagall, Gauguin, Kandinsky, Modigliani, Rousseau, Siqueiros, and Utrillo. Rouault's heavy impasto and bold treatment was a particular influence on Gershwin. He once said, in discussing this artist, "I am keen for dissonance; the obvious bores me. The new music and the new art are similar in rhythm, they share a sombre power and fine sentiment." Often he would say, "If I could only put Rouault into music!"

The self-portrait, signed and dated 1934, was painted during the summer spent at Folly Beach, just outside of Charleston, South Carolina, where Gershwin, in company with Henry Botkin and his all-around aide Paul Mueller, settled in close proximity to Du Bose Heyward to work on the score for *Porgy and Bess*. Gershwin wrote to a friend: *The place itself is very different from anything I've seen or lived in before & appeals to the primitive man in me. We go around with practically nothing on, shave only every other day (we do have some visitors, you know), eat out on our porch not more than 30 feet from the ocean at high tide, sit out at night gazing at the stars, smoking our pipes. . . . The 3 of us, Harry, Paul & myself discuss our two favorite subjects, Hitler's Germany & God's women.*

The nearby Gullah Negroes provided for Gershwin and Heywood what the latter called "a laboratory in which to test our theories, as well as an inexhaustible source of folk material." Describing the experience of listening to spirituals, Heyward wrote *that to George it was more like a home coming than an exploration. The quality in him which had produced the* Rhapsody in Blue *in the most sophisticated city in America, found its counterpart in the impulse behind the music and bodily rhythms of the simple Negro peasant of the South.*

In this atmosphere and away from the interruptions and distractions of New York, Gershwin finished one scene in the opera, worked on the second, and squirreled away ideas for future compositions. He also found time to paint.

The self-portrait, satirical or "whimsical" (as his brother Ira termed it) though it may be, is not foreign to the descriptions given by those who knew Gershwin. "Dy-

namic," "ebullient," "vigorous," "arrogant," "ruggedly masculine" are some of the words frequently used to characterize him. He had prominent features—a boxer's broken nose, a noticeably underslung jaw, and a protruding heavy lower lip that turned up in what was described as a cynically cryptic expression—some called it a perpetual sneer. Gershwin had a nervous habit of simultaneously twisting his neck and stretching out his jaw. He had dry neck bones, he claimed, and "lubricated" them the way others crack their fingers and knuckles.

Gershwin painted himself on two other occasions, in top hat and tails (1932) and in checkered sweater (1936), both in the collection of his brother Ira, but, in picturing himself with a keyboard, he represented not only his profession but also his greatest passion. "I have never seen a man happier, more bursting with the sheer joy of living than George was when he was playing his songs," recalled Bennett Cerf. Harold Arlen, in speaking of Gershwin's music, once said that "anyone who knows George's work knows George. The humor, the satire, the playfulness of most of his melodic phrases were the natural expression of the man."

Armitage, Merle, ed. *George Gershwin.* New York: Longmans, Green, 1938.

———. *George Gershwin: Man and Legend.* New York: Sloan & Pearce, 1958.

Ewen, David. *A Journey to Greatness: The Life and Music of George Gershwin.* New York: Henry Holt & Co., 1956.

Jablonski, Edward, and Lawrence D. *The Gershwin Years.* Garden City, N.Y.: Doubleday & Co., 1973.

Kimball, Robert, and Alfred Simon. *The Gershwins.* New York: Simon Atheneum, 1973.

Schwartz, Charles. *Gershwin: His Life and Music.* Indianapolis: The Bobbs-Merrill Co., 1973.

Robert Joseph Flaherty 1884 1951
By Jo Davidson 1883–1952
Bronze
40.6 cm height
Signed: *Jo Davidson, 1944* [across back of shoulders]
1944
NPG.73.21

Robert Flaherty, described by his biographer Arthur Calder-Marshall as that "large Irishly handsome over-life-size man with the wonderful blue eyes and an outflow of human love which was almost insensitive because it gave out so much that it took very little in," was modeled by Jo Davidson when in his sixtieth year. It was a fallow time for the father of the documentary film, one of his "Saharas," as Flaherty termed periods when he was not making a picture.

The years since his return from Europe at the beginning of the war had been frustrating ones for the inventor and master of camera observation. *The Land*, a government-sponsored film dealing with the problems of soil erosion and migratory labor, had been overtaken by the wartime pressures for increased agricultural production. It was given a gala première at the Museum of Modern Art, and then shelved. A stint with the War Department Film Division, recording defense factories, parades, and war-bond drives, proved to be uncongenial for a man who had made his reputation filming primitive societies. Flaherty was thereafter ostensibly in retirement but in reality awaiting a sponsor who would appreciate his particular talent for depicting

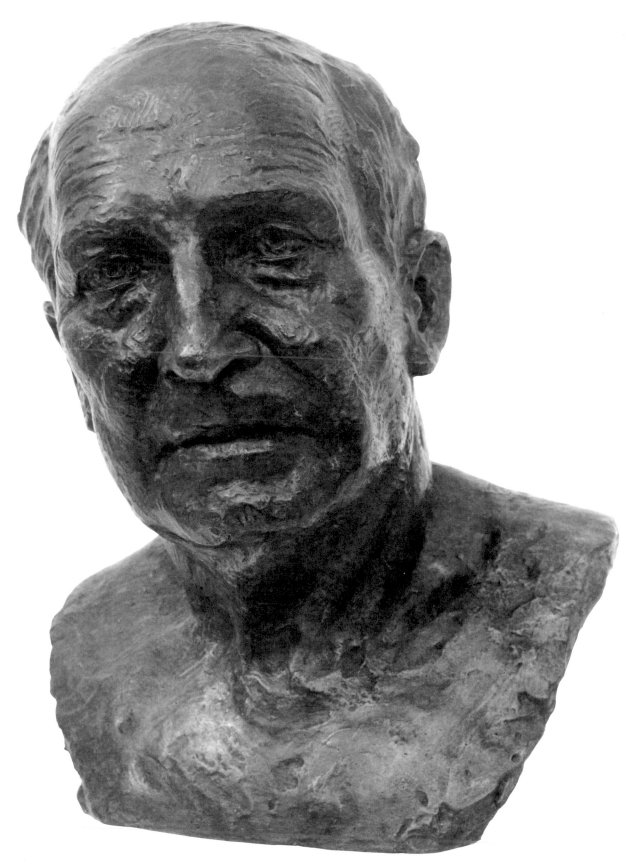

Robert Joseph Flaherty by Jo Davidson, 1944

man's response to the challenges of nature. Restless, as he had been all his life, Flaherty gravitated between his farm in Vermont and the rooms he maintained in a New York hotel.

He was, said his friend, poet Oliver St. John Gogarty, "a big expansive man with a face florid with enthusiasm and eyes clear as the Northern Ice." "Effulgence," said Calder-Marshall, best described Flaherty. "He was like a light shining." Author Robert Lewis Taylor, who saw him just about the time of the portrait, wrote: *Flaherty is a round, jovial, gregarious man. His face, conditioned by tropic suns and arctic blasts, has a cherubic ruddiness, and his head is circled by a fringe of silky white hair. . . . Like some other artists, Flaherty is disregardful of clothes. He is bothered slightly by the heat—both here and in the tropics—and he wears frayed linens or other light suits in the summer. He often forgets to shift them in the fall. "My God, it's unseasonable!" he's likely to cry to a friend as he pads stiffly up the street in seersuckers in December. Flaherty, Taylor noted, has a good deal of trouble arranging an ensemble each morning, for the reason that his clothes, together with the rest of his possessions, are scattered over several continents. Things tend to pile up on him during his travels, and he has found it expedient to check a bag here, drop off a crate there, and maybe send a suit out to the pressers with the idea of retrieving it in a few months as he rolls along.*

Over twenty years earlier, Flaherty, then an arctic explorer, with no precedents to guide him, had taken camera in hand and spent sixteen months filming real Eskimos as they went about the business of survival in their natural environment. *Nanook of the North*, which was still being shown to discriminating audiences throughout the world, was never a box-office success, but it made Flaherty's reputation as a filmmaker of genius. From that time on, the self-taught amateur was recognized as a master of selection and arrangement, and almost everything he did was greeted with huzzahs by the critics. But, as Flaherty himself said, "Prestige never bought anyone a ham sandwich." His films were not great money-makers, and nobody ever backed him more than once.

Flaherty stood, he said, in relation to Hollywood "like a bastard child in a nunnery." His first experience with the film capital had been with Famous Players (later Paramount), for whom he made his second movie, *Moana*. Filmed after he had spent a year absorbing the atmosphere and culture of Samoa and then refilmed after he discovered that the newly developed panchromatic film was especially suited to the tone and light of the South Seas, this was regarded by cinema enthusiasts as the most beautiful motion picture yet made. But the gentle unfolding of a young man's coming of age was lacking in spectacular action and devoid of a passionate romantic relationship. Famous Players was disappointed and unwilling to undertake the special promotion that Flaherty knew the film required. Predictably it was a commercial fiasco. Especially galling to Flaherty was the discovery, made many years later, that Paramount had heedlessly destroyed the negative of this his favorite production.

Flaherty and Hollywood tried each other once again in 1927, when he was signed by Metro-Goldwyn-Mayer to produce a movie based on a travel book entitled *White Shadows in the South Seas*. M.G.M.'s large film crew had not been long on location in Tahiti, when Flaherty, appalled by their insensitivity to the native culture, tore up his lucrative contract and withdrew from the picture.

The following year, tempted by the opportunity to record the Pueblo Indians of New Mexico, he signed on with the Fox Corporation. Flaherty, to whom filmmaking was a discovery process, delighted in the spontaneity of children and planned the film around a small Indian boy. Fox, on the other hand, wanted the action to center around the non-Indian "romantic leads." The film was never made, and Flaherty was not again asked to work for a Hollywood company.

In this long career Flaherty had made only a handful of major films—*Nanook of the North* (1922), *Moana* (1926), *Man of Aran* (1934), *Elephant Boy* (1937)—but each was a work of distinction. Ahead was another great picture. Even as Flaherty posed for Davidson, negotiations were under way for a film descriptive of oil well technology. Like his first film, sponsored by Paris furriers as an advertising venture, this, too, would be underwritten by a commercial company. Standard Oil, willing to subsidize a work of art as a public relations gesture, granted Flaherty what proved to be an unlimited budget and the right to all profit from the film. In search of a story which would dramatize the oil business, Flaherty and his wife Frances, who had been his collaborator since the long-drawn-out making of *Moana*, would spend three months traveling in the Southwest. In the bayou country of Louisiana they sighted an oil derrick being towed through the marsh grass and, as Flaherty later wrote, "this familiar structure suddenly became poetry, its slim lines rising clean and taut above the unending flatness of the marshes." He related, "Almost immediately a story began to take shape in our minds, built around that derrick which moved so majestically into the wilderness, probed for oil beneath the watery ooze and then moved on, leaving the land as untouched as before it came." To humanize the epic of the machine, Flaherty determined that the excitement of testing, sounding, and drilling for oil should be seen through the eyes of a "half wild" thirteen-year-old Cajun boy. After nearly two years in the making, *Louisiana Story* was released in 1948. Film critic Paul Rotha wrote: *Here the boy is as palpably real as the swamps he lives in, and the process of oil-drilling is observed and described with a clarity and drama unmatched in my experience of seeing films. This is a real educational film: it is also a poem, and the two things work together.* Calder-Marshall remarked, *Surely no more perfect reconciliation of industrial progress with the natural order was ever conceived than the concluding shot of the boy climbing the 'Christmas tree' of the capped well with his coon in his arms, shouting farewell to his oil-men friends as the tug tows their fabulous oil-derrick to new waters.*

When the bust was made, both artist and sitter were in the last decade of their lives. It had been over forty years since Jo Davidson had first wandered into an empty art studio, "found the clay bin, put my hand in it, and touched the beginning of my life." Like Flaherty, whose only training had been a three-week course in motion picture photography, Davidson, whose sculpture education was little more than some instruction in the mixing of plaster and the building of an armature, learned in doing. In the ensuing years Davidson, nearly as peripatetic as Flaherty, had done busts of literally hundreds of the world's great. "I see you make heroes out of mud," Mahatma Gandhi had said to him. "And sometimes vice versa," Davidson replied.

Davidson worked with great rapidity, generally requiring only one sitting and finishing sometimes in less than two hours. He wrote in his autobiography: *My approach to my subjects was very simple. I never had them pose but we just talked about everything in the world. Sculpture, I felt, was another language altogether that had nothing to do with words. As soon as I got to work, I felt this other language growing between myself and the person I was "busting." I felt it in my hands. Sometimes the people talked as if I was their confessor. As they talked, I got an immediate insight into the sitters.* Davidson said, "It takes two to make a bust. The important thing is the rapport between the artist and the sitter."

With Flaherty the rapport was there. Davidson, a Russian Jew born in New York's Lower East Side, and Flaherty, an Irish Protestant who had spent his adolescence in the Canadian gold fields, were the best of friends. Liberals both, at the time of the sitting they were fellow members of Davidson's brainchild, the Independent Voters Committee of the Arts and Sciences for the Reelection of Roosevelt. Convivial and

witty men, the two spent many an evening together at the Coffee House Club, or at Costello's Bar on Third Avenue.

Richard Griffith, in *The World of Robert Flaherty*, described the filmmaker as he held forth among friends at his favorite New York haunts: *Being served at his table was as if you took the food as a gift from his hands, you must always have another drink, just one, and above all things you mustn't go home. In his presence you weren't allowed to pay for so much as a postage stamp. A checkbook was a means of facilitating the diffusion of money, a savings account was non-existent. In the North, men share all they have.* Griffith added that this profligately outgiving man "felt instinctively that everything created by man belonged to everybody, a vast pool on which all were free to draw. . . . Sharing and making and liking are the qualities you think of when he comes to mind."

Brinnin, John Malcolm. "The Flahertys." *Harper's Bazaar.* December 1947, p. 146.

Calder-Marshall, Arthur. *The Life of Robert J. Flaherty* (based on research material by Paul Rotha and Basil Wright). New York: Harcourt Brace & World, 1963.

Davidson, Jo. *Between Sittings.* New York: The Dial Press, 1951.

Griffith, Richard. *The World of Robert Flaherty.* New York: Sloan, Pearce; and Boston: Little Brown & Co., 1953.

Rotha, Paul, and Richard Griffith. *The Film Till Now.* New York: Funk & Wagnalls Co., 1949.

Taylor, Robert Lewis. *The Running Pianist.* Garden City, N.Y.: Doubleday & Co., 1950.

Winston Spencer Churchill 1874–1965
By Douglas Chandor 1897–1953
Oil on canvas
127 x 101.6 cm
Signed: *Chandor/1946* [lower left]
1946
NPG.65.76
Bequest of Bernard Mannes Baruch

A year following the Yalta meeting of February 1945, Winston Churchill sat to Douglas Chandor for what was originally intended to be a depiction of the Big Three. The idea for a group-portrait had originated with President Franklin Roosevelt, who had approved Chandor's sketch for a large painting showing the Allied leaders seated around a table. The president intended that three identical pictures be commissioned by the government, one to be given to England, one to Russia, and the third to hang in the United States Capitol. Roosevelt had posed less than a month before his death. Stalin refused to sit. He told Chandor that he was too busy and that the artist could work just as well from photographs. Chandor replied that in that case he might as well be painting Washington crossing the Delaware, and the triptych was never executed.

It was natural that Churchill, with his affectionate regard for Roosevelt, should respond with alacrity to his friend's wish that he sit for the portrait. Ever since the two leaders had gotten to know each other in August of 1941, on board ship off the coast of Newfoundland, their association had been an extraordinarily close one. "It

is fun to be in the same decade with you," Roosevelt once wrote to Churchill. For his part, Churchill said, "Our friendship is the rock on which I build for the future of the world." On another occasion he wrote, "Anything like a serious difference between you and me would break my heart."

The English historian Isaiah Berlin has noted: *The relationship was made genuine by something more than even the solid community of interest or personal and official respect or admiration—namely, by the peculiar degree to which they liked each other's delight in the oddities and humours of life and their own active part in it. This was a unique personal bond . . . which they shared with each other and few, if any, statesmen outside the Anglo-American orbit . . . and it gave a most singular quality to their association.*

When he sat to Chandor, Churchill was no longer prime minister. With the war all but over, he had been turned out of office in July 1945, overwhelmingly rejected by the electorate. In sadness he had written, "The power to shape the future would be denied me." Crushed that the people had turned down his bravura leadership in favor of higher wages, shorter hours, and free eyeglasses, he wallowed in resentment for a while. He declined all honors, including the Garter, saying, "Why should I accept the Garter from His Majesty when his people have just given me the Boot?" "I refuse," he said, "to be exhibited like a prize bull whose chief attraction is in its past powers." This mood of self-pity did not last long. His zest for life overcame his wounded pride, and he was back in the fray as the active leader of the opposition. At an age when most men would have been willing to retire—Churchill was seventy-one—he was already looking forward to his next go as prime minister, an opportunity which indeed would come again in 1951.

The winter of 1946 seemed a good time to absent himself from England. With no general election likely for some years, he could conveniently leave Anthony Eden to keep watch on the "gloomy State vultures of nationalisation." Announcing that his doctor had advised a holiday in a warm climate, he embarked on the *Queen Elizabeth* on January 9th, bound for Florida.

On February 14th, in a room at the Miami Beach Surf Club, Churchill began his sittings with Chandor. He wore, when the artist was not concerned with costume, his famous wartime "siren suit" and carpet slippers. For the final record, however, he posed in his uniform as honorary commander of the Royal Air Force—as Roosevelt had intended that he should. For one who was always, as his political rival Clement Atlee put it, "standing back and looking at himself—and his country—as he believed history would," the choice of the Royal Air Force uniform could hardly have been better. It symbolized England's "finest hour," a time when the incomparable voice of Churchill and gallantry of British airmen stood firm against a Nazi conquest.

The uniform displaying the RAF insignia and five rows of campaign ribbons was likewise a happy choice for the artist. Chandor's biographer, in discussing a portrait the painter had done of an American military officer, commented, "There's no doubt about it, polished buttons . . . insignia and perhaps a ribbon or two do help a fellow." He added, "Certainly they help the portrait painter. They help him out the way silk coats and ruffs and buckles helped Van Dyck."

It was assuredly no accident that Chandor included the ever-present cigar—nicely off to the side so as not to detract from the dignity of the whole. It was essential to Churchill's image. Setting out on one occasion to survey the damage done by the German Luftwaffe, he sent an aide back for the forgotten cigar. "The people expect to see it," he explained.

The major event in Churchill's nine weeks in America was to be an address at Westminster College in Fulton, Missouri, an engagement influenced by a postscript

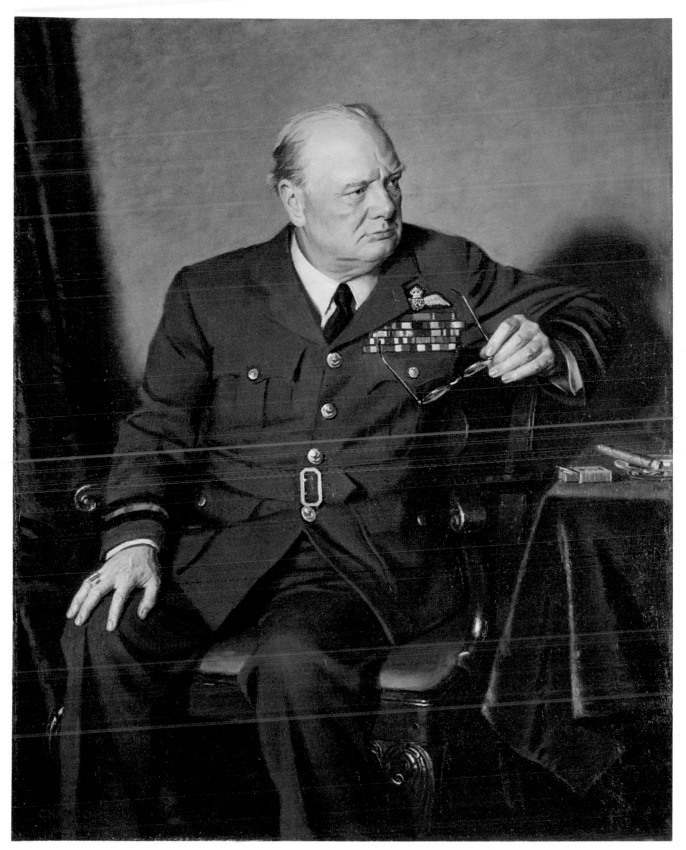

Winston Spencer Churchill by Douglas Chandor, 1946

scrawled on the bottom of the official invitation which read, "Dear Winnie, This is a fine old school out in my state. If you come and make a speech there, I'll take you out and introduce you." So it was that the Florida sittings were interrupted in early March, while Churchill and President Harry S Truman proceeded by special train from Silver Spring, Maryland, to Missouri. Margaret Truman reported that the party had a delightful journey. Truman taught Churchill how to play poker, a game at which the latter became quickly adept. It was something like one he had played in the Boer War, he explained. Churchill, when served his favorite beverage, came up with more war reminiscences. "When I was a young subaltern in the South African war, the water was not fit to drink. To make it palatable we had to add whiskey. By diligent effort I learned to like it."

At Fulton, Churchill gave his first public warning of the dangers of Russian aggression, bringing into the English language the slogan of the Cold War era when he said, "From Stettin in the Baltic to Trieste in the Adriatic, an iron curtain has descended across the Continent."

Back in the East, Churchill resumed the portrait sittings, this time in Chandor's studio at New York City's Waldorf Towers. Mrs. Churchill was likewise sitting for her portrait, and, as Churchill awaited Chandor's finishing touches on the two, he and the artist discussed painting techniques, in particular the relative merits of using a palette or flat table for mixing colors. Churchill, the press reported, favored table mixing. Undoubtedly, the world's most famous Sunday painter expressed other opinions also on matters relating to his favorite hobby. As eloquent and impassioned about painting as he was about politics, Churchill once wrote, "I cannot pretend to feel impartial about the colours. I rejoice with the brilliant ones, and am genuinely sorry for the poor browns."

Churchill, the man who said, "I cannot but return my sincere thanks to the high gods for the gift of existence," nonetheless suffered from recurrent spells of depression, the "black dog" he called it. It was in one of these bad times that he had first discovered painting, was "rescued" by it, in the days following Gallipoli, the World War I disaster for which he, as first lord of the admiralty, had been responsible. At a time when he felt "like a sea-beast fished up from the depths," he turned to painting bright landscapes with "audacity." Until the last melancholy decade of his life, when apathy finally overcame the old man, he continued the most enthusiastic of painters. Revealingly, he once said, "If it weren't for painting, I couldn't live; I couldn't bear the strain of things."

On March 19th, after seven sittings, and just one day before Churchill's departure for England, the portrait was finished. He looked at it and said, "I think it's admirable. I would recognize it immediately. It's a masterpiece."

Churchill would have had a natural compatibility with any artist, but Chandor, British-born and trained, was particularly sympathetic. Like Churchill, the young Chandor had had a thirst for military glory, lying about his age in order to serve with the First Life Guards when only seventeen. His career as a portraitist in fact had begun under military circumstances, as he sketched his fellow World War I soldiers during lulls in the action. Like Churchill, who was a public figure at twenty-five, Chandor also knew early success. When he was twenty-four, and only a few years out of the Slade School, he was given the opportunity of painting the Prince of Wales. "Half of London" came to see the portrait of the future king, whose abdication speech, made some seventeen years later, would be written by Churchill. In 1923 Chandor painted a group-portrait of the assembled heads of the British Empire—a work which most assuredly must have had the sentimental approval of a man who

later would resist Indian independence, saying, "I have not become the King's First Minister in order to preside over the liquidation of the British Empire."

By the mid-twenties, when Chandor came to the attention of the famous art dealer, Sir Joseph Duveen, the artist was already a smashing success, painting the rich and titled of Churchill's own world. Duveen, however, sensing that Chandor's talents were "singularly suited" to the tastes of American millionaires, urged him to cross the ocean and provided letters of introduction. Chandor arrived in New York in 1926, and within a few days was in Philadelphia, at work on a portrait of the Philadelphia socialite and collector, Mrs. Edward T. Stotesbury. By 1931 he had been commissioned to paint Herbert Hoover (National Portrait Gallery) and members of his cabinet. Within two more years he was married to a Weatherford, Texas, girl, an alliance which opened doors to yet another portrait-buying segment of American society. His first association with Franklin Roosevelt came in 1935, when the Young Democrats of Texas commissioned Roosevelt's portrait for the Capitol at Austin. Five years later the president's mother sat for a portrait intended as a gift for her son's new library at Hyde Park. "I shall always be indebted to you for so priceless a treasure," Roosevelt had written to Chandor in 1942.

Churchill's portrait was exhibited in New York and purchased by Bernard Baruch for $25,000, the highest price, at that time, ever paid for a contemporary portrait. According to reports in *Time* magazine, the financier intended to hang it in his apartment for a while and then give it to some museum. Baruch, who had known Churchill since the days of World War I, was one of his oldest friends.

By act of Congress on April 9th, 1963, Churchill was made a citizen of the United States. President John F. Kennedy, noting that the granting of this honorary citizenship was a moment unique in the history of the United States, said, in part: *In proclaiming him an honorary citizen, I only propose a formal recognition of the place he has long since won in the history of freedom and in the affections of my—and now his—fellow countrymen. . . . In the dark days and darker nights when England stood alone—and most men save Englishmen despaired of England's life—he mobilized the English language and sent it into battle.*

But perhaps it was Churchill himself, speaking to a joint session of Congress on December 26th, 1941, who expressed his personal bond with America in the most memorable way. The son of the American-born Jennie Jerome told Congress, "I cannot help reflecting that if my father had been American and my mother British, instead of the other way round, I might have got here on my own."

American Heritage Magazine and United Press International. *Churchill: The Life Triumphant: The Historical Record of Ninety Years.* New York: American Heritage Publishing Co., 1965.

Eade, Charles, ed. *Churchill by His Contemporaries.* New York: Simon & Schuster, 1954.

Gilbert, Martin. *Churchill: Great Lives Observed.* Englewood Cliffs, N.J.: Prentice-Hall, 1966.

Pelling, Henry. *Winston Churchill.* New York: E. P. Dutton & Co., 1974.

Vaughan, Malcolm. *Chandor's Portraits.* New York: Brentano's Publishers, 1942.

Richard Wright 1908–1960
By Miriam Troop 1917–
Pencil on paper
35.3 x 27.7 cm
Signed: *M. Troop 1949 Paris* [lower right]
1949
NPG.72.50

Richard Wright, the celebrated black novelist, annihilator of the stereotype of the "happy Negro," was sketched in Paris by Miriam Troop. Ms. Troop, who saw him in 1949 when he was forty-one, remembered him to have been "of medium height, light-skinned, small featured, and dressed neatly in a brown plaid jacket, tan slacks, and a white T shirt. His black hair was cropped close." Writing over twenty years later, she recalled that "he smoked constantly, filling ashtrays as he moved around the room in a sort of Humphrey Bogart fashion, one hand casually in his pocket, the other holding his cigarette." Wright, high-strung and tense, rarely relaxed. Director John Houseman, who worked with him in connection with the 1941 Broadway production of *Native Son*, remembered him as "a surprisingly mild-mannered, round-faced, brown-skinned young man with beautiful eyes. It was only later, when I came to know him better, that I began to sense the deep, almost morbid violence that lay skin-deep below the gentle surface."

With the publication of *Native Son* (1940), "the story of a boy born amid poverty and conditions of fear which eventually stop his will and control and make him a reluctant killer," Wright was compared on all sides to John Steinbeck, Theodore Dreiser, and James T. Farrell. The book immediately became a best seller. *Black Boy* (1944), his fictionalized autobiography, sold over 400,000 copies within the first year. Gertrude Stein read it and wrote, "Dear Richard, It's obvious that you and I are the only two geniuses of this era." Mississippi Senator Theodore G. Bilbo found it necessary to denounce the book on the floor of the Senate, saying: *It is a damnable lie from beginning to end. It is practically all fiction. There is just enough truth to enable him to build his fabulous lies about his experience in the South. . . . It is the dirtiest, filthiest, lousiest, most obscene piece of writing that I have ever seen in print. . . . But it comes from a Negro and you cannot expect any better from a person of this type.* Wright exulted. "Seems that the folks in Miss. are learning that a *Black Boy* once lived there. But I think *Black Boy* will be read when Bilbo is dead and his name forgotten; I really believe that."

It was not only from the white South that the criticism came. The black middle class and many white liberals were repulsed by Wright's negative treatment of black life. The leading black intellectual, New England-born and Harvard-trained W. E. B. DuBois, found *Black Boy* to be a "harsh and forbidding story that makes me wonder just exactly what its relation to truth is." DuBois, forty years older than Wright, bristled that one born on a plantation, living in Elaine, Arkansas, and the slums of Memphis, would have the effrontery to claim to know the whole Negro race. He conceded, nonetheless, that Wright "uses vigorous and straightforward English; often there is real beauty in his words even when they are mingled with sadism." Admitting his bafflement, DuBois concluded, "Nothing that Richard Wright says is in itself unbelieveable or impossible; it is the total picture that is not convincing."

Whatever the reservations, few would deny that Richard Wright's books were enormously stirring. And, since they were translated into many languages and widely read everywhere, Wright had the satisfaction of including the whole literate world

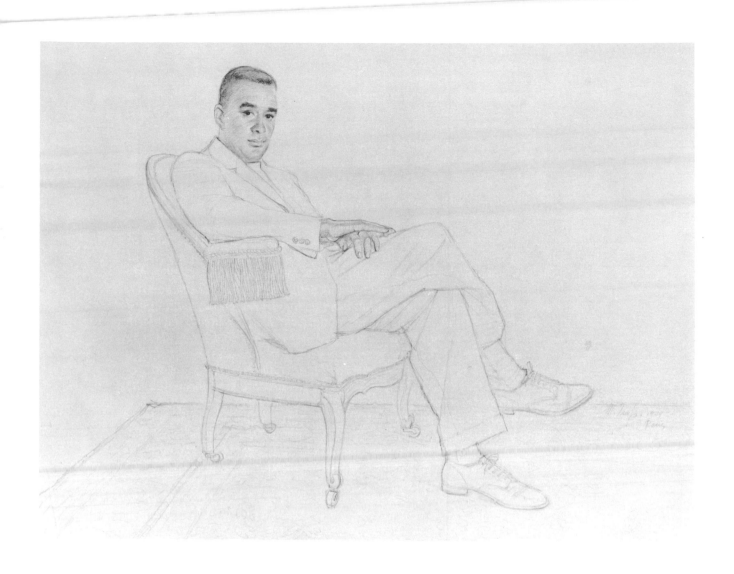

Richard Wright by Miriam Troop, 1949

when he said, "They had been led to look at the Negro and laugh; well, they are learning to look at him and let their mouths fall open."

The writer of brutal and angry prose was essentially a gentle soul, painfully sensitive, and with a chronically nervous stomach. One friend recalled that he "alternated between sullenness, when he felt rejected by whites (stupid though they might be), and volatile warmth when sensing kinship in spirit." Fellow writer Owen Dodson recalled that Wright had a particular feeling for little children, stopping to talk to them on the street, giving them a special smile. Dodson wrote, after Wright's death, "I remember Dick best this way . . . the Black Boy who became a man, but never forgot the mystery and wonder of childhood even when he was a great figure." "His laugh," remembered another, "was almost childlike."

Richard Wright forever bore the scars of his background. The real hurt of hunger had been one of his earliest memories. His father was a sharecropper who had deserted the family when Richard was five. His mother was felled by the first of a series of paralytic strokes when Richard was ten, and, as he wrote in his autobiography: *My mother's suffering grew into a symbol in my mind, gathering to itself all the poverty, the ignorance, the helplessness; the painful, baffling, hunger-ridden days and hours; the restless moving, the futile seeking, the uncertainty, the fear, the dread; the meaningless pain and the endless suffering. . . . A somberness of spirit that I was never to lose settled over me during the slow years of my mother's unrelieved suffering, a somberness that was to make me stand apart and look upon excessive joy with suspicion, that was to make me self-conscious, that was to make me keep forever on the move, as though to escape a nameless fate seeking to overtake me.*

Passed around from one relative to another, Wright ended up spending his adolescence in Jackson, Mississippi, with his maternal grandmother, a strict Seventh Day Adventist who burned his books and smashed his laboriously contrived crystal radio set. On his part, he waged open warefare against "a ritual of worship that reaches down and regulates every moment of living."

By the time his mother could scrounge decent clothing so that he could go to school, Wright had already learned to read, but because of the disruption brought about by his mother's illness, he was thirteen before he had completed one year of formal education. A year later he published his first short story in the local black newspaper, and graduated from the ninth grade, valedictorian of his class. A high school for blacks was just then starting in Jackson, but for Richard Wright, living on the beneficence of others, the time had come to make his living. Intent on accumulating enough money to get out of Jackson, he worked at any menial job he could find. In the fall of 1925, when he was fifteen, he set out for Memphis, where he worked in turn as porter, messenger, dishwasher, and optical lens cleaner. He also began to read anything he could get his hands on, buying secondhand copies of *Harper's*, *The Atlantic Monthly*, and *American Mercury*. Because he was black, the privileges of the local public library were denied Wright, but with a borrowed card he pretended to take out books for a white co-worker (not until one month before Richard Wright died in Paris, on November 30th, 1960, would the Memphis public libraries become desegregated). Beginning with H. L. Mencken's *A Book of Prefaces* and followed by *Prejudices*, this youth, brought up in an environment of physical violence, discovered that Mencken "was using words as a weapon, using them as one would use a club." With Mencken as a bibliographic guide, he moved on to discover Sinclair Lewis, Theodore Dreiser, Joseph Conrad, Sherwood Anderson, Alexandre Dumas, Fyodor Dostoevski, Leo Tolstoy, and others. Later he would write: *My reading had created a vast sense of distance between me and the world in which I lived and tried to make a living and that sense of distance was increasing each day. My days and nights were*

one long, quiet, continuously contained dream of terror, tension, and anxiety. I won-
dered how long I could bear it.

Certainly the South, in the days immediately before and after the first World War, was no place for any black who read books. Wright reflected, in an interview in *PM* given in 1945, "The environment the South creates is too small to nourish human beings, especially Negro human beings. Some may escape the general plights and grow up, but it is a matter of luck."

In 1927 the twenty-one-year-old Wright left the South and arrived in Chicago. The poverty and squalor was much the same; there was, however, a "saving remnant of a passion for freedom." Avid to be more than a porter and dishwasher, Wright success-fully passed the examination for postal clerk but was denied certification because of substandard weight. He reached the required weight only to find that the job had been a casualty of the depression. Ultimately he had no alternative but to go on relief. In perhaps the only piece of real luck in his life, the social worker assigned to the Wright family was Mary Wirth, whose husband was a prominent sociologist at the University of Chicago. Impressed by this bright young man who was writing poetry, articles, and short stories, she introduced him to her husband, who furnished him with reading lists in sociology and psychology. Mrs. Wirth assisted in Wright's job placement, and in one relief office assignment he was put in charge of a ghetto youth club. He later wrote of this experience: *Each day black boys between the ages of eight and twenty-five came to swim, draw and read. . . . They were a wild and home-less lot, culturally lost, spiritually disinherited, candidates for the clinics, morgues, prisons, reformatories, and the electric chair of the state's death house. For hours I listened to their talk of planes, women, guns, politics, and crime. Their figures of speech were as forceful and colorful as any ever used by English-speaking people. I kept pencil and paper in my pocket to jot down their word-rhythms and reactions.* He would draw heavily on these notes when he came to create Bigger Thomas, the pro-tagonist of *Native Son.*

As was the case with many other creative people during these years of depression, Wright was drawn into the orbit of Communist activity. For the first time in his life, he met white people who accepted him as a person and utilized his talents as a writer. In the early thirties he became a card-carrying member of the party. He after-wards wrote: "As anyone with common sense could easily guess, I was a Communist because I was a Negro. Indeed the Communist Party had been the only road out of the Black Belt for me." In 1937 he moved to New York to become the Harlem editor of the *Daily Worker.* After the invasion of the Soviet Union by Germany, when the Communists stifled the fight against racism in the interests of wartime cooperation, Wright was disillusioned. He broke publicly with the party in 1942.

Shortly after the end of the war, Wright moved to Paris. He had come first to France in 1946 as a guest of the French government. Made an honorary citizen of Paris, feted and lionized, he felt quite at home in the world of his idols of the "Lost Generation." He had found, he wrote to a friend, "such an absence of race hate that it seems a little unreal." But the always-cynical Wright was never deluded into think-ing that France was Eden. He concluded, "Most of the earth today is the same; hunger for jobs, food, houses. . . . It is the same as with the folks down in Mississippi, but here it happens with a tiny bit more of beauty and grace."

After eight months in France, he returned to America in January of 1947, eager to settle in the home he had purchased in Greenwich Village. The man hailed by critics as "one of the most important literary talents of contemporary America" found him-self called "boy" by the New York street vendors. Well-groomed and scholarly-look-ing though Wright was, he was nonetheless denied entrance to many restaurants and

served salt in his coffee in others. An international celebrity, he still had to travel to Harlem to get his hair cut. Married to a white woman, he and his wife were often subjected to jeers and catcalls from the street rowdies. His was too proud a nature to tolerate the indignities of a racist society with equanimity. Moreover, the fear of physical violence was never out of his mind. "Fear," he reiterated often, "is the most dominant emotion of Negro life. We're all scared all the time." He was determined that his six-year-old daughter should not grow up in this emotionally crippling atmosphere.

In July the family returned to Paris, and Wright would not live in America again. However, he retained his citizenship and never regarded himself as an "expatriate." Bitterly outspoken against the racism in American society, he accepted the label of un-American but not anti-American. He once wrote to Gertrude Stein, "It is very easy to damn America by rejecting America. . . . I criticize America as an American and you do too, which I think is the only way to do the job."

Wright had been away from America for nearly two years when Miriam Troop asked him to sit to her in 1949. At home in the intellectual ferment of Paris, he was embroiled in cold war politics. Along with Jean-Paul Sartre, he was active in the non-Communist left, a movement which struggled to provide an alternative between the United States and the Soviet Union. His denouncement of the Atlantic Pact caused deep resentment among the Americans in Paris. On the other hand, in disagreeing with Paul Robeson's declaration that black Americans would never fight against Russia, Wright incurred the wrath of the Communist sympathizers. He said bluntly that American blacks would never forget that the Communists had relegated the civil rights struggle to second place during World War II.

Wright was busily engaged in lecturing, giving interviews, visiting friends, traveling about Europe. He was reading heavily, particularly the German existentialists, and part of each day was spent at the Café des Deux Magots deep in discussions of existentialism. Spasmodically, he worked on the two novels he had started in America, but these were never to be published. For the most part he hadn't felt like writing. "Writing froze on me," he said. It would in fact be September 1952 before he finished *The Outsider*, his first published book in eight years.

For the past year he had been involved in preparations for the production of a motion picture based on *Native Son*. With the help of *Green Pastures*' author Paul Green, the book had been dramatized in 1941, but Wright, who had little interest in the stage, was only peripherally involved. Movies, on the other hand, fascinated him because, he said, "I think peoples' lives are like movies." He had long been interested in seeing a film made from his book, but, after a Hollywood studio's suggestion that Bigger Thomas be made "an oppressed minority white man," Wright was convinced that the picture could never be made in America. He was delighted, therefore, when he received an offer from a European producer who planned to shoot the film in Argentina. Wright was to have general supervision of the production and would himself play the starring role. In preparation for this, the now-well-fed forty-one-year-old man was strictly dieting in the fond hope that he could achieve the look of a malnourished twenty-year-old. By July he had lost thirty-five pounds. As Miriam Troop saw Wright, he was looking forward with great anticipation to his film career and the opportunity of bringing his story to a far larger audience than he could ever hope to reach through the written word. He little guessed that the venture would prove to be a dismal failure.

Miriam Troop, an illustrator who had studied at the Pennsylvania School of Design for Women (Moore College), the Pennsylvania Academy of the Fine Arts, the Barnes Foundation, and the Art Students League of New York, had had considerable

experience doing pencil portraits of celebrities, most recently Norman Thomas, Helena Rubinstein, and Wright's friend, James T. Farrell. She has always insisted upon working from life. As she was leaving for Europe in the spring of 1949, the art editor of the *New York Times* magazine suggested that she arrange sittings with well-known figures for possible illustrations in future Sunday supplements. Shortly after her arrival in Paris, she called Wright, and he readily agreed to pose.

Wright was living in the middle of the Latin Quarter, close to the American school that his daughter Julia attended. His publisher and most of his friends were in the neighborhood. In short, as his French biographer, Michel Fabre, has said, "He now lived in the heart of an intellectual capital, within reach of everything that mattered to him."

Ms. Troop remembered his living in a "seven story apartment house of the kind built for the upper middle class and the rich in Paris, a century before. The building was dank. The odor of cooking was in the air. The walls were peeling." Ms. Troop, writing many years after the fact, had forgotten which floor the Wrights occupied, but she recalled passing through the courtyard and climbing the inner stone stairs. She wrote, *I remember his wife, the young white woman who let me in and who, I later learned, was an American from Brooklyn. She was petite, large-eyed and brown-haired. There was also a small child still in night-dress who peered into the parlor where the writer and I sat.* The artist added that the parlor walls were dotted with prints, photographs, and drawings bearing dedications and autographs. She noted that "despite these latter mementos it seemed that the drab apartment had been let, furnished."

Since the Richard Wright portrait was not a commission, the artist felt free from what she called "the usual burden of the portrait artist, i.e., pleasing the patron, or more accurately catering to common expectations." Ms. Troop's recent experience, drawing hundreds of heads of service-men as part of the wartime USO program, had made her aware of the limitations of the traditional bust portrait. Attitude, dress, furniture, she said, were as revealing of personality and character as were the features, and she intended, therefore, to show Richard Wright standing or sitting in casual attitude.

"Wright," she detailed, *followed my suggestions for poses, alternately standing by the wood panelled wall, the velvet drapes of the window and the marble mantle. Minutes passed. No position seemed proper and it was with relief that I saw the chair shown in the drawing. It was unlike anything I had seen before; pseudo-Napoleonic in style, covered with silk stripes on back and seat, its curved arms bore elaborate epaulets of the kind once worn by military and naval officers. Wright sitting in that chair seemed to point up the incongruity of this situation so I drew the native son of Chicago's slums in that French setting.*

Fabre, Michel. *The Unfinished Quest of Richard Wright*. Translated by Isabel Barzun. New York: William Morrow & Co., 1973.

Ray, David, and Robert M. Farnsworth, eds. *Richard Wright: Impressions and Perspectives*. Ann Arbor: The University of Michigan Press, 1973.

Troop, Miriam. Unpublished recollections of the Richard Wright sitting, written for the National Portrait Gallery records, October 5, 1972. Washington, D.C.

Webb, Constance. *Richard Wright: A Biography*. New York: G. P. Putnam's Sons, 1968.

Wright, Richard. *Native Son*. New York: Harper, 1940.

———. *Black Boy*. New York: Harper, 1945.

Cole Porter 1891–1964
By Soss Melik 1914–
Charcoal on paper
48.3 x 63.5 cm
Signed: *Melik* 1953 [lower left]
1953
NPG.74.32

*One of twelve portrait drawings commissioned by Evelyn Vogel, a
prominent soprano of the 1920s and 1930s. Upon her death, ten of these
portraits were repurchased by the artist, who wished to keep them
together as a group. The collection was subsequently acquired by the
National Portrait Gallery*

Cole Porter was sixty-two when Soss Melik drew his portrait. Sketched in Porter's
Waldorf Towers apartment, he posed seated at the piano with a musical score before
him. Asked by the artist what the title page should read, Porter was silent for a time,
seemingly wistful. Then he said, "Make it *Kiss Me, Kate*." After another pause he
added, "It's my mother's name, Kate—Kate Cole Porter." *Kiss Me, Kate* is considered
by most to be his finest musical comedy.

Richard G. Hubler, who ghosted an autobiography which Cole in the end declined
to publish, saw him close to this time and wrote: *My impression was that Porter was
a small man in repose. But I noticed when he was talking or playing the piano—not
too well—he seemed almost perceptibly bigger. He literally gained stature from his
work. When he chose, he could dominate a group with his personality but he did
not often make that choice. He had a big-eyed, sensitive face—extraordinarily calm
for a man who had suffered as much and as long as he had—with a well-tanned skin.
What little remained of his hair was combed precisely in the middle.*

Many observers commented that Porter's most striking feature was his gentle brown
eyes. "One finds eyes as frank and questing as his only in the strange koala bear,"
wrote Hubler.

Porter lived with constant, and often intense, pain. A riding accident in 1937 left
him with legs that were never to mend and which occasioned some thirty-five opera-
tions. He carried on in what can only be regarded as heroic fashion, working, travel-
ing, partying very much as usual. "Geraldine" and "Josephine" he dubbed his re-
calcitrant legs, and, when finally faced with the amputation of his right leg in 1958,
he said whimsically, "Geraldine has been unfaithful to me, in her fashion." Until the
last years, when he asked, "How can one help being depressed when all those you're
closest to are dying?" he maintained a facade as witty and urbane as his songs. In 1954
he said to Hubler, "What have I got out of life? Happiness, for the most part, and an
income which has pleased me." He noted, "I am happiest when working alone on a
new score with pad and pencil and rhyming dictionary."

It was often said of Porter that he seemed never to age. Brendan Gill, in his intro-
ductory essay to *Cole*, remarked, "People who hug life to them, though they grow
older, never grow old: Cole carried with him to the grave not the ravaged face of an
old man but the ravaged face of a young one."

Porter, born to wealth, educated at Yale and Harvard, married to a rich woman of
extraordinary beauty, moved all his life in the world of amusement and glamor. He
had many friends and no enemies. This intrinsically shy man was the intimate of the
rich and famous, a major adornment of celebrated circles everywhere. His image, par-
ticularly in the twenties, was that of an international playboy. In his memoirs, dic-

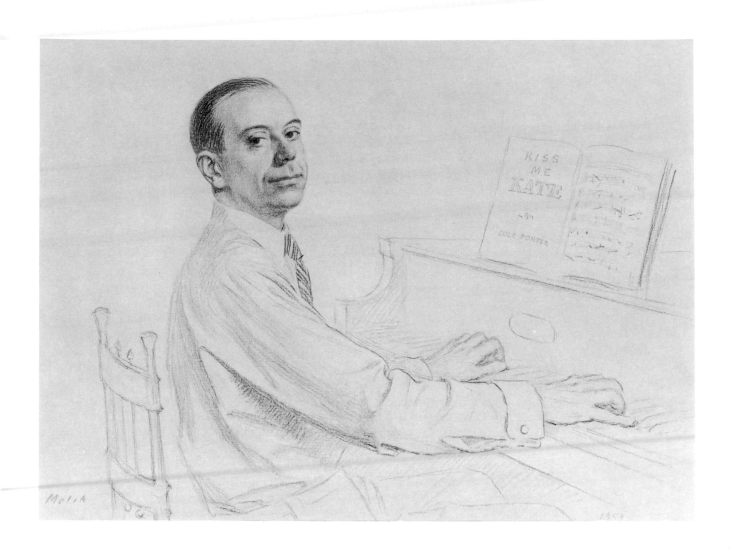

Cole Porter by Soss Melik, 1953

tated in 1954, he understates this reputation in characteristically Porterish terms: *The legends about the whole European idyll of Linda and myself are greatly exaggerated, I may say here. It is true that we bought a $250,000 house in Paris with zebra rugs and a platinum-leaf room, but we rarely used it. We were generally somewhere else—in England, Italy, or Spain. As for the four-year lease on the Palazzo Rezzonico, it is true we held parties which the social set of that day felt to be a little dazzling. The opinion as to which was the most vulgar was divided between the one where we had six hundred guests and fifty gondoliers for guard, with spotlighted tightrope walkers and fancy dress, and the one where Diaghilev brought his ballet company to dance and I supplied him with fireworks, a fifty-foot statue of Venus, and two hundred thousand candles to light up the sky. I personally was proudest of my* galleggiante. *This was a gigantic barge that held one hundred fifty guests. I designed it for a Venetian hotel and it plied the canals for months, loaded with visitors, with a French chef, a colored Dixieland band, a wine cellar, and a ten-dollar cover charge.*

Porter's life style at the time of the portrait was less spectacular but still luxurious. He was no longer a playboy but still very much a bon vivant. Six months of each year were spent in California and six months in New York, with weekends at his Williamstown, Massachusetts, estate. All his life Porter lived surrounded by a surfeit of material possessions. As a thirteen-year-old schoolboy from Peru, Indiana, he had arrived at Worcester (Massachusetts) Academy with luggage that included paintings, statuary, and an upright piano. But, even as he wallowed in all the best things in life, what he wanted more than anything else was success on Broadway.

His mother had destined him for this success. By the time he was six, she had decided that he would be a musician. Piano and violin lessons and trips each year to Chicago for two weeks of theatre and opera nourished his natural propensity toward music. Kate Cole Porter, who herself played satirical burlesques of popular tunes, determined, perhaps unwittingly, the form that her son's musical talent was to take.

From the first Porter delighted his circle of friends and acquaintances with his tuneful sophisticated melodies. Before he graduated from Yale, he had written over three hundred songs, including the immortal "Bulldog Yale." Yet, as he put it, "For nine hard and miserable years, I was the most outstanding failure in the musical world." He was thirty-seven before he had his first smash in *Paris*.

Sometimes it took him twenty-five minutes to compose a tune; at other times it would be days. He wrote in his lifetime the words and music to over fifteen hundred songs. Gifted with remarkable powers of concentration, he said he could work anywhere. Seated between two bores at a dinner party, he put his mind to work at composing. At the time of his accident, while waiting for the ambulance to arrive, he wrote "Long Last" for *You Never Know*. When his mother was stricken with a cerebral hemorrhage in August of 1952 and he sat outside her door waiting for the end, he beat out the *Can-Can* finale. "It was," he said, "one of the strangest experiences of my life but the number had to be done."

Despite his genius, Cole Porter's ego was, as he himself said, "always a rather frail and delicate bloom." Support from his mother and his wife Linda was a constant necessity for him. He wrote, in tribute, "I've had two great women in my life. My mother, who thought I had this talent, and my wife, who kept goading me along, in spite of the general feelings that I couldn't appeal to the public." Even after he had known many a sweet success, he was highly sensitive to criticisms of his work. He once said, "God damn 'Night and Day!' Every time I write another tune, someone is bound to say it isn't as good as 'Night and Day'!" He was bothered when critics said that he wasn't the composer he once was. "It's not from his top drawer," was a particularly wounding phrase. He had to be constantly reassured that his songs were

good. His first flop in 1916, *See America First*, sent him off to join the French Foreign Legion. His last disaster, the 1958 television score for *Aladdin*, occurring when he was alone in the world and increasingly ill, ended his musical career.

The opportunity to do the score for *Kiss Me, Kate* came to him at a time of great self-doubt. He had suffered a series of failures. People were saying that he was through, and he wasn't sure that they weren't right. Both his mother and his wife were in precarious health. He had developed a pathological fear of being without money. With an income that put him, during World War II, in the ninety-two-per-cent tax bracket, he worried about being unable to afford his months in California, and had visions of having to sell some of his treasured possessions. He undertook a musical based on Shakespeare's *Taming of the Shrew*, only because a projected collaboration with a writer of soap opera was clearly a mistake and he desperately needed work to prevent total demoralization. Once into the task, he composed furiously, turning out between February and May of 1948 some twenty-five songs, seventeen of which were eventually used. Author Bella Spewack begged him not to write any more numbers. She was less than delighted when Porter called her at 2:30 A.M. to sing, in "his lovely, velvety small voice," the just-completed "Why Can't You Behave?" And even after that, the ideas kept coming, and he couldn't hold back from sending on "Brush Up Your Shakespeare"—although with the note that Bella would probably cut her throat.

In the thick of his labors his dog jumped on him "with charming enthusiasm," causing an abscess and ulcer just over a large nerve center. "This started all the nerves in my leg raising terriffc hell and the pain has been so great that the drugs have had practically no effect." After admitting that he had been in agony for three weeks, he wrote to a friend, "My show is very exciting. I've written 15 songs and have about five more to do. You'll like this score. It's so simple it sounds as if it had been written by an idiot child."

Kiss Me, Kate proved to be "the perfect musical," needing no changes after its Philadelphia opening. It went on to New York and ran for 1,077 performances. The songs, which included "Another Op'nin', Another Show," "Why Can't You Behave?," "Wunderbar," "So in Love," "We Open in Venice," "I Hate Men," "Too Darn Hot," and "Always True to You in My Fashion," were some of the best in Porter's prolific career. *Anything Goes*, which his words and music had made into a hit despite a botched book, remained a sentimental favorite with him, but *Kiss Me, Kate* symbolized his finest work. Asked if *Kate* was the perfect musical success, he replied, "Almost. Then unfortunately along came a little thing called *South Pacific*." Speaking of Rogers and Hammerstein's "Some Enchanted Evening," he said with a twinkle, "If you can image it taking *two* men to write one song."

At the time of the portrait, he had finished *Can-Can*, a modern adaptation of French music-hall songs of the 1890s. The reviews were mixed, and a crushed Porter took to his bed. In the end it ran for a respectable 892 performances and contributed "I Love Paris" and C'est Magnifique" to the list of Porter hit tunes.

Artist Soss Melik was born in Russia, and studied at the National Academy of Design in New York. Commencing in the late 1930s, Melik sought to document the faces of the significant literary and theatrical figures of the era. His friend, literary critic Alexander Woollcott, who believed the project to be a "most worthy effort," arranged for many of the sittings. By the time Cole Porter posed, Melik had drawn such celebrities as Franklin P. Adams, Maxwell Anderson, Sherwood Anderson, Stephen Vincent Benet, Louis Bromfield, Pearl Buck, Zane Grey, Moss Hart, Ernest Hemingway, George S. Kaufman, Sinclair Lewis, Edna St. Vincent Millay, Marianne Moore, Eugene O'Neill, Robert Sherwood, Booth Tarkington, Thomas Wolfe, and Alexander Woollcott (all now in the collection of the National Portrait Gallery).

As he sat for Melik, Porter's mood was nostalgic. He talked of the past, particularly of those years when he had rented the Palazzo Rezzonico. As a boy in Indiana, Porter had been fascinated with the view of the Grand Canal of Venice painted on the curtain of the local theatre. When his grandfather died in 1923, leaving his mother a half million dollars, which she promptly divided with her son, Porter had the chance of fulfilling his boyhood dream of living in a Venetian palace. Seated in the chair which had originally been in the Rezzonico, he told Melik, "In the 1880s, when John Singer Sargent, as a very young artist had a studio at the Rezzonico, he used this chair in a portrait he was doing of a lady pianist." Porter went on, "It's a magnificent building." He seemed particularly pleased that Frank Duveneck also had had a studio in the Rezzonico. "Duveneck was from my part of the States—from Cincinnati which isn't far from my home town of Peru, Indiana." The cosmopolitan Porter added, "And William Chase was from Indiana as were other fine American artists and writers."

Richard Adler, in summing up Porter's career, described him as "the Adlai Stevenson of songwriters." Adler said: *He was an aristocrat in everything he did and everything he wrote. Everything had class— even a little pop song like "Don't Fence Me In." There are no other writers like him. . . . Cole wrote exquisite melodies. And the openness and simplicity of them. I mean, when you go—you'd be so easy to love— with what we call footballs—whole notes—he knew how to write that open song that a singer can belt. He had that commercial instinct. He was also lucky to have lived and died at the right time, because he lived in an era of flourish.*

Eells, George. *The Life That Late He Led.* New York: G. P. Putnam's Sons, 1967.

Gill, Brendan. "A Biographical Essay." *Cole.* Edited by Robert Kimball. New York: Holt, Rinehart & Winston, 1971.

Hubler, Richard G. *The Cole Porter Story.* Cleveland and New York: The World Publishing Company, 1965.

Rachel Carson 1907–1964
By Una Hanbury
Bronze
29.2 cm
Signed: UNA [left side of neck]
1965
NPG.69.19

Rachel Carson was less than four months away from death when Una Hanbury met her for the first and only time at an Audubon Society dinner. Mrs. Hanbury, sculptor of human and animal figures, decided then and there to model the renowned author of *Silent Spring.* Following Miss Carson's extemporaneous speech, the two talked, and Miss Carson indicated that she would be pleased to have her bust done. Mrs. Hanbury was surprised, she recalled later, to find the fifty-six-year-old scientist–author so feminine and so petite. She was struck, she reported, by Miss Carson's "tremendous vitality." It was this characteristic the artist chose to capture and underline.

Mrs. Hanbury detected no signs of Rachel Carson's illness, and only when she called, in early April, to arrange for the sitting did she learn that Miss Carson was near death. The end came little more than a week later on April 14th, 1964. In consequence the bust had to be done from memory supplemented by photographs. *Life*

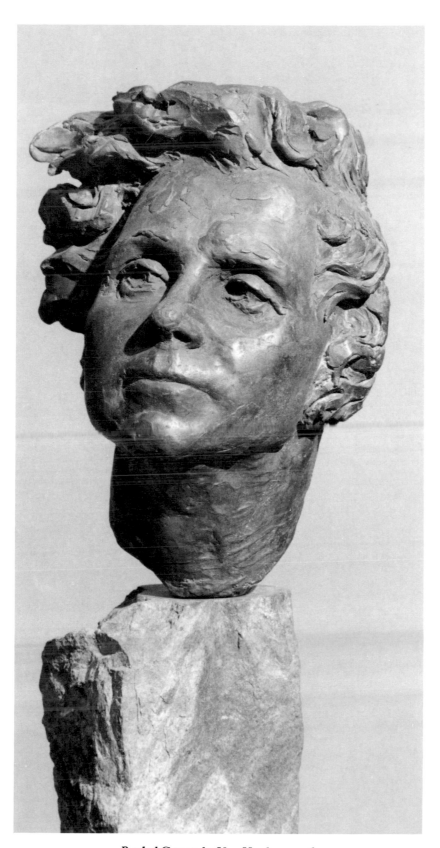

Rachel Carson by Una Hanbury, 1965

magazine provided a series of photographs showing the naturalist in her beloved Maine tidal pools. Miss Carson, a neat and particular woman, who always wore a hairnet when she was out-of-doors, was persuaded, with the greatest of difficulty, to let her hair blow free.

Mrs. Hanbury has been sculpting for as long as she can remember, and doing portrait busts since the age of fourteen. Born in England, she studied at the London Polytechnic Schools of Art and the Royal Academy of Arts. Coming to Washington in 1944, she became a citizen of the United States, and was living, at the time she executed the bust, in northwest Washington, not far from Rachel Carson's Silver Spring home.

For most of her life Rachel Carson had been a very private person. But with the publication of *The Sea Around Us*, sans jacket photograph, in 1951, the world became curious about this obscure bureaucrat in the Fish and Wildlife Service who could translate the complexities of biological science into clear and beautiful language. *Newsweek* found her to be "a matter of fact, quiet woman." The *New York Herald Tribune* described her as "of medium height, quite slim, and blue-eyed." The paper also noted that "she is credited by her friends with a very nice sense of humor, but, on the other hand, not much small talk." The *New York Times* saw her as "a small solemn-looking woman with a steady forthright gaze of a type that is sometimes common to thoughtful children who prefer to listen rather than to talk."

Miss Carson herself acknowledged that she was a disappointment to those who expected her to be completely nautical. She remarked, "I swim indifferently well, am only mildly enthusiastic about seafoods, and do not keep tropical fish as pets. Speaking of pets—my very closest nonhuman friends have been cats."

Her biographer, Paul Brooks, wrote, "No one who knew her—and particularly who had explored a beach or tide pool with her—could fail to sense a youthful enthusiasm, a sense of adventure that, to the end of her life, turned the humblest trip into a voyage of discovery."

Silent Spring, which detailed for the first time in layman's language the dangers of indiscriminate use of pesticides, caught the attention of the world and made Rachel Carson's name a household word. She became overnight both a heroine and the center of a storm of controversy. "Hers admittedly was a one-sided presentation but so was Harriet Beecher Stowe's *Uncle Tom's Cabin*," said the *New York Times* editorially after her death.

The book, first published in 1962, was the product of more than four years of incredible labor—painstaking research to buttress her case against inevitable attack, and exacting writing, revised again and again. "I am," Rachel Carson said, "a slow writer, enjoying the stimulating pursuit of research far more than the drudgery of turning out a manuscript." Only after the book had been read aloud, to guard against "passages where disharmonies of sound might distract from the thought," did it meet her meticulous standards.

Long before the work was complete, Rachel Carson knew that she had cancer, but, as she wrote to her doctor, "I still believe in the old Churchillian determination to fight each battle as it comes ('We shall fight on the beaches' . . . etc.) and I think a determination to win may well postpone the final battle."

There were other illnesses too, a "whole catalogue," as she put it. She wrote to a friend, "If one were superstitious it would be easy to believe in some malevolent influence at work, determined by some means to keep the book from being finished." Plagued now with iritis and arthritis, she described the "tremendous lot of work" still to be done before she could let the book go to the printer, as being "rather like those dreams where one tries to run and can't or to drive a car and it won't go."

Somehow the manuscript was completed, and when she realized, from the reaction of her publisher, that her message would get across, she took her cat into the study and put on a recording of Beethoven's Violin Concerto. "And suddenly the tension of four years was broken," she wrote to a friend, *and I let the tears come. I think I let you see last summer what my deeper feelings are about this when I said I could never again listen happily to a thrush song if I had not done all I could. And last night the thought of all the birds and other creatures and all the loveliness that is in nature came to me with such a surge of deep happiness, that now I had done what I could—I had been able to complete it—now it had its own life.* Even so, she could have hardly foreseen the success her book would have in arousing public opinion against the poisoning of the earth. As the *New York Times* put it after her death, "she was a biologist, not a crusader, but the power of her knowledge and the beauty of her language combined to make Rachel Carson one of the most influential women of our time." Conservationist David Brower succinctly explained her success: "She did her homework, she minded her English, and she cared."

Her last year was a procession of honors and awards, the most deeply satisfying of which was membership in the American Academy of Arts and Letters. Crippled further by a heart attack, she wrote: "So many ironic things. Now all the 'honors' have to be received for me by someone else. And all the opportunities to travel to foreign lands—all expenses paid—have to be passed up." Now that her name could lend weight to any cause, she wrote, "I keep thinking—if only I could have reached this point ten years ago! Now, when there is an opportunity to do so much, my body falters and I know that there is little time left." She wanted time to write a "Help Your Child to Wonder" book and a big "Man and Nature" book. "Then I suppose I'll have others—if I live to be 90 still wanting to say something."

Brooks, Paul. *The House of Life: Rachel Carson at Work.* Boston: Houghton Mifflin Co., 1972.

Rothe, Anna, ed. *Current Biography, 1951.* New York: H. W. Wilson Co., 1951, pp. 100–2.